DEAD Weight

DEAD Weight

Essays on Hunger and Harm

———

Emmeline Clein

Alfred A. Knopf, New York 2024

THIS IS A BORZOI BOOK
PUBLISHED BY ALFRED A. KNOPF

www.aaknopf.com

Knopf, Borzoi Books, and the colophon are registered trademarks of
Penguin Random House LLC.

Selected material originally appeared in the following publications: "Coda:
Against Dissociation Feminism" as "The Smartest Women I Know Are
All Dissociating" in *BuzzFeed News* on November 20, 2019; and "Skinny,
Sexy, Seizing" as "Do You Want to Be Sad, or Skinny? The Slippery Solution
of Wellbutrin" in *Vice* on June 14, 2021.

Library of Congress Cataloging-in-Publication Data
Names: Clein, Emmeline, author.
Title: Dead weight : essays on hunger and harm / Emmeline Clein.
Description: First edition. | New York : Alfred A. Knopf, [2024] |
Includes bibliographical references. Identifiers: LCCN 2023022274 (print) |
LCCN 2023022275 (ebook) | ISBN 9780593536902 (hardcover) |
ISBN 9780593536919 (ebook) Subjects: LCSH: Eating disorders in women—Social
aspects—United States. | Body image in women—United States. | Feminine
beauty (Aesthetics)—Psychological aspects. | Eating disorders in popular
culture. | Eating disorders in literature. | Clein, Emmeline—Mental health. |
Clein, Emmeline—Health. Classification: LCC RC552.E18 C54 2024 (print) |
LCC RC552.E18 (ebook) | DDC 616.85/260082—dc23/eng/20231002
LC record available at https://lccn.loc.gov/2023022274
LC ebook record available at https://lccn.loc.gov/2023022275

Jacket design by Janet Hansen

Manufactured in the United States of America

First Edition

for the girls who saved me

to EGC, ACV, ABC, CLSB & EXM

It's never seemed particularly obvious to me that
hot girls are having such a great time.

—VIRGINIE DESPENTES, *KING KONG THEORY*

When I can't eat it's because I feel totally alone.

—CHRIS KRAUS, *ALIENS & ANOREXIA*

This is a love story and I apologize; it was inadvertent.

—EVE BABITZ, *SLOW DAYS, FAST COMPANY*

Contents

DEAD Weight

Prologue

Have you ever seen a girl and wanted to possess her? Not like a man would, with his property fantasies. Possess her like a girl or a ghost of one: shove your soul in her mouth and inhabit her skin, live her life? Then you've experienced girlhood, or at least one like mine. Less a gender or an age and more an ethos or an ache, it's a risky era, stretchy and interminable. It doesn't always end. That ever-gnawing void can make you want a body to match, one that looks as hungry as your heart is. Sobbing and throbbing, a lot of the most beloved icons of girl culture are very, very sad, and very, very skinny. They are beautiful, and their sorrow only adds to their sex appeal. Tears drip down cheeks onto supple pouts, but that suppleness never extends to the rest of their physical forms, which tend toward extremely slender. Bodies shrink to ever-smaller sizes as sad girls lose their appetites, distracted by all that emoting.

The sexy, skinny, sad girls consume a lot of alcohol and drugs, but they don't eat often, and this is integral to the trope. Marissa Cooper, with her hidden vodka bottles and torrid affairs, chasing oblivion in *The O.C.*, is not so different from the young heroines of Jean Rhys novels, drinking their way through the bars and hotel rooms of European cities. All these girls distraught enough to delight us, drinking on empty stomachs. Those girls prefer Pernod to food. Marissa's generation-defining low-rise jeans and spaghetti straps hang off her bones. She's a dead girl walking from the jump, all jutting angles and a handle of liquor in her bag. Young adult novels are so often sketches of sad teenage girls

subsisting on some wildly minuscule portion of food, licking single spoonfuls and slicing things too thin. It's not just young adult literature either; in so many stories, a certain kind of girl is always "subsisting." I've run into that word, stopped and underlined it, more times than I can count. It is a term implying spartan survival, never the luxury of living. These girls opt for other luxuries: longing stares, hearing the cadence of their names in whispers, slipping into sample sizes.

In the eating disorder memoirs I studied diligently when I started starving myself in 2007, at twelve years old, writers subsisted on cigarettes and specific foods I won't tell you about. I have a file on my computer of all the foods I'm not naming now, a file filled with the pithy lists of starvation diets written by women writers I admire. These were usually offered up in curt trios, holy trinities. These girls thought themselves saints of something, and I nodded and kneeled. They wrote hunger haikus, so I copied them down dutifully, a disciple. I planned to list them here, before I realized I don't want to write one of those religious texts, rife with commandments and sublime suffering and hierarchies. Too many people I love have misread a memoir as a manual.

I don't want to inspire anyone to restrict their intake, dietary or emotional. I want to give something to sad girls, former ones and almost ones and aspiring ones and current ones and their lovers and their haters, that sounds like a symphony or a screamo band or a country song to cry to, cacophonous and guttural and probably trying too hard. I want to drape the living skinny, sexy, sad girl in hazard lights instead of letting her corpse soak up the spotlight, and I don't want to demonize her even as I try desperately not to glamorize her, because it's really not her fault. She probably just watched the same movies I did.

In middle school in the mid-aughts, I read young adult novels with titles like *Suicide Notes from Beautiful Girls* and *Pretty Little Liars*, listened to Paramore on a loop and watched *Gossip Girl* and *The O.C.* obsessively. In books and on screens, the skinny, sexy, sad girl usually likes to numb herself. If unconsciousness is unavailable, she might distract herself from the pain with a high. A lot of these characters don't survive their storylines. Bright young things flame out. We all know what happened to *The Virgin Suicides'* series of pubescent, pallid

blonde beauties. Flower-crowned and drowned, Ophelia is an icon to girls cruising for a muse. Daisy, *Girl, Interrupted*'s bulimic character, died by suicide on her birthday, and she is the only girl in the book who gets called *sexy*. *13 Reasons Why*'s high school protagonist Hannah overdosed as a literary character and slit her wrists once she was adapted to television, Emma Bovary drank poison, Anna Karenina dove in front of a train, and I'm only halfway through the alphabet in Wikipedia's list of "Suicides in Fiction." I'm just name-checking the most famous ones, the girls you've clicked past or gazed at, maybe even cried over. Sad girls lilt through their lonely lives, becoming beloved only in death. It doesn't seem to matter how many times we watch this type of girl die; we can't learn our lesson, won't saint them until they martyr themselves for the cause.

I was already sad, so I thought I might as well express it, like many of these girls did, with my body. I stopped eating as much and spent hours scrolling through Tumblr, finding other sad girls and reposting their poems and black-and-white photography. I watched my body shrink in the mirror, proud to discover how powerful my mind was. Lying in bed at night, I imagined the inside of my stomach, whatever I'd eaten that day stacked neatly against bloodred walls. My mother noticed the sculpture to self-hatred I was hammering away at and sent me to a clinic, where I was first given the diagnoses of "eating disorder," "anxiety disorder," and "depression." Finally, I didn't feel like a fraud. I was officially as sad as my idols and my online sisters.

Susan Sontag once wrote the phrase *sororal death* in her journal—she thought it meant women dying for each other, and she didn't think it existed, suicidal solidarity, but then, she'd never spent time in an eating disorders ward or stood watch outside a bathroom a friend was throwing up in. Anne Boyer, writing a theoretical framework for breast cancer, defines *sororal death* as *dying of being a woman*. She writes a membership roll: the women authors who died of breast cancer or suicide to avoid the progression of breast cancer. Other sororal deaths I'd include: deaths from eating disorders, which have some of the highest mortality rates of any mental illnesses, and deaths from botched plastic

surgeries. Dying of the demands of womanhood, the fascism of femininity. Boyer includes Jennifer, one of *Valley of the Dolls'* starlets, who chose death instead of a mastectomy because she thought her lover and her public loved her for her hourglass body. I imagine sororal deaths by body fascism, corpses wrapped in spandex. Some yearnful, clumsy girl going to return her weights to the bin after an exercise class, but her hands are sweaty. Her dumbbell slips and lands on someone's skull. A girl taking her Pilates rollover at the wrong angle snaps her neck. A woman strangled by the bands of the Megaformer, tangled and terrified. Someone puts their gloves on wrong in boxing class, hits their partner too hard and gives her a brain bleed. I don't mean to make this all about working out; I only bring it up because I find myself fantasizing about or fearing imminent death whenever I'm in an exercise class, breathing hard and wishing harder.

I'm trying to be honest here: I've always wanted to live the kind of life that ends up in a story, but those are fiction. Being my own sexy, sad icon started getting dangerous, so I'm trying this instead. I am writing this for and through all the girls who died sororal deaths. I am trying to harmonize with a ghost choir. Throughout this text, I quote my sisters in italics and use traditional quotation marks for the doctors, scholars, news outlets, and others who think they know what we're up to. I quote my sisters by their first names, because I feel like I know them. When I say sisters, I don't mean people of a specific gender. I mean anyone who's ever felt trapped by the genre of their life story, anyone who's ever hurt themselves hoping to become beautiful, anyone who's ever mistook an admiring look for love, ever longed to lick another's pain off their tongue, taste their sweat and feed them chocolate. If you've survived the kind of girlhood I've been trying to describe here, I hope you'll let me call you my sister. The skinny, sexy, sad girl's silhouette has haunted so many of our dreams. She hawks her sick sort of beauty, purring false promises from just over the horizon line. But someone stranded her at the vanishing point, where she recedes ever farther into the distance the closer we get, and they don't want us to reach her because then we might save her, convince her she's been lied to like the rest of us. I'm trying to row a lifeboat, and write a love letter, and learn to swim. I am writing this for the living girls hiding in their bedrooms obsessing over the dead

ones, the hungry girls and horny girls and hidden girls, the dead girls who thought the only way they'd be remembered was by sliding into their place in the canon-cum-mausoleum, for all the girls who weren't wrong and all the girls who were.

An aside, and I'm just talking to my sisters now: I want you to know I know how much it hurts, the hunger and the misunderstanding and the things they write about you, and I know how smart you are. I'm attempting to write a book to replace the ones I know you read backward, cautionary tales turned guidebooks and novels turned scripture. I'm not trying to outsmart you, I'd never think I could, but I'm trying my best not to give too many numbers or site names or other potentially triggering details. It's not that I don't think you can handle it; it's that you shouldn't have to. Too many eating disorder memoirs are still mired in the disease's self-hatred, obsessing over our flaws, the fears that rust at our edges, orange-green poison; we've all seen bile in the toilet. Other books have been condescending or too cautious or adversarial, but what I want is to level with you, to sit cross-legged and talk about the thoughts that almost killed us, until we decided not to let them and sent them out into the internet instead, which is where I first found you, and finally let out the breath I'd been holding.

I spent years trying to write about the mental health issues my friends and I live with, and I kept finding myself slotting us into the same roles, even though I know we're more complex than all that. The narrative pulls me out like a riptide, exciting at first, getting me breathless, and all of a sudden I am too exhausted to swim back. The water's warm, after all. In a fiction writing class in college, people liked these stories. Girls related, said they too had idolized their saddest, skinniest friend. I thought I was painting our portraits, but what I was doing was closer to editing an Instagram, using apps to whittle away at our waists and add moody filters, oversaturating colors and dragging my finger across the contrast bar, bringing out bones. Marissa, Edie, all the It Girls: my muses were cautionary tales I mistook for role models. Molding myself

in their image left me both hungry and smug, even as the doubt crept in—could everyone tell how hard I was trying to keep it together, or fall apart beautifully? Was there a difference, if I wanted to be loved? The question kept me up at night, scrolling, as my stomach growled.

For aspiring skinny, sexy, sad girls today, there's still Tumblr, but there's also Twitter, and there are listicles online that serve as syllabi. *Thought Catalog* recommends *Edie: An American Girl,* a tale of an adolescent anorexic socialite turned supermodel's descent into addiction, and *The Bell Jar,* starring a magazine intern turned mental patient, in its curated list of "10 Essential Books for Sad, Young, Literary Girls." These girls get photographed, angular arms captured in camera flashes, and dress their bodies like dolls. They often work in or around the fashion industry, familiar with spotlights and sample sizes. In their list of "9 Sad Girl Books for Your Sad Girl Autumn," Electric Literature also suggests *The Bell Jar,* along with Rhys's *Voyage in the Dark* and Ottessa Moshfegh's novel about a beautiful blonde pill addict, a girl who goes days between meals.

Aspiring skinny, sexy, sad girls spill their secrets and post selfies online, after reading about fictional sad girls in books and watching them on screens big and small, listening to their lyrical wails. We read books about skinny, sexy, sad girls written by skinny, sexy, sad girls, and if we're really devoted we watch the movie versions of the books we just read and then read about the actresses falling apart behind the scenes. We're all sisters in sorrow here, starving for something and desperate to stun you into silence. We're hungry for affection and attention, likes and love. You don't have to applaud, but you have to watch. Follow me on Instagram and Twitter and OnlyFans, and I'll be artistic and sad and skinny and sexy in an infinite circuit. It's just our high-intensity interval training, I mean—how do you stay in shape?

In the eating disorder memoirs, the girl recovers, but she often still wants us to know how close she got to the ultimate finish line. In so many of these stories, she blames her sisters for sending her there, teaching her their tricks and comparing limbs in high school hallways, and then in hospital wards. The only way to survive seems to be renouncing

your suffering sisters, transfiguring them into mean girl villains or naïve, vain illness vectors. I'm trying to find out what might happen if we blame someone other than each other and ourselves for a change. In an exploration of her own anorexia diagnosis, the writer Rachel Aviv visits a therapist who treated her on an eating disorder ward in her childhood. She tells him she feels like she was *taught the illness* by other girls, girls like her best friend from the hospital, whom she googles, only to find her obituary and an article about her brief life, pockmarked by anorexia hospitalization after anorexia hospitalization.

Once, between hospitalizations, that girl went to a party. I can imagine her angst, or I can feel it, and I wish I'd been there to say hi and ask how she was feeling. Uncomfortable and uncertain among the socializing strangers, she saw a girl she'd once been in eating disorder treatment with and made a beeline for her, *hoping to reminisce about things that happened when they were institutionalized, but the girl was trying to escape.* Her former patient-peer shook her off; she was *assimilating* into the *normal* world, done with sick, starved girl world. The message was: *You make me vulnerable.* The contagion of identification, the terror of slipping into a story with a sad ending, the notion that porousness between people is potentially toxic rather than what makes life worth living. This scene is tragic because it is true and invented, because we were taught to believe it. But we don't have to be solo heroines on lonely journeys; we can also be sisters and friends, side characters in someone else's story without meeting her fate. We can, maybe, even be the person who changes it.

Can I tell you a story that isn't mine? I'm going to be doing that a lot, but it's because I can't tell where you stop and I start, or I don't think it matters, not when we're locked on the same ward. Besides, so many of our stories are so similar, I slipped into yours in my dream last night, and you're welcome here whenever you want. Let me make you a drink and tell you about someone you might have been.

On Our Knees

The Sexiest Woman in the World is on her knees. What's she up to? We're in a small town in Middle America: Devil's Kettle, Minnesota. I want to know where your mind went first, and I want brutal honesty, because things are about to get gruesome. Did you imagine her praying or giving head, those big red lips pursed or parted in supplication? Those big red lips are dripping blood, the Sexiest Woman in the World is drenched in it. Her knees hit the kitchen tiles hard—that's going to bruise. She opens her mouth wide enough to deep-throat a dick and spews black vomit. The liquid is luminescent, pooling on the floor in front of the refrigerator. Rewind a minute, and the Sexiest Woman in the World is crouched in front of a fridge, which is gaping open and bathing her in fluorescence. She pulls out a rotisserie chicken and throws it to the floor, tears off the plastic lid and dumps the meat on the ground, begins ripping it off the bone with long fingers and shoving it in her mouth.

The Sexiest Woman in the World is Megan Fox, at least according to *For Him Magazine*'s annual rankings. A year before her coronation, she is playing a cheerleader possessed by a demon in the middle of a bulimic episode in the movie *Jennifer's Body*. Early in the film, Jennifer's body, which is very hot, is spotted by the brooding lead singer of an emo boy band, who decides she'd be perfect for a virgin sacrifice. Unluckily for this satanic singer, Jennifer had anal sex last weekend and vaginal sex years ago, so Satan thinks she's a fucking slut and has a demon enter her during the ritual. Over the course of the film, Jennifer's body gets emaciated, bloodied, tied to a rock, turned into a succubus, and impaled

on a kitchen knife. Jennifer's body also gets hungry and horny. She eats boys and makes out with her female best friend, a girl so hungry for affection her nickname is Needy.

Jennifer's body dies in the end, but not before she bites Needy during a homoerotic fight scene. Turns out, demonic possession is contagious. The film ends with Needy in an asylum, scratching her glowing scar and levitating up to a window, which she kicks through. She marches confidently into the surrounding woods. Rare: a blonde girl walks alone at night, unafraid. Cut to black, credits roll, pink neon script, but then— just kidding. Now we're in a hotel room with the satanic boy band. They've been living large, touring the country, and now they're snorting coke, cackling, and then they're screaming. Blood splatters the wall and we get the movie's real ending, a blonde girl bingeing on a boy band's flesh. In Megan's own words, this is a movie about the myriad ways *girls can be nightmares*.

Once, a scared woman checked herself into a hospital looking for a cure. Like many such women, she had done some research about her symptoms. She told the doctor she had anorexia, she was afraid, and she wanted to live. Partaking in the long tradition of male medical professionals disregarding women's words, gazing at their bodies, and assigning them pathologies, he looked her up and down and made some judgments.

This psychologist, Gerald Russell, oversaw an anorexia clinic, and this woman did not look like his anorexics. In his notes he wrote that she wasn't thin enough. Also, her skin was too pink. His anorexics were wan, and this woman looked healthy. Red flag, maybe she was a liar. He got her talking and found out she often ate in massive quantities and then made herself vomit.

Russell had a discovery on his hands. The year was 1972, and another doctor was about to get famous naming a girl disease. Over the next seven years, Russell met thirty more women whose weight he described as "average" or "overweight" in his clinical notes, and who reported binge eating followed by forced vomiting. In 1979, Russell published a paper defining *bulimia nervosa*, in his words "an ominous variant" of

anorexia nervosa. Bulimia comes from the Greek word *boulimia,* meaning "ox hunger." The medical literature is unclear about whether Russell was implying that his bulimics had the appetite of an ox or that they had large enough appetites to eat an entire ox, but you get the picture. A diagnosis required three criteria: subjects must have a compulsion to overeat, have a compulsion to purge after the binge, and be "morbidly fearful of becoming fat." According to the paper, the main difference between bulimics and "true anorexics" was that the former "tended to be heavier" and "more active sexually."

Bulimics had arrived. They climbed onto the platform and donned the silver medal. They had a diagnosis now, something written on their case files other than "aspirational anorexic," a consolation prize for having the fatter, sluttier, greedier eating disorder. That reputation would turn out to be hard to shake. *The British Journal of Psychiatry* called the disorder anorexia's "ugly sister" in 2004.

Twenty-six years before Russell discovered his disease, a girl named Carol was daydreaming during a history class about the ancient Roman Empire when it hit her: she didn't need to be denying herself. The teacher was discussing their reading on ancient Roman feasting rituals, which included a mid-feast vomit break, so the feasters didn't have to stop eating when their organs distended. What was she doing, dieting all day, gazing longingly at pasta in the dining hall, when she could simply eat everything and then throw it back up? Excited, she crossed her legs and bounced ankle on ankle, anxious to tell her best friend her idea.

Jane was a jealous girl, and convincible. She gazed askance at akimbo limbs on the campus green, wondering why she couldn't sprawl out like that. She'd already been searching for a way to eat endlessly without gaining weight, to no avail. At thirteen, she had ordered gum from a catalog because it claimed to be seeded with tapeworm eggs, which would hatch in your stomach and eat what you did before your body could digest it. That turned out to be a scam, but those worms still wiggled through her intestines at night sometimes, when she let herself fantasize before falling asleep. In daylight, she declined pastries, pining for a parasite.

So Carol proposed the plan, and the girls stole brownies from the dining hall, begged the kitchen workers for ice cream cartons, and staked out the dumpsters for stale bread. Before school dances, they binged, eating until their stomachs swelled up, rubbing each other's protrusions like they were pregnancies before stumbling down the hall to the bathroom. They bumped ankles on the bathroom floor and smelled each other's breath after brushing their teeth, guarding their secret. They didn't tell anyone, and they thought it was their idea. Jane kept it up once they graduated, through college and movie sets and marriages, and eventually she read magazine articles describing what she'd been doing for decades as a disease. Later, she learned two of her father's five wives had been bulimic, though they didn't have a name for it then. *I thought it was just me, Carol, and the Romans,* Jane Fonda insists in a documentary about her life.

Put a group of girls in a house and you'll catch the rank scent of vomit soon enough. Maybe the perfume wafting around has a rancid edge, smells like it's hiding something. Look at the way the girls are looking at each other. Watch a reality show if you don't believe me, or join a sorority. Former stars of *America's Next Top Model, The Bachelor,* and *The Hills* have spoken out about developing bulimia in their reality show housing. Two of the Spice Girls became bulimic while living with their fellow starlets. One member of a girl group recalled *our eating disorder* in an interview. A 2013 study found a 47 percent increase in the probability a girl will vomit or use laxatives to lose weight if she joins a sorority.

Fade in, it's 2004: the year that academic journal called bulimia anorexia's "ugly sister." In Fresno, Miss California is giving a speech to a group of middle school girls. These aren't all the girls in the middle school, or a subset of pageant girls or bookworms or aspiring actresses. These are girls the school believes are at risk for developing an eating disorder based on their responses to a survey. Miss California tells these girls her story. Thirteen and thirsting for affection, she nursed a crush on a boy. He told her she'd look better lighter, which is where our cautionary tale really starts, when she learned she could trade food for admiring looks. She rolls up her sleeve to show them the fuzzy coat her

body sprouted when she didn't have enough flesh to keep her warm, not quite a battle scar but definitely leftover armor. She warns the girls about the health problems anorexia can cause, the lifelong heart irregularities and metabolic issues.

As bad as she makes anorexia sound, she takes pains to paint bulimia as worse. She tells them another story, one meant to humiliate her ugly sisters, the sorority of bulimics she went to college with. She tells the classroom that those girls made themselves throw up so often that their regurgitated stomach acid melted the metal pipes in the walls, and the plumbing had to be replaced.

Miss California wasn't the first to blame bulimics for plumbing issues. Snopes, the fact-checking website, has an entire page, bibliography and all, devoted to the story, which, in the end, it deems a legend. Another woman writing a memoir about her own eating disorders recalls a security guard watching her attempt to enter a locked bathroom with *a smirk* on his face. At the college she went to, they kept the *bathrooms off the rotunda locked*, an attempt to *stop girls from throwing up, everyone said, in the way this comment was always made: those pathetic, gross, superficial girls*. Those wasteful, selfish bulimics, at it again. Wasting food and destroying property, making messes. Girls can be nightmares.

In 1983, *Social Work* journal published what purported to be a review of the literature written in the few years since bulimia was "discovered." The article claims that "initial binge eating in almost all bulimic females could be linked to real or imagined male rejection: the pursuit of thinness is begun in the pursuit of love." *The New York Times* reported that most bulimic women "have little self-esteem and measure their worth through the eyes of others." Supposedly, they struggle to fulfill their "submissive role as women." The woman becomes sick because she swallowed whole societal mores around womanhood in a heterosexual patriarchy and then couldn't keep them down, or live up to them. On the other hand, the queer experience of eating disorders is disturbingly little studied. But in the past decade scholars and research institutions have started exploring this terrain, which has turned out to be dangerous, filled with sinkholes and whirlpools, cliffs girls jump off. Eating

disorders were long assumed to be illnesses of heterosexual girls hiding from men or fearing rejection from them, while lesbians were off in an overgrown field, fucking far away from the patriarchy and its fetish for slimness.

But gay girls grow up in the patriarchy too, and the spores of sickness get planted in our brains early, by the magazines on our moms' bedside tables and the billboards we see out car windows, the mannequins in the mall. I used to think the thinner the girl, the more gorgeous, about girls I didn't want to admit I liked a little more than I thought I should, even as I recognized the self-harm it took for them to look that way, and was practicing myself. What I'm saying is that gay girls are people too, our subconsciouses are not just feminism textbooks even if we wish they were, and patriarchal body ideals can be just as pervasive in queer minds. On top of the regular old beauty ideals, a young gay girl's urges can feel wrong and make her want to harm the body having those desires, or at the very least make that body look like the bodies of girls we've been taught boys like, because that might help us keep our secret a little longer.

Recent research has, unsurprisingly, found that LGBTQ people are in fact a high-risk population for eating disorders compared to their heterosexual peers, and queer women are especially at risk for bulimia. A 2006 article in the *International Journal of Eating Disorders* called "same-sex sexual experience" a "risk factor for bulimic symptoms." A 2020 paper reported that fully 82 percent of lesbians interviewed "based their self-worth on their weight," and while bulimic symptoms decreased over adolescence in heterosexual girls, the "odds of fasting, using diet pills, and purging increased" for lesbians, who were twice as likely to engage in bulimic practices by the end of high school. Bulimic practices can be an attempt to embody the feminine stereotype queer women fear social punishment for deviating from. In the words of one woman who spoke to a researcher: *I just saw being thin as being straight and being accepted,* and she'd found only one way to be thin.

While the bulimic is imagined as a caricature of the archetypal straight woman, maniacally organizing her life around enticing a man, the anorexic is cast as a caricature of the idealized girl-child. Scholars have argued that the anorexic fears becoming a woman at all, starves

herself to stave off menstruation and the entrance into the coliseum of romance that usually comes soon after, followed eventually by motherhood. The anorexic is read as rebellious and selfless, rejecting society's sexist paradigm for women while hurting no one but herself. On the other end of the spectrum, the bulimic is cast as the anorexic's revolting foil, trying too desperately to fit the role she thinks is expected of her, wasting money and food and time only to fail anyway. The anorexic is a perma-girl, and the bulimic is a woman who constantly measures herself and never measures up. The personality traits attributed to anorexics center on self-denial, anxiety, and a need for control, while bulimics are assumed superficial, not to mention self-indulgent. These dichotomies are encoded in patients' own testimony. Bulimics call anorexics *the successes* when discussing different types of eating disorders with researchers, who have called bulimics "failed anorexics."

Failures or not, women were bingeing and purging long before anyone told them they had a disease. While Marie of Oignies is often cited as one of the world's first anorexics, saints like Veronica Giuliani and Mary Magdalene de' Pazzi feasted voraciously, "gobbling down food in secret" and sometimes vomiting in the aftermath, according to Rudolph Bell's *Holy Anorexia*. They sat down at long wooden tables and scarfed loaves of bread and slabs of meat, lifted rusted goblets to their lips to wash it all down with wine and milk. Afterward, the women moaned. Tears rolled down their swollen cheeks as they admitted they'd fallen prey to the devil's temptations. The rivalry between the transcendent, saintly anorexic and the gluttonous, devilish bulimic was being set up in the Middle Ages.

In addition to their lineage of martyred saints, modern anorexics also have suffragettes on a spindly branch of their family tree. The Women's Social and Political Union presented medals to suffragettes who went on hunger strikes while imprisoned for protesting, silver bars engraved with the length of their fast. The striker would pin the ribbon to her breast, announcing her accomplishment to the world: SIX WEEKS 1909, THREE MONTHS 1908, FOUR MONTHS 1912.

Audrey Wollen once wrote about choosing Irish hunger strikers during the Troubles as her subject for a high school history project around the same time she first stumbled into *the germinal concept of political*

hunger strikes on pink pro-ana [pro-anorexia] message boards, drawing a straight line between self-starvation as protest in prison and the girls around her who refused to eat in aughts-era California. Anorexics find their ancient sisterhood in saints, suffragettes, and political resistance movements, while bulimics are cast as capitalism's spoiled, overfed daughters, shoved into a sorority house with leaky plumbing.

BULIMIA CAN KILL, blares the headline. This is true—one study reported a 3.9 percent mortality rate for bulimia, and study after study finds elevated suicide rates among bulimics. But the headline doesn't end there; I've been holding out on you, keeping some information to myself, like the greedy bulimic flirt I am. It says BULIMIA CAN KILL A SMILE, and it doesn't mean metaphorically. As in, *Better Homes and Gardens* is not worried about bulimics' mental health, the deep depressions bulimics can slide into. *Better Homes and Gardens* is worried about bulimics' toothy grins, the self-imposed threat their vomiting habit poses to their beauty. The article warns that stomach acid can cause tooth decay and tells bulimics not to brush their teeth after making themselves throw up, even if they want to get rid of the bad taste in their mouth, because toothpaste after stomach acid is a recipe for rot. Elsewhere, anonymous bulimics admit the amount of money they've spent repairing the damage to their teeth; one spent thousands on tooth removal and dentures, only to ruin the dentures too.

A friend recently told me she ran into a girl we once knew but have only seen on Instagram lately. She must be editing her photos, she said, because in person, her teeth are black. Another friend, squished and sequestered in a leather booth, leans toward me. She's tipsy, telling secrets. She pulls down her bottom lip with her index fingers and bares teeth. *See how brown they are at the bottom?* she says, words a little garbled by the fingers in her mouth, as she taps her gum line with a finger. *I can't get rid of the fucking stains, no matter how many white strips I do. I want to get veneers.* I think of the stains I am almost rid of, the white lines on my wrist thinner than a strand of hair you can see only in certain light. I promise her the rot is unnoticeable. *Who's getting that up close and personal with your teeth anyway?* I ask, but I know that's not what it's about;

it's about the constant reminders of how heavy our self-hatred is, sitting like stones in our stomachs, but also of the ways we can live, the stories that sound like science fiction until we bend them into our routines.

I feel like I need to hiccup. I've been waiting here, agonizing on the cusp of it, for hours. There must be something stuck in me, caught in the curve where mouth caverns into throat. Something unswallowed, but I can't reach it with my fingers. I have two in there now, deep. One of my nails hits the back of my throat and I dry-heave.

After, always, we are disgusting and disgusted with ourselves, and then we remember. Maybe we aren't superhuman, but we've trained for this. At twenty-two or -three or -four, I sometimes woke up on friends' couches after a blackout, and they told me I'd vomited into a bush or a bag or in the back of a cab the night before. The first feeling, and I'm ashamed of this now, but I'd always feel it, right before the shame and the cold sweat, was a sublime calm, a relief so raw it was anesthetic, overwhelming. Thank god, I'd think, I got all those calories out of me, the cocktails and the shots and the drunkenly ordered fried food. I was grandiose and grateful to my body, quietly complimenting it on its efficacy as a machine that maintained its minimization of itself. Not remembering the moment, erasing the pain, just felt like further optimization. Calories consumed but not counted. I imagined my stomach empty save for a small pool of acid, my engine oil.

We wanted to wipe the blackboard clean, ready to be covered in scribbles. We wanted an empty bowl, ready to be refilled. But when we finally get off the bathroom floor, the mirror shows us that we haven't even wiped our mouths clean. Puffy faces and skin like a sack; you shouldn't look like this after all that work, we tell ourselves. Shame seeps into the saliva between our teeth; the aftertaste is awful. So we start again, not least to get the taste out of our mouths.

A teenager goes to college dreaming of becoming a beautiful genius. Later, she will claim she's forsaken the beautiful part of her goal, never mind that she achieved it. She abandoned that pursuit after years in what

she told one of the United States' oldest magazines was an *anorexic and bulimic blackout*. She never tells interviewers exactly how she started eating and stopped drinking and began keeping her food down, or when she taped the note reading VANITY IS THE ENEMY to her bedroom window.

Both of Ottessa Moshfegh's most famous novels feature bulimics, one as the star of the show and the other as an irritating recurring character, constantly getting on the protagonist's nerves with her insecure drivel. The first novel, *Eileen*, is narrated by an older woman looking back on her twenty-four-year-old self. That girl was a chew-and-spit and laxative bulimic who endeavored to maintain a prepubescent girl's body at all costs. A mousy brunette who did not catch anyone's eye, poorly dressed and overly made-up. She ate entire boxes of chocolates, putting the chewed-up candy pulp right back in the wrappers. She hated foods considered healthy and instead ate sugary and mayonnaise-textured foods, only to swallow a handful of laxatives and spend hours in the bathroom.

The second novel, *My Year of Rest and Relaxation*, is narrated by a modelesque blonde heiress who lives in New York City, the physical and financial opposite of the last book's star. Still, she too finds life fucking depressing, so she decides to abuse prescription pills and sleep for most of the year, fasting in her sleep for days at a time. This book's bulimic is that girl's best friend, a jealous, designer-brand-obsessed wino who won't shut up, as prone to word vomit as actual vomit. In this one, the bulimic doesn't get a good life; she gets killed on 9/11. The beautiful blonde is able to metabolize her frenemy's death into an existential reawakening and emerge from her year of drug-induced bed rest and incremental anorexia reborn.

Eileen, which centered the bulimic, was met with critical acclaim, but also a particular obsession with the protagonist's bad looks and love of her own bowel movements. You'd think the setting of a juvenile prison or the almost-lesbian relationship or the multiple instances of child molestation or the woman-on-woman crime would draw critics' attention, but you'd be wrong. They couldn't stop talking about how radical the notion of an ugly heroine was, couldn't stop quoting the passages where the narrator describes her post-laxative shits.

Moshfegh found this irritating, telling another magazine she *just got*

so sick of everybody saying how gross and ugly she was. And I was like, well, would you say that if she looks like a model? So I was like, fuck you! I'll write a book about a woman that looks like a model. Try to tell me she's disgusting! And that just proves you're a misogynist. That book, the one where the bulimic dies and the thin girl learns from it, is the one that got Moshfegh major magazine profiles accompanied by full-page portraits.

It's Thanksgiving 2007, and another fictional heiress is sulking. She has daddy issues. Her father left her mother for a man last year and is spending the holiday between satin sheets in Paris. The table is set lavishly, gold candlesticks and multiple glasses at each seat. The heiress is decorated lavishly too, in a lacy white babydoll dress and matching headband. She tells her mother she isn't hungry, grabs an untouched pie off the dessert tray, and stomps out of the dining room.

Now we're in a well-appointed kitchen, which is bustling with staff. The girl slams the pie onto the counter, and the women in uniform quietly exit the room. They know what's about to happen; they've seen this before. She stabs, dough cracks, steam rises, and she brings hulking forkfuls of pie to her mouth again and again, goo getting on her lips. Between bites, we watch flashbacks of legs in tights and red high heels beneath a bathroom door, white teeth biting into macaroons and ripe fruit. The plate is empty soon. She stares at her reflection in the translucent refrigerator door, and we next see her on the floor of her bathroom, calling her best friend, crying.

This all goes down in a *Gossip Girl* episode titled "Blair Waldorf Must Pie!" after which the character's bulimia is barely ever mentioned again. Blair has one conversation with her best friend and foil, Serena, the kindly dumb blonde to her manipulative evil genius brunette, and we are supposed to believe that she's recovered, that this relapse was a one-time thing. In the Gossip Girl books, Blair's bulimia is no minor plotline addressed in flashbacks. Instead, it's a major part of her character and an omnipresent aspect of her lifestyle. Bulimia is inconvenient: Blair is always having to do things like rapidly chew slabs of steak in three bites at five-star restaurants and barricade public bathroom doors so no one catches her. Or she rents a suite at the Plaza to fuck her boy-

friend in, dresses up in lingerie, orders a feast for the two of them, and scarfs it fast when he doesn't show up, then has to arduously unlace her corset to purge. Or she's on her way to the bathroom at a gala when an elderly socialite grabs her elbow to ask if she'd like to join the young philanthropists committee, and she has to gulp down her own vomit.

Bulimia in a book is one thing, but beautiful girls barfing on prime-time television is another. Blair isn't the first fictional girl to have her bulimia excised in a television adaptation. In her jump from the page to the small screen, *Pretty Little Liars'* Hanna Marin goes from bulimic brunette to blonde with bad memories of being bullied for her size in middle school, but she got over it. Moshfegh's Eileen made it to the silver screen in 2023, and in the film adaptation, the character never takes laxatives.

Bulimics often attract eye rolls, condescension gristled with fat that gets stuck in a critic's teeth. Blair Waldorf is no exception. One of the character's fictional classmates calls her "the bitchiest, vainest girl in the entire senior class, or maybe the entire world." Janet Malcolm, reviewing the book series for *The New Yorker*, called Blair "an antiheroine of the first rank: bad-tempered, mean-spirited, bulimic, acquisitive, endlessly scheming, and of course, dark-haired," someone who is never depicted "knowing when enough is enough." The author of the Gossip Girl series called Blair a "girl of extremes." These are adjectives and addictions often attributed to bulimics: their appetites are voracious, for food and belongings and drinks and drugs. She is bratty, bingeing, and betting she can get away with it.

Back when I abused laxatives regularly, my favorite brand came in little orange spheres. I used to take them immediately after a binge, when my body clenched up and my brain started sparking with shame. I'd swaddle myself in my comforter like a baby, knowing I would shit myself like one when I woke up, and then I'd take a sleeping pill so I could be unconscious until it happened. I brought them with me when I went out to dinner, and sometimes showed up late because I had to turn back halfway to my destination, when I realized I'd forgotten them. Once I met my friends, I'd lie and say the subway was delayed. If I took one I'd say I had a stomachache, pop it in my mouth like an Advil, and

rush home. I'd never tell my closest friends what I was doing with these pills, even though I had no problem telling them about other symptoms of my eating disorders, about blacking out fast because I hadn't eaten, or the dazed, hungry days I spent wandering my neighborhood in middle school, counting steps. Those stories were slim like I wanted to be, concise and just complicated enough. Girl is intelligent, so she notices that she is not perfect and decides to become pure. Not, girl did that and it was so hard, it made her so hungry, now she spends hundreds of dollars on extravagant meals and then swallows something that gives her diarrhea, sobs on the toilet, and does it all again next week. The girl gorging herself and then vomiting or shitting on purpose wants too much, is gross, a freak, nothing but a vessel for waste. The girl wasting away, on the other hand, is refined and restrained, so tasteful she won't deign to taste anything, introspective. I didn't tell anyone about the laxatives because I thought people would tell the gross girl to close her orifices, but ask the clean one to open up to them.

But even bulimic eating disorders are only lonely in daylight. At night, in the undercover dark and the blue light of a computer screen, the internet is crowded with hungry girls sharing body heat. On an eating disorder forum I used to frequent, there are thousands of threads about bulimia. A sampling includes: *How many times have you purged today? Just the #. Just purged successfully for the first time. Any advice—im scared. Who told you you are fat? Am I alone? Help.*

The thing about bulimics is we want it both ways. We have a sweet tooth and cravings for meat so intense they make us think we're anemic. We have thinspiration saved to our phones, and we follow food porn accounts on Instagram. We wear exercise clothes to binge eat. We read wellness blogs while waiting for the fast food we DoorDashed to arrive. Our yearning is abject and our habits grotesque. Our suffering is painful, and our lifestyles are exhausting, emotionally and physically, so is it any wonder some of us turn to gallows humor, and some of us turn to actual gallows? One in three women with a history of bulimia will attempt suicide.

Okay, even I can tell I crossed a line with that one. But it's easy to lose track of a line that blurs and bends—don't you ever laugh until you cry? Imagine breaking a mirror because you can't bear to stare at your

reflection for one more second. You could tell that story with dry wit, or you could tell it with tears running down your cheeks, but either way you'll miss at least one piece of glass in the cleanup and end up drawing blood when you walk barefoot through the room.

Writing about my body is like breaking that mirror, cathartic and chaotic and unclean. I find sharper corners than I expected, but I also discover smoother surfaces. I gather the shards of glass and put them in a bowl, plan to make a mosaic. I used to think of recovery as a puzzle, racking my brain to see how the pieces could possibly fit, but sure that one day they would, and I'd be done.

The approach to eating disorder recovery employed by many medical professionals parallels the wellness industry's approach to everyday anxieties, encouraging us to become whole. Ostensibly, we are broken, but we can tape ourselves back together—with group therapy and gratitude journaling and cognitive behavioral therapy (CBT) and antioxidant serums—and become our real selves. Our real selves eat mostly whole foods, which are probably plant-based, maybe drink in moderation, take a lot of vitamins, work out because exercise feels good, and happen to be beautiful. This self speaks in even tones, she is even-keeled. We fail to become her, fall back into brokenness. But lately I've been wondering what's so wrong about being broken, as long as we're still here. Our broken, bulimic selves remind me of the collages I used to make out of magazines on my bedroom walls, taping one girl over another, sometimes obscuring someone's leg with someone else's beach waves, someone's torso with a screaming headline. I like the look of a collaged girl, a girl with mismatched limbs and words written on her body, glitter nail polish painted over her pores. She's unnatural and a little disturbing, sure, but she's sparkling, and she's with her sisters.

In a movie I watch again and again, Kirsten Dunst plays a bulimic bridesmaid who spent high school getting called bitch face, throwing up lunch in the bathroom while her best friend, a larger girl who got called pig face, guarded the stall. The film follows a foursome of best friends over the course of one of their wedding weekends. Kirsten is sexy and snarky and sneaky, cheating on her boyfriend in a bar bathroom and

almost making herself puke in the bathroom of the bridal suite. But everyone in this friend group is fucked up and fucking people they probably shouldn't, and late in the film one of the girls gets rejected by a man after telling him about her suicide attempt, and then overdoses on pills the morning of the wedding. Kirsten saves the girl and the day like only a bulimic could: by shoving her fingers down her friend's throat. She holds her friend's clammy body as she pulls the poison out of it, and kisses her stringy hair as it comes up. The man watching is confused and horrified, afraid Kirsten is hurting her friend, shouting at her to stop. *I did it to myself for years, she can handle it,* she says sharply; she knows how much a girl's body can take. He asks her why she'd ever do that to herself, and she clutches her now breathing friend to her chest, rubs soft circles into her back, and says, *I wanted to be beautiful.*

When *Bachelorette* came out, it got bad reviews, just like *Jennifer's Body.* One critic wrote that the movie was "ruined not by the actresses or the script, but by the tone—and not just ruined: destroyed, mashed into a pulp." The tone is what I love about the film: it's taut and tense and sometimes tone-deaf, but somehow still tender, flipping from bitter to sweet to scathing to simply, starkly sad. It's that livid, longing bulimic voice, screaming with a sore throat, half digesting things and throwing up pulp.

Needy's boyfriend is about to bleed out, and she just wants to know why. *Why do you need him, huh? You could have anybody that you want,* she wails at Jennifer, her ex-bff turned cannibalistic demon, who's just binged on her boyfriend. *Is it to tick me off or is it because you're just really insecure?* Needy knows what she's doing, drenched in the black bile Jennifer just barfed onto her, moments after removing her teeth from Needy's boyfriend's neck. Jennifer's voice is throaty and threatening when she responds, *I am not insecure, Needy. God, that's a joke. How can I ever be insecure? I was the snowflake queen.* Then Needy stabs her with her sharpest insult, inserted into Jennifer's softest spot, the kind of thing you only know about someone if you've slept next to them. *Yeah, two years ago when you were socially relevant. . . . When you didn't need laxatives to stay skinny.*

The bulimic opens her mouth wide, Megan Fox's face is transformed by makeup and special effects, and that mouth becomes a gaping tunnel leading nowhere good. She's not speaking sexily anymore, she's screaming, staccato, as she stalks forward: *I am going to eat your soul and shit it out.*

Needy's boyfriend dies, but one boy's body isn't the point. Well-meaning boyfriends and evil boy bands were never the point in this story; it was Jennifer's body we came here for, the way everyone looked at it and the way it moved, the violent upkeep it required. We don't think Needy is a bad friend when she draws a bloody X across it and puts Jennifer out of her misery, but we're not surprised the society that put that boy band at the top of the charts also puts Needy in a prison for criminally insane women.

We know they won't be able to keep her there long; girls with screams that guttural are great at revenge. Plus, those girl diseases are catching; eating disorders and demonic possession pass through pink lips and whispers across pillowcases. Needy and Jennifer never slept in separate beds at sleepovers. High school girls know what their best friends are eating. Needy could always taste blood when Jennifer was out biting boys. These girls can be nightmares, but they can also be daydreams, counting calories and comparing crushes, killing each other and then killing each other's rapists. Women can't have it all, but girls can definitely do both.

Sin/Symptom

Girl after girl admits it: she eats trash. Trash? the intrigued interlocutor asks, as in, junk food? No, and now their eyes are wet, glistening; the girls are avoiding eye contact. But they go on, because it's time to tell the truth, because they've tried everything else, the lying and the pill popping, the speed and the starving and the stealing. So they explain: I eat out of garbage cans and crouched beside dumpsters. I eat what I threw away.

One double-bags the dregs of a fast-food feast, scraps of sparkling foil and limp fries. She takes it to the trash outside so, she tells herself, she won't come back to dig through the fetid black, dragging her nails against plastic until she feels it, the give of a hamburger bun, an embrace. Now, kneeling next to the dumpster, fistful of bread in her hand and aluminum under her nails, she is numb, unsurprised, alone. Her mouth is opening and closing, and she is, for a few fleeting minutes, nowhere at all. Another girl in another apartment sprays Windex on pastries before shoving them in the garbage. Someone else pours vinegar over pasta. None of it works; we roll up our sleeves and bury our arms in the dross. They've been telling us "you are what you eat" since we were kids, and trust us, we know.

The trash bag is bulging, breaking, overstuffed with meaning and metaphor. To people who binge, the trash can is a cipher and a kaleidoscope, a mirror and a camouflage, an altar and a site of utter abjection, a confessional: Is there anywhere else you can cop to your most revolt-

ing cravings, admit the darkness and depth and dirt of your want? The trash is where we end up in our nightmares, choking on rotten takeout.

In her memoir, Susan Burton writes toward her college self, hunched *behind the dumpster* bingeing, *all alone.* Someone creates a Reddit thread entitled *I binged and now I feel like trash.* When writer Sophie Kreitzberg *felt like trash* post-binge, the feeling metastasized fast: *I felt like trash; I felt like a failure, and there were moments when I even felt like I didn't deserve to live.* Someone remembers the cyclical return to *the scene of the crime,* bingeing and purging only to *find myself back in the garbage can pulling out discarded binge food.* It is also a place to hide the evidence: *I learned how to throw up in garbage cans.* A girl lives among the detritus of her disease, with *trash everywhere* save *a small patch free to get from my bed to the door.* Often she avoids walking that plank and facing a world that sees her body as a waste of space.

I read all this writing toward, into, and from the trash, listen to the wails echoing around the bottom of the bin, and add my hoarse voice to the choir. I remember hurrying, hugging plastic. After, in bed, thinking about the people who threw me away, I recited insults like mantras. I thought that if I could convince myself I was worthless garbage, I could motivate myself to change, throw my old self in the trash and emerge the next day a new person, one who wanted less and received more. This is a mindset many binge eaters share, as do dieters and anorexics and bulimics, all of us indoctrinated into the same cult of consumption and yearning, hunger and harm.

Unlike anorexics and bulimics, binge eaters who do not restrict or purge find themselves shoved into a dingy diagnostic garbage can. Binge eaters are gawked at, condescended to, and interrogated by doctors who prescribe weight loss and assume people in pain lack discipline, will-power, and logic. When doctors do recognize they're dealing with a disease, they often characterize it as wasteful ingestion of unhealthy food: meals that look more like trash than sustenance.

The public, and people with other eating disorders, generally share this view, which considers binge eating disorder (BED) *the black sheep of the eating disorder tribe,* as one tweeter put it. One person who suffered from anorexia, bulimia, and BED writes, *the worst one so far has been the*

binge eating disorder, the other eds were awful but you still fit in with society's expectations. Someone else concurs, noting that *the way people treat you with BED makes you cry like 4 times a day.* People describe shame that only made them sicker, desperate for a different disorder, which they often ended up with years later.

On one such thread, a person writes, *I wish it was anorexia instead of this. . . . at least then . . . I would be praised and respected.* Someone replies, saying that despite suffering alternately from anorexia, bulimia, and BED and knowing *they are all awful,* they *feel the same way,* are *jealous* of their anorexic sister. *She is so skinny and pretty and people like her.* Many testimonies center on the interpersonal experience of disordered eating, the sympathy and validation other eating disorders engender in contrast with the isolation incited by binge eating. A 2019 study in the *Journal of Bioethical Inquiry* cites a patient saying, *I think a lot of people understand where anorexia comes from, it's just an extreme diet, whereas this isn't, it's a lack of self-control. . . . I was just very ashamed of putting on weight, ashamed of eating food, and also quite lonely.* The researchers concluded that the patients in their study held a "belief in a diagnostic hierarchy" that put binge eating at the bottom: a "shameful moral failing."

Reflecting this, BED narratives often pivot on moments of extreme debasement, when the person compares their body or mode of eating to an animal's. One writer calls herself a *twitching creature, a sea lion,* and *a squat round mammal.* She *gobbled,* ate *like a horse.* Someone eats off the floor. The animal comparisons are often accompanied by detailed descriptions of uncontrollable bodily effusions post-binge—one memoir includes a meticulous recounting of a night the narrator was awoken by her own vomiting, and she's not the only one.

A binge, Princess Diana said, leaves you *disgusted at the bloatedness of your stomach, and then you bring it all up again.* Diana, the people's princess, the first modern girl. Attempting to explain both Diana's staying power and her lifelong battle with crippling, consuming sadness, Megan Garber elegized Diana's "unruly humanity." Stiff upper lips were not her specialty, she was more of a wobbling lip kind of girl, on the brink of tears or bursting into laughter.

In an episode of *The Crown,* a fictionalized Diana appears in close-up,

eyes watering. We hear heavy breathing. She paces. Then she breaks. She lifts the top off a silver tray and starts eating. Then she is over the toilet, heaving, back arching, fingers in her throat, mouth gulping and gaping, and then she's on all fours. The bed, the tears. Her wide, wide wants are unevolved, animal; adults don't eat like that. Those fingers in her throat like a baby being burped, the hands and knees stance like a dog, sends the message home hard. Diana's unruly humanity, her primal instincts, the animal urges she couldn't quite tame. Bingers cast as baser mammals.

All this abjection is partially rooted in audience expectation, bingers putting up with the gasps in exchange for the eyeballs. They know what their audience thinks of them, and they've been taught to think it about themselves too, but aren't we all animals? The endless association of bingeing with primal urges and primal shame dehumanizes binge eaters and bulimics alike, and inspires disgust, an emotion intended to obscure the similarity between the way we cope with modernity and the way everyone else does. Bulimics tried to cheat the system, bent over a toilet instead of just abstaining from that cake, and the viewer is meant to be grossed out, to think they got what they deserved, curled up on cold tiles.

People in pain on their bathroom floors, afraid in the middle of the night, post online, *scared shitless. I've never felt this sick,* someone writes. Another person, another night, is *in the worst pain i've ever been in.* Another asks, is anyone else *ever afraid your stomach will literally explode after a binge?* They include disclaimers—they know how this sounds— but these aren't hysterical girls; these are people who are finally listening to their bodies, and this really happens. People have died of esophageal and stomach rupture after binges.

In one of these threads, someone recounts the story of a girl who *died on the ground naked.* People go to emergency rooms in terrible pain, too ashamed to explain to their doctors what is happening. Families find out people have been bingeing only when they go into septic shock after abdominal tears. Yet despite the dangers and prevalence of binge eating, little research is devoted to its mortality rates. BED is far more common than anorexia or bulimia—BED's prevalence in the general population is double anorexia's, according to a 2018 study, and the disease is "one

of the primary chronic illnesses among adolescents," according to *Adolescent Health, Medicine, and Therapeutics,* which reported that 26 percent of adolescent girls and 13 percent of adolescent boys experienced symptoms. Yet a 2013 *Current Opinion in Psychiatry* meta-study reported that "data on long-term outcome, including mortality, are limited. . . . Little is known about the course and outcome of BED."

While we're talking about trash, we should address the toxic landfill we are all living atop: fatphobia. It leaks its gaseous hate into the air, and we inhale deeply, promising to start our next diet tomorrow, as cancers form in our organs from the chemicals in our diet foods and our hearts beat erratically, trying to keep up with our changing shapes. Yet fatphobia has been written into narratives of binge eating disorder since it began to be diagnosed by doctors, who have been rolling their eyes and shaking their heads disapprovingly for decades. Their story casts victims as villains and a prison as a paradise, but we bought in anyway, and millions of people are paying the price with their lives, trapped in a cycle that always ends with more waste. Food and money, yes, but also relationships and, in too many cases, years of life. We throw people away, and then we're surprised when they go dumpster diving, looking for love where we told them they belong.

The eighteen-year-old girl only ate in the dark. In daylight, she swallowed little more than scraps. But with her family asleep and the sun down, she sat in the shadows and shoved food in her mouth. She went to see her doctor for an unrelated issue, seeking treatment for migraines. The doctor saw her size and referred her to the hospital's nascent obesity department. In 1955, she confessed her habit to Dr. Albert Stunkard, a specialist in the newly formed field of obesity studies. He told her to adopt a calorie-restricted diet, as he told most of his patients, but found himself unable to forget her strange story. Soon, more women seeking weight loss treatment showed up in his office, tearful and telling secrets eerily similar to that teenager's.

They nearly starved themselves all day long, but once the moon rose, they followed the electric hum and fluorescent glow of refrigerators and microwaves and found themselves in their kitchens in the

moonlight. With no one watching, they couldn't stop eating. The doctor was startled by the patients shifting in their seats as they spoke softly, words spilling into each other once the listing began. He scribbled notes, nodding. Name brands and numbers, cuts of meat and quarts of sauces, cereal brands. In the light of day, these women didn't just diet; they often restricted their intake to levels Stunkard called "morning anorexia." These women were also fat at a time when obesity was still a small medical field and a semi-rare phenomenon, with only 9 percent of the U.S. population officially deemed overweight. During those brightly lit hours of hunger, many of his patients thought about food constantly, distracted by dreams of what they might eat, even as they promised themselves they wouldn't.

Night fell, they couldn't rest, and hours later, full and finally falling asleep, they promised themselves, the universe, and any god that might be listening that they would turn over a new leaf the next day. They saw their binges as crimes not only against their diets, but also against morality, understanding themselves as sinners. One compared their behavior to a *murderer*'s. Ashamed and afraid of weight gain, the next morning they wouldn't eat, planning to go to bed hungry in the hopes of reversing what they'd done the prior night. By nightfall, their growling stomachs sowed fantasies of food, and they found themselves back in the kitchen.

Stunkard called this problem night eating syndrome in a 1955 paper. He laid out the symptoms: "morning anorexia, evening hyperphagia [pathological overconsumption of food], and insomnia." His patients had come in seeking weight loss, so he referred them to diet clinics, where they were taught calorie restriction, the prevailing approach (then and now) to the treatment of obesity, which (then and now) usually resulted in little to no long-term weight loss. Instead, patients attempting to follow restrictive diets often started bingeing more frequently, or experienced initial success followed by a return to intensified bingeing. Both groups developed what Stunkard termed "the dieting depression": "emotional disturbances during efforts at weight reduction," usually also accompanied by post-diet weight gain.

Soon, Stunkard hypothesized a "relation between the eating pattern and life stress"—perhaps NES was a stress response to patients' "fail-

ures" in weight loss treatment, or to the fact that if successful, such "weight loss was accompanied by disabling emotional illness." A body rejecting a diet, not indicating its need for one. Stunkard also observed binges occurring during the day that provoked shame and secrecy, just like night eating. His patients experienced "awesome distress" and "bitter self-condemnation" post-binge, committing themselves in its wake to "quixotically austere diets, usually of very short duration," followed by another binge. Neither binge eaters nor night eaters responded to weight loss treatment, leaving him "convinced that weight-reduction programs were not nearly as effective as was generally believed" and that they "might not be harmless," but instead emotionally destructive and physically dangerous.

It wasn't just binge eaters and night eaters who didn't respond to weight loss plans based on calorie restriction. A vast majority of Stunkard's overweight and obese patients didn't lose weight on diets. Those who did often regained the lost pounds (and more) following treatment. Stunkard was one of the first scientists to notice and admit that dieting didn't work and often triggered depression. Without using eating disorder terminology, he effectively acknowledged that dieting could cause eating disorders, noting extreme emotional problems, gastrointestinal issues, and dangerous eating habits in the wake of diets. In a 1959 paper, he used thirty years of data to show that 95 percent of restriction-based diets failed to cause long-term weight loss in obese patients. Today, studies have repeatedly found that around 80 percent of dieters do not maintain their weight loss for even a year, and up to two-thirds regain more weight than they originally lost. The chances of long-term weight loss are lower for larger people—a 2015 study reported that the likelihood of "attaining normal body weight was 1 in 210 for men and 1 in 124 for women" deemed obese, or less than a single percent chance. Stunkard emphasized that periods of calorie restriction were often followed by, and perhaps even induced, compulsive binges.

Earlier that same decade, a famous 1950 experiment had demonstrated the direct correlation between periods of starvation and periods of extreme overeating. As World War II drew to a close, Western governments were faced with a civilian population that had endured semi-starvation due to wartime conditions, so they wanted to know what

semi-starvation's psychological effects might be. Ancel Keys directed what would become known as the Minnesota Starvation Experiment to answer this question by subjecting thirty-six conscientious objectors to a semi-starvation diet of half their normal intake. The starving subjects "ruminated obsessively about meals and foods" and "reported relentless hunger." They experienced cognitive declines, gastrointestinal issues, and depression—symptoms doctors have pointed out are also associated with eating disorders. Some subjects even developed body dysmorphia, reporting anxiety about regaining weight during the experiment's refeeding phase, despite reporting no negative feelings around their body size prior to the experiment. During refeeding, when the men were allowed an "unrestricted" diet, they didn't readopt their prior relationship to food, instead "succumb[ing] to eating binges" that caused "feelings of self-reproach" admitted in "hysterical, half-crazed confessions" and even followed by vomiting in some cases. The extreme hunger developed during semi-starvation lasted much longer than researchers had expected; it did not abate even after large meals. One subject was hospitalized after a severe binge. Subjects were still bingeing regularly and reporting extreme hunger five months after the starvation phase ended. Some admitted to scrounging in garbage cans for food.

The midcentury medical establishment did not see a connection between the semi-starvation in the experiment and the self-induced semi-starvation afflicting, say, a dieting woman, or the doctor-prescribed semi-starvation occurring in weight loss clinics. Perhaps it seems specious to compare an experiment explicitly focused on starvation to the experience of the average dieter or person in weight loss treatment, but in reality the conditions of Keys's experiment were alarmingly similar to the diet regimens patients were inducted into by weight loss doctors back then, and are extraordinarily, alarmingly similar to diet plans prescribed to fat people today and those suggested in mainstream publications for people of any size. Keys's subjects ate approximately 1,600 to 1,800 calories a day during the "starvation" phase, which is actually hundreds of calories *higher* than the daily total weight loss clinics commonly prescribed. Those numbers are also hundreds of calories higher than the daily intake often suggested by popular programs like Weight

Watchers, Jenny Craig, and MyFitnessPal today—for both people deemed overweight and those considered "normal." A popular spa in California offers multiple daily calorie plan options, the largest of which reportedly clocks in at around Keys's rations. As Naomi Wolf noted in *The Beauty Myth,* prisoners at the concentration camp Treblinka were given the same total daily calories prescribed at top American weight loss clinics when she was writing, which was also a higher total than the daily allotment during multiple stages of the ProLon Cleanse, a diet system sold by Gwyneth Paltrow's Goop. A 2020 study concluded that disordered eaters and chronic dieters (a Venn diagram I'd argue looks more like a circle) experience "psychological deprivation akin to those who starve."

Starvation's effects occur even at less extreme levels of malnourishment. Underfeeding your body incites a biological drive to binge eat, the body's attempt to refuel while storing excess energy in case you enter another period of restriction. Every person has a weight range that their body, if nourished, will likely settle at; this is called the "set point" and is usually within a range of ten pounds or so. Nutritionist Christy Harrison explains that "if you drop below that range through diet-induced weight loss, a healthy body responds by doing everything in its power to make you eat." This explains the ravenous hunger the Minnesota experiment's subjects experienced, as well as the voraciousness Stunkard's night eaters and binge eaters experienced after years of dieting. It might also explain the fact that "dieting is actually a consistent predictor of future weight gain" rather than weight loss across multiple studies, according to obesity researcher Janet Tomiyama. It could also explain why so many recovering anorexics develop BED: up to 40 percent of women recovering from anorexia experience its symptoms.

Online, someone asks her virtual compatriots: *Have any of you had just the one type of ED? I've been through BED bulimia ana . . . pls tell me i'm not the only one.* She is not, and because of this, I can't write about one eating disorder without writing about another. Doing so would play right into the doctors' hands, which are outstretched, proffering pills and weight loss pamphlets. The psychiatrist Hilde Bruch published the first best-selling book on anorexia in 1978, which early on calls it "a disease that selectively befalls the young, rich, and beautiful." But even

in a book that, in a generous reading, accidentally glamorizes anorexia while establishing an exclusionary diagnostic stereotype, bingeing is inescapably present, occurring in response to starvation. Many of Bruch's anorexics admitted to secret binges, and those who didn't binge fostered food fantasies that became more extreme as they became thinner. Before bulimia was named, Bruch described anorexics who binged and then forced themselves to vomit. She wrote that the hunger gets "overpowering," so anorexics eat "prodigious amounts . . . about which they feel secretive and guilty." She estimated that "about 25 percent of anorexic youngsters go through the binge eating syndrome." Stunkard had also noted the copresentation of anorexia and bingeing, writing that "as many as 50%" of those "walking skeletons" binge, and that bingeing is in fact "more commonly associated with anorexia" than obesity.

Yet BED is still too often considered a willpower issue associated with fat people, who are often directed to programs like Weight Watchers by doctors. One woman recalled visiting her physician multiple times seeking treatment for BED. Instead of a referral to a mental health provider, she was *made to feel like I was lazy, that I had no willpower, that I just needed to lose weight.* Telling this story to Refinery29, she said, *I left doctors' offices in tears, with discounted Weight Watchers memberships.* Given the fact that, as one study put it, "a growing body of evidence has supported the causal link between dietary restriction and binge eating," these people's disorders are likely being exacerbated, not healed, by these programs. A Weill Cornell Medical Center eating disorder expert described dieting as the "proximal trigger" in most cases of BED they'd seen, and the former director of Tufts University's eating disorder program said that the increase in all types of eating disorders "is directly proportional to the number of people going on diets."

The endless proliferation of six- and twelve- and eight-week diets feeds a cycle where giving up on one diet allows people to binge before starting yet another. There is an entire side of TikTok devoted to #lastnighteating, the final feast consumed the night before a diet begins. One woman writes that her eating habits *fluctuated from Perfect Weight Watchers Angel to shove-everything-I-possibly-can-down-my-throat.* Back when Stunkard was doing his first studies on bingeing, one of his patients had already experienced this, calling their dieting

extremist. . . . If I don't diet perfectly, I just give up . . . and eat until my gut aches before embarking on the next diet.

Despite the vast evidence base proving that diets don't work, often cause eating disorders, and especially exacerbate binge eating, many doctors still disbelieve the psychological and physical underpinnings of bingeing. By and large, fat people with BED are still prescribed weight loss before they are prescribed eating disorder treatment. As the fat activist Deb Burgard has said, "We prescribe for fat people what we diagnose as eating disordered in thin people." And what we prescribe is perversely likely to make them larger—as we've seen, dieting is correlated with long-term weight gain—and endanger their lives in ways then blamed on their size. All of this entraps larger people in a never-ending cycle of shame, blame, and pain in service of flawed diagnostic regimes and a profitable, fatphobic beauty standard.

The psychological and physical effects of starvation follow undernourishment no matter the cause, which means people who are hungry due to food insecurity experience many of the same symptoms as dieters and disordered eaters, along with the added stressors of poverty. Little research is devoted to eating disorders in low-income communities, but the studies that do exist reveal a strong correlation between food insecurity and disordered eating, especially binge eating. A 2020 *Current Psychiatry Reports* review reported that food insecurity was "cross-sectionally associated with greater likelihood of binge eating." Food-insecure households often live in a "feast-or-famine cycle," bingeing in preparation for periods of scarcity when they must restrict. The government's attempts to help families dealing with food insecurity, especially the Supplemental Nutrition Assistance Program in the United States, "inadvertently exacerbate this cycle by providing benefits once per month" that are "redeemed disproportionately" soon after they are received. Recipients told researchers that they felt "immense excitement" upon receiving monthly benefits, a sensation that was often followed by feeling "out-of-control during overeating episodes," a pattern that closely follows BED symptomatology. Another study analyzed in the review suggested that BED was almost twice as

prevalent among food-insecure than food-secure participants. These populations also suffer higher levels of bulimia, as people often resort to purging after bingeing; food-insecure individuals were over twice as likely to purge as food-secure participants in another included study.

On top of food insecurity, the working poor are disproportionately affected by the "temporal disorganization" of contemporary eating habits, in the words of scholar Iain Pirie, which have shifted away from three set meals a day, shared with friends or family. As wage inequality has risen alongside changes to the labor market that push more low-income people into shift work, more and more people are forced to eat alone and in moments of stolen time, between shifts and on the go. A fast-food worker who cannot eat for the entire duration of an eight-hour shift is understandably likely to binge when they finally get home and have been hungry all day. Workers forced into "chaotic eating patterns" are also likelier to eat fast and highly processed foods, because these options are the least time consuming and most affordable.

Many fast-food workers report fifteen-minute meal breaks, which is just enough time to order and consume a meal in their workplace, where many of the menu items advertised as "meals" are calorically equivalent to the binges analyzed in studies. Fast, frozen, and processed foods—often the most affordable options—have repeatedly been proven to have addictive properties. Brain imaging has shown that processed foods, high in artificial sweeteners, incite reactions in neural pathways similar to those of psychoactive drugs. As Pirie notes, "Major food manufacturers maintain sizeable research departments devoted to determining the exact balance of fats, sugar, salt and additives that maximise the palatability of their foods." These foods have been compared to recreational drugs by researchers enough to lead to the creation of Yale's Food Addiction Scale—a survey that applies *Diagnostic and Statistical Manual of Mental Disorders* (the *DSM* is psychiatry's classificatory encyclopedia) definitions of substance abuse to people's relationships with various foods, and it has been used in BED research.

People of color are disproportionately likely to fall into lower-income brackets, which makes them more likely to get caught in food-insecurity-induced bingeing and restricting cycles and in turn deal with BED and obesity. Racism plays a role in the aforementioned moralizing; Black

women's appetites often serve as the butt of a cultural joke, construed as overly large. Twenty-one percent of Black households report experiencing food insufficiency, which we've seen is highly correlated with binge eating. As Danielle Carr writes, "Food insecurity . . . makes a racialized underclass dependent on cheap and empty calories," while government agencies mount campaigns casting those calories as uniquely sinful to consume. Prevalence estimates for BED among Black women range widely, from 1.5 percent to fully 36 percent, a range that reveals the fungibility of the diagnosis as well as the omnipresence of its symptoms.

In 2021, Charlynn Small and Mazella Fuller published *Treating Black Women with Eating Disorders,* the first clinician's handbook of its kind, despite long-standing evidence that eating disorders affect Black and white women at similar rates. In fact, Black girls are over 50 percent more likely than white girls to suffer bulimic symptoms, and Black girls' eating disorders have repeatedly been found to present more severely: Black girls' scores on a bulimia symptom severity scale were an average of 17 percentage points higher than those of white girls. Small and Fuller explain that "*DSM* criteria are based on white populations," so diagnostic measures and treatments were "developed and validated in samples that did not include Black women whose disordered eating may be more likely to take the form of bingeing." In 2022, the *International Journal of Eating Disorders* devoted an issue, for the first time, to eating disorders in people of Black, African, and Indigenous heritage, citing the fact that "many of the factors contributing to more severe COVID-19 disease course and increased mortality" in these groups are also "relevant to the field of eating disorders," especially "timely illness identification." The racism embedded in the medical establishment combined with low-income people's lack of access to care meant that many people of color received treatment for COVID later on in their illness trajectory, when they were much sicker. Similarly, people of color are less likely to be diagnosed with anorexia than white people, and they are more likely to suffer for longer periods of time when they are diagnosed. This renders full recovery far less likely; early intervention is one of the few factors associated with long-term remission of eating disorders.

Among the issue's other findings was that compared to white patients, patients of color saw doctors who were "less likely to ask about their

eating behaviors." In one online forum, a Black patient wrote, *doctors laugh in my face when coming to them about my issues. I've never been formally diagnosed with anything because they never take me serious.* This creates a landscape where 22 percent of white women in one study had received treatment, while only 7 percent of Black women had, as doctors underdiagnose Black women en masse.

One Black woman reaches out to her peers online, writing, *any black girls out there feel as if the way society treats you because of your weight as a black woman fueled your ED?* Virtual voices rise in response, with sorrow and rage and similar stories. *Being underweight makes me fit more into certain beauty standards so I kind of feel less othered,* someone writes. *It's like having "good hair," it lessens the blow of colorism and racism and all the other isms.* These posters are pointing out that living in a body of color in a world that worships white beauty standards can, disturbingly, render disordered eating an assimilationist coping strategy.

Many Black women suffer from anorexia before developing bulimia or BED. But while white women often receive multiple different diagnoses over the course of their illnesses, Black women often have their first, restrictive eating disorders completely missed by doctors who associate Blackness with fatness. A twenty-year-old Nigerian-British student told the website Black Ballad that unprompted comments by her doctor, implying her weight was too high, were the *catalyst* for her anorexia. That illness went untreated and became BED and bulimia. People on Twitter state the case clearly, posting missives like *fat Black girls dont get real eating disorders let the doctors tell it* and *binge eating is the only eating disorder that everyone agrees that Black people experience at rates like everyone else. Now let's talk about anorexia.* Someone posts: *me, black and fat: as u can see in my file, i have severe major depressive disorder, severe major anxiety disorder, severe ADHD, binge eating disorder, anorexia . . . doctors: yes i recommend that u eat less.* Author Mikki Kendall fears for Black women who are shamed instead of offered help: *The societal narratives that position the curviness of black girls' bodies as a warning sign of future obesity mean that as young women, we're often congratulated for watching our weight when our food restriction might actually be the symptom of a real mental health problem.*

When the writer and journalist Anissa Gray, a Black woman, went to

counseling with her white wife, the counselor assumed the intake form that listed an eating disorder was Anissa's wife's, despite Anissa's name at the top. *It was as if she could not believe her eyes,* Anissa wrote. Whitney Trotter, a Black clinician, says that one of the first questions she asks Black patients who deal with bingeing is "Are we bingeing because of the prolonged restriction that never got diagnosed due to being in an underrepresented body?" Trotter believes many of her Black female patients with anorexia have been misdiagnosed with BED, fueling the shame that often incited their initial restrictive disorder. In the end, "eating disorders are a social justice issue," as eating disorder expert Kelli Ruggless has said. They are diseases that emerge at the "intersection of racism, patriarchy and diet culture" where "food deserts, food swamps, blind spots in healthcare" and fatphobia foster an epidemic and recast it as an entire population's moral failing.

One Tumblr user who runs a recovery blog reminded readers not to blame or shame themselves for bingeing after periods when they can't afford food or are refused time and space to eat nourishingly at work: *If you don't choose to diet but are food insecure, if you don't choose to skip meals but get no breaks to eat at work . . . you're suffering the same effects of restriction and deprivation as the solidly middle class dieter. Plus the compounded trauma of marginalization. You are not the problem here!* And yet the food-insecure, fast-food-consuming fat person is perennially cast as the problem, entrenching the lie that bodies are built by individuals instead of systems. Rather than recognizing that food insecurity, the temporal structure of low-wage workers' days, and the addictiveness of processed foods render poor people especially vulnerable to bingeing and obesity alike, fat and poor people are demonized, imagined to make bad choices, and prefer unhealthy food. Then they are sold products, diet plans and foods that are only likely to exacerbate their eating problems. In doctors' offices, they are prescribed purchases of dangerous, expensive diet programs that provoke disordered eating behaviors and told they are at risk of—threatened with—fatal complications like heart disease and diabetes, warnings wielded to spur them into diets, despite the fact that rapid weight loss and variability in body weight resulting from repeated dieting can lead to dangerous heart deterioration and disease.

Many of the studies connecting fatness to heart disease and death have confounding factors—the most confounding being the massive prevalence of extreme dieting, and in turn, weight cycling, among people considered overweight or obese by medicine. Sixty-eight percent of women deemed "obese" report dieting to lose weight, five times higher than the rate for women who fall into the "normal" range, and a 2019 study from Columbia University's Irving Medical Center concluded that "women with a history of yo-yo dieting or weight cycling—a pattern in which weight loss is followed by subsequent weight gain—had more cardiovascular risk factors than those who maintained a consistent weight," regardless of what that weight was.

This means that much of the data on fatness and cardiovascular problems may actually be data demonstrating the dangers of dieting, because most of the studies connecting obesity, cardiovascular disease, and mortality aren't analyzing people who have maintained a stable "overweight" body their whole lives, but instead chronic dieters consistently attempting to change their size. Writing in the *International Journal of Epidemiology* about a rare attempt to control for chronic dieting in a study of mortality and obesity, researchers concluded that "all of the excess mortality associated with obesity in the Framingham study can be accounted for by the impact of weight cycling." Weight cycling is also correlated with depression, endometrial cancer risk, hypertension, metabolic syndrome, and stroke—an alarming array of risks facing the 56 percent of American women attempting to lose weight at any given time, who will most likely lose and regain that weight multiple times; women who were often encouraged to embark on this sickening journey by their doctors. Just as weight cycling might cause much of the cardiovascular disease blamed on obesity, diet pills containing phenylpropanolamine, now banned, caused many strokes and heart attacks attributed to obesity, because people with higher BMIs were more likely to use these dangerous supplements. One analysis found that taking these pills, which 22 percent of weight loss clinic clients have been found to do, is associated with a death risk over ten times higher than that associated with an obese BMI.

In fact, the CDC's 2002 National Health and Nutrition Examination Surveys found no association between "overweight" BMIs and early

death, and a 2005 *IJE* review of nationwide data discovered instead that
the "ideal weight for longevity was overweight." A 2013 *JAMA* review
of decades of research on millions of subjects concluded that "grade 1
obesity overall was not associated with higher mortality, and overweight
was associated with significantly lower all-cause mortality." Fearmon-
gering around the fatality of fatness, in spite of evidence to the contrary,
continues apace, while little ink is spilled on the terrifying and proven
lethality of eating disorders, which kill an estimated ten thousand people
annually in the United States alone. In 2020, a study titled "Have Our
Attempts to Curb Obesity Done More Harm Than Good?" assessed
the consequences starkly: "Dieting may also lead to the development
of eating disorders, which can be much more deleterious to health than
obesity." This occurs both when binge eating is biologically incited by
dieting and when an extreme, doctor-endorsed diet suggested to a big-
ger child becomes anorexia: 36 percent of teens treated for anorexia
symptoms were previously deemed obese. But bingers are imagined as
giving up on themselves and giving in to their greed, exhorted to extri-
cate themselves from a food system they never asked to be entrapped in.

Stunkard's studies on binge eating and the inefficacy of dieting came
out in the late 1950s, but instead of a decrease in dieting, the '60s saw
an explosion of for-profit diets—the founding of Weight Watchers, the
release of the first low-calorie meal replacements—as well as a sud-
den and extreme increase in the use of amphetamines as diet pills. Like
the Minnesota Starvation Experiment, the 1960s amphetamine epi-
demic was in part a result of wartime conditions. Throughout World
War II, soldiers stayed energized on limited rations by liberally pop-
ping amphetamines, which were provided by the military. As the battles
wound down, amphetamine manufacturers realized they needed civilian
customers. One hired the marketing man who'd sold army officials on
amphetamines to start rebranding the pills as a weight loss drug. The
American Medical Association (AMA) approved amphetamines for
weight loss at the end of the '40s. By 1952, amphetamine production
had quadrupled. While Stunkard was writing about the "dieting depres-
sion," diet doctors were opening clinic after clinic, prescribing pills to

almost anyone who wanted them. In 1962, production hit a new peak, with enough amphetamines produced for every American to receive a prescription that year. In the late 1960s, "up to one half [of all amphetamine prescriptions] were diverted from medical channels," according to an NIH report—about a quarter were prescribed in weight loss clinics instead. Eighty-five percent of amphetamine users were women.

A number of these women were dying. One died at her desk, in her college dorm room. They died of heart attacks induced by diet drug toxicity. In "The Dangerous Diet Pills," an explosive 1968 *Life* magazine investigation, a reporter decided to find out how many diet pills she could get prescribed for weight loss in six weeks. The FDA estimated that there were five to seven thousand "fat doctors" in the United States. She went to ten of them and ended up with 1,500 pills in her bedroom. Several of the doctors prescribed pills mere minutes after meeting her, and one of them "congratulated" her "for catching the [weight] problem early" when there was no problem. Meanwhile, a coroner told her he saw "one case every six weeks in which I suspect the death was due to diet pills." The resulting congressional investigation eventually led to a ban on the sale of amphetamines for weight loss in 1979.

The diet food, junk food, and fast-food industries all took off in the next decade—the '80s saw the founding of diet food juggernauts like Lean Cuisine and Healthy Choice alongside alarm about increasing obesity rates. In turn, Americans were exhorted to diet by governmental bodies, their favorite magazines, and their news broadcasts. Weight Watchers, founded in 1963, had more than 4.6 million members in 2018. A 1992 study reported that up to 15 percent of people who subscribe to a diet program like Weight Watchers and 71 percent of people who attend Overeaters Anonymous (founded in 1960) meet the criteria for BED.

Today, that disorder is often treated with amphetamines, the very drugs we just saw have a lethal history and have also been proven addictive, especially in "overweight" patients, who comprise 80 percent of people diagnosed with BED. In the 2000s, drug companies wanted to get back into the weight loss game they'd been kicked out of, so they funded research and public awareness campaigns calling for official recognition of obesity as a full-fledged chronic disease, a redefinition that would mean drugs could be made (and sold) to treat it. The World Obe-

sity Federation, the International Obesity Task Force, and the Obesity Action Coalition are three of the largest organizations devoted to raising awareness and advancing research on obesity's risks and potential treatments. They all receive funding from drug companies with stakes in weight loss drugs and surgeries, and therefore in fatness being considered fatal. The World Obesity Federation receives funding from companies including Novo Nordisk (manufacturer of weight loss injectables Ozempic and Wegovy) and Eli Lilly (manufacturer of weight loss drugs including Mounjaro). Seventy percent of the International Obesity Task Force's funding comes from companies behind weight loss pills. Obesity Action Coalition has been funded by both Novo Nordisk and Allergan, the company that makes Lap-Bands, a surgically inserted weight loss aid. Drug companies funneled tens of millions of dollars to these organizations over the past twenty years. Novo Nordisk alone spent over $26 million on donations to obesity charities and researchers, and the company directly funded doctors who went on to speak positively about their drugs Wegovy and Ozempic in the media without disclosing their compensation—what public health professor Simon Capewell called an "orchestrated PR campaign." Their investments paid off: In 2013, the AMA officially declared obesity a chronic disease (against the recommendation of its own Council on Science and Public Health), and two years later, the FDA approved three diet drugs that had previously been rejected for safety concerns. In 2021, the FDA approved Novo Nordisk's Wegovy and Ozempic, and as of this writing, Eli Lilly's weight loss drug Mounjaro is expected to receive approval for weight loss treatment within the year.

This is not an uncommon strategy for pharmaceutical companies. In 2012 the journal *Psychotherapy and Psychosomatics* devoted a section to the myriad conflicts of interests of the panel members revising the fifth edition of the *DSM*. Researchers found that "69% of the *DSM-5* task force members report having ties to the pharmaceutical industry." One pharmaceutical company, Shire, which produces the amphetamine Vyvanse, approached BED using weight loss drugmakers' obesity playbook. In the aughts, as BED became more widely recognized, and the AMA considered adding the disorder to the upcoming *DSM-V*, Shire began contributing funding to the Binge Eating Disorder Association,

an advocacy group, while also embarking on an awareness campaign and running two trials attempting to treat the disorder with amphetamines. With estimates of the prevalence of BED hitting over 6 percent of the population, a *DSM* diagnosis along with FDA approval for treating that diagnosis with Vyvanse would create millions of new customers for Shire, amounting to what the company's CEO estimated at between $200 and $300 million in future annual sales.

Shire has a history of shining a light on a misunderstood condition in the hopes of gaining approval to treat it with its drugs. It did so for attention deficit hyperactivity disorder, and after making billions selling amphetamines to freshly diagnosed ADHD patients, Shire was cited and fined by the federal government for "inappropriate marketing," encouraging doctors to liberally diagnose ADHD in patients, leading to addiction and cardiac side effects. Yet with only two twelve-week studies on Vyvanse and BED, the FDA approved the amphetamine to treat it in 2015, seven years after Shire began its campaign for BED to be included in the *DSM* and two years after that campaign was successful (BED was included in the 2013 *DSM-V*). The FDA explicitly prohibited Shire from marketing Vyvanse as an obesity drug, while naming the same drug the sole pharmaceutical treatment for binge eating patients, the majority of whom are considered medically overweight or obese. As *The New York Times* reported, in the days following the FDA's decision, "patient advocacy groups—freshly infused with donations from Shire—began driving social media traffic to a company website that provides advice on how to raise the issue of binge eating with a doctor" and ask about treating it with Vyvanse. Diagnoses proliferate, and start to seem more like vehicles for selling drugs than anything else.

In a review of Shire-funded educational modules designed for clinicians and patients, researchers writing in the *Journal of the American Board of Family Medicine* reported that non-Vyvanse treatments for BED were described as "inferior to lisdexamfetamine [Vyvanse] because they do not cause weight loss," never mind the FDA's prohibition of the drug's use for weight loss. The modules mentioned none of amphetamine's side effects (including addiction, myocardial infarction, and stroke). While Vyvanse might decrease bingeing, it does so

by suppressing appetite, so the periods of artificially low hunger and the resulting dietary restriction lead the body to crave a binge, as all types of restriction do. One person, writing in a thread titled *Vyvanse is not the answer to your binge eating,* described the post-medication compulsion to binge: *The worst part is when I'm off my meds. Oh my god. I get so hungry and ravenous that I will eat until my stomach hurts and even then I still feel the need to eat. How in the world was this medication appropriate for binge eating disorder?*

A woman kept dreaming of eating spare change, coins slick and metallic in her mouth. By the time she began bingeing on money in her nightmares, Susan Burton had been suffering from alternating bouts of anorexia and binge eating disorder for decades. As a teenager she discovered the *power of lightness,* the attention thinness can bring a girl who's felt overlooked. Restricting gave way to bingeing, a pattern she knows *is not unusual.* The cycle continued into her forties.

When she started bingeing, she sought recognition in stories, searching bookshelves *for identification.* She *wanted to feel less alone,* but all she found were anorexia and bulimia memoirs, a void of information that left her feeling *freakish.* Susan couldn't admit her bingeing to her closest confidants, finding it easier to *admit to the anorexia than the bingeing,* which she saw as *intractable and illegitimate,* unspeakable. Instead, she repeatedly resolved to *quit food,* a decision that only ever led to the *particular desperation of being a woman alone at night in a kitchen.*

Her 2020 memoir, *Empty,* was one of the first major literary memoirs centering on BED. The book attempts to overturn the trash can BED festers in, forcing the rest of us to look at its rotting refuse, the corpses and failed relationships. Susan is furious that anorexia and bulimia are considered serious diseases, while *"binge eating disorder" is copy in a magazine ad showing a sad kneeling woman surrounded by food.* She's aiming to disrupt that dichotomy, writing *there is nothing JV about BED*—an admission that this is a competition. She just wants bingers to chart for once. But try as we might to unlearn them, our places in pecking orders are deeply ingrained. Susan writes about her anorexic eras with palpable pride and her bingeing with a combination of grief and disgust, play-

ing right into the contradictions that kept her silent. *Heavy,* she'd *never wanted to stay awake,* but thin, she was *fiercely alive but also faint.* The anorexic is ecstatic, an almost-levitating saint—she might be faint but she's floating—while the binger is terminally corporeal.

But believe me, bingeing can be ecstatic too, and she'll admit it if you read closely enough. As much as we are taught the opposite, nourishing ourselves simply feels good. Sometimes, *reveling in my derangement,* Susan felt protected and empowered by her binges. She wrote while moving hand to mouth. She attributes a hedonistic high to bingeing, but is nourishing yourself after years of starving really so hedonistic? Susan recalls one binge undergone *like a nurse was standing over me.* She swallowed the food down like *medicine.* She considers this a moment of self-sabotage, proof of her inability to control herself, but why not admit that food is medicine, especially when you're hungry? I'd like to imagine her submitting not to an imaginary nurse, but to her own will to live, her suppressed belief that she deserved to satisfy her hunger. But even after years of recovery, it's difficult to deprogram ourselves, to unlearn the association between food and sin, *a girl was always ruined by her body,* she writes. I pause, reminded of a book I once read that referred to "Eve's impulsive snack," the consumption that got her kicked out of Eden. A girl body can ruin a paradise; these diseases of girl bodies might bring society to its knees.

Empty is positioned as *a symptom: a purge.* "Purge" is the operative word, implying Susan's desire to fit in the bulimic box, to be deemed someone with another eating disorder. The book ends with Susan's fantasy, what she dreams of this book becoming, which turns out to be research material. She imagines scientists using her story to inform their studies. One of Stunkard's subjects waxed poetic about their desire *to be a good experimental subject.* Perhaps that would *redeem the waste,* Susan writes, still judging that dumpster-diving girl, trying to claw her way out of the trash and into the textbooks. She's hoping nobody else will feel the way she did, back when she yearned for a diagnostic box that would explain her pain, deem her sick instead of stupid and self-indulgent. But I don't think that container will be as warm as she imagines; diagnoses are often less homes than petri dishes, where we're glassed in and under observation, which often becomes judgment. The

doctors and the researchers have studied us like animals in a lab and deemed us a strange species of bad girl, often a lost cause, for centuries. I hope Susan knows her book will find a lonely girl looking for a sister in the bookshelves, a girl like the one she once was, who won't feel like she's the first person who couldn't nourish herself in a society that wants her to starve.

Stephanie Covington Armstrong started bingeing at summer camp. At home, where she was raised by a single mother, money was tight and food was often scarce, *a luxury not to be taken for granted.* Dropped into a cafeteria, the buffet was *food heaven.* Stephanie *gorged* at every meal. When the summer ended, Stephanie was thrust right back into the cycles of food-insecurity-induced restriction she'd grown up with. She was a girl in her late teens, a Black girl attending a school of mostly white ones, a girl with sexual trauma in her past and a fraught relationship with her family. She sought salvation in food, and *though the comfort was only temporary, food—something that, like love, I never had enough of as a child—seemed to be the salve I needed.* But consuming it began to make her feel ugly, in a world where *the message that thinness is the only way to find lasting happiness and love* was everywhere she looked, from the magazines she read to the movies she watched to the words out of men's mouths, spoken while staring straight into her eyes: *I love watching you eat. . . . You eat like a truck driver and never gain weight.*

That summer turned out to be the eye of a tornado that took Stephanie through her teens and twenties, a vortex of bulimia and its *faithful companion anorexia.* Her life became consumed by *dieting, overexercising, fasting, bingeing, purging, calorie counting, abusing laxatives, juicing, enemas and trying every get-thin-quick scheme.* In her memoir, *Not All Black Girls Know How to Eat,* she doesn't cite her bingeing as its own disorder, at first clinging to the same old stifling hierarchy. She writes that *anorexia made me feel like I was floating in a cloud high above the mere mortals,* while bulimia left her with self-loathing. Eventually, after years of pinballing between disorders, she realized that her problem wasn't bulimia or anorexia per se, but a spectrum of behaviors around food, from those officially deemed dangerous enough to treat by the medical

establishment to those normalized by an industry that wants us to buy its *get-thin-quick* schemes. Those behaviors, and the beliefs she held about food, reminded her of nothing as much as her sister's heroin addiction.

She began to see herself as an *addict* whose *drug of choice was food*, so she sought out support and structure from a program designed for self-identified food addicts: Overeaters Anonymous. In OA, she found herself isolated by her race, in a space mostly filled with white *privileged girls*, but she also found that even these *daddy's girls'* stories were, in many ways, *mirroring [her] own.* She heard tales of *pain and rage, sadness and loneliness, hurt and sorrow* that were also stories of *behavior surrounding food*, tales she knew by heart. The friends she made there became her *lifeline*, never made her *feel judged.*

Recently, researchers have begun investigating the popularity of OA among binge eaters, wondering whether, in a world where over half of binge eaters never seek treatment for their illness, and those who do report "treatment dissatisfaction, and high rates of failure to receive treatment attributed to stigma," OA might be an "overlooked intervention," according to a 2021 *International Journal of Environmental Research and Public Health* report. OA was founded by a woman who went on an extreme diet in college and soon found herself hungrier than ever, driven to binge in secret. One day, she came clean to her neighbor, who shocked her with her reply: she was in the same sinking boat. They started talking, supporting each other through what they called their addiction to food, and soon founded OA, which grew rapidly. Another group, which called itself Gluttons Anonymous, if you needed any more proof that bingers are convinced they're sinners, had formed independently a few years prior. The two merged in 1962.

The addiction paradigm achieves much that the medicalizing paradigm doesn't: it smashes the barriers separating disordered eaters of all stripes, allowing them to commune instead of compete, offering a support system instead of a prescription. The dismal recovery rates for eating disorders—decades of research indicate that less than half of anorexics and bulimics will fully recover, while long-term outcomes for other eating disorders are little studied—can inspire pessimism, and diagnoses can blind us to our similarities by convincing us a cer-

tain behavior is our defining feature. But the addiction framework also defines us by just one part of ourselves, wielding that facet like a knife, carving out yet another narrow slot we are told to fit our expansive, expanding selves into.

In her writing about the "epidemic of addiction attribution" that conceptualizes an array of substances and experiences—drugs, alcohol, food, work, exercise, shopping, stealing—as potentially addictive, the philosopher Eve Kosofsky Sedgwick argues that when we reframe a drug user as an addict, "she is propelled into a narrative of inexorable decline and fatality, from which she cannot disimplicate herself except by leaping into that other, even more pathos-ridden narrative called kicking the habit." Forced into a fork in the road, offered the divergent alleys of "Just Do It and Just Say No," the person with a bad habit finds themselves frozen. When and if they do choose a path, its endpoint is preordained. Suddenly, they know the ending to their life story, but are told they won't be its writer.

These binary constructions replicate the dichotomies of both the diagnostic model and diet logic, in ways that can perversely profit the diet industry. In a world where so many foods are designed to be addictive, where diet logic encourages alternating bingeing and restriction, and where medical treatment is stigmatizing and often ineffective, the addiction model still requires that we understand ourselves as addicts, rather than see our culture, our food systems, and drug and diet companies as conspiring to encourage addictive patterns. When we believe we are *sinners* and *criminals* who *deserve to be punished* because we are *out of control,* we don't demand change to any of the underlying structures that are actually out of our control, controlled by corporations. In its current iteration, the addiction model still makes us blame ourselves and then retrofit our stories into some fictional hero's journey of abstinence and discipline over the compulsion to consume—stories rooted in the very values at the heart of anorexia and its hold on so many minds.

Online, someone pondering the failures of our diagnostic regime wrote, *i always say i have a dual diagnosis of anorexia and binge eating disorder, because i've had BED for years, but only when i was underweight was i considered anorexic, despite my BED (without purging) still being a big part of my life. diagnosis shouldn't be so black/white.* Their story

highlights the harms of subdividing diagnoses, as well as placing them in a hierarchy, and the role of fatphobia in both of those issues, but it also pulls at another thread, which is that binaries are an integral component of disordered eating's hold on our minds. It was that artificial construction of indulgence against self-denial that led Susan to promise herself she would *quit food,* a vow that left her ricocheting between bingeing and anorexia. According to an expert at Walden Eating Disorders, a residential treatment facility, diet culture instills "black-and-white or all-or-nothing thinking styles," and I worry that the addiction paradigm does this too, rendering recoveries predicated on it tenuous and also, sometimes, requiring us to be as cruel to ourselves as we were when we binged, just with a new vocabulary.

Must we limit our identities, and in turn, our possibilities, like this? At the very end of her memoir, Stephanie Covington Armstrong writes, *I am anorexic, bulimic, a compulsive overeater, but I am also a mother, daughter, wife, friend, and writer, and I am grateful to be here today.* She's lived many lives, and she is living in more than one storyline. I want to know why she believes she is someone who struggles to eat *but* someone who is beloved, *but* someone with a talent and a craft. I am anorexic, bulimic, a compulsive overeater, and I am a daughter, a friend, and a writer, and I don't think any of those roles are contradictory. My friends do not love me in spite of my disordered eating, but through it and around it, and they love the person that pain wrought. If we keep writing the same stories, keep casting so few characters in so few roles, we'll never escape those trite, tragic endings. So tell me about the scars on your soul, how you healed them and who helped you press on the bandages. Tell me your fear food and your favorite food. Tell me your story from the start, and make sure I can't guess the ending.

Red Virgin, Red Heifer

The summer after seventh grade, I became a Bat Mitzvah girl and an oxymoron. According to the Torah, my Bat Mitzvah made me a woman, but in 2007 suburbia, real adults were always asking me how it felt to be a Bat Mitzvah girl, leaving me wondering how I could be a woman while still a girl. On the cusp, peering over a cliff or stepping onto a stage. But that wasn't the only liminal label I received that year, and the biblical commandments weren't the only ones I was studying. The year I spent practicing my Torah portion was also the year I first oriented my life around losing weight, and the year I first heard a doctor say the words "eating disorder," though he didn't say the words I am ashamed to admit I desperately wanted to hear him say: "anorexia nervosa."

The words he chose instead were "Eating Disorder Not Otherwise Specified" (EDNOS). This is the diagnosis you get if you have symptoms of anorexia or bulimia, but are "subclinical" or "subthreshold," considered not symptomatic *enough,* or display symptoms of multiple disorders but not "enough" of any one. Often, as in my case, EDNOS patients are simply suffering from anorexia's behavioral, cognitive, and emotional symptoms but are not considered medically underweight "enough" to be deemed anorexic. The most recent edition of the *DSM* changed EDNOS's name to Otherwise Specified Feeding and Eating Disorder (OSFED), but until 2013, it was called EDNOS. I will be using both terms here, because many suffering people, including me, spent years with the EDNOS diagnosis. I ended up in that doctor's office at the

end of a year I'd spent struggling with food, a year in which I'd been Bat Mitzvahed, been ditched by my best friend, and joined Tumblr. I read the Ten Commandments and then I read something called the "Thin Commandments," and I believed back then, but I had doubts. About myself, about Ana, about God, about the girl who left me. Instead of investigating, I scrolled in the dark. Repetitive motion, left hand on the keyboard and right hand moving from the cereal box to my mouth. I brought a religious intensity to my rituals: I reblogged, I chewed, I hearted, I swallowed. Judaism teaches that reading is devotion, study sacred. So I sought out an education in the only realm that ever felt spiritual to me, whisper circles and chat rooms. On the internet, girls told me the commandments they lived by.

I mouthed words and memorized. I found the marked page in the Tanakh and practiced my Torah portion, and then night fell, and I logged on. I studied the screen, the poems about eating disorders and the food logs and the quotes from starlets who died young and thin. Eating disorders and Judaism and girlhood, these mazes and matrices, spiritual planes on which you can be lost and found at the same time. The girls on Tumblr lived according to rules that involved food, but also feelings and a higher power. Things you can and can't eat, and why. Judaism has rules like these too: kashrut, a system of byzantine bylaws bounding meals in words and prescriptions and guilt.

My Torah portion was the story of the red heifer, a female cow used in a ritual purification ceremony. In order to be eligible to die to purify a Jew, she must be spotless, a single shade all over, and she must never have been pregnant, milked, or yoked. This is female purity: smooth, sacrificial, untouched, hasn't worked a day in her life. When the same story is told in the Quran, Moses calls for a sacrificial red heifer "neither a calf nor immature, between two conditions." This too is part of purity. No longer a girl, not yet a woman: the perfect age to die sacrificially. I chanted the story in Hebrew, hungry. I was creating my own kashrut, a system of fasting and ritualistic rules cobbled together from magazines, diet books, blogs, eating disorder novels, and Google searches. I hadn't yet gotten my period or kissed anyone and wouldn't for years. No longer a girl, not yet a woman.

* * *

People called her the Red Virgin; earnest Marxist and rumored asexual, Simone Weil only had eyes for Him. No sweet tooth either, no appetite she'd satiate at all, restricting her intake since about fourteen, around the age she would have had her own Bat Mitzvah, if her Jewish parents had been religious. Male philosophers called her ugly, odd, disturbing, disturbed, the girl philosopher who didn't eat and didn't fuck, but they couldn't stop writing about her. "This was certainly an admirable being, asexual, with a sense of doom about her. Her undeniable ugliness was repellent, but I personally felt she had a true beauty," one of those men wrote. Jolie laide, an abject appeal, men have long been drawn to doom-laden girls.

I listen to a YouTube video of Weil pronounced in multiple languages. German: *vile,* French: *veil.* On HowToPronounce.com, users can vote on which pronunciation they think is correct, and they vote for *vey.* I listen to writers and bishops and artists talk about how she's influenced their work, and they pronounce her last name variously: *wail, wheel, while.* Simone the disgusting, the obscured, the anxious, the frustrating, the scream, the sob, the cycle, the infinite.

That triangular hair I know so well. Subtle wave, obvious frizz, thick thick thick. She left ink and ashes everywhere. *Gravity & Grace:* the title of her posthumous manifesto on mysticism, and maybe her secret to slipping between the cracks of a cruel world's binaries, religious, gendered, political, not to mention that anorexic double bind: disappearing so visibly, the selfish selflessness. Find the void and grace will fill it, renounce the self and feel real love; our *faults* are a result of our *incapacity to feed upon light.* Nearing weightlessness, daring gravity. She wrote about chasing emptiness while wasting away. *Grace fills empty spaces.* All the descriptions call her awkward, skeletal, a stick figure. Scarecrow girl who gets cut up and refuses bandages, trailing blood around the farm, the factory, the workplaces where she is not much help, but means well. The Categorical Imperative in Skirts, so serious, the Martian, so strange. Simone and her taste for affliction, her distaste for food, emptying herself. A poet writing toward her imagines *joy so*

pure it hurts, pain so pure it soothes. I read that, and I think, the feast, the fast, the purge, the prayers.

In middle and high school, anorexia tasted holy, at least when I said the word aloud, whispered it in bed as I browsed Tumblr or recited it silently in my head, my Shema. That *x* sound, slinky. Bland like I imagined a sacrament cracker, sawdust in my mouth but a spark in my step. Also, like the sacrament cracker, denied to me by the people in charge, the adults who told me I was not anorexic, just a girl who took her reasonable diet "too far." At the outpatient center, the anorexics were the stars, with their spiky shapes and gravitational pulls, attracting yearning gazes and disciples in the waiting room, dispensing cigarettes in the parking lot. So much of the anorexia literature uses this language of space, science spiked with almost religious awe, and lately I've been wondering whether that is the allure. The hard scientific vocabulary of astrophysics, gravity and centrifugal forces, an obsession with mass and density, lends the anorexia narrative an aura of experimentation, the scientist's narcissistic selflessness, hoping for grandeur but claiming it's for a cause.

I obsessively read about the Christian saints who starved themselves for Jesus, living alongside other women. Women who rendered eating a sacred ritual by consuming only food far holier than the meat my mom bought for my kosher dad at a special butcher, nothing but the Eucharist, blood wine. Women who cannibalized their lover and never had to fuck him and stayed so thin all the while. I was so young, looking at the black-and-white photos of thighs in ripped tights on Tumblr and masquerading an interest in thinspiration with an interest in art history, doing school projects on female saints so I could look at the legends and portraits I thought being that thin got you.

I used to love Yom Kippur for all the wrong reasons. It was an excuse to fast in public instead of private, and at the end of the day, a feast. Paradise for a girl with an anorexic mindset and burgeoning bulimic tendencies. Near the end of middle school, in a collapse of my ideals or a conflation of them, I had an epiphany. I could use the Jewish laws

of kashrut to camouflage my otherwise disturbing diet. At a barbecue, shaking my head at a cheeseburger, I said I was keeping kosher. At breakfast, it was a pig's stubborn refusal to chew its cud keeping me from that bacon, not its caloric content. I promised people I was getting in touch with my culture, not trying to touch bone, pry thighs apart.

In Hebrew school, we learned when and why we shouldn't eat, the days we should spend in synagogue instead, standing with empty stomachs, doing calf raises on our tiptoes for the kashrut. Jews fast to atone for sins, in mourning, in gratitude, in advance of sacred meals, and, in some sects, as supplication. On the internet, girls made similar deals with their goddess, a deified iteration of anorexia they called Ana. The microgenre of pro–eating disorder (pro-ED) content that centers on reconceptualizing anorexia as a religion is small and largely not embraced by today's pro-anorexia (pro-ana) communities. Online, little evidence of a cult of Ana remains, but in the early aughts, she was mentioned on approximately a fifth of pro-ana blogs, according to a 2006 study in *Eating and Weight Disorders*. While overt religiosity was always a relatively niche part of the pro-ana internet, and its influence has declined today, the historical and philosophical entanglement between Judeo-Christian thought and anorexia remains an insidious, if mostly invisible, part of many people's eating disorders, including my own.

Somewhere around 2001, a goddess of anorexia emerged from a forum and quickly began appearing on sites that presented anorexia as an explicitly spiritual, moral, and transcendent pursuit. Don't let them call you sick; tell them you're *walking in Ana's path*. By and large, these blogs presented Ana as more Old Testament God than Jesus figure, an alternately wrathful and loving omniscient, a ghostly Kate Moss whispering her shibboleth, *nothing tastes as good as skinny feels*. I read one site's Ana Commandments, formatted like the Ten Commandments: *thou shall not eat without feeling guilty*. Another blogger's Ana Creed paralleled the Nicene Creed: *I believe in a wholly black and white world, the losing of weight . . . the abnegation of the body and a life of ever fasting*. Teenaged, I looked up the definition of "abnegation" and liked how serious it sounded, how smart. I wasn't developing an eating disorder; I was self-abnegating. Saint Catherine of Siena wrote, *Without mortifying the taste, it is impossible to preserve innocence*. Years later, reading

Simone, I was jarred by the similarity between her rhetoric and the pro-ana blogs. She insults herself for *laziness* and *inertia,* claiming to *sully* the earth with her misery, sounding for all intents and purposes like the self-recriminating online anorexics calling themselves *lazy, worthless.* Of course, I know her fasting was political, but it was easy to confuse her voice and Ana's, with Simone writing things like *We have to fasten on to the hunger.* Especially on my computer screen, in a web browser. The internet is where I learned to ignore context.

Diagnosed, anorexics express a sense of moral purity reminiscent of fasting mystics'. Superiority complexes require an inferior party, and in the world of eating disorders, EDNOS, bulimia, and BED are diagnoses associated with overwhelming, leaking embodiment, an utter lack of control of the body's urges in stark contrast to the intellectualized and spiritualized strength attributed to anorexia. As one study put it, "Bulimia Nervosa and Binge Eating Disorder are typically viewed in opposition to AN, and therefore become symbolic of moral weakness. . . . they are often conceived of in binary terms: chaos and control; disgust and purity; vice and virtue."

In anorexia narratives, the moment of diagnosis is simultaneously cathartic and structuring, a benediction. In these stories, anorexics clutch their medical records in shaking hands like totems. Author Leslie Jamison writes that her anorexia diagnosis gave her *a sudden, liquid thrill* when she saw it in writing, *as if the words had constructed a tangible container around those intangible smoke signals of hurt.* She felt *consolidated.* At the outpatient clinic I attended, the anorexics were the golden girls, despite their sallow skin. They got the longest worried stares and the most attention from the doctors. The bulimics were gross and glamorous with their high-tech system, the vomiting and the laxatives, the wigs. The girls like me, the EDNOS girls, were in between, not enough of anything and too much of everything at the same time. My diagnosis didn't feel sacred or liberating. It felt like a pity prize and, honestly, a fucking dare.

Online, people diagnosed with EDNOS describe the sickening invalidation induced by their diagnosis. *Cant wait to fit into the typical anorexic*

diagnosis by next year just so i can feel valid for once 🙏, one girl tweets. By "fit into the diagnosis," she means lose weight and exacerbate her illness: people often receive EDNOS diagnoses when they have anorexia symptoms but their weight isn't low enough to meet the *DSM*'s criteria for anorexia, so they get sicker in an attempt to "earn" an anorexia diagnosis. Even people with anorexia diagnoses find the hierarchy stressful and stimulating at the same time, motivating disordered urges. Someone tweets about feeling like *a bad anorexic* who *can't even properly live up to my diagnosis.* Another person writes, *I don't think enough people talk about the social hierarchy of eating disorders. . . . Bulimia is NOT "failed anorexia." Binge Eating Disorder is NOT laziness and voluntary lack of self-discipline. OSFED is NOT any less valid than anorexia.*

In a 2019 study published in the *Journal of Bioethical Inquiry,* researchers interviewed women who had received multiple different eating disorder diagnoses in order to investigate the emotional impact both of different diagnoses and of transitioning between diagnoses. This is a common experience: Research conducted in the mid-1990s showed that up to 50 percent of people who are initially diagnosed with anorexia later develop bulimia. Another study in 2005 suggested that 27 percent of people initially diagnosed with bulimia later develop anorexia. The 2019 paper found a waterfall of shame in these "diagnostic crossovers," which pummel people who begin their treatment journey anorexic and end it with a different diagnosis, or begin their treatment journey with EDNOS and get sicker in an attempt to move up in the morally fraught rankings. *I think I was worth more as a person when I was anorexic,* one interviewee says. Another described a diagnosis of bulimia after anorexia as a fall from *honour* to *total shame and humiliation.* Every one of the study's participants tacitly agreed there were better and worse diagnoses. This paper was titled "Pride Before a Fall: Shame, Diagnostic Crossover, and Eating Disorders."

EDNOS is by far the most common eating disorder. Eighty-one percent of adolescents and 75 percent of adults diagnosed with eating disorders suffered from EDNOS, according to a 2012 study. With the publication of the *DSM-V* in 2013, BED was classified as a stand-alone diagnosis instead of a subcategory of EDNOS, which was renamed OSFED. This, and the slight loosening of restrictions on anorexia

diagnoses—such as the removal of the (alarming) requirement that cisgendered women must have missed at least three menstrual cycles to receive an anorexia diagnosis—means that OSFED/EDNOS is slightly less common than it once was, but it is still the most common ED diagnosis. Yet it attracts condescension from the medical establishment, which sees the diagnosis as an eating disorder sale rack, a grab bag of symptoms. We are read as unserious disciples, toying with disorder instead of actually falling ill. This, despite a lifetime mortality rate rivaling anorexia's and EDNOS patients scoring "just as high on measures of eating disorder thoughts and behaviors as those with *DSM*-diagnosed anorexia nervosa and bulimia," according to the National Eating Disorders Association (NEDA). Yet we are deemed *ednos wannarexics,* in one Tumblr user's words, implying a failure to execute on our goals. Like any wannabe, we desperately want to be someone else, but just don't have what it takes. A dividing line rooted in a distinction between desire and drive, slithery want and stone-cold certainty. The stigma makes people even more determined to clamber up the diagnostic pyramid. With EDNOS, one person felt like a *wannarexic, lost a BUNCH of* weight in an attempt to escape her *stupid EDNOS* diagnosis. Someone else announced that they'd finally hit a BMI low enough to qualify for anorexia: *BMI [redacted] BITCH WANNAREXIC WHO.*

The scholars say *anorexia mirabilis,* holy anorexia, barely exists today. But in medieval Europe, droves of devoted Catholic girls stopped eating and started getting canonized. Of the holy women designated by the Roman Catholic Church as saints, blesseds, or venerables, it's estimated that anywhere from 37 to 61 percent starved themselves. In 1380, a thirty-three-year-old woman named Catherine died of starvation after repeatedly embarking on prolonged fasts since the age of sixteen. According to legend, Catherine had eaten nothing but the daily Eucharist for years before she died, the stale crackers drawing blood from the roof of her mouth. Her extreme fasting garnered her a following across Christendom, and she wrote treatises about asceticism, its spiritual highs and physical lows, the necessity of passing through the latter to attain the former.

Catherine and her ilk were taking to an extreme an ideology first espoused by men in ancient Greece and elaborated by male theologians and philosophers since at least the fourth century. For figures like Plato, Augustine, and Descartes, transcending the dichotomy between mind and body—what Descartes called dualism—was humanity's ultimate challenge. These men used words like "prison" and "cage" to describe their bodies, which supposedly entrapped the mind. In this paradigm, which still holds sway over today's technophilosophers, the body holds the intellectual force hostage with its base urges, its "slimy desires," in Augustine's words. These slimy desires, most prominently lust and hunger, spark fear in the hearts of the Great Men by virtue of their unpredictability and intensity. Men who control governments, politics, land, and culture want to control themselves too; they do not want to feel anything they didn't plan for and can't contain.

In their quest to unshackle mind from body, the philosopher-kings needed somewhere to trace their disgusting, desirous urges back to, a vessel for shame and blame. They found one in a figure they saw as the epitome of the bodily, a sexual receptacle that also offered food: woman. The gender binary propped up the mind-body binary, coding control, discipline, and intellect as masculine while the feminine coalesced around leaking needs, oozing urges, and flowing emotions, according to scholars from Julia Kristeva to Susan Bordo. And while these men couldn't always control their own urges, they could certainly control women. This theology links the appetite for food to the appetite for sex and ties both to the sin of gluttony, all while casting women as far less able to control those urges than their male counterparts. The Christian solution to the mind-body problem was asceticism: discipline and denial in the name of God, control of the passions through utter abstinence from all sensual pleasures. Jerome, one of the forefathers of monasticism, wrote that women especially should abstain from food and sex, because their mind-body connection was stickier, stronger than men's, rendering their urges harder to resist. Lauding women who transformed their "whole life [into] a fast," he wrote that the twinned appetites for food and sex render fasting integral to abstinence: "Nothing so inflames the body and excites the genital members unless it be undigested food." Starving, Catherine traveled medieval Christendom, showing off the

emaciated body that proved her spiritual transcendence and flight from femininity, that dripping, desperate state. She once wrote to another woman that *a full belly does not make for a chaste spirit*. Another fasting girl, Marcella, sainted after her death, "abstained from wine and flesh . . . and never spoke with any man alone," according to Alban Butler's *Lives of the Saints*.

Simone saw Plato and his Greco-Roman peers as the forerunners of Christian theology, calling Plato the *father of mysticism*. She wrote that she first felt *bottomless despair* when she was around sixteen and realized that she could *hope to have no access to the transcendent realm where only authentically great men enter and wherein lies truth*. Until she discovered asceticism, denying herself the platonically feminine urge to eat. This is also around the time she first wrote in her journal about considering suicide. Her brother said, "She had gotten into habits where she ate very little." *Eternal beatitude is a state where to look is to eat,* she wrote, words that taken in another context could presage every pained, prideful, hungry girl scrolling a foodporn tag. Her logic, derived from Plato and the Christian fathers, was an ascetic logic, one the scholar Leslie Heywood, in her book *Dedication to Hunger: The Anorexic Aesthetic in Modern Culture,* has called an *anorexic logic* that runs through the Western canon, prizing pain and bodily submission.

Holy anorexics, corseted and cloistered. Female mystics forsook bread to demonstrate their faith, the fact that they'd forced their bodies into submission with their minds. Many died before the age of thirty-five, like Simone would. Religious language often accompanies eating disorder narratives. Our hungers are cast as demons, our emptiness as purity, our shrunken bodies as innocence maintained. The binge as evidence of demon possession: when ascetic nuns were discovered breaking fasts, their convents often claimed that the devil had assumed a nun's form and broken into the larders to feast.

When the anorexic girl felt like loosening her white-knuckled grip on hunger, like giving in to her urges, she lay very still and *looked up at my Kat Mitchells poster, my own form of prayer*. Kat Mitchells is a bulimic pop star in a novel called *Thin Girls,* which follows a *supportive suicide*

squad of girls undergoing eating disorder treatment. Kat is the first girl who made our protagonist wonder about *the line between wanting her and wanting to be her, indecipherable.* That line has been faint for me my whole life, so I understand the urge to draw other lines in thick, felt-tip pen, to designate between good and bad in food when you don't want to have to think about the other things you want inside you. That hunger leads her down the same path it led me, toward denying all her drives: *some things about the body I learned to control: my sexuality, my appetite.*

As a young teenager, I wrote elaborate fan fiction in my mind at night. I imagined heterosexual couples from my favorite TV shows, forcing myself to adopt a third-person narratorial perspective in order to avoid choosing a gendered perspective. I was afraid of which one I'd pick, or that I'd want to go back and forth between the two. This approach didn't always function as planned; boundaries I set for myself never stay in place long, even now. In the dark, door locked and shades drawn, I got under the covers and squirmed around, narrating sex scenes between teen heartthrobs. By the time I flipped onto my stomach gasping, I forgot my own rules, found myself fantasizing in the first person. I switched perspectives, slipping between characters, imitating her sharp intakes of breath and arching back and then inhabiting his confidence, hands that caressed with conviction. I thought about my hand between her thighs, my tongue at the hollow of her throat, and then his teeth at my earlobe, his fingers on my ass. When it was over I swore it wouldn't happen again, told God I was sorry, I'd stick to my omniscient perspective. I begged. *Please don't let me be gay.*

I prayed in negatives. *Please don't let me get fat, please don't let me die alone.* I didn't know what I wanted then, other than a path to follow. I wasn't sure I would ever be able to name the way I wanted to be touched and by whom. To calm down, slow my beating heart and clear up the storm spreading between my eyes, I dug my fingernails into my palms and thought about every item I'd eaten that day. I envisioned them floating in the void against my eyelids, and then settling in the red room of my stomach, pressing the skin outward and upward, molding a mountain out of me. Eventually, I slept.

In another book about gay girls with eating disorders, Melissa Brod-

er's *Milk Fed,* the protagonist's lust and hunger are similarly assumed to be interchangeable, if not entwined, and both appetites receive the same prose treatment. She exclaims, *fuck me!* when she eats, and when she performs oral sex on another girl, her clitoris *became a juicy piece of pulp.* In one scene, her *horniness felt like hunger itself. Fully famished,* she *didn't know whether it was food or sex* she wanted. In their closeted experiences of anorexia, both protagonists believe they have *needs too big for this world,* dangerously untapped emotional and physical appetites. They react by restriction, drawing boundary after boundary, shaming themselves for their appetites before the world can do it for them.

In both books, the anorexic can't indulge one hunger without indulging the other. My impulse to even use the word *indulge* in that sentence, and ones like it throughout my writing about girls and their appetites, alarms me—I meant satisfy, but the connotation of sin infiltrates all my attempts to be objective about eating or fucking the way I want to. Women with our two mouths, our double sets of lips. Slutty girls sucking and spewing from their dual slits. In these stories, it seems like we starve, deny ourselves sustenance in both holes, or we are gluttons, consuming at both ends, to extremes.

It probably tasted tangy, knowledge. Juice on her lips, dripping down her chin, did she realize then? Overcome by the bittersweet spice, crisp between her teeth, did she keep biting and chewing and swallowing until her hand was sticky and nothing but an apple core remained, seeds spilling onto the grass, the shame settling in? That what-just-happened, who-was-in-charge post-binge blur, the collision of humiliation and self-hatred, wondering whatever happened to your willpower.

Gwen Shamblin Lara, the creator of an incredibly popular Christian weight loss program that many former devotees have traced long-lasting eating disorders back to, called Eve's original sin "the cardinal instance of overeating." Hers is not the only Christianity-infused weight loss program, but one of a litany that includes books with titles like *Slim for Him* and *More of Jesus, Less of Me.* This trend is a logical bridge between full-scale fasting girl mystics and the modern Ana devotee.

Eve's ostensible gluttony is often posited as the sin that set the ball of human foibles rolling down the hill out of Eden, "the gateway vice," in the words of one Christian website.

Simone believed *vice and depravity* are almost *always, in their essence, attempts to eat beauty, to eat what we should only look at. Eve began it. If she caused humanity to be lost by eating the fruit, the opposite attitude, looking at the fruit without eating it, should be what is required to save it.* For Simone, anorexic since her teens, this stance may have been both literal and metaphorical. She is advocating contemplation and attention, applying the division between looking and eating to human relationships. She argues that most people love others *like cannibals,* for the emotional sustenance they offer. Instead, we must love *the hunger in a human being,* their desire for life, love, connection, and we must love all equally, loosing ourselves from our separate skins and slinking into the sea of humanity.

According to much of the clinical literature on anorexia, a boundless need for intense human connection tortures the anorexic, who lacks a certain individuality, has "difficulties in autonomous function and sense of personal identity," harboring instead a desperate desire to be part of a community. In an essay-letter to Simone, the writer Nancy Huston wonders whether *having once been constrained, you decided to wish only and always for constraint,* whether Simone detached from *actual, living relationships* because she feared how deep her desire for them ran. I did this in my own anorexia-adjacent days, abandoned by friends and told I was too clingy, too prone to spilling and sweating emotions I should have kept inside. Eventually, I thought I'd try just emptying myself, so there would be nothing to ooze out and disgust the people I wanted to love me.

Simone wanted to *love impersonally,* to love everyone for the yawning caverns of yearning that made them human. *Utterly pure good* requires *affliction,* aching emptiness transforms into receptivity. She wanted to understand people's pain, so she felt that she had to suffer as much as those who suffered most. Simone conflates nourishing the body with satiating emotional needs, casts starving oneself of both as a path to a purified, ethereal morality. *When we do not eat, our organism consumes its own flesh and transforms it into energy. It is the same with the soul. The*

soul that does not eat consumes itself. The eternal part consumes the mortal part of the soul and transforms it. The first sentiment sounds eerily like a diet book explaining how calorie deficits work, while the second applies that logic to the metaphysics of morality. This is a common theme in more modern anorexia narratives, this focus on physics in conceptions of ethics. An anorexic astrophysics student, the star of Sarah Gerard's novel *Binary Star,* calculates wavelengths and wonders about exploding suns. Her story ends in blackness and fire, her fate a black hole, like the star that is the book's namesake and her one obsession other than food. As the story hurtles into the hot dark, she becomes a vegan anarchist, channeling her anorexia into what she believes is a revolutionary altruism, saving animals and saving humanity's soul. But there are casualties, herself included. The thing about that mind-body binary is that severing the two is usually lethal.

Recovered anorexic and eating disorder scholar Gail Sher writes that doctors misunderstand anorexics and are unable to help them because they do not recognize anorexics' *superior stance* and *inflexible agenda,* the religious fervor they've had since the Middle Ages, the emotional-spiritual hunger driving their starvation.

Academics condescend, saying anorexics are simply "starving for attention." The books abound: *Holy Anorexia, From Fasting Saints to Anorexic Girls.* The male doctors pathologize and the feminists idealize. The male doctors see another permutation of the attention-hungry hysteric, the anorexic as hunger artist asking someone to notice her, a boyfriend or a daddy or a doctor. Women writers keep trying to rescue the sullen, sullied saints' reputations, reading food refusal as feminist rebellion against the patriarchy, death by starvation as self-crucifixion on the cross of their female oppression. Simone situated herself in the in-between, starving in solidarity with the world's starving, as a revolt against all oppressions, yet leaving sisterhood unmentioned.

Chris Kraus, philosophizing about her and Simone's shared anorexia in a book called *Aliens and Anorexia,* contributes to the canon of anorexia moralism, casting the disease as part of a *panic of altruism.* Recognizing the connections between a culture's food and its inequities and injustices

apparently catalyzes an extreme reaction: utter removal of the self from the corrupt system. In a book about her obsession with Simone, and the invisible thread she sees connecting her own intellectualism, artistic pursuits, and anorexia to Simone's, Chris writes about the way scholars who conceptualize Simone's anorexia as a disease misunderstand it. To Chris, it's a moral, political philosophy: *The more you think, the more impossible it is to eat,* she writes, claiming that food went bitter when she learned about Big Agriculture, hard to swallow like the coins she bought it with, and coffee turned salty like the sweat of the laborers who picked the beans. In such a society, *to disappear is the quickest route to being truly admirable.*

Taken to their extremes, the anorexic's and the philosopher-kings' logic understands the body as outside the self, its desires alien to those of the trapped consciousness. Like me, Chris obsesses over Simone's nicknames, the Martian and the Alien. Perhaps those terms offered an identity beyond even what *anorexic* does today, offering Simone that elusive anorexic goal, escape from the human body and the society it's stuck in. An anorexic speaking to her doctor in 1908 desperately wished to be *completely bodiless,* and a friend recovering from an eating disorder once told me about their desire to replace their body with an orb. Six years before her death, Simone went to the chapel of Saint Francis in Assisi. Overcome by the urge to get on her knees and pray, she felt herself *rise above this wretched flesh, to leave it to suffer by itself, heaped up in a corner.*

For Chris, Simone's conversion from person to alien via anorexia is not an escape from a gender role, but an escape from the role of citizen, a role she sees as inevitably complicit in injustice. The anorexia that elicits this transformation is *not evasion of a social-gender role, it is an active stance: the rejection of the cynicism that this culture hands us through its food.* Simone wrote that *eating is looking,* but Chris seems to be saying eating is believing. I agree that the world is unjust, but giving up hope that it might be changeable, or even worth living in, seems more like an embrace of cynicism than a rejection of it. And Simone had faith to a fault, ending up *accused of being starry-eyed and overexalted.*

If the anorexic is protesting not the constricting female role in society but the society itself, then the sociologists and feminist historians and

doctors have missed the point. As Chris put it, they were too obsessed with convincing anorexics that "a boundaried sense of self," a thick coat of hardened nail polish between a girl and the world, "is the only worthy female goal." Where the doctors see the boundary as one between the anorexic and the people she wants to emotionally invade, Chris sees it as one between her and all those suffering to enable her lifestyle. So self-destruction can be strategic, in Chris's conception of anorexia. But I don't buy it: Once all the good girls are dead, who does she want writing? Simone might have seen her starvation as an act of radical empathy, sharing her basest sensations with those suffering most, an attempt to reject false distinctions between people, her impulse to *love impersonally*. What Chris sees as a stark dividing line between Simone and the broken world, I see as Simone's rejection of all its dividing lines. She begged to be dropped behind enemy lines during World War II, never mind the danger, and refused to eat more than the rations children were given in occupied France. But constructing anorexic logic as ethical this way pushes moral purity dangerously toward nihilism; dying because other people are dying doesn't help anyone figure out how to live in this cruel, cut-up world. Anorexia embraces boundaries rather than breaking them, offering people an artificially pure perma-girlhood to live and die in.

During the time Chris spends thinking instead of eating, she also obsesses over finding *the perfect food*. Alone in her apartment, writing this book and *bruising easily from malnutrition*, she fantasizes about eating crab legs. Some of Simone's final journal entries are wistful meditations on food; one of the last letters she wrote her parents includes a detailed description of garlic mayonnaise she once ate. Catherine of Siena's records of ecstatic visions are largely made up of hallucinatory feasts. I wish Chris would take a mallet to a crab, dip meat in butter. I wish Simone put mayo on a chunk of baguette instead of dying.

We met working at a restaurant, both of us twenty-five and frantically trying to figure out our lives. Our first real conversation off the clock was about food but did not occur over it. Instead of eating, we drank, pink wine to pink lips. I don't remember how we got on the topic,

probably because we didn't need to find it, since it found us so early. It slithered into our brains and bent them maybe permanently, breathed heavily into our ears for years and maybe left an aura around us, or gave us a certain gait. In any case, I often find others who lived with that voice curled in their frontal cortex, a god with vocal fry and a mean streak, gaunt as Jesus on the cross. I just know they can smell it on me too. She spoke and I listened, *yes yes yes*sing every so often, and I spoke and she listened, nodding hard. We told each other when it first occurred to us to maybe just stop eating and see which of our problems went away, and we told each other whether it worked, and what we ate and didn't.

She was the first girl who loved me back, and she had a religion and an eating disorder in her past too. When we were together, we ate and we fucked, and maybe it wasn't so different from those stories I find so frustrating, the ones that confuse the desire for sex with the desire for sustenance, that imply a girl who struggles with her desire to eat can only learn to do so without guilt and pain once she becomes a love object. I want us to be past that by now, but then again: We ate things glistening with butter and fried to gilded and flaking, kissed with lips greasy and then wine stained. We chewed and then we sucked, and we moaned during both. I licked her neck, and her sweat was salty, savory, and I licked something chocolatey later and it was sweet, and I turned my tongue over in my mouth and savored both sensations. But it wasn't so pornographic or so gluttonous—really, more than anything, it felt innocent, though I don't like that word either, or the dichotomy I'm drawing. I feel backed into a corner though, like I always have, presented with binaries.

Let me try again, in the liminal space between Judaism and Christianity and anorexia and bulimia and saints and sinners. It wasn't innocent and it wasn't sinful. It didn't feel like the high of something "sinfully delicious" in my mouth or the high of nothing near my mouth all day, asceticism. It wasn't willpower or lack of it; it was decisive desire. It was wanting to touch parts of her and inhabit parts of her at the same time. It was freedom, and maybe grace, my fingers in her mouth, still sticky from something caramelized I'd put in my own mouth earlier. The feeling of fullness without pain, not feeling faint at all, not afraid of the gravity of my own weight, not wanting to float away but grateful,

for the first time, to be held down by my body, in a bed with someone who made me want to break every boundary I'd ever made for myself. God, that's cheesy. But I used to be unable to write the word "God" in letters, because my Hebrew school teachers told me not to, and I used to be unable to eat cheese, because the girls on Tumblr told me not to. With her, I wrote *god god god* in my journal and bought expensive cheese and prayed to someone I was pretty sure wasn't listening, asking, also for the first time, for nothing to change.

In the morning with her, I forgot that my stomach slides down in a shape I hate when I lie on my side, my mind completely consumed by the hill of her cheek and the words needled into her ribs and the shades of gold in her hair. That forgetting, is that love? In *Milk Fed*, the protagonist muses that *love is when you have food in your mouth that you know is not going to make you fat*. Instead of a fantastical, calorie-free food, a holy wafer, maybe for queer girls with eating disorders, the ability to forget the fear of fatness itself is part of love. In my experience of queer love and eating disorders, there is an ingrained sense of sin, sure, lessons you were taught about indulgence and gluttony that loop in your brain the next day, despite their falsity. But it's not just a risk or a fall. There is safety in love, especially between two girls who are bigger than they once were, and more alive.

I worry that the emphasis on love as curative accidentally brings us back to the very ideas these novels are otherwise revealing as outdated and harmful. In those stories, girls with eating disorders don't recover until they find love. I was mostly recovered from my eating disorder by the time I met the girl who made me forget it completely for moments, but I doubt I'd have been able to be in a real relationship, to love her freely and fully, if I was still learning how to eat. In the thick of it, there's no space or time for love, there's only calories and light-headedness and a sense of purpose so pure it's impossible, meaningless. A drive to self-destruction might make a statement, but you won't be there to see it.

Years ago I climbed the hill to the Cloisters, the Metropolitan Museum's medieval art gallery. I wandered the hushed halls looking for illuminated manuscripts on the saints I used to Google Image search, and I

stopped at a book open to a page illustrated with a golden crucifix. And then: what looked like a vagina, the oval drawn in a reddish orange like the morning sun, a black slit dividing it. The plaque below the book read: THE PRAYER BOOK OF BONNE OF LUXEMBOURG. According to the caption, Books of Hours, Christian devotional texts from the Middle Ages, often depicted Jesus's fifth crucifixion wound, the open gash along his ribs, as a vagina leaking red and white, blood and fluid. The Son of God getting his period, bleeding like his sisters? Walking on water, Jesus was an alien from the in-between, holy ghost and flesh that bled, a man with a vagina in the middle of his chest, a Jew who created Christianity.

Maybe you think I'm getting carried away, swerving out of my lane, taking things a little far here. Girls with eating disorders are always taking things too far, and all these binaries and boundaries are getting old. Once we start questioning the gender binary, all the other walls we've built around our sexual, religious, and other identities start to sink into the muck. Gaze over those sinking walls, and things we've long understood as vices and attached to women start to look a little different, get hit with golden-hour light instead of a flashlight beam. A dirty leak becomes a thirst-quenching geyser. Gender, sexuality, religion, diagnosis: these are all ways to box people in, to categorize, to normalize some identities while marking others as identifiably deviant. A scarlet letter, a Jewish star. We keep coming up with more categories as though that's the solution, but what have they ever done but separate us, give us boxes to curl up inside, where we might feel safe but also more alone? There is comfort in nomenclature, in understanding your location in a matrix, but where there is fear there is also freedom, space to run and someone you might love to run into.

On her deathbed, Simone spoke to a Catholic priest. Simone, a Jew enthralled by Jesus, a girl who crossed boundaries religious and intellectual. He listened to her philosophize and found her theorizing "too Judaic and too feminine." The physical void she'd made her body into, to match the one in her soul, it was too vaginal, too ancient and dark. He didn't get it, obsessed with his binaries. To Simone, the whole point

was to be nothing and therefore feel everything, to dissolve boundaries, the ones between states and people and the ones between planes and dimensions, to look from your void to the next person's and say, I understand, and I'm sorry. *To love purely is to love the hunger in a human being.* Simone was a saint, a friend wrote a year after she died.

But the priest was dismissive, and she died. Biographers argue over whether she should be sainted or diagnosed. Why not both? The coroner's report says, "The deceased did kill and slay herself by refusing to eat whilst the balance of her mind was disturbed." Doubling up on those verbs, the insistence that she did it to herself, because what would it mean to blame the priest, or the lineage of priests, or the society she saw for what it was? The coroner casting Simone's death as a suicide lets the world off the hook, a world that is also a panopticon, built on the boundaries she asked a religious man on her deathbed to break.

She thought we were all too siloed, refusing to look at each other for fear of what we might learn about ourselves and each other, and she was right, but she felt everyone else's voids too deeply, and fell into the final one. The death certificate placing the last label, after a lifetime of labels. A transformation artist, a hunger artist, undergoing so many conversions: Jew to Christian, human to alien, fed to hungry, alive to dead. The death certificate and the medical and religious establishments transform a communal tragedy, a daughter, friend, sister, comrade lost, into an individual story of bad choices. Her mind was disturbed, but so is mine, and who disturbed us? So she chose death and I wish she hadn't, like so many of my sisters, but I can't say I don't understand. But if we keep disappearing, we can't make the world any more livable, and we're just giving the people who made it more space, and they'll keep saying we did it to ourselves.

The anorexic's hunger is spiritual, and so is the mystic's, and so is the anorexic mystic's, but multiple hungers can coexist: you can look, think, and eat. I do not want to believe that to eat means to give up on filling the spiritual void, but so many anorexic artists, philosophers, and otherwise intelligent women seem to disagree. Anna Freud once called anorexia the "asceticism of puberty." Adolescence can be a time when the body begins feeling like a cage, one you don't have the key to.

Sudden lumps, surprise blood, caught breath at the scent of someone, a pinch in your pelvis you didn't ask for and don't understand—so many slimy desires. In a society that weight shames and slut shames, I get it, everyone's obsession with your body can make you want to remind them you have a mind. So fear of the depth of our appetites can make us want to telescope those drives, convert our emotional and physical and sexual hungers into the spiritual. In the epilogue to *Holy Anorexia*, a doctor writes that anorexics suffer because they desire a connection deeper than most people are willing to offer; they want to feel "deeply, intensely, and consistently connected in a way that is beyond the abilities of most human relationships." If people keep getting fed up with us, why should we keep feeding ourselves? I know I'm reaching, but I'm trying to reach out to you, trying to point out that so many ways we think about eating are sick, moralizing, and misleading, and making a lot of us ill.

Scrolling Instagram recently, I saw an ad for a sweatshirt that read, in block-printed letters, PRAYER IS WHATEVER YOU SAY ON YOUR KNEES. I wondered what kind of kneeling it meant: Over a toilet, with a dick in your mouth, in a church pew? What if it was the same in all those scenes, and what you wanted to say was how did I get here and where am I going?

When I began trying to write about my body and my Bat Mitzvah, I needed structure. I wanted to color outside the lines, but I couldn't see them in the first place. Or the boxes kept getting smaller, and my marker was too thick. When Hebrew is annotated for cantillation, or chanting, each line is boxed in, vowel markings below and trope markings above, telling the reader how to move their mouth, how to project their voice. I wanted that, or the rules of Kashrut, or the Thin Commandments. I wanted to make you feel it too, the panicked claustrophobia and yet the fear of being kicked out. I wanted to try to climb over the fencing, and when I got infected cuts, I wanted to cauterize them with my words, and then bandage them with someone else's. I wanted to burrow under, lose my breath, and taste dirt bitter and moist in my mouth, expired Little Debbie brownies.

I tried using statistics to bookend stories, but it became a gimmick, which is the furthest thing from an eating disorder or a sexual identity or a religion, or trying to define any of those for yourself young. Still, I am trying to replicate the feeling of living within limits you do not know if you chose, between lines you cannot tell if you are currently, actively drawing. Am I working from a blank canvas or a map? Am I holding a pen or a knife? Either way, I am carving. Like trying to hack away at a "gospel of Cartesian dualism," as one scholar put the dichotomy between bulimia and anorexia, with an unsharpened pencil with no eraser in a doctor's consultation room at age thirteen, filling out a multiple-choice survey. A feeling like the lack of free will and an exercise of willpower steelier than anything you thought you contained in that mushy, aching body. Between mimicry and creativity, a love-hate relationship, frenemies. The image already exists, the story has been written, the girl bodies are in the museums and on screens of all sizes, frozen. I pause the video, zoom in on the Instagram, caress the glassed-in girls. I trace their bodies and expand them, throw my phone against a mirror.

The fences feel impenetrable, but someone built them, decided what counted as sick and made us believe their definitions were anything other than a group of men's whims. We looked around at the endlessly replicating mazes and started making our own in miniature, inventing our own rules the first time we surreptitiously googled the calories in something someone offered us to eat. That first online search, and then there are calories in things you wouldn't think of. Suddenly, the strictures are everywhere you look, because you put them there, so you close your eyes and dream of breaking them. If you're me, you try to see the invisible lines everyone else seems to know about, but you can't, so you avoid anything that might whet any of your appetites instead.

So I learned to find something sacred in skeletons and something profane in the way my skin folded. I was never ashamed of a protruding bone the way I still sometimes am of my protrusions of flesh. I am ashamed of my shame, but I struggle to unlearn religion, to deprogram my mind from thinking in terms of negation, numbers, calories. I find myself googling calories sometimes the same way I find myself praying, on the verge of tears or sleep, automatic and soothing, a sense of con-

trol. That old Ana voice, Valley girl tenor but the rhythm of a litany. A pro-ana blog: *I believe in calorie counters as the inspired word of God. . . . I believe in hell, because sometimes I think I'm living in it.*

On Twitter, a girl proposes a *petition to the* DSM: *eliminate ED labels, and call it "eating disorder" instead so that we can stop feeling invalidated when we don't fit the anorexic diagnosis.* All the diagnoses place us in competition and ensure we can't speak to each other from our separate wards and notice all our similarities. Whatever eating disorder a person is struggling with, they are in extreme pain, emotional and physical. When there is so much symptom overlap, why are we so obsessed with cleaving problems that are blatantly connected, separating sufferers into stifling diagnostic boxes? I'm not convinced ever more detailed diagnoses will alleviate the problem rather than exacerbate it. I wonder if we are afraid of calling all eating disorders just that, eating disorders, because the catchall term might catch almost all of us.

The ever-increasing number of diagnoses, the sexuality and gender labels we obsess over, the religious sects. We've always been a culture obsessed with taxonomy, because people in boxes are easier to surveil, and therefore to control. What five descriptors do you put in your Instagram bio, or your dating app profile? But what if we see our inability to fit on one side of a binary—of an eating disorder, sexuality, gender, or religion—not as a failure, or an inability, but as a refusal to be defined by the people who want to tell us who and how to be? I don't want to be legible to this society. Adrienne Rich once wrote, *This is the oppressor's language / yet I need it to talk to you.*

The more we refuse legibility, the more we confuse the people diagnosing, judging, shaming, and classifying us, the closer we get to comforting each other, climbing out of our boxes and meeting in a green field where anyone who feels like a girl can make a speech about it; the closer we get to a world our dead sisters could have lived in. Instead of trying to define ourselves through a series of labels, we could embrace being oxymorons, anachronisms, girls living liminally, straddling the void, inviting everyone in for a nightcap and a late-night meal. Simone thought God loves *as an emerald is green.* In the state of perfection, she too would *love as an emerald is green,* would be *I love* instead of a person

who loves. If it doesn't quite make sense, it's because the *oppressor's language* isn't designed for love. I want to be love too, and an emerald, and precious, and found.

A gaggle of girls rides an escalator, heading who knows where in the dark. Fluorescent lights strobe. Then their hands, pressing together and pulling at some sticky, transparent substance. Their faces, Vaseline shiny, lips dangling drool. Their glistening cheeks pressed tight, I can't tell who's who. Hands on each other's faces, they peel off their masks. We see hair, lip, forehead, hood against barbed wire. *I must be hollow enough, I'm so tired of subjectivity.* The song is called "Female Vampire," off the album *Blood Bitch*, by Jenny Hval. Vampires belong to hell, but on her song "Heaven," she's standing in a graveyard of girls, and the tombstones are so tall and hard, *I want to sit on them, put death inside my body.* A tombstone becomes a cock, a girl is a vessel and she wants to be full. She wants to fuck a gravestone but *beckon the cupcake.* I want to open my mouth so wide against hers that our faces melt into each other, I want to taste her tongue, I want to eat every single pastry I've ever scrolled past on Instagram, I want to get drunk and eat an entire challah, I want to take another stab at being beautiful, and this time I don't want to bleed for it. Diagnosis: certainly unsaintly, eating disorder not otherwise specified.

I want to be a girl against God, a girl against all gods, religious and otherwise. I've long deleted the Tumblr where I saved all my favorite images of my own religious figures, many of whom died for their cause. On the track "Angels and Anaemia," Jenny's voice wavers and shakes, elongates the words, *I could love you wildly, girly, wildly, girly, boundlessly, wildly.* I imagine Simone with wings, frizzy hair halo, moving jerkily to the song's otherworldly beat.

"Too Sick to Trust"

Inside Eating Disorder Treatment

C went on her first diet at age ten. Her closest friend was a small girl, one who'd recently shunned a larger classmate. C feared that fate for herself. She'd been called clingy by former friends and worried the close bonds she wanted were too intense, weird. At a school outing to a pool, she overheard snickering and her name, the words "whale" and "huge." At home that afternoon, she paged through a magazine her mother had left in the living room and discovered that an entire section of *Women's Health* was devoted to women's weight loss. She took notes. By the time she was almost done with middle school, she was keeping her caloric intake dangerously low. Soon, she was regularly forcing herself to throw up after meals and abusing laxatives. She wasn't the only one. Her friends would keep watch outside of bathroom stalls for each other and text about how their diets were going. One day, one of these friends fainted between classes. She wasn't in school for six weeks, and when she returned she wore a hospital bracelet and baggy clothes, and left each day at lunchtime.

C was afraid—of fainting to the linoleum floor, of the thin, transparent tube in her friend's nose in the selfie she'd sent her from the treatment center, but also of eating without immediately purging, of becoming bigger and hearing the whispers, catching the looks. She googled "eating disorder" and found some self-assessment quizzes online. She filled out one on the website of an eating disorder charity and another on the website of a treatment facility, which recommended she schedule a call with an intake specialist. She spoke to the woman

on the other end of the line softly, sitting on the floor of her closet, but when the adult asked her to put her mom on the phone she hung up, hands shaking, shame encroaching. She couldn't believe she had the audacity to consider herself sick the way her friend was. Still, she told her mother about the call a few days later, after an afternoon of hunger pangs and a woozy headache.

Soon she found herself in her pediatrician's office, being told that her weight was "normal" for her height and age. She recalls the therapist her mother brought her to saying she *wasn't thin enough to have anorexia which caused me to spiral and drop [number redacted] pounds in a month because I felt like no one would care until I looked physically sick.* When she showed up in her pediatrician's office again, far sicker, she was immediately referred to a residential treatment center, one that, unbeknownst to C or her mother, employed marketing professionals to promote their facility to this physician's office.

The intake appointment was lengthy, involving weighing, blood draws, blood pressure tests, and a comprehensive interview about C's daily eating habits, thought patterns, and social life. The coordinator concluded that C should be diagnosed with Eating Disorder Not Otherwise Specified because she displayed both anorexic and bulimic symptoms. However, she also believed that C had the best chance of recovering with multiple weeks of residential treatment. This was an expensive prospect that insurance companies resist approving, especially for eating disorders that do not fall into the anorexia or bulimia categories. To get insurance coverage for eating disorder treatment, patients must meet strict biometric qualifications—a low weight for anorexia or electrolyte disturbances for bulimia, for example. One treatment center's intake coordinator, quoted in Rebecca Lester's 2019 ethnography of eating disorder care, *Famished*, said she tries to "diagnose according to the *DSM*.... But, honestly, I can't fully separate that from the insurance situation." She has to "figure out how to package the client so she will have the best chance of obtaining insurance coverage." In C's case, this was achieved through a weight-reliant anorexia diagnosis, and C's insurance approved a three-week stay.

Once settled in the treatment center, C found herself subject to constant surveillance and measurement, a regimen hauntingly similar to the

one she had imposed upon herself at the height of her disorder. Constant weigh-ins, an obsession with calories. Mealtimes were fraught, theatrical, and infused with numerical information. Her statistics seemed integral to her team's conception of her prognosis. The treatment center's staff insisted that C's worth wasn't measured by the number on the scale, but she didn't think they acted like it. *They tell us that numbers shouldn't matter, that obsessing about them is all part of the eating disorder, but then they weigh and measure us constantly,* she thought. This realization rendered recovery outside the center, without constant external vigilance, a paradoxical prospect.

The world inside was simultaneously comforting and confusing, a place where *value is placed on all the things the anorexic places value on (namely, food, weight, and symptomatology),* in the words of Kelsey Osgood, a writer and recovered anorexic. It was also terrifying; C saw fellow patients reprimanded for their resistance to meal plans, called "noncompliant," and punished with feeding tubes and solitary confinement for refusing food. She made friends with her roommate, who was soon kicked out for hiding uneaten food, a decision C found obviously *counterintuitive,* as not eating was clearly an eating disorder symptom.

C's therapist insisted that her eating disorder was a second self, a false friend seeded between her synapses, capable of mind control rendering her untrustworthy even to herself. They would say, *"this is the eating disorder talking," when you try to describe desires or moods,* C remembers, a notion that muddled her own sense of agency, and made her question her capacity for recovery. Could she trust her own mind, let alone the friends she was making in group therapy? She was praised when she was able to parse an "ED thought" from a supposedly genuine thought and applauded when she narrated her illness in external terms, casting it as a bad friend or an abusive lover, and herself as an embattled warrior, building her mental boundaries brick by brick to keep her eating disorder out. She was meant to forge a new identity, one that was self-contained, not seeping out all over the place, with word vomit or literal vomit.

C followed her meal plan and regained weight more quickly than the center had expected. Too quickly, as C found out when her insurance deemed her "medically stabilized" after she hit her goal weight,

and then refused to keep paying for her treatment. C was discharged right when she needed intensive support most. Eating disorder sufferers often recall the weeks after initial refeeding as emotionally devastating, a time when recovery is tenuous, and purging and restricting are painfully alluring ways to numb the novel pain of living in a new body. As Jennifer Gaudiani writes in her book on eating disorder treatment, *Sick Enough,* insurance forces patients out of treatment when they are "just weight restored enough to panic" but haven't "stayed long enough to do the psychological work to tolerate [their] body changes."

C relapsed. When she showed up in an emergency room with cardiac arrhythmia, at a dangerously low weight, she was sent to that hospital's eating disorders ward, which quickly discharged her once she was deemed physically stabilized. The hospital recommended she return to residential treatment, but C's insurance considered this relapse proof that she had "failed" the highest level of care, so it would be hard to get approval again so soon. Her multiple interactions with the healthcare system meant she was heading toward a "chronic" designation in her insurer's books. Originally, her insurer had refused to pay for more treatment because she did not present as sick enough, but soon she would be considered too sick to treat.

When patients relapse soon after residential or inpatient treatment, or gain weight in treatment more slowly than their insurer expects, insurers often claim that the patient, rather than the treatment, "failed." Enough "failures" lead insurers to mark patients "chronic." Insurers are reticent to approve treatment for chronic cases, afraid of losing money on patients deemed unlikely to recover. Yet when a patient is sick but not meeting an insurer's biometric barometer for illness, insurance might approve only outpatient care. "Failing" at this lower level of care, plus losing more weight, is often the only way patients can access comprehensive care in the first place. People with eating disorders are forced into a treatment merry-go-round, and treatment coordinators are rendered authors, narrativizing their patients' stories into the narrow silo of deserving sick person: "sick enough to warrant care but not too sick to benefit from it," in Lester's words.

After C cycled in and out of emergency rooms twice more, her parents—scared for their daughter's life—decided to pay out of pocket

for a full month of residential treatment. They took out a second mort-gage on their home to cover the $36,000 price tag. Years later, the total C's family had spent on treatment surpassed $200,000. C was racked with guilt, terrified of wasting her parents' money. She was overcome with shame about the needs, bodily and emotional, that she'd origi-nally tried to tamp down with anorexia. When what had allured as a simple diet spiraled into sickness, C found herself in a place promis-ing to teach her ever more mechanisms of self-control, when what she needed was to let go. Desperately attempting to corral her thoughts, urges, and appetites into the correct cages, C thought all this regimen-tation was eerily reminiscent of the way she'd previously constrained her hunger, convinced herself she didn't really need that next meal. If her eating disorder had been in control of her then, and the treatment center was running the show now, when, she wondered, would she be taught to make her own decisions, be told she could trust her gut, learn how to listen to her hunger? By then, she knew better than to ask. She ate according to her prescribed meal plan, stared at the nutrition charts, and sometimes, in the rec room, between morning weigh-in and break-fast, she daydreamed about living an entire day without thinking about her body at all.

When the girls are dragged out of bed by flashlights and high, imploring voices, it is still dark outside. Everyone gathers in the hallway, heavy comforters and thin hospital blankets draped around their shoulders, which are hunched in defensive postures as the girls attempt to stay warm and unscrutinized a little longer. Beneath the blankets, flimsy hos-pital gowns, tied loosely at the back. Some stand, shifting anxiously from foot to foot, biting nails or scratching gooseflesked skin. Others slump, closing their eyes until their names are called. One is avoiding eye con-tact, another waving weakly at a friend. One by one, girls are brought into a small examination room, where they shrug off their makeshift cloaks and step onto a scale. Some are allowed to see their weight; others face away from the numbers. Next come the blood pressure cuffs and the thermometers under tongues, the frigid fingers on thighs and chest and evaluative eyes on ribs and wrists, brows wrinkled toward spines.

The nurse on duty tsks and shakes her head and nods meaningfully and sighs, scribbling away. Girls are reminded to avert their eyes from their lengthy files as they're asked invasive questions. The results of these fifteen-minute inquisitions-cum-medical-examinations will be logged electronically later and passed on to each patient's insurance company, which will then decide whether they are sick enough to stay in this treatment center another day.

This scene in the documentary *Thin* depicts an average morning inside a residential eating disorder treatment center, revealing the paradox inherent to the dominant model of eating disorder treatment: the places meant to help patients realize that their weight is not the defining facet of their personhood are entirely oriented around their weight. This focus is largely driven by the demands of insurance companies, which require physical proof of illness—"evidence" like meeting a low weight threshold, exhibiting blood disturbances or liver or kidney dysfunction—both before they approve treatment and daily during treatment, for patients to stay. Eating disorders are the only mental illness class treated this way by insurers; no other mental illness diagnosis is predicated on biological "proof." Obviously, eating disorder treatment includes weight restoration for many patients, but the constant, quantitative data collection patients are subjected to reinforces the numbers-focused logic of their disorders, an ethos driven home further by the constant trickle of patients from the facility, sent home before they are mentally ready because their bodies no longer look sick enough.

This is especially and painfully true for patients who never present as underweight at all. One patient who has been in and out of eating disorder treatment for almost two decades told me, *my body is large enough that insurance companies push back all the time.* Less than 6 percent of people with eating disorders are medically underweight, yet most insurers require an underweight BMI to approve treatment. This demand renders unsurprising the otherwise startling statistic that only around 10 percent of people with eating disorders ever receive treatment.

When people who fall into "normal" or "overweight" categories are rejected for treatment, the experience often worsens their disorders. Professionals are telling people with illnesses powered by the belief that

their bodies are too big that they are literally too large to deserve care. One Twitter user posted about avoiding seeking treatment because she was so *afraid of them saying you're not thin enough to have an ed.* A former patient described *multiple rejections* for just this reason, and receiving approval months later, only when their *weight had gone drastically down.* As one treatment center's executive director told *The New York Times,* "We've had folks who are denied authorization then come back later, and their eating disorder has escalated since the last time we saw them. That's pretty common."

Writing in *Vogue,* Michelle Konstantinovsky recalled petitioning a *fairly generous* insurer for eating disorder treatment and being *informed I did not qualify . . . because my weight was not considered low enough to merit the level of care I was seeking. And so I could choose to either go into debt or fall deeper into my disorder in an effort to meet insurance criteria.* Under these conditions of austerity, treatment centers purposely send patients to lower levels of care with the full knowledge that they are likely to end up back in their intake room even sicker, just a few months later.

In one horrific and emblematic case Lester observed, a treatment team prescribed calorie restriction to a woman suffering from anorexia. Unable to gain weight at the pace her insurance company mandated, she was failing to demonstrate a desire to get well in its eyes. Her severe symptoms were read as noncompliance, and her insurance refused to fund further care. Her clinical team thought the only way to keep her in treatment was to ensure she joined a nearby clinical trial for a new treatment. That trial was taking only patients who weighed in at 80 percent of their healthy body weight, and this patient weighed more than that. This catch-22 reveals various levers of the eating disorder treatment complex as the sharpened knives they are: Most studies are being carried out on severely underweight people, reinforcing the stereotypes that prevent people from receiving diagnoses and care. Insurance companies safeguard their profits as people get sicker. In the end, the woman's treatment team thought the trial offered their patient her best chance at survival, so they put a severely anorexic woman on a diet.

According to one survey, 97 percent of eating disorder specialists believe that their patients' lives have been endangered by their insurer's

decisions, and 20 percent blame an insurance company for a patient's death. One intake coordinator, faced with a chronic bulimic who clearly needed inpatient treatment, knew immediately upon reviewing her file—a series of hospitalizations and little recovery progress—that the woman's insurance would only pay for outpatient care. Talking about that patient with Lester, she said she "heard later that the client died. She's not the first, and she won't be the last."

S struggled with anorexia for over a decade and received inpatient treatment five different times. Speaking to me, they wondered, *was I really lucky to have low weight anorexia?* A rueful chuckle, a shake of the head: obviously not. However, they explained, *the fact that I had what the stereotype was really worked for me in terms of accessing the treatment that I needed. Whether it was treatment that works is another question, and whether it was treatment that I consented to is another question.*

A psychiatrist, a nutritionist, and a doctor are meeting to discuss a "problem patient" in the center: Polly, a girl who's been caught sharing her antianxiety medications with a friend, another bad girl known to hide regurgitated food in her room. The professionals cluck their tongues, theorizing that Polly might be inciting a mutiny, making her fellow patients less receptive to the center's dictates. They worry about the development of a clique, sick girls who see themselves as sisters making each other sicker by whispering about calories. These girls rub each other's backs while they sob over nutritional supplements but swallow them down, encouraging each other to eat. They giggle on twin beds as they trade trauma stories, accuse each other of *wanting to be the sickest one here*, but hug minutes later, forgiving and forging friendships. Polly, the girl under investigation now, is called "sneaky" and a "bad seed" by her treatment team, who come to the conclusion that she is simply too sick to be helped without her symptomatic behavior infecting other patients further.

Meanwhile, two gaunt girls take deep drags on their cigarettes and exhale into a vent in the ceiling. We are in the bathroom of Polly's room, and she and Shelly are blissfully unaware that Polly's fate is being decided down the hall. They chat about their respective meal plans, com-

paring calorie counts and their doctors' and dietitians' pronouncements on their sicknesses. They laugh. They sigh heavily. Right now they're best friends, but soon Polly will be kicked out. She will relapse, purging as soon as she finds out she is being forced to leave; she described this relapse as a reaction to the stress of her expulsion. Her mother will beg the treatment center to let her stay, explaining through tears that her daughter's rule flouting is a symptom, imploring them to save Polly's life. But they will hold fast to their decision. Shelly will leave months later. Both will relapse multiple times, and only one of them is alive as I write this. Polly died by suicide at thirty-three years old, "a direct result of her internal battle with the eating disorder," according to her sister.

Prison, safe haven, school, summer camp, hospital. Language of matriculation, learning and leveling up and aging through, is threaded throughout narratives of treatment written by former patients, sitting uneasily alongside straightforwardly medical and carceral terminology. People who cycle through these treatment centers also cycle through identities, alternately finding themselves students and prisoners, friends and foes, star pupils and expelled rebels—all identities constructed by committee. Eating disorders have been cast as a search for identity, understood by clinicians as a "hijack[ing of] the developmental process," as Lester puts it, leading treatment programs to cast themselves as parents and principals, rerouting rebels into normative adulthood.

But often these institutions produce perma-girls who can end up wanting to be *the perfect patient* rather than someone who isn't a patient at all. Treatment is predicated on inculcating docility while pretending to teach autonomy, because that artificial autonomy is also what is expected of adults under capitalism. You can choose your own adventure, but only from the scripts on offer. Enclosed together, the forever adolescents teach each other tricks, share survival stories, and end up learning coping mechanisms that are also eating disorder symptoms, because an eating disorder has always been a way of coping with this society. And like everything else in said society, hierarchy is everywhere, your best friend is also your competition, and there are clear tiers.

Writing about receiving treatment for anorexia across hospitals and

residential centers, Kelsey Osgood describes herself as a *kindergartener* the first time she enters treatment. Later, she is a *good novitiate* with a *master's degree* in anorexia, ticking off *anorexic milestones* to a newer patient and calling her hospital records her *anorexic résumé*. Another woman writing her way through anorexia hospitalization, Rachel Aviv, remembers arriving on an eating disorders ward young and immediately recognizing the older girls as *mentors*. Entranced by her elder pseudo-sisters, *girls versed in the illness,* she became an *anorexic-in-training,* watching them *compare bones.* She *acquired a repertoire of anorexic behaviors* from *girls who took care* of her even as they almost hurtled her down an infinite hospital hallway. Eating disorder expert Joan Jacobs Brumberg differentiates between the "career anorexic," who might spend most of her adolescence and adult life cycling through treatment centers, and the girls still in the disease's "recruitment" stage, infected by their elders in treatment.

Rachel remembers a *sense of collectivity* on the ward, other girl patients as *friends and mentors,* but in retrospect that communalism is shadowed by the *machinery behind the structure of our days,* the engine of *perverse American individualism* informing *the way the girls compared stats.* She can see that the motor is the problem, not the girls used as grist for it. In a place designed around size, calories, and quantification, where people are taught how to talk about their obsessions with those things, what are they to do but compete over who's smallest? In the storytelling competition too, concision wins. Despite her evident sympathy for her former sisters, years later Rachel resists the label of anorexic, writing that she *wonders if I ever had anorexia in the first place.* I have to be honest, this hurts my feelings, though I get it. She doesn't want to be lumped in with the girls who can't get over it, wants to write the last chapter in that story, move on. It might be fiction, but at least the book is closed. She wonders why, though she was *"recruited" for anorexia,* it *never became a "career," didn't provide the language with which I came to understand myself,* as it did for so many girls on that ward.

The recovered patient, the girl who graduates, rather than getting stuck in the infinite treatment cycle, is one who knows the difference between "ED mind" and her own mind, who's learned the "right" thoughts to have. Treatment professionals ghostwrite a straightfor-

ward narrative of recovery for patients, one enabled by learning a new language through which to talk about their thoughts. The recovering patient must learn that many of "her" thoughts are not strictly hers, but her disorder's. One therapeutic technique commonplace in treatment centers is writing a letter to your eating disorder as though it were a second consciousness hiding in your mind, and then ritualistically bidding it goodbye upon recognition that its beliefs are harmful. Patients are taught to interpret their "ED minds'" thoughts through the clinic's therapeutic language, interpreting them as irrational distortions classified according to cognitive behavioral categories, rather than reactions to the world a person with an eating disorder is living in, the world they will be thrust back into when they leave the clinic.

Two patients conversing about receiving more attention when they were dangerously thin might be instructed to stop talking like that, told that they misread those interactions or warned against triggering each other. As one person put it in a thread titled *eating disorder treatment centers are fucked*, in treatment *no one was allowed to talk about food, their struggles, their experiences, their hardships*. Instead of sympathizing with each other and thinking through why they might not want attention from a society that would only give it to them for starving themselves, patients are encouraged to disbelieve their own memories, reconceive of their reactions to experiences as distortions by "ED mind." One former patient recalls being taught to *mistrust* her thoughts, even to think of them as *misinformation*. In their book *Health Communism*, Beatrice Adler-Bolton and Artie Vierkant describe medicine inculcating "a distrust of self-identification," rendering statements of identity "suspect unless and until validated by an outside authority." This occurs in treatment when insurers and clinicians obsess over numbers and push people to mold their stories into the shapes patients know will get them off the locked ward.

A patient remembers being repeatedly told her questions about the logic of treatment were coming from her eating disorder rather than her own mind, an idea the staff used to explain their refusal to answer her. *If ever I had any questions about my meal plan, I was told it was the disorder talking. If ever I questioned the methods of treatment, it was my disorder*

talking. When I resisted having the [feeding] tube placed, you guessed it, disorder talking. Kelsey told me that the therapeutic notion of *"disordered thinking" implies that there is some kind of platonic "ordered thinking" out there, that certain people think in the "appropriate" way and others don't,* an idea that is *wildly infantilizing,* and encourages patients to be *wary of our thoughts and our feelings,* rather than learn to endure them without engaging in disordered eating to survive them.

So you saw yourself in the mirror, remembered a time someone called you fat, and now you're sobbing so hard you can't breathe? You're "overvaluing thinness." Check off the symptom and suddenly, supposedly, it is no longer a part of you, as though selves aren't built through a series of experiences. This narrative structure flattens and invalidates a wide array of experiences and harms, but it does so especially painfully and clearly in instances of racism, transphobia, and fatphobia, when being told your memory of an experience is actually a distortion by "ED mind"—one you can reframe positively—becomes an act of invalidation and often retraumatization.

Not everyone can retrofit their existence into the dominant recovery narrative. Patients of all ages, races, and genders are dying. No one should be getting sacrificed on a pyre of discarded narratives just so treatment centers can tell a simple, sad story at the funeral, a story about a person who was sick, too sick to accept reality, attached instead to their supposedly pessimistic distortions. There is a difference between not accepting reality and not being able to survive it.

The way someone is treated by others, based on their legible identity as a woman, person of color, trans person, or fat person, for example, may very well trigger disordered eating, yet cultural etiologies for these diseases are underexplored in the field. Iain Pirie, writing about eating disorder scholarship, observed that the "role of macro-level structures in the development of disordered eating is effectively relegated to secondary status." Margo Maine, in an analysis of eating disorder treatment handbooks, found "no references to feminism in the index of major textbooks." Responding to Renfrew, the United States' oldest eating disorder treatment center, hosting a conference on feminist perspectives on eating disorder treatment, one therapist wrote an op-ed railing against

feminist interpretations of the diseases, calling them "shortsighted" and "politically motivated," and feminism a "one-sided, anti-scientific perspective" that "is a turn-off to academic and empirically minded types."

It seems to me more politically minded, one-sided, and shortsighted to attempt to excise politics from an illness that sufferers, time and again, trace to a beauty ideal that is entirely political. In the words of one sufferer, *my eating disorder had everything to do with affluent white womanhood, something not available to me, but that I was systematically surrounded by.* Mikki Kendall, writing about Black women's experiences with disordered eating, explains the way symptomatic behavior can feel like a survival tactic in a society stacked against you: *While complexion can't change, weight can. . . . Obsessive dieting isn't just about being considered more attractive; for many, it could feel like the key to having access to quality housing, fair treatment by the legal system or simple respect in day-to-day interactions.* Every single person I spoke to who had received residential treatment said that their programs did not engage with cultural explanations for these diseases, that they ignored feminist and antiracist understandings of eating disorders that patients told me could have been helpful to their recoveries.

If we want to get empirically minded, we might look at the relapse and mortality rates associated with our current modes of treatment: only about half of anorexics and bulimics who receive treatment will ever fully recover (often after multiple relapses), and at least 20 percent will develop chronic illnesses or die. Long-term studies on BED and EDNOS/OSFED relapse rates and mortality are more rare but, when they are carried out, come to similar, strikingly sad conclusions: EDNOS mortality was estimated at just over 5 percent in 2009, and EDNOS was the diagnosis associated with the highest posttreatment relapse rate in a transdiagnostic sample. More than half of patients who receive "successful" hospital treatment will relapse within a year, and a 2015 literature review admitted that many current treatments fail to "relate to or integrate any basic science at all." Treatment, then, is often a lengthy, cyclical, painful journey that too commonly ends in relapse and, in a horrific number of cases, death. Instead of understanding this "crisis of care," in the words of the field's own experts, as evidence that the current model doesn't work, the medical establishment instead

chooses to demonize eating disorder sufferers. They are cast as manipulative, malingering, willfully ill people with "self-inflicted illnesses," in the words of one clinician quoted in *Famished*. Insurance premiums rise, treatment centers rake in cash, and the system is able to "maximize its exploitation" of the ill, "pathologizing with one hand while generating capital with the other," in Adler-Bolton and Vierkant's words.

Eating disorders are a form of debility that removes young people from school and adults from the workforce. They are also a form of debility that bolsters capitalism, creating a profitable industry invested in self-improvement through a self-knowledge darkly predicated on reimagining the self as untrustworthy. Cognitive behavioral tactics are all about re-narrativizing: applying classificatory schemes to genres of thought and medicalizing our every move. One former patient recalls treatment as a place where staff were very *trigger-happy with slapping labels* on thoughts and behaviors. Kelsey told me that the *most terrifying thing* she witnessed over years of treatment was a girl's return to an outpatient group after spending time in a hospital and a treatment center. When the group therapy leader asked what she'd learned about herself in treatment, the girl did not relate anecdotes or talk about the specifics of her illness, but *literally recited the* DSM *symptom list from memory*. Treatment hadn't taught her *how to move through the world if you're having difficulty with it*, but *how to borrow* language.

The storytelling about selfhood taught in treatment destroys solidarity and pits patients against each other, as people forming friendships are told by their treatment staff that they are reinforcing each other's disordered thoughts. The only way out is learning to play the recovered role, stacking stones between yourself and the girls who know too well what you mean, until you've built a wall so high you can barely hear them calling your name. Their voices and the one in your head are untrustworthy, and only in your ritual renunciation of reality are you welcomed back into the rest of the world, where sometimes you miss the girls who get it. In a YouTube video about her treatment experience, a teenage girl remembers a fellow patient accusing her of *stealing her symptoms*. Some scholars argue that anorexia is a taught disease, learned verbally. A voracious reader can quickly learn to deny her more literal hunger. One woman told me she's never forgotten the exact lunch Caro-

line Knapp laid out in her anorexia memoir, in a paragraph of detailed, step-by-step prose. Such instructive detailing isn't rare. Many memoirists offer excruciatingly specific rundowns of daily intake measured in bites, licks, and calories. In Marya Hornbacher's *Wasted: A Memoir of Anorexia and Bulimia*, which another memoirist called *the eating disorder bible*, Marya traces the onset of her own disease to another book, *The Best Little Girl in the World*, whose protagonist she made her role model. Kelsey recalls *verbal plagiarism* of symptoms in group therapy sessions. This is language of theft and imitation, not contagion; language that reveals the internalization of the narrative of their illness they've been fed, a volitional one that blames other ill girls even as it worships them.

Eating disorders and addiction are the only mental illnesses construed as willful, self-inflicted, and they are also the two mental illnesses with the highest fatality rates, a combination that should beg the question of whether this paradigm is killing people, in part by teaching doctors to conceive of their patients as their enemies. One eating disorders handbook cautions that negotiating with an eating disorder is like "negotiating with a terrorist." Both doctors and insurers understand symptoms like restricting, bingeing, and purging as choices, and they in turn penalize patients for being sick by withholding care. A former employee of an eating disorder clinic told me that many treatment staff consider eating disorder patients "stubborn" and "spoiled." A nurse writing about their experience on an eating disorder ward called patients "manipulative" and prone to "playing mind games to get what they want."

We can understand treatment centers as carceral finishing schools draped in medical lingo, educational institutions designed to indoctrinate patients into a subjecthood amenable to capitalism, one where the heroine's journey from sickness to health is predicated on individualistic self-knowledge and a resigned kind of autonomy that renders people pliable and isolated in ways that reinforce each other. Dr. Jennifer Wang-Hall, a radical eating disorders therapist, has described the range of inpatient experiences her patients have undergone as "infantilizing at best, traumatizing at worst," inadvertently using language reminiscent of the terminology of schools and prisons that eating disorder memoirists tend to use metaphorically.

Infantilization happens on many levels, from strict scheduling to

constant supervision. One former patient compared her center to a *daycare*. People in residential treatment are given meals they played no part in putting together and usually only a small part in choosing (many locations let patients choose from a few options, and a very small subset teaches patients to construct plates of food themselves), and are then trained to eat them in a highly ritualized, surveilled way. This forces them into an extremely childlike role that renders eating outside of the treatment setting, without the set menus and supervision, terrifying, arduous, and often impossible, despite the fact that choosing, preparing, and eating food autonomously, without extreme emotional turmoil or too much ritual, is the very skill set effective eating disorder treatment should impart. As one former patient told me, *care is focused on this idea of removal from your context and not giving you the tools to maintain recovery within your life*. Kelsey told me that treatment transformed the way she understood herself as a person in the world, encouraging her to see herself as *a person who required oversight in order to live. Starting this process when you are thirteen or fourteen years old, the idea that I could have my own judgments about the world, or that I could feel things that didn't require some sort of intermediary presence to explain to me or help me parse out my feelings,* was foreign, something she had to *unlearn* to maintain recovery outside treatment, in her daily life.

Traumatization, though an extreme term, is not an exaggeration of what goes on in many clinics. The rewriting of life stories I have been describing does not occur without coercion, threats, and pain. One punitive tactic is tube feeding; although it is often employed as a medical necessity, it is also utilized as a punishment when people do not comply with a center's demands. People who have been through it almost universally use words like *terrifying* and *traumatizing*. It is excruciatingly painful, and human rights groups warn that the practice can rise to the level of torture. One former patient describes being *constantly threatened with tube feedings,* and another, who was force-fed multiple times, *absolutely did not need it, it was just to teach me a lesson about being bad,* while another was told by her treatment team that *the feeding tube was not a medical necessity but a motivational tool.* After repeated tube feedings, another patient felt *defeated* and *dehumanized.* In a thread entitled *Trauma from Treatment,* people swap stories. Someone writes, *I wish it*

had never happened to you, or me, or anyone. It's kind of horrific the way they treat us in (many) treatment programs.

I thought I was going to be the perfect patient, another writes, and I wonder how many of us felt that way, how many of us talked ourselves to sleep, telling the story we thought we should be living until it felt true, and suddenly, the girl sleeping next to us was a threat instead of a lifeline. One person described it succinctly to her sisters in the cyberverse, better than I ever could, so I want to quote her directly now: *when this largely traumatized population is seeking life-saving intervention for their medical condition, they are being stripped of their personal boundaries, their autonomy, their own insight. They are told over and over again that they are too sick to trust themselves or be trusted.*

Insight is defined in the mental health field as the ability to accurately describe a morbid change in oneself. But accurate according to whom? Boundaries and autonomy are both redefined in the clinic as frighteningly permeable while you are sick—that girl's pain could be yours if you get too close—and rendered in reinforced steel once you recover, a paradigm that completely ignores the fact that recovery is a durational state and sickness a spectrum. Instead of seeing the obvious failure of these treatments in relapse rates (which reach 41 percent in the single year following residential treatment), treatment construes the relapsed as chronic cases. Their almost corpses in the corner of the cafeteria become warnings. The goal seems to be building a suit of armor from self-management techniques, alongside a ritual rejection of the girl who couldn't hack it and her sisters, still stuck inside the false safety of the center.

The bodies have no faces. Drawn in primary colors on huge sheets of construction paper, the girls' silhouettes are stocky: bulging bodies rendered in thick Crayola bright lines. Kneeling over these pages are the girls themselves, skeining their self-image onto paper with shaking hands and bitten lips, wet eyes. The doctors and therapists stand watch, wearing worried expressions. When the patients are done drawing, a therapist asks the girls, all of whom are thin and white, if they really believe these bodies are reflections of their own. They nod ardently,

fists clenched. Then the therapist tells them to pair up and prove each other wrong. One girl lies down atop the girl she thinks she is, and the other traces her physical form with a red marker, and then they switch. Standing back from their split selves, the girls gasp and tear up, express awe and disbelief. Speaking in soft, soothing tones, the therapist tells them she hopes the girls can now finally see that they have body dysmorphia, that their beliefs about their size are false: They are the red waifs within those big bodies. And aren't they thin, and aren't you sick, confused, fearful girls relieved to finally find out who you are? There are shaking shoulders and damp cheeks as the girls stare at their secret, skinny selves.

Versions of this scene appear in *Thin; What's Eating You,* a reality show about eating disorders; and countless other films, shows, and books about eating disorder treatment. Body tracing was long a cornerstone rehabilitation activity in many treatment centers and remains so in some today. In the archetypal eating disorder narrative it is often positioned as the turning point, the lightning strike moment. Reality is finally recognized and grace, in the form of diagnosis, is accepted. They have eating disorders, and they have body dysmorphia. They have a plot and a climax, and they're starting to see a happy ending on the horizon, one where they might live in slightly bigger bodies, but never the ones they drew in a haze of self-hatred.

The moral of this scene is that the patients are not fat, and they will not be fat if and when they gain weight, because they are currently emaciated. The underlying lesson is that their desire to lose weight was wrongheaded only because they are not fat, not because extreme weight loss is always dangerous and unhealthy. The relief expected and performed by these girls upon this realization encodes the belief that the bigger bodies they drew would be horrifying to live in. It casts the symptomatic behaviors they are learning not to practice in their small bodies as potentially reasonable, even warranted, in the bigger ones they thought they were living in. This is a recovery paradigm that reifies the fatphobia at the heart of our eating disorder epidemic, and it is also one of the myriad ways current treatments reinforce the logic of eating disorders.

But let's return for a moment to the cast of characters here. In all

the filmic versions of this scene I've watched, and almost all the literary ones I've read, the patients engaging in this therapeutic experiment are white, skinny, cisgendered women. Sometimes their ages range, but otherwise these vignettes have little variation. This is important and alarming for a few reasons. While it may reflect the reality of patient populations at expensive private treatment centers, that reality itself is emblematic of larger problems of treatment access and efficacy, and the ways both are entwined with the narratives most often told about eating disorder trajectories.

Lauren Greenfield's eating disorder treatment documentary, *Thin*, following Polly, Shelly, and two other girls, came out in 2006, accompanied by a photography book with the same title. In the prologue, Greenfield describes choosing an eating disorder treatment center as her subject in the wake of the success of her prior book, *Girl Culture*, which explored American girlhood in all its glittery, grasping, dirty pain and glory. She writes that the treatment center, with its "atmosphere of a college dorm," fostered "'girl culture'—female bonding, competition, gossip, cliques," as well as "natural drama and tension that was emotional, narrative, and cinematic." Eating disorders are cast as an expected, if unfortunate, aspect of girlhood, the seedy underbelly of more trivialized forms of bad behavior associated with girls—gossip, exclusion, hierarchies. The emphasis on the space's narrative allure reflects the powerful hold of illness narratives on the popular imagination, and the way stories of mental illness, and eating disorders specifically, exert a strange magnetism in their sororal cyclicality, their histrionics, climaxes, and reversals.

Greenfield writes that part of *Thin*'s goal was to "tell a broader story about the diversity of the population affected—older women, women of color, adolescents, and obese women . . . which I could do more effectively in photography" than on film. She does not explain why the film's efficacy would be hindered by the inclusion of diverse bodies. In the book, a wider range of patients are pictured alongside first-person narratives of how they ended up in these pages, permanently preserved in treatment's purgatory. Still, the film's four main characters—thin white women—are given the most visual and verbal space, and Greenfield's stated effort at diversity extends only to the inclusion of one

Black woman, one Latina woman, one fat white woman, and a few white women over the age of thirty. The fat woman, Cathy, says she felt *alienated* in treatment, and the one Latina patient, Ata, says, *it's sad because every time I've been in treatment, I've been the only minority.* The Black patient, Cheryl, describes a nurse expressing surprise and disbelief at her presence, asking why she wants to be thin when *Black women are supposed to be shapely.* Anecdotes like these appear wherever people of color and fat people talk about eating disorder treatment and reflect both their lack of access to treatment and staff's misunderstandings of their illness experiences, and the way these phenomena perpetuate each other.

The prominence of the ED narrative centering on a thin, rich white girl drives a vicious cycle. People fitting the stereotype are more likely to be diagnosed and more likely able to pay for treatment, where their presence renders them the group on which studies and research are largely focused. This seeds the stereotypical narrative into the medical literature studied by generations of doctors, so the majority of eating disorder research centers on white cisgendered female patients, despite the fact that epidemiological demographic prevalence does not reflect this. Doctors often disbelieve people of color's eating disorder symptoms—one study presented clinicians with either a Black or a white patient, suffering the same list of eating disorder symptoms. Almost half diagnosed the white patient, while only 17 percent diagnosed the Black patient, results that highlight how often eating disorders are overlooked in general, and the expanse of that blind spot for Black populations.

Online, people of color post stories about attempting to receive treatment. One poster, identifying herself as a *Black woman who's been in and out of treatment for more than a decade,* writes that when she sought treatment and looked for a program that had a Black therapist and would take her insurance, she found *literally, one. In the entire country.* One Black patient hospitalized for an eating disorder, interviewed for the Substack newsletter *Mental Hellth,* described being the only Black person at the facility, where they were *labeled as non-compliant quickly* and *put into solitary confinement—for doing the same things everyone else was doing. It was basically just racism.* Another Black patient wrote about being unable to recover in treatment settings where all her doctors and therapists were white, and finally finding recovery years later, when she

saw a Black clinician. Today, she wonders, *if I'd had a black therapist when I was first hospitalized ten years ago, could I have recovered for good back then?* In addition to the dearth of Black therapists treating eating disorders (the eating disorder nonprofit Project HEAL "generously" estimates that only 5 percent of eating disorder providers in the United States come from BIPOC and LGBTQ backgrounds), there are only twenty-five Black dietitians working in the disordered eating field in the entire United States.

Gender diversity is similarly underrepresented in clinical staff, creating a harmful rift in understanding between clinicians uneducated in gender literacy and gender non-conforming (GNC) patients, who report *dismissal, mistreatment, and incompetence* from eating disorder clinicians who are largely untrained in the ways eating disorders interact with gender dysphoria, or even in basic competence with gender-inclusive language. A 2016 study in the *Journal of LGBT Issues in Counseling* interviewed almost a hundred trans and GNC patients who had received eating disorder treatment, and not a single one described their experiences as positive. Many wished they'd never gone to treatment.

Dagan VanDemark was researching their senior thesis on gender dysphoria and body dysmorphia when they decided to call eating disorder treatment centers and assess their trans cultural competency, asking questions on behalf of a hypothetical trans woman friend. To their horror and alarm, every single person they spoke to was unaware if their employer even accepted trans patients, and many asked *invasive, inappropriate and ignorant questions* about genitalia and sexual orientation. VanDemark went on to found the FEDUP Collective, a nonprofit that aims to "provide accessible, gender-literate community-led healing spaces" for trans and GNC patients and offer training in gender-affirming care to treatment professionals.

B, a nonbinary person who has been in and out of treatment for over a decade, decided to pursue a graduate degree in the field after being subject to *transphobia, ableism,* and *fatphobia* in treatment, but found the field so rife with violent gender illiteracy that they ended up quitting their job at a treatment center. They felt *singled out* as the only trans or queer person on the staff, and the only one raising issues specific to those populations. One trans patient described misgendering as *par for*

the course in treatment. Another *can't help but wonder how my life might have been different if anyone who saw me in the course of my treatment had been able to recognize my gender dysphoria and inform me that there were ways of addressing my extreme discomfort with my postpubertal body other than starving myself.*

Speaking at Renfrew's 2022 conference for clinicians and therapists, Sand Chang, a nonbinary clinician and PhD, gave a training on gender-literate education in the eating disorder field. Chang began by recalling their own education as an aspiring clinician, when they found themself "educating my professors" rather than learning about the dangerous intersection of gender dysphoria and disordered eating. They discovered that in this particular clinical landscape, "having a great deal of experience working with eating disorders may be a hindrance" to treating GNC patients, because stereotypes were so embedded in experienced doctors' education and practices. Chang explained extremely basic concepts around bodily sovereignty, saying, "Trans identity in and of itself is not a disorder," and "Being trans isn't something that needs to be treated but acknowledged." That an eating disorder professional would assume providers needed to be told that being transgender isn't a mental illness illuminates how direly misunderstood GNC patients are in treatment. Chang recalled the questions that haunt trans patients in treatment: *Will they try to blame my eating disorder on my gender identity? Will they be more focused on my genitalia than my treatment?* Chang also provided distressing anecdotes, recalling trans patients who were denied hormones in treatment because the provider decided to "treat the ED first," before the dysphoria. The limited research that has been carried out in trans populations shows that gender-affirming care often leads to a decrease in eating disorder symptoms, yet patients continue to receive counterintuitive, invalidating care.

The interaction between gender dysphoria and body image often renders cognitive behavioral approaches to improving body image harmful, because these techniques function as a denial of patients' realities. In the words of one researcher, "body image disturbance is more than a cognitive distortion" for these patients. According to Chang, the "acceptance messaging" used around body image in treatment can harm trans patients. This paradigm contends, "You think this in your

head but we [the professionals] know the truth" about your body, an invalidating stance that is basically a restatement of what trans people have heard from a transphobic society throughout their lives. When any desire to change their external appearance is read as a disordered eating symptom—a "cognitive distortion"—rather than understood as a valid urge to bring a body into alignment with a patient's identity, treatment perpetuates the oppression that was likely part of these patients' disordered eating in the first place. As one patient told a researcher, *a trans person may be trying to control unwanted aspects of their body structure with their eating disorder; trying to assure them these aspects are "okay" or "normal" is NOT the right answer and only aggravates dysphoria.*

The primacy of the thin white girl's narrative in this specific sick role also obscures the strife of fat people with eating disorders. No fat patients are present in *Thin*'s silhouette-drawing scene, but all four thin white patient-protagonists are. Imagine the shame induced by completing that activity as a fat person. Even if fat patients do not participate, the activity's existence and their exclusion from it would compound the preexisting shame that exacerbates symptoms. Internalizing its lesson, one rooted in fatphobia, could understandably motivate a fat person to resist recovery.

As of 2013, people suffering from all the symptoms of anorexia other than low weight can be diagnosed with "atypical anorexia," a subtype of EDNOS/OSFED. Given the levels of diagnostic crossover in all eating disorders, and the corrosive shame associated with EDNOS, deeming fat people with anorexia "atypical" seems, like much eating disorder treatment, likely to reinforce the logic of their disorder, and in this case motivate "atypical" anorexics to become "typical" anorexics. This is already happening, and it is sending people into near-death spirals. Fat people who are diagnosed with eating disorders receive diagnoses years later than thin people. One study found that people diagnosed with atypical anorexia receive that diagnosis after suffering for 11.6 years on average before diagnosis, compared to 2.5 years for people with typical anorexia. Atypical anorexics recall years of bringing clear eating disorder symptoms (heart palpitations, hair loss, electrolyte imbalances,

and lost periods) to doctors who responded by encouraging them to continue their weight loss. One person recalled friends who were driven deeper into illness by disbelief and even encouragement of their disordered behaviors by medical professionals. They described seeing *people struggling with nonclinical AN be praised for those behaviors, because they started at a high weight. They were physically ill because of it—incredibly so—but because they were now slim, and not emaciated, no one gave a shit. They were just proud they'd lost the weight.*

One person, who described themself as overweight when they first told their therapist about their eating disorder, wrote that because of their size, *he didn't believe me and so many, many years passed before I started having seizures and losing my hair and eventually obtained minor brain damage from what was absolutely EDNOS.* One patient, interviewed by *The New York Times,* said she lost a significant percentage of her body weight while starving herself, yet was diagnosed with "compulsive eating." Amid all this, when the rare academic study includes bigger bodies, illness severity does not vary with weight, begging the question of why weight requirements are in use at all. As one self-identified *survivor of (undiagnosed) anorexia who has always been really fat—even when near death from my ED—*put it, *it should be considered criminal negligence for weight to be used as a diagnostic criterion for a mental illness.*

When fat people are diagnosed and able to access treatment, it is often riddled with fatphobia. One person told me that they still feel conflicted about whether the treatment they received was helpful, because *so much harm was caused while I was there.* Fat patients report overhearing cruel comments on their size from treatment staff, and employees separating them from the patients with *normal* eating disorders, giving them smaller meal plans than other patients with parallel diagnoses. Even with an atypical anorexia diagnosis, staying in treatment while fat is extremely difficult in the current insurance reimbursement regime. Even in treatment centers actively attempting to strip fatphobia from their model, insurance demands make doing so difficult. One former staff member of a treatment center that attempted to utilize a Health at Every Size model that did not rely on weight as a measure of health said they still had to weigh patients and track biometrics in order to work with patients' insurance.

Both the book and film version of *Thin* traffic in what some eating disorder survivors have called *eating disorder porn*, while reviewers praise the film's depiction of "beguiling, life-threatening illnesses." The word "beguiling" is the skeleton key here, unlocking the secret hiding in plain sight of eating disorder treatment narratives: too often, they serve as motivation and are read for instructions by people in the grip of disease, an impulse that is clearly not unaligned with the larger culture's approach to the "beguiling" prospect of life-threatening weight loss. These are illnesses rooted in body comparison and competition, so content ostensibly designed to raise awareness and reduce stigma often instead ends up being used for motivational collages. Both iterations of *Thin* are brimming with visible vertebrae, super-slim silhouettes, scars, numbers, and scales. Over and over again, we hear that *the perfect anorexic is dead*, or *the best anorexic is six feet under*, from girls getting ever closer to becoming her. These statements are symptomatic, and they are suicidal, and they are also potentially infectious, but the problem is that they are, for those saying them, true, and it's not their fault we don't want to hear them because we are afraid to ask ourselves if we believe them, or where they might have learned them.

For all its flaws, the film offers rare, in-depth footage of how eating disorder treatment is carried out in residential facilities. And although much has changed in treatment since the 2000s, much has stayed startlingly the same. While patient populations have become more diverse as treatment access expands, treatment is still often inaccessible to people of color, poor people, fat people, and GNC people, a lack of access reflected in the film's cast. The film also depicts these clinics' failures and successes in real time, revealing the ways they foist blame on to suffering people and reinforce the logic of eating disorders in their regimens of "care." At the same time, the camera catches moments of tenderness between girls who want each other to survive even as they question whether they themselves deserve to live, and sometimes the screen shows the rushing current of recovery, the moments of motivation and meals that might turn into epiphanies.

A person who went through residential treatment writes, *I think I miss it?* into the internet ether, unsure. *I don't know if there was a day spent there that I didn't cry*, they write, but it was also the only place where *I*

felt seen and I felt loved during a dangerous, terrible time, and it is still one of the only places they ever found *friends who understood*. Anne Boyer, writing about the sororal sorrow of breast cancer, mourns her dead sisters, and the fact that only the survivors get to tell their stories: *to those victors go the narrative spoils*. I want to let the dead girls tell their stories without ventriloquizing a ghost, putting words in her hungry mouth without asking. I am trying to warp the recovery narrative, rip off its spandex and point out our folds, and the fact that it has suffocated so many of my sisters.

The story we've been told about recovery is just that, a story, and one that relies on other stories, which were once ours, before we broke and bent to the demand that we whittle them down into the waifs we wanted to be. But how can slimming down our stories be the way we learn to live in these bodies? They want us thinking in straight lines, linear paths, goals and willpower and rewards. Remember when we whined about missing the discipline we used to have, and they told us it takes more discipline not to starve ourselves? They were wrong, but we nodded along. It took love, and your hand in mine, and splitting a snack. But they kept telling us it was about the stories they told us and the voices in our heads, so we wrote those. When we tried to write our own stories, into our protrusions and curves, we sometimes still got stuck in the rote roles we played back then. It's not our fault—we spent so much time studying. Let me keep trying:

Elegy After Gross Misunderstandings

Alyssa first considered killing herself when she was thirteen years old, upon realizing that the dress she wanted to wear for her Bat Mitzvah did not fit her. Suicidal ideation might seem like an extreme response to a too-small dress, but I and too many people I know can relate to the feelings of worthlessness, shame, and, honestly, simple terror pulled taut through the body, inspired by the thought of existing in a physical form that feels too large. Those feelings are often greeted with sighs, hugs, and we've-all-been-there nods by mothers, therapists, and older friends, normalized like many disordered eating symptoms as part and parcel of adolescence, aging out of innocence and into the era of pain and performance otherwise known as womanhood.

But back to Alyssa, who is about to stand on a bima in a dress she hates, hating her body, be anointed a woman by a rabbi, and begin enduring an eating disorder that will consume much of her adult life. Soon after her Bat Mitzvah, she began seeing a therapist, a practice she maintained throughout high school, years in which she lived at a higher weight. In the pre-college summer heat, Alyssa made a vow I've read in countless eating disorder memoirs, stories posted online, and text messages from friends. Away from home, alone and adult, she would commit to shrinking her body. Back home for Thanksgiving significantly skinnier after just a few months, she received *a deluge of external validation that was irresistible.* Her doctors believe her anorexia was "firmly establish[ed] by age eighteen."

Alyssa finished college, went to graduate school, and became a star

academic, researching and publishing often, even as she struggled with anorexia over the course of the next fifteen years, during which she attended outpatient eating disorder treatment on and off. When she was thirty-three years old, her illness had reached a severe turning point and she moved home. She came down with hypercalcemia, a condition in which blood calcium levels become dangerously high, risking heart and brain damage. Despite the fact that hypercalcemia is known to be associated with anorexia, a diagnosis Alyssa had now had for over a decade, doctors did not thoroughly treat her anorexia while she was a hospital inpatient, instead focusing on physical stabilization.

She was quickly discharged with the suggestion that she enter residential eating disorder treatment immediately, and she spent the next seven months trying to do so. As her disease raged, she fought with her insurance company, trying to find a center it would pay for, and she struggled with treatment centers to "meet their admission criteria," specifically the weight criteria. The program she eventually received insurance approval for ended up rejecting her for being a single pound too underweight; they likely didn't want the legal liability and directed her to a hospital, once again for inpatient physical stabilization rather than the holistic psychiatric, medical, and nutritional care she needed. When that program discharged her, they recommended she get the type of residential care she had previously been denied, but Alyssa never did. She was not interested in repeating the grueling, demoralizing process of proving she was a deserving patient, which she had already endured to no avail.

Instead, she received care on an outpatient basis from a primary care physician, a therapist, and an eating disorder specialist for the next three years. At age thirty-six, she reached out to Dr. Jennifer Gaudiani, one of the founders of the ACUTE Center for Eating Disorders at Denver Health as well as her own clinic, the Gaudiani Clinic, and a board member of both the *International Journal of Eating Disorders* and the Academy for Eating Disorders Medical Care Standards Committee. Together, they embarked upon a course of treatment oriented around harm reduction. Such treatment is rare, but when doctors practice it with patients who have been ill for a long time and have not been helped by traditional treatment, it is defined as treatment aiming to "reduce the

frequency, intensity, and potential lethality of life-threatening or life-shortening behaviors" rather than attempting to induce complete abstinence from them, according to eating disorders expert Dr. Joel Yager. Alyssa's harm-reduction plan allowed her to gain weight more slowly than mainstream treatment would have allowed, letting her maintain some of her behaviors as coping mechanisms even as she tried to renourish herself as much as she could bear to. But her long-term malnourishment had altered her metabolism so any weight gain at all was difficult, even as she ate more.

After nine months, she told her doctor she was *utterly exhausted* by the anguish she felt while attempting to gain weight, an experience so unendurable that she was starting to think her disease might be one of the 20 percent of anorexia cases that are lifelong or terminal. Her doctor reminded her that inpatient and residential care were both available to her, but she also told her that, as someone with evidence of "chronic" anorexia and a yearslong history of failed treatment, she could enter palliative care or hospice care, both of which are forms of end-of-life comfort care usually associated with patients diagnosed with terminal physical diseases. Because Alyssa lived in Colorado, a state where medical aid in dying is legal, she would also be eligible for MAID drugs, a lethal combination that varies by state. To qualify, her doctor had to believe that without treatment and left to eat however she chose, she was likely to die of anorexia complications within six months. Alyssa thought through her options, and then she wrote to her doctor, saying she wanted to enter hospice care and *obtain access to the medications that would support my legal right to die should I wind up choosing this path*.

In keeping with the laws surrounding MAID, Alyssa's competency to make this decision was assessed by a local psychiatrist, who evaluated her and deemed her decision-making abilities intact. The first palliative care doctor she saw did not feel ethically comfortable prescribing MAID drugs for psychological illness, because they were legalized for diseases like cancer, so the eating disorder specialist who had first informed Alyssa of their availability prescribed them instead, once Alyssa had been in hospice for six weeks. She never took them, instead becoming "unresponsive in the natural course of her malnutrition," and died in hospice in the presence of her family.

I first read about Alyssa's life in a *Journal of Eating Disorders* article written by Dr. Gaudiani, who prescribed Alyssa's MAID medications; Dr. Yager, the former president of the Academy of Eating Disorders; and Alyssa herself, listed as a posthumous author. The piece, published in 2022, was titled "Terminal Anorexia Nervosa: Three Cases and Proposed Clinical Characteristics," and it outlines the story related above alongside two other cases of patients who entered end-of-life care for eating disorders, one of whom took MAID medication and another who died, like Alyssa, of malnutrition in hospice care. When I first read the article, I cried, and I couldn't quite believe this was what eating disorder care had come to, and then I was surprised I hadn't expected it. Anorexics in their thirties sent to hospice to die after years of mistreatment and misunderstanding by insurance companies and treatment providers; the healthcare system reframing its utter failure to treat this disease by simply deeming a treatable condition terminal; a girl sent to her deathbed by a doctor.

I found myself reading the article over and over again, trying to imagine Alyssa's face and invent her voice, wondering what her favorite book had been and wanting to call the insurance company that kept her in purgatory for seven months—time that could have been spent saving her life—and tell them they were murderers, and then call the treatment center that told her she was too underweight and curse them out. I knew who the clear villains were, but I didn't know how to feel about the doctor who informed her of the hospice option, who prescribed the MAID medication. This might be surprising: at first, I wanted to hate her as much as I hated the insurance companies and the treatment centers, but I also understood what she and Alyssa understood: that the treatment Alyssa was likely to receive would have probably extended her life only briefly, caused her great emotional pain, and perhaps even exacerbated her disorder. I don't know if those likely realities lead me to believe Alyssa couldn't have been saved, just that I am not confident she would have been, and I know she was in unbearable pain.

When Alyssa first met Dr. Gaudiani, she told her, *I really want a life, to use my master's in Social Work degree to help others heal, to find a partner, and to experience pleasure, laughter, joy, and freedom, including from my own brain.* Less than a year later, Alyssa felt that her anorexia

was too far gone for her to ever experience those things. In a portion of the article that Alyssa wrote, she states that she would *not have qualified for Hospice care unless my illness was terminal (i.e., not reversible for me in light of physical, mental, emotional damage to my body)*. Hospice and the availability of MAID spared Alyssa the agonizingly slow and physically painful death many anorexics experience, as well as the prospect of dying by suicide, which almost one in four anorexics attempt, and instead offered her what she said was *a sense of ease and peace of mind in my final stage of life*. She wrote that although many doctors didn't agree that her illness was terminal, many offered her treatments that did not promise long extensions of her life and that would have required her to *live in the hospital* (emphasis hers), an experience she and multitudes of other anorexics have found traumatic and painful. The final item in Alyssa's list of *personal considerations* and *challenges faced* as she made this decision was *gross misunderstanding about anorexia nervosa in general*.

Alyssa's parents point to her first inpatient stay, when the doctors treated her hypercalcemia without treating her eating disorder, and the seven months she spent trying and failing to get into a residential center as a "missed opportunity to attempt changing her disease trajectory," and they are likely right, as multiple studies have linked treatment nearer to the onset of anorexia to a greater likelihood of recovery, while studies into anorexia deaths have connected mortality to receiving treatment further into the disease's progression. That insurance companies continue to require biometric proof that these diseases are sufficiently advanced before they will pay for treatment, even as research exists definitively connecting early treatment to literal survival and later treatment to higher fatality rates, is straightforwardly murderous on the part of those corporations. Anorexia is often described as "slow suicide" by both doctors and sufferers, but it can just as easily be understood as slow-motion murder.

In the "Terminal Anorexia Nervosa" article, the authors write that Alyssa first felt suicidal when she "realized that her body was too large to fit into standard dress sizes." Our *gross misunderstanding about anorexia* begins at the sentence level when in even an academic article about someone who has died of this disease, Alyssa's body is cast as the failing, uncontainable actor. Why write that her body was too large to fit

into standard sizes, rather than that the dress did not fit her (psychiatric professionals have noted the fatphobia encoded in the separation of plus and standard sizes, in a country where 34 percent of teen girls are buying plus-size clothing)? This might seem minor, yes, but so too does a Bat Mitzvah dress not fitting, and that, we've seen, can kill.

Whether Alyssa was referencing our willful blindness toward the anorexic ethos that pervades our culture, the stigmatizing narratives she heard from family and peers, or the medical establishment that in claiming to treat her disease repeatedly conveyed to her that she was sick in the wrong way, too sick to save, and then helped her die of her disease, albeit comfortably, we will never know—but I wonder whether she was writing about all of it.

Alyssa and her coauthors close the article by outlining a potential clinical definition for "terminal anorexia nervosa," a condition that they theorize as a progression of "severe and enduring anorexia nervosa," a diagnosis known as SE-AN, which is itself not recognized in the *DSM* but first began appearing regularly in the clinical literature in 2010. Over the past decade, SE-AN has been explored in dozens of articles, though to date there has been only one randomly controlled trial studying the syndrome, which is defined as anorexia nervosa that "persists for more than 3–7 years (depending on the author) after appropriate treatments." According to one study by Yager, around 20 percent of anorexia patients qualify for an SE-AN diagnosis, which serves largely to concretize the otherwise amorphous label of "chronic" often applied to these cases by medical and insurance companies. In his article "Managing Patients with Severe and Enduring Anorexia Nervosa," Yager writes that these patients are often "demoralized" and decide to "opt out of intensive treatment." He goes on to write that doctors "managing patients with decades-long disease" and coexisting diagnoses must be "realistic about the low odds of effecting cure and adjust treatment expectations accordingly," expanding their approaches to include "low-intensity treatment . . . at times extending to palliative and hospice care."

A group of eating disorder experts including Dr. Walter Kaye, who founded and directs the Eating Disorders Treatment and Research Program at UCSD, cowrote an op-ed in *JAMA Psychiatry* warning that this turn was a result of the current economics of treatment. They fear that

"repeated treatment failures, insurance denials leading to premature discharge, revolving-door experiences, and clinician burnout potentially contribute to a worrying pattern of opting for palliative care or hospice for the chronically ill."

Yager and his coauthors define terminal AN as something of a next step on the diagnostic ladder for patients who have progressed from AN to SE-AN. They lay out "proposed clinical characteristics": the patient must be over the age of thirty, have a diagnosis of anorexia nervosa, have received "high-quality, multidisciplinary eating disorder care" (the definition of "care" is left very broad), have proved their "decision-making capacity" and expressed that they "understand further treatment to be futile . . . and accept that death will be the natural outcome." Alyssa, in a portion of the article attributed to her, wrote that she wanted to share her decision-making process to *help other patients and physicians as they consider and weigh the option of utilizing MAID,* but she is not *recommending that all patients with terminal SE-AN have access to such medication,* the prescription of which she felt was *a tremendous act of love* in her case.

I feel sheer, simple terror reading about the diagnostic stepladder envisioned in that article. Eating disorders are notoriously competitive diseases, and the existing diagnostic hierarchy inspires shame and makes people sicker as is. As we've seen, patients often present with EDNOS before developing anorexia, which they often fall into as a result of feeling that they are not sick enough to receive treatment with EDNOS (a belief reinforced by many insurance companies' authorization processes), and their diseases often worsen further when they eventually make it into treatment. If SE-AN and terminal AN are officialized as diagnoses, I am as terrified as I am confident that a similar series of events will likely play out, and even more people than already do might die of their eating disorders. If people with EDNOS are starving themselves further to evade the disdain-laden label of wannarexic and pining for anorexia diagnoses, why wouldn't we expect people suffering from a competitive disease defined by the dread of not being sick enough, a disease where the moment of diagnosis is described in terms otherwise reserved for religious conversion experiences, to crave the diagnosis of severe anorexic once it is made available to her? One survivor told me she found the existing array of diagnostic labels not empowering or de-

stigmatizing but *instructive*. When almost a quarter of anorexic patients already attempt suicide, and the diagnostic hierarchy we already have is driving patients deeper into disease, it is difficult to imagine that the very existence of a terminal AN diagnosis wouldn't make it one some patients start to strive for.

The article defining terminal AN sparked a feverish debate among eating disorder specialists, many of whom found the very conceit of such a diagnosis dangerous and negligent, and the prescription of MAID extraordinarily distressing. MAID is generally prescribed to people with a physical disease with a prognosis of six months or less. In the article "Terminal Anorexia Nervosa Is a Dangerous Term: It Cannot, and Should Not, Be Defined," the director of Johns Hopkins' Eating Disorders Program, Dr. Angela Guarda, and her coauthors point out that most people who fit the SE-AN criteria "will not die within six months" when left to their own devices and emphasize that "there are no clear staging criteria comparable to those used for cancer to help define terminal cases." Beyond this, they emphasize that "malnutrition exacerbates depressive and obsessional symptoms, promotes eating disordered cognitions and impairs decision making," rendering it extraordinarily difficult for a severely malnourished patient's desire to die to be taken at face value. Anorexics who have been ill for many years, who have been told that they "failed" treatment rather than that treatment failed them, and who are haunted by guilt over the financial burden their illness has placed on their family "may self-identify with the label" just as girls crying in a dressing room may self-identify with the anorexia label. The authors worry that "defining terminal anorexia risks colluding with anorectic reasoning that improved quality of life and potential recovery are hopeless prospects."

The problem is that the larger treatment regime, not to mention society as a whole, is "colluding with anorectic reasoning," and the anorexic's belief that they will never recover, while symptomatic, might be correct, as the mortality rates remind us. I understand where Alyssa was coming from, and reading her doctors' words, I believe that they were trying to lessen her pain with the tools available to them, which were blunt instruments and weapons when what she needed was something we haven't yet found. Dr. Gaudiani has said that her patients are

dying of a "disease of despair," one that often begins when people fol-
low the logic of thin worship that our society endorses, and one that
is often treated by doctors who exacerbate it. She tells her patients, "I
completely understand why you binge and purge, when doctors have
essentially prescribed these behaviors to you" when you weigh more,
a point more doctors should be making, one that understands patients
as insulted and lied to, rather than stupid and vain, overreacting. She
continues: "When you have gained weight in the context of recovery,
they stigmatized you. When you lost weight in disease, doctors praised
you." She is right, and sometimes cycling through sickening, invalidat-
ing medical centers is as likely to kill, and do so far more painfully, than
a drug that might make you feel like you're finally falling asleep after
decades spent starving on a StairMaster.

Still, I think their solution compounds the problem and puts lives
in danger even if it might marginally lessen pain for some patients.
Although Alyssa and her doctors genuinely believed the existence of
a terminal diagnosis providing access to palliative and hospice care is
what "brave, suffering" long-term anorexics deserve, it feels to me like
a capitulation to the failing system, an admission that literal death is less
painful than receiving treatment as it currently exists and that we are
unlikely to come up with anything better in the life spans of currently
living anorexics. The embrace of this solution by eating disorder doc-
tors and patients themselves reveals how deeply embedded our lethal,
gross misunderstanding of anorexia is, a misunderstanding that leads us,
as a society, to place so little value on anorexic life that we are allowing
people to die of treatable mental illnesses before they reach middle age,
with little to no public outcry.

If that sounds like a logical leap, consider the fact that there is no
other psychiatric illness for which an official terminal diagnosis has been
proposed. There is also no equally lethal epidemic that receives so little
media coverage. Opioid use disorder, which rivals and in some studies
surpasses anorexia as the mental illness with the highest mortality rate,
is covered on the front pages of major newspapers regularly and has
not been given a graduated diagnostic scale that marks some sufferers
as doomed. Placing a terminal label on a psychiatric disease for the
first time could easily mark the beginning of a descent down a terrify-

ing, slippery slope—toward a eugenics-inflected conception of mental illness, wherein treatable mental health problems become grounds for a person's life to be cut short. Anorexia's status as the first psychiatric illness to receive such a designation reveals just how little the medical establishment values the lives of people with eating disorders. Lester has suggested that eating disorders might be the "problem child" of American healthcare, but I'd argue that they are more like a chink in its armor, or the bullying victim haunting sorority row.

But in the end, all these metaphors are evasive and insufficient. By which I mean that even when we are trying our hardest, caring about each other on the brink of collapse, it's almost impossible to exorcise the stereotypes we've been swallowing about these illnesses for decades. Comparing an eating disorder to a problem child casts the patient as a spoiled brat once again, the disease an expression of a rebellious phase or passing adolescent entitlement, and my own metaphors are just as facile as Lester's, because *the healthiest way of being ill is one most purified of, most resistant to, metaphoric thinking,* as Susan Sontag once wrote, which is why I keep telling you names and describing death in detail. Let me be clear: we can't find the right relational analogy because the problem is our relations themselves. Treatment centers demonize friendships among patients while trying to produce subjects who can function as individuals in a society the disease exists in response to. If treatment centers attempt to resocialize people who cannot survive under our social conditions, shouldn't we question the social conditions rather than condemn those individuals to die, even if painlessly?

Alyssa cowrote that article because she wanted to help people like her. The older women in *Thin* sob in group therapy, begging the younger girls not to follow in their footsteps. Kelsey Osgood told me about a small study she once read that tested a novel treatment that seemed promising to her: *meet friends twice a week for coffee.* S told me that a *mentor with lived experience* and *peers who can just be encouraging* are the best parts of treatment, especially for *populations that are almost inevitably harmed by going into the current treatment centers.* A girl writing online worries about the *sweet, tube-fed souls* she met in treatment and fears they are still stuck in hospitals or have ended up underground. I read the phrase *I wonder if she is alive today* on message boards over and

over again, girls grasping at each other through the internet, girls hoping the ones they left behind aren't ghosts. The ones who are gone can still speak through those of us who knew them. If we let their stories widen and zag, we can learn who they were. Listen closely, and you can hear her now.

Anatomical Remodeling of the Heart

I used to keep laxatives, Plan B pills, and blow in a small jewelry box. It was a Bat Mitzvah present, so using it for this purpose felt appropriate, since I never felt more like a woman than when I was desperate to forget something I'd let inside me. And there were a lot of those: meals and men and ideas and ideologies that didn't daunt me back then, despite their heft. Now, I'd give anything to take back the decision to open my mouth or my mind. Young and prideful, prone to rolling my eyes, I thought I could handle it. Growing up on the cusp of the girlboss era, playing with Business Barbie and President Barbie and reading *Seventeen* and *Time for Kids,* I thought I didn't have to choose between beauty and brains, because I didn't have to choose at all. Everything was for sale, as long as I was willing to work for it. Constant consumption was encouraged. Little girl, big world, open wide and eat it all up. What a voracious reader. She must be going through a growth spurt, that appetite. She devours all the newspapers in this house. Called on in school and cooed over at home, I am told I am wanting correctly; this appetite is appropriate, even exceptional.

Until. I miss a memo, and the girls around me are gone, and they don't miss me at all. I ate the fries off their trays in the cafeteria right up until there wasn't a seat for me, and it's only then that it occurs to me that they might have been hungry after all, and I was supposed to stay hungry too. They'd been reading those magazines like math textbooks, learning to count and cut calories. The girls I knew are gone, replaced by skinnier girls with straighter hair and softer voices, and I'm slurping

soda alone. The switch is sudden, blink and you miss it, head stuck in a book and mouth full, chewing too loudly to hear the announcement.

Childhood was a trial run, hope you enjoyed all those free samples. Now it's time for the next period (have you gotten yours yet?). This one is called the rest of your life, and there are dues to pay. Look up the word "metabolism"; yours is going to slow down soon. Start learning body science. Make calorie math your favorite subject. Think about time: you only have a limited amount before wrinkles wend their way into your skin, and even slenderness won't save you then. That personality of yours? A little much, make it memorable but simple, straightforward: this is a branding exercise. Become easy to swallow and don't swallow as much as you have been, or burn it off.

So you adopt a life hack that is also a self-harm practice, a plan B. The wanting and wasting, boom and bust, binge and purge, expansion and recession. And then the artificial stimulus, the Fed printing money: pills and supplements and powders. Nestled between bloody intestines are our darkest desires, which aren't really that dark at all. They're bright, really, downright futuristic. We want bodies like the iPhones we've been clutching in sweaty palms since we first learned to hate ourselves, constantly upgraded to higher storage capacity and slimmer width. We want a streamlined interface and an infinite feed. We want a delete button, the ability to build an entirely new profile. We want to be codable, hackable, too hot to fail. We want what they sold us: resets, reinventions, and bailouts.

Metaphors for the body abound: a many-horse-powered machine, a delicate ecosystem, a knife-cut sculpture. Eating disorders might skirt the body's regular rules, but they're still invested in symmetry and measurements, engineering; the body reimagined as a race car instead of a sensible sedan. Built for speed, stares, grinding to a sudden halt and burning up, sparking gasps.

At first, the hum. A nicotine head high, a purring engine. The numbers going down, the compliments adding up, eyes and sighs, attention distilled and poured into a shot glass, the liquid thrill of hurting to be happy, the burn that means you're about to start sparkling. The hang-

over, the tolerance, amber streaming into a bigger glass for a smaller high. Gazes go from jealous to startled, turn nervous before becoming repulsed, which precedes their wholesale disappearance, the averted eyes that remind you of where you started, when they didn't see you at all. Not that you notice anything anymore, through the blurred vision and breathlessness.

The vertigo and the palpitations ramp up rapidly. Eating disorder deaths often happen frighteningly fast, symptoms spiking outside the expected trajectory, bodies rejecting their places on a graph. Eating disorders kill in a variety of ways, despite the image in your mind's eye: an emaciated girl in a billowing hospital gown, perhaps. In reality, one of the most common causes of death related to eating disorders, yet least reported on, is one that takes place when the person is supposedly in recovery. There are rafts of studies on "sudden death" in eating disorder patients. In medical terminology, "sudden death" is defined as an "abrupt and unexpected occurrence of fatality" with no obvious proximate explanation.

About one-third of anorexia deaths are coded as sudden death. Eroding the organs, whether by starvation, laxative abuse, or purging, can cause the heart to skid to a halt in a surprising number of ways. Electrolyte imbalances from purging induce seizures. Gastric rupture occurs between a binge and a purge, when the stomach or intestines burst, leading quickly to necrosis, septic shock, and death. Autopsies carried out on eating disorder patients who died sudden deaths report gut renovations of the body's core systems, complete rewirings that allowed the body to run faster on far less fuel but came with a high cost to engine life. These documents call this phenomenon "starvation-derived anatomical remodeling of the heart." I am trying to draw a parallel between our attempts to anatomically remodel ourselves into a physically impossible ideal with the capitalistic attempt to entirely remodel the individual into an ideal, productive worker. I am trying to say that both attempts are murderous, and occurring under the cover of moralizing, medicalizing rhetoric. But this is where the metaphors start to break down, which is also the point. The body eventually belies the calorie counting ethic we've been taught, revealing that it is not, in fact, an economic model that can simply be erased, written anew on an infinitely fresh whiteboard, and solved for again.

In a society defined by obsessions with both consumption and self-discipline, not to mention self-surveillance, eating has transformed into a math problem and a performance. As the war on obesity met foodie culture, we learned to photograph and post our meals as well as our workout regimens, and eating disorders became ever more prevalent. Is it any wonder we've replicated our country's consumptive contradictions and crises within our own borders, in our bodies?

Bulimia was introduced to the *DSM* in 1980, the beginning of the "greed decade" that brought us neoliberalism, fast money, Wall Street scams, shopaholism, the "low-fat lie," the fanaticism for fitness magazines and aerobics, and easy access to bingeable, ultra-processed foods. Extreme diets, anorexic troughs are recessions, an orientation toward austerity: 2008 was both the peak of the Great Recession and the high point of aughts tabloid coverage of starlet skinniness, not to mention the peak of the pro-anorexia Tumblrverse. What followed the aughts' anorexic aesthetic were the twenty-teens, a decade of grifters and start-up founders lying through their teeth and almost getting away with it, and it was also an era of girls sticking their heads in toilets and exiting bathrooms with minty breath, lying as confidently as any con man. I don't think I am listing coincidences. Like the start-up billionaires torpedoing their own companies, we were girls heading toward a crash. Like most disruptive technology, the eating disordered person's full-system reboot has a dark underside. Endless consumption overfills landfills; toxic chemicals leach into groundwater. The seas rise and flood cities. We eventually break down, break bones, and break our own hearts.

A cruel joke curdles over two corpses, never mind the expensive coffins and anguished obituaries. As soon as their bodies were buried, people started whispering about their stopped hearts. Snickering or choking up, they wondered what went down those girls' gullets right before their last breaths. One died skinny and the other died fat, but both died famous, so the tabloids took tips, the journalists typed rumors, and their readers tittered, turned the page, teared up, and tore out the pictures.

Cass Elliot and Karen Carpenter both died of heart problems at age

thirty-two, alone in bedrooms, fatalities that might be coded as "sudden death" cardiac events today. The two singers died almost a decade apart, in 1974 and 1983, a span of time during which bulimia was first defined and diagnosed, the first best-selling anorexia books hit shelves, the prevalence of both diseases skyrocketed, and an eating disorders section was added to the *DSM*. Though Cass wrote publicly about her *starvation* diets, her size would have prevented her from receiving an anorexia diagnosis. But Karen's spiky silhouette fit the stereotype, and she was diagnosed in 1981, two years before her death, which became one of the first attributed to anorexia in the popular press.

Karen's death was followed by articles about the "good girls'" affliction. Before the 1970s, eating disorders were considered rare. "Most people had never heard of anorexia," per *The New York Times*. By 1981, the first academic journal to focus exclusively on eating disorders was publishing regularly, and its editor estimated that 10 to 15 percent of college freshman women were "involved in" eating disorders. In the wake of Karen's death, one poll reported that almost half of American girls knew someone they believed suffered from anorexia.

No treatment centers dedicated specifically to eating disorders existed then in the United States—eating disorders were treated in general psychiatric hospitals or through therapy, as Karen was. A man named Samuel Menaged saw both a population that needed care and an extremely profitable hole in the market. In 1985, he opened Renfrew, the first residential treatment center for eating disorders in the United States. Two years later, every bed was filled, and a lengthy wait list motivated the construction of a second facility. Today, there are more than two hundred residential treatment centers operating in the United States, including Renfrew's two residential clinics and eighteen outpatient ones. This boom in treatment availability is not alleviating the epidemic—in 2008–2009, emergency eating disorder hospitalizations were up 24 percent compared to a decade earlier, even as the number of treatment centers tripled.

By 2023, the number of treatment centers in the U.S. had more than doubled again. Meanwhile, anorexia's mortality rate approaches 20 percent, and deaths from the far more common EDNOS/OSFED are also strikingly high, surpassing 5 percent in some estimates, which many in

the field consider an undercount. Typical mainstream treatment models report long-term remission rates no higher than 40 percent, meaning they don't work for at least 60 percent of patients, who repeatedly fall ill before recovery, develop chronic illness, or die. These are truly terrifying, tragic numbers. Yet many institutions are choosing not to grieve this human loss. Instead, they calculate its dollar value, transforming the dead into lost profit and converting the potential to save lives into future revenue.

In 2020 the Academy for Eating Disorders, Harvard's Strategic Training Initiative for the Prevention of Eating Disorders, and Deloitte Access Economics published the first report on the "social and economic cost of eating disorders" in the United States, analyzing just how big a drain all these people with eating disorders present to the economy, going as far as estimating the dollar "value of a statistical life year": the monetary value placed on one year of an anonymous person's life. This is a calculation government agencies use when doing cost-benefit analyses of proposed legislation, and though it's purportedly a measure of the government's willingness to spend on health and safety measures, its existence is an admission that one human life can be converted into a dollar amount.

The bulk of the publication is devoted to health system costs, productivity costs, and efficiency losses. Productivity costs include both absenteeism—workers missing from the workplace due to eating disorders—and presenteeism—workers not performing at peak levels due to their eating disorders. Total costs added up to $64.7 billion in 2018–2019, in addition to a "wellbeing" loss of $326.5 billion from "reduced quality of life . . . and premature death . . . measured in monetary terms by multiplying a value of a statistical life year by the years of healthy life lost." The study predicted an increase in eating disorders by 2030 and attributed more than ten thousand American deaths in 2019 to eating disorders. Rather than a complete failure of medicine, the increasing severity of the eating disorder epidemic is apparently a sign of the "growth of the global eating disorder market" to business publications like *Globe Newswire*, an opportunity they estimate will be worth $764 million by 2030.

But let's get back to the fun stuff, the smirks and wordplay. Remem-

ber, I was going to tell you a joke? It's short, sharp, a punch in the guts of all the girls agonizing over the size of their stomachs. Here's how it goes: if Cass and Karen had shared a ham sandwich, they'd both be alive today. As in, if the silly, superficial girls had been able to do some simple math and split a meal down the middle, they might both have survived, saved by calculations and an understanding of cause and effect. What the joke misses, other than the obvious fact that corpses aren't comic currency, is that girls with eating disorders are actually extremely adept at solving this sort of formula. They are practicing economists, constantly calculating inputs and outputs and obsessing over margins, making predictions.

Like all economists, they can lose sight of human costs: hitting gross domestic product goals and getting to your goal weight both require sacrifices that are difficult to put into numbers. Some statistics that are easier to set in stone: the hours spent conducting autopsies, the dollars spent on diets and doctors, the graves of girls who have died of eating disorders. In the 2006 film immortalizing the joke, the man telling it chuckles, the crowd cackles. That year, eating disorder hospitalizations were up 18 percent from five years prior (they have since increased), and 24 percent of eating disorder patients also presented with associated cardiac dysrhythmias, an increase of 125 percent since 2000. A twenty-two-year-old model named Luisel Ramos died of a heart attack in the middle of a runway show. She was not the only model to die of anorexia complications that year. Just three months later, twenty-one-year-old Ana Carolina Reston died of anorexia-induced organ failure.

The autopsy ruled Cass's death a heart attack caused by "myocardial degeneration due to obesity." Contemporary studies have found that being medically overweight, or weighing in the first band of the obese range, is not correlated with earlier death, yet the belief that her size— rather than her periodic self-starvation, and the weight cycling we know is linked to cardiac events—killed her persists.

Obituaries for Cass took the fat-shaming further, spreading the rumor that she choked on a ham sandwich left on her bedside table. That legend still haunts her family; her daughter called it "one last slap

against the fat lady." As laughter bounces off the walls and into eternity, it is not difficult to imagine selling your soul to shut the hecklers up, calculating your way out of the echo chamber even if it kills you.

Cass knew what her society thought of fat people. She'd blinked through bad jokes, *been so depressed* about her weight that she considered avoiding going out in public *so people wouldn't see me*. Instead, she invented *a fabulous new diet,* a disciplinary regimen of food economics that would slough off surplus skin but cost her her body's basic functioning. In the aftermath, Cass wrote that her diet works, but *can give you acute tonsillitis, hemorrhaging vocal cords, mononucleosis, and a dangerous case of hepatitis.*

These are the types of trade-offs people suffering from eating disorders make, often at first unknowingly, before the disease slithers into the slimiest crevices of your mind, seething at you: beauty hurts. Physically, yes, but also a sensation not unlike the stabby twinge of watching your savings dwindle as you buy the status symbols you've been taught to want: a cynical calculus made in the eye of a psychological cyclone. A tendriling gnaw that starts in the pelvis and leaves you nauseous. After you've suffered all the insults and appraising eyes and gaunt, glossy girls in magazines, the high winds suddenly stop the moment you figure out the formula. Stillness, the narcotic, numb knowledge that you ran the numbers and solved for x: your smallest self, curled up in the fetal position in the calm before the storm.

Girls have long been medical guinea pigs, and our experience as eating disorder patients is just one chapter in a story that starts before the lobotomies and continues today with dangerous experimental weight loss drugs and eating disorder treatments. As an illness class, eating disorders can be understood as guinea pigs for the post-1980 model of mental healthcare, one aligned with the biological model of mental illness and neoliberal economics. That experiment can almost categorically be deemed a failure, one that turned us into sacrificial lambs.

Eating disorders were first recognized as an epidemic issue in the same decades that market-oriented reforms were remaking Western economies, ushering in the modern era of opaque globalized financial

systems, heightening inequality, cyclical economic crises, and consumer capitalism. In 1984, Fredric Jameson published *Postmodernism; or, The Cultural Logic of Late Capitalism*, outlining the restructuring of contemporary life around commodification and consumption, and the *International Journal of Eating Disorders* published a paper investigating the suddenly "widespread" bulimic psyche. The third edition of the *DSM* had thudded onto doctors' desks in 1980, heavier than earlier editions. The first two were slim tomes outlining diagnoses in broad strokes, designed to help psychiatric professionals describe their patients' suffering in the hopes of discovering its underlying, unconscious sources. The third edition heralded a transformation in mental health diagnosis and treatment, a reconception of diagnosis as a concrete taxonomic endeavor. Less an art of description than a process of elimination through checklist—part of the larger reordering of life around counting and calculations, data-based self-surveillance oriented toward optimization.

The new *DSM* was also part of an effort to create a guidebook for psychiatrists akin to the diagnostic manuals used by physical doctors. Doctor and writer Laura Kolbe describes those as tools for "cognitive rationing and cognitive investment banking" by a medical establishment beset by overworked doctors and overcrowded hospitals. With economic terminology already infecting the way doctors conceived of their time and energy, cognitive rationing quickly became care rationing. During the prior decade, the Nixon administration had aimed to cut skyrocketing healthcare costs by replacing individualized care rooted in long-term doctor-patient relationships with data-driven, widely applicable techniques that could be replicated by any doctor, with any patient. The rise of "evidence-based treatment," considered cost-effective because it had been studied in large-scale trials, meant that randomized controlled trials replaced individual case studies as the gold standard of psychiatric research.

These turns ushered in an utter transformation in the treatment of all mental disorders, but they uniquely affected eating disorder care because of their timing—right when eating disorders were first widely recognized and standardized treatments developed. That 1980 *DSM* was the first to include a stand-alone eating disorder category. As Lester

writes, the "shift in the *DSM* in the 1980s to a more descriptive mode of diagnosis (versus an etiological or interpretive one) emerged hand in hand with economic transitions in healthcare funding that focused on increased efficiency and cost savings and were based on outcomes that could be quantified," so psychic suffering was reframed "as collections of cognitive, behavioral, or biological symptoms that could be objectively measured." This set the stage for a collusive cycle between psychiatry and insurance, transforming a person who was once a patient into a math problem meant to be solved using economic formulas.

Throughout the '90s, for-profit insurance companies and health maintenance organizations—which had emerged in the wake of the Nixon administration's passage of the Health Maintenance Organization Act, introducing "the concept of for-profit healthcare corporations to an industry long dominated by a not-for-profit" model, according to the National Council on Disability—were consolidated by investment firms. Today over half of the most popular plans are owned by such firms. Profit-driven insurance companies want to pay for proven investments, and it is difficult to prove the efficacy of an extended, intimate relationship between patient and therapist. The demands of insurance rendered the relationship between psychiatrist and patient episodic, transactional, and pharmacological, when it was once long and emotional.

The "chemical imbalance" theory of mental illness—the notion that a deficit of certain neurotransmitters in the brain causes mental illness—had been outlined in the *Journal of Psychiatry* in 1965, and it was soon adopted and endorsed by much of the psychiatric community. Credited for reducing the stigma of mental illness, the theory ostensibly deflected shame from the patient, blaming biology instead of personality, and reframed the diseases as treatable with medication. As of 2016, over half of American psychiatrists have stopped practicing psychotherapy completely, opting instead for medication management. Within this scarcity economy, cognitive behavioral therapy has become one of psychiatry's favorite non-pharmaceutical tools. Aaron Beck wrote the first CBT manual in 1979, arguing that many mental illnesses were not mood disorders but cognitive ones, which he proposed to treat with a universally applicable, systematized protocol provided through a fixed number of standardized, time-limited modules. These teach patients which thoughts

are "productive" and "unproductive" and how to replace the latter with the former, according to popular online explainers and CBT handbooks.

CBT quickly became the "favoured choice" for companies "looking for cost-effective alternatives to traditional psychotherapy," according to *BMJ Mental Health*. Elsewhere, *Cognitive Therapy and Research* reported that "despite the enormous literature base, there is still a clear need for high-quality studies examining the efficacy of CBT," which "is questionable." In his book *CBT: The Cognitive Behavioural Tsunami*, Farhad Dalal argues that CBT upholds a "managerialist mentality" that prizes notions of health rooted in potential productivity. Unsurprisingly, many companies offer CBT to employees, which one provider explained is a smart investment, as "untreated mental health issues can drive costs related to productivity." CBT is "perfectly suited to capitalism," as P. E. Moskowitz writes, because "it doesn't ask you to challenge your place in the world or how you think of things, it just asks you to modify your response." Under this model, the thin, cisgendered, white, straight patient might be free of stigma and thrilled with their Lexapro prescription and CBT exercises, but it is not shocking, then, that a paper on CBT's efficacy also pointed out that "no meta-analytic studies of CBT have been reported on specific subgroups, such as ethnic minorities and low income samples," groups whose psychic struggles under capitalism are difficult to solve with positive thinking.

While the American Psychiatric Association's recommendations for treating eating disorders include a range of therapies (including nutritional counseling and psychotherapy), CBT is reliably listed near the top of its suggested treatments for bulimia (paired with antidepressants), binge eating disorder (paired with psychiatric medication), and anorexia. These techniques are considered first-line treatments, according to a 2017 *Physiology & Behavior* analysis, despite the fact that the same study concluded that "there have been only a few attempts to test the cognitive behavioral theory of eating disorders," the majority of which have not reported positive results—one found a 44 percent rate of relapse just four months after treatment.

Aside from CBT, pharmacological treatment and genetic etiologies are well-trod realms of eating disorder research. Despite plying patients with everything from SSRIs to antipsychotics and stimulants, research-

ers have yet to find a drug that reliably helps most patients. The reams of research devoted to genetic studies have thus far mainly revealed that a person is more likely to develop an eating disorder if a parent or sibling has one, a finding that can just as easily be attributed to household environment as genetics. As Dr. Howard Steiger has written, genetic explanations can "relieve blame" and stigma from the patient, but such shame could just as easily be reduced by externalizing blame on to not chemical imbalances or genes but the misogynistic white supremacist society the patient grew up in, though in that scenario they may not remain a lifelong customer of the mental healthcare system.

Some experts are attempting to question our reigning ineffective treatment models and the disease etiologies they rest on. But while these figures recognize that eating disorders are complicated biopsychosocial illnesses, the result of an interplay between environment and genetics that must be analyzed from many angles, most are still resistant to centering cultural explanations in eating disorder scholarship, unwilling to accept the slim ideal's pivotal role in the disease. Doing so would destabilize the biological model of mental illness and demonstrate that eating disorders may not be curable with behavioral thought exercises and pharmaceuticals—a revelation that would cost a lot of parties a lot of money. The same parties, incidentally, that are funding many of the studies into those etiologies and treatments, while public institutions neglect eating disorders. One report from *World Psychiatry* called eating disorders the illnesses with funding "most discrepant from the burden of illness": federal funding was $0.73 per ill person in 2015, compared with $86.97 per person with schizophrenia, for example.

Meanwhile, eating disorder treatment is understood by business publications like *Forbes, TechCrunch,* and PE Hub as a growth market. PE Hub called treatment centers one way to satiate investors' "appetite for high growth scale assets," an opportunity private equity and venture capital firms have seized, buying up centers and rapidly expanding stand-alone ones into chains. None of this growth has been at all constrained by the fact that mortality rates have remained stable and high through it all, implying that the treatments aren't working, or the fact that a 2016 editorial by a group of concerned eating disorder doctors calling for "transparency" from private centers reported that

equity-backed treatment centers provide "scarce," if any, data on their outcomes and often offer treatments with "no documented utility."

Reflecting larger macroeconomic trends, one of the biggest treatment conglomerates, Monte Nido, received investment money from a venture firm in 2012, after which it tripled in size and was resold. Its facilities have since been reviewed as *very very bad . . . with poorly trained staff* by former patients and as "unsupportive, unsafe," and "understaffed" by former employees. One former employee of a treatment chain, which is part of a conglomerate that also treats other mental disorders, said the company moved staff across wards, sending people "without any training in eating disorders" to eating disorder units to cut costs. They said their program's wait list "was always bursting, so there was a lot of just cycling [patients] through." Data-driven standardization leading to decreased quality of care is an unsurprising result of investment-funded expansion: one survey given to investors found that up to 85 percent ranked the "public health impact" of an investment as "not at all or somewhat important." Eating disorder doctors writing in *Psychiatric Services* have pointed out that the corpus of peer-reviewed literature includes "very little" collected from residential centers. At the time of a 2020 review, fewer than twenty peer-reviewed studies had been published on them, most of which lacked controls and half of which had no follow-ups. But investment firms have an even stronger thirst for profit than insurance companies, combined with a less risk-averse ethic. They fund the people who move fast and break things, which in the realm of healthcare can be bodies.

While researching this essay, I briefly browsed the website for a "medication-assisted weight loss" start-up. Minutes after navigating away from the page, when I opened Instagram on a separate device, I saw an ad for the same company, encouraging me to "Learn More" about a drug to "reset metabolism, stabilize blood sugar, balance your biology, and regulate insulin levels," all of which would lead to "weight loss . . . powered by medicine." In a font so small it was illegible before I screenshotted the ad and zoomed in, a disclaimer told me the medication is FDA-approved only for diabetes but may be prescribed at a "provider's discretion."

The site is part of another boom sector for investors: the telehealth industry. Venture capital firms pumped $29.1 billion into online mental health platforms in 2021, nearly doubling their previously record-breaking 2020 investment. According to a report on this boom published on the APA's website, these interventions "target a wide range of conditions, including anxiety, depression, insomnia, trauma, and substance abuse, and a number aim to . . . improve well-being through mindfulness, meditation, and weight loss." The APA's inclusion of weight loss in an article about mental healthcare implies that dieting can be mental healthcare, implicitly buying into the fatphobia undergirding many eating disorders. The piece highlights Noom, a weight loss app that has been repeatedly accused of exacerbating and inciting eating disorders. Another article on the telehealth boom highlights Equip, a virtual eating disorder treatment program that has received millions in funding from firms including the Chernin Group, Tiger Global, General Catalyst, and Optum Ventures. Those firms are also invested in yet another overlapping growth market, currently projected to balloon to $725.6 billion by 2032: the weight loss market, which includes the app I encountered.

Optum Ventures, Tiger Global, and General Catalyst are all also invested in addiction treatments. Other than eating disorders, addiction is the only mental illness almost exclusively treated in residential centers that are as expensive as they are ineffective, and therefore profitable for the investors counting on a growing population of lifelong repeat customers from both epidemics. As the opioid epidemic worsens, rates of remission in the wake of what are considered the field's gold-standard treatments rival even ED treatment's distressing numbers: one study estimated the posttreatment relapse rate for opioid addiction at 91 percent, with 59 percent of patients relapsing within a week of discharge. The average cost of a stay in these residential addiction centers sat at close to $10,000 in 2022. As a 2023 article in the business publication *Marketplace* put it, addiction treatment is "now seen as a big moneymaker." *The Wall Street Journal* reported that venture capital firms invested $2.9 billion in treatment centers in 2022, and one market research firm forecasts an expansion of the addiction market to $10 billion by 2030. Meanwhile, money is also pouring into untested online treatment modalities, as with eating disorders and weight loss.

That the same firms are funding eating disorder treatment, addiction treatment, and weight loss start-ups underscores the fact that these aren't just disturbingly intertwined industries but interrelated gears of one larger economy that profits off pain. The treatment industry, though perhaps not purposely, is currently functioning along an economic model parallel to the weight loss industry's, creating patient-customers who cycle in and out of treatment for decades. A leaked Weight Watchers business plan explicitly stated the company's reliance on its product's failure, which transforms dieters into lifelong customers: Weight Watchers members return to the program on average four times—that's "where your business comes from," according to the former CEO. Few treatment facilities publish their readmission rates, but the ones that do suggest that about 45 to 77 percent of their patients are readmitted. They tell the same story as weight loss companies in more mournful terms, emphasizing the disease's tragic intractability rather than their failing methods. Meanwhile, patients have reported staying in residential facilities more than ten times in a lifetime of disease, and mortgaging homes or accruing tens of thousands of dollars of debt to pay for it.

Weight loss companies inevitably drive some of their customers into disordered eating (a NEDA survey of college students found that 35 percent of diets become "pathological" and up to 25 percent of them "progress" into eating disorders). Once those customers are sick, they might turn to a treatment program that unbeknownst to them is funded by the very same firms funding the weight loss app that led them down this path in the first place. Weight loss companies, in effect, produce customers for eating disorder treatment companies. This is not to say that investors are conspiring to sicken people, but that they have no incentive to invest in treatment that works, or disinvest in treatment that creates lifelong customers for multiple products they are invested in.

One of those products was an app called Mindstrong, a venture-funded (by firms including Optum Ventures and General Catalyst, both of which also invest in eating disorder treatment and weight loss apps) start-up offering CBT via twenty-minute text conversations with therapists. The app claimed its algorithm could predict patients' depressive troughs before they even began. The data it collected to feed its algorithm wasn't just users' in-app history. It was also users' "scrolling,

clicking, tapping, and other touch-screen behaviors" done when they were not using the app, used to "predict cognition and mood." The vein that apps like Mindstrong are capable of tapping into takes the current iteration of internet surveillance—in which social media companies use data on our public-facing online lives, content consumption, and shopping behaviors to predict what ads will successfully sell us things—to a harrowing new level: one where our mental health diagnoses, emotionally inflected patterns of phone usage, and engagement with healthcare professionals can be sold to the same Big Tech firms that already know everything else about us.

A 2020 *Journal of Humanistic Psychology* paper investigating mental health app data collection during the COVID-19 pandemic concluded that these apps "take individuals at their most vulnerable and make them part of a hidden supply chain." One data scientist told technology theorist Shoshana Zuboff their data could be used to "engineer the context around a particular behaviour. . . . We are learning how to write the music, and then we let the music make them dance." In a nightmare scenario, which seems more and more likely, companies could learn how to trigger a binge or a mood swing, and then advertise a quick fast-food delivery or a prescription drug. Zuboff coined the term "surveillance capitalism" to describe the information ecosystem that turns people into piles of profitable data points, creating "behavioral futures markets." Those have been mapped out, their murderous margins calculated in studies that estimate the statistical value of a life lived "productively" to the dollar.

The purpose of that AED, Harvard, and Deloitte study estimating the monetary value of a life, with all its callous statistics and dollar signs, was to give eating disorder researchers, patient advocates, and nonprofits hard economic data they could bring to congresspeople, to convince them to pass legislation rendering treatment more financially accessible by forcing insurers to pay for it even when patients do not display physical evidence of illness. While that goal is valiant, it is also somewhere between naïve and dangerously negligent. While economic arguments about lost productivity and profit have been used to convince Congress to ease restrictions on healthcare access before, valuing human life in terms of the potential dollars made and spent in a lifetime will only

get us so far. Taken to its logical conclusion, the formula will result in access to treatments that make us into the types of subjects that work and spend, subjects therapies like CBT attempt to produce. These are not therapies that heal, even if they get us spending and making money for more years.

If a person truly recovers from their eating disorder, they may have more energy for work and shopping, but they will also no longer be a customer of the weight loss industry, which, like the insurance and pharmaceutical industries, invests heavily in lobbying and political donations. Perhaps Congress will pass legislation that increases access to failing modes of treatment, treatment that releases people back into the world that sold them diets, where they can buy a Weight Watchers meal. What Congress is unlikely to pass is legislation encouraging childhood and adolescent education on the dangers of dieting, the wide range of bodies that live long, healthy lives, and the racist and misogynistic origins of fatphobia, education that might actually decrease the prevalence of eating disorders, as many experts have suggested. But increasing access to treatment simply widens the industry's customer base, something investors are betting on. That bet rests on the continued reign of the existing beauty standard and the continued maintenance of the false division between dieting and eating disorders. We cannot genuinely facilitate recovery when we still believe that dieting is not a dangerous problem. When our goal is simply to not let the beauty standard murder us, yet we let it continue molding us, it will strangle and scar us, and we won't be able to save everyone.

People with eating disorders—the vast majority of whom are women and femmes—are suffering in public and dying in horrifying numbers. The scale and severity of the problem begs the question of why we continue to research disproven paradigms and treat patients using failing models. When our existing models, the ones that leave 20 percent of anorexic patients to spend their whole lives ill or die, largely reject cultural explanations for this disease, why are we still so resistant to even trying models that center on the role of the slim ideal and consider feminist and antiracist etiologies? The answer appears in invisible ink, signatures on cashed checks, a trail of hyperlinks: the chain of money that leads from eating disorder treatment centers, weight loss compa-

nies, CBT companies, and pharmaceutical companies back to the same pool of investment capital.

Attempts to use the logic of capital to solve the problem of eating disorders inevitably fail, because eating disorders are good for capital. People who die of eating disorders after years of expensive treatment, and people who die after decades of dieting, buying pills and subscriptions and surgeries, are good for capital. If those same people lived long, healthy lives without eating disorders, they would not be customers of either industry, both of which are currently considered growth sectors. Taken together, these two markets have a valuation nearing a trillion dollars, revealing capital's certainty that eating disorders will be a growing problem for years to come.

The boom in spending in eating disorder care and the advocacy around increasing access to treatment do not reflect actual progress in reducing deaths. Instead, they are the literalization of, as Adler-Bolton and Vierkant write of other capitalist approaches to healthcare, "the dream chased by capital's true believers: with modifications to its systems, we can slow slow death to a crawl and render statistical genocide statistically insignificant." This is a fantasy that has time and again proven itself a pipe dream.

A girl's voice, vocal fry lilting into the valley of the vacuum, tells me *every guy thinks that every girl's dream is to find the perfect guy,* before she tells the truth. *No, every girl's dream is to eat without getting fat, duh.* There are thousands of videos set to this sound on TikTok, most of them montages of foods a magazine might call "indulgent" or "sinfully good." There are burrata balls breaking, Nutella oozing out of croissants, crème brûlées cracking, spaghetti in bread bowls.

What this TikTok gets at so incisively, making mouths water and heads nod, is the notion that even in her dreams, the girl posting knows she can't have both the food she wants and the love she yearns for. But on Instagram, where even our dreams get filtered, the squares are filled with beautiful women eating junk food. Limbs are long and pizza is greasy. A selection: A woman in a booth at In-N-Out Burger, facing a tray heaped with golden fries, a double-stack burger, and a milkshake. A

woman on her back in bed, in nothing but lingerie, surrounded by bags of Chips Ahoy!, mini-muffins, and Twinkies. This Instagram account is called You Did Not Eat That, and its raison d'être is calling out women for posing with food the account owner does not believe they actually ate, based on the size and shape of their bodies.

The accused liars are acrobats, attempting to perform the conspicuous consumption our culture encourages while staying small. They are economists, calculating the hours of exercise required to cancel out what they ate, and chemists, mixing pills and powders to flush everything out. On Instagram and TikTok, I am served high-definition, portrait-mode photos of triple-layer cakes as often as influencers wearing workout separates and celebrities selling appetite-suppressant lollipops. Our economy besieges us with dueling imperatives, imploring us to indulge and then preaching restriction. Our feeds fill with algorithmically defined perfect-for-us products that are only a click away, while exhortations to purge our closets pop up in the next square. Charts and graphs proliferate, listing "low-calorie high-volume foods" dieters can eat in large quantities.

Twenty-first-century food systems encourage bingeing alongside restriction and purgative restarts. We are expected to engage in bodily self-management, so those who eat along the exact lines the food system encourages end up demonized when they are fat and cast as a drain on public health. Time and again, the rise in obesity worldwide, and especially in the West, has been tracked and correlated with the pivot toward highly processed food. These changes to our food systems, and, in turn, our economy, can also be traced over the peaks and valleys of the eating disorder epidemic.

A bulimic describes their process as eating *something unhealthy that I crave,* safe in the knowledge that they are *gonna go to the bathroom right afterward to erase it.* This erasure is at the core of all bulimic behavior, and the impulse to binge that precedes it is provoked by our food systems, our algorithms, and our culture of dieting. Under the cover of late-night dark, we can binge shop online, binge whole seasons of a TV show, swallow thousands of calories, and then change our minds, print a return label, refresh the web browser, take a pill, and pretty soon, pretend it never happened. Back to the whiteboard, writing a brand-new

equation. Alongside a photo of a pantry filled with junk food, someone tweets about the urge to *binge and purge all of that with no guilt*.

Lately, Big Pharma has a different fantasy to sell us, a syringe of chemicals that won't allow us to *eat without getting fat*, but promises to suck the yearning to consume right out of us instead. Riding the subway recently, I sat in a car covered in photographs of women holding syringes. Bands of abdominal flesh pinched between manicured fingers, syringes pricking skin. The words "a weekly injection for weight loss" floating above it all, and an invitation: "download." The ads were for an app that prescribes Wegovy and Ozempic, the injectable weight loss drugs approved by the FDA in 2022, which function by disrupting the body's natural insulin production and slowing digestion, suppressing hunger and inciting extreme nausea if someone taking the drug eats even a normal-sized meal, according to many patients. These drugs are currently projected to make their manufacturers billions and change the face of the weight loss industry, according to *Bloomberg* and *Forbes*, despite scant long-term research, alarming side effects, and the fact that patients who come off the drugs report rapidly regaining lost weight. The ads I saw were for a company funded in part by General Catalyst and the Chernin Group, both also funders of an eating disorder e-therapy, and, in GC's case, Mindstrong and an addiction e-treatment too.

If I logged on to one of these sites, as *New Yorker* journalist Jia Tolentino did in her reporting on these drugs, I would be prompted to enter my height and weight, be paired with a prescribing doctor who would speak to me via virtual chat, and, after a few minutes and more than a few hundred dollars, have vials and syringes mailed to my apartment. To see if the drugs were accessible to people not deemed overweight, Tolentino joined the app and easily received a prescription (in the article, Tolentino describes herself as wearing a size 4). She didn't take the drugs, writing that they seemed like an "injectable eating disorder." I'd agree, and I'd argue that they will also act as steroid injections into existing eating disorders, as ads like the ones I saw and these drugs' accessibility render it terrifyingly likely they will be prescribed to people with eating disorders, especially the majority of disordered eaters who do not present as underweight.

If bulimia was the eating disorder of Reaganomics and millen-

nial girlbossery, and anorexia was the eating disorder of aughts-era austerity, these drugs might foster an eating disorder for a new age of technocapitalism, wherein we try to recast hunger as just another inconvenience we can eliminate with an app. Of fat people who have struggled with self-love, a plastic surgeon told Tolentino that "they're no longer going to accept that they should just be happy with the body they have," and will instead be able to buy and inject their way to the one they want, fatness rendered just another archaic fossil, as outmoded as the corded phone. Never mind if Ozempic costs us our enjoyment of food or causes cancer (after being told that these drugs have been proven to cause thyroid cancer in rodents, someone taking Ozempic told *New York,* "I'm like, Thyroid cancer's not that bad?"), or if all our bodies start to lose their unique forms and look ever more alike.

The futurists running these companies promise us a frictionless existence, free of life's inconveniences. According to an online explainer on the role of friction in physics, without it, "it would be very difficult for people or cars to get moving or change direction." Do we want to keep traveling in the direction Big Tech and Big Pharma have been leading us? What these drugs offer isn't a full life, but one lived in the uncanny valley, where appetite is an outdated relic of a less evolved era. Their boosters want us to imagine that future as unencumbered, but I'm worried that if we unburden ourselves of our drives, we'll end up empty inside. That frictionless existence will be lethargic and lonely; we'll be Barbies entrapped in plastic packaging. Disorientingly numb, with a bit of mild nausea: the body's muffled scream, a reminder that you aren't an iPhone-enabled avatar, but an animal meant to eat and shout and fuck and even be inconvenienced sometimes by something you can laugh at over a meal with a friend whose body looks unlike yours. By offering to untether us from our urge to nourish ourselves, the technocapitalists are effectively offering to turn down the volume on our will to live. All that to bring us closer to the slim ideal that has been sickening us all along, and is what, in a better world, would actually be a relic of a less evolved era.

Injections of cash from investors, injections of chemicals from corporations, injections of thin fetishism straight into girls' arteries. Weight cycling and eating disorders alike cause heart attacks, yet we're feeding coin after coin into the pinball machine, sending girls ricocheting

between diets and drugs and diseases. The flashing lights are distracting, just like the artistically shot advertisements, but they're all versions of the same old sold-out show, which is one we've seen before, where the girl ends up beautiful and dead. Capitalism and the thin ideal are shapeshifters: Silicon Valley rose from the ashes of the 2008 recession, the wellness boom brought us orthorexia, and Ozempic and buccal fat removal stole the stage back from body positivity. The stock market rebounds, and the eating disorder numbers tick ever upward. The men in suits count cash.

I realized I was a pawn a long time ago, to a multitude of forces I don't believe in. But in the words of another bulimic, Annie Ernaux, *understanding shame does not give the power to erase it.* When I go directly from the bagel store to the Goop store, running on fumes and self-hatred, and pick up metabolism-boosting tablets and appetite-suppressing vinegars, I am behaving, in Pirie's words, like "the ideal consumer," the "dieter" who "will spend a lot on food and even more to lose weight—and the cycle never stops." But the dieter isn't the consummate consumer; the person with an eating disorder is, switching gears from anorexia to bulimia as quickly as a shopaholic accruing debt and opening a new credit card. The girl with an eating disorder throws her head back and laughs at the old-fashioned choice she's presented with by treatment and women's magazines alike: restrict or binge, really? We are modern girls now; we can do it all. She's best at everything, so she's figured out a way to keep consuming without the consequences, to obey dueling directives while onlookers watch, spellbound and a little nervous. If she's not obeying the laws of gravity, will she eventually hit the ground?

The bulimic mindset, always in search of that iPhone reset to factory settings, waiting for her software update, can echo the rhetoric of the tech bro moving fast and breaking things to get his way. These economic logics are everywhere we look these days, and that includes our bodies, minds, and pathologies. Psychotherapist Linda Riebel writes, condescendingly, that bulimics "blithely ignore . . . the bodily havoc wrought by bulimia," supposedly working from the assumption that "I'm special,

so I can get away with it: eat without getting fat, purge without getting ill." Sounds a little like American exceptionalism, Manifest Destiny hits the buffet. *I was the Miss America of purging,* a bulimic tells her. *It seems as if the rules don't apply to me . . . it's easy to solve. I don't have to admit error; I'm above being inconvenienced.* Perhaps she thinks she's achieved that frictionless existence the tech boosters taught us to want.

Where anorexia might be the physical embodiment of a conservative economic model, traditionalist with its simple graphs and straight lines, bulimia is all sharp turns, peaks and valleys. We are entering Web3, when girls are taught young to imagine themselves as algorithms. Bulimia might be a bull market or a game of blackjack when you're counting cards. A hacker ethos, a thirst for shortcuts, a stone-cold certainty that the numbers will cancel each other out. Rewiring your inner calculator, fuck set points and homeostasis, let a girl get high. Pop the pills, endure the pain, hide the proof, delete the code. Like investing your last dollar, it feels high risk and high reward, requires ingenuity. Upgrading the technology before anyone catches on, or before the bile burns your esophagus. The gag you didn't expect, the stomach acid brighter than the neon snack you started this with, cold sweat and handfuls of hair in your sticky palm. Heart palpitations, caught breath and wilting vision, blotted thoughts. People with eating disorders might be unknowingly embodying the ethic of the capitalists funding our diseases, taking it so far we prove their predictive models wrong, crash the computers, end up in the hospital. Even the Deloitte consultants knew it: once we're dead, no one can make money off us.

Karen Carpenter died of heart failure mere weeks after she started drinking a syrup that induced vomiting, while she was at home, supposedly recovered from anorexia. Like many anorexics, she developed bulimic symptoms in the vacuum left by her anorexic ones—like capitalism, eating disorders evolve and adapt and refuse to be killed. Meant to be taken very few times in a life, if at all, the drug Karen took quickly erodes cardiac tissue. Anatomical remodeling of the heart, a new economic model forced on to an unprepared society, the complete system upgrade that crashes the computer. All those metaphors, though, don't settle on the skin. The body, in the end, isn't a metaphor; it is flesh and folds and heaving breath and a beating heart. The body, in the end, is hungry.

Starving in the Cyberverse

After the search bar, two paths diverge in the dark. Down one: pain and potentially dire straits, spiky shoals of self-hatred and self-harm, but also love, care, shared secrets, girls who get you. A place where no matter how sick and sad you are, someone will say *same*. Down the other: girls who got off the other road before it careened over a cliff. Pain too, but also a life where picking up a fork doesn't have to mean a fork in the road, a life like you lived before, back when you and your body were on speaking terms.

Imagine a girl, maybe she's twelve, who had a bad day at school. Someone she liked ignored her, someone she admired announced their diet, someone she loved skipped lunch, so she did too, not for the first time. She came home hungry and tearful, and then she came here, to a cornucopia of anonymous, anytime friendships. To a feed that wouldn't cost her any calories. She clicks down the first path, and suddenly she's tumbling. Images pile up, ideas and icons replicate rapidly, tabs accumulate, and then the screen freezes.

She waits, and reads, and once everything is buffered, she keeps clicking.

In the mid-aughts, the media started sounding the alarm about a dangerous new cult run by teenage girls. At this very moment, the articles implied, your daughter might be e-signing a suicide pact when you thought she was just online researching a book report. According to outlets like *The New York Times, The Washington Post, The Guardian,* and *The Atlantic,* girls were joining "the world's most dangerous secret

society," writing "crazy" blogs devoted to their "disgusting" value system. Dr. Oz devoted a full television episode to this "dangerous online movement." On Tumblr, BlogSpot, LiveJournal, and other message boards, girls had been building communities where psychological diseases were supposedly spreading "contagion-like" to "innocent and vulnerable" youth. The virtual world inspiring this moral panic was the pro-eating disorder (pro-ED) internet, which in the broadest terms consists of an online ecosystem of blogs, message boards, and social media accounts where people suffering from disordered eating gather online to create and share content about their illnesses.

Like most online subcultures, the pro-ED internet is a strange space spanning a range of viewpoints, a reality that is not reflected in its media coverage. That coverage is instead largely sensationalist, casting the people, mostly teenage girls, who run the sites and create content as villains attempting to "recruit" devotees, and those who read the sites as impressionable, almost agency-less incubators of bad behavior. In the media's imagination, it's a "horrifying" web of "tips on weight loss and how to keep it secret," and "creative writing glorifying eating disorders." The "ghastly subgenre" of images intended to inspire a desire for thinness is cast as a "moral outrage, even a public-health threat."

The content on these sites can indeed be "horrifying"—but much of it is not created by the posters themselves, but by the very media industry calling it "excruciating." While some imagery on these sites is user created—photos of a poster's body, for example—much of it is pulled directly from magazines, movies, television, and tabloids. A teenage girl might post an image straight from the pages of *Vogue* or *Us Weekly* on her blog, alongside a caption expressing her desire to look like the person in the image, the one the media zoomed in on and printed on glossy pages, while no one was looking at or listening to the girl reposting it. With a few strokes of her laptop keys, an underage girl enacts a transformation: an image that was once celebrated is suddenly dangerous.

This begs the question: What message was she supposed to get, if not that the body lent so much ink and paper is one she, the nonfamous girl, should aspire to emulate? In turn, what makes the girls reposting these images more "dangerous" than the editors, advertisers, public relations professionals, and media executives who published them first?

By stirring up a moral panic about pro-ED communities, casting a teenage girl as patient zero of a social contagion, the cultural arbiters who forged the standard she's worshipping evade responsibility. Their stance also ignores the legions of people posting content that is pro-people-with-eating-disorders rather than pro-disorder itself, in that many posters are simply creating spaces for people suffering at the hands of our beauty standard to talk about that pain with others going through it. The demonization of pro-ana creators serves to obscure the pro-ana society they're living in, channeling blame at girls in bedrooms instead of adults in high-rise offices who are simultaneously selling "inspirational" stories about celebrity weight loss and horror stories about disturbed teenage girls obsessed with celebrity weight loss.

In 2007 I was a seventh grader who lost her seat at the lunch table. Lonely and confused, I decided to figure out what made me unworthy of the attention of the girls I'd loved, not to mention the boys they were starting to get crushes on. I pored over photos of myself and my former friends, and the only difference I could find was the size of our stomachs. I remembered all the magazines I had stacked by my bed, pointing out the same difference in celebrity friend groups. Something clicked in my mind, so I sat down at the computer and started clicking.

A 2009 paper reported that google-searching "thin and beautiful" led the engine to suggest the user next search "how to become anorexic." *The New York Times* published a series of investigations into pro-ana, with titles like "Secret Society of the Starving" and "Web Sites Celebrate a Deadly Thinness." The articles weren't wrong, per se; I remember linked Xanga pages and Tumblrs rife with sickly celebrities. Blinking cursors, coded to trail glitter across the screen as I scrolled, sparking thoughts of breadcrumbs I was learning I shouldn't eat. Limbs and scars and stars and song lyrics. But I also remember seeing the same images and tips I found on thinspiration boards in the magazines I bought with my mom.

Women's and celebrity magazines were (and still are) rife with rigid diet regimens, extreme exercise trends, and exhortations to embark on juice cleanses. Controversial opinion: a juice cleanse is taking anorexia

for a test ride. It is in fact difficult to differentiate from the liquid-only fasts you might find on a pro-ana site, where "tips and tricks" often replicate magazine regimens but are covered by the media as "highly dangerous." One journalist called pro-ana a "perverse distortion of Weight Watchers," endorsing weight loss in general while stigmatizing teenagers for teaching each other how to do it. *The New York Times* encouraged parents to "distinguish between routine pre–spring break dieting and something worse." This paradox is deeply embedded in mainstream understandings of pro-ana: weight loss is a normal, laudable goal, while pro-ana is disturbing, dangerous, and deviant. In the words of one Tumblr user, *the tips and diet advice offered by pro-ana are really not any different in their actual *content* to what you see in 100% legal girls' and women's magazines.* This is not to say that this content is safely consumable for young people or to condone its publication, but to point out the hypocrisy of journalism that casts content as deviant when it is written by teenage girls and normalizes it when it is written by grown adults who should actually know better.

Those adults wrote about eating disorder rumors in articles with titles like "How I Got Thin Fast," advertising a starlet's "diet secrets and how she almost went too far." "Going too far" is the ever-present theme in articles about scarily skinny famous girls in this era, a verbal construction that implies they started off on the right track. One pro-ED forum devoted to celebrity bodies anoints some "thinspo" (an abbreviation of thinspiration) and others its opposite, "reverse-spo." On its face, this is "perverse," per *The New York Times.* It is cruel and promotes unhealthy ideals. While the pro-ED community did come up with the (admittedly alarming) terms "thinspo" and "reverse-spo," the images they post, and to which they apply those terms, are often pulled directly from mainstream magazines, movies, and television. Magazines didn't explicitly use terms like "thinspo," but they did publicly shame women who gained weight, and many future thinspo images were originally printed under headlines like "How She Lost the Weight." Translation: how she went from reverse-spo to thinspo. The concept of reverse-spo clearly subjects women to indefensible insults that I am not condoning. But it is important to remember these are insults children and teenagers learned from adults writing in powerful publications, which also

taught these mostly underage people to live in terror of hearing those terms applied to themselves. The bloggers categorizing women's bodies aren't inventing anything; they are simply reading the room they've been locked into.

One journalist described an interview subject suffering from anorexia and bulimia as "very attractive," before relating that "to be beheld is, to [her], so painful that after meeting me in person, she was still vomiting and crying with fear over the possible consequences of cooperating with this story a week later." He quotes another interviewee explaining that talking to fellow sufferers is helpful because *people just need to know that they aren't reacting in a completely crazy way* to the world around them. The author follows this vulnerable admission from his subject with mockery and condescension: "The problem is that by and large, the people posting on these sites are reacting in a completely crazy way." And these ostensibly concerned journalists casually include instructive content in their reporting. Articles list exact caloric amounts consumed by subjects, quote pro-ana diets, and name diet pills, all while emphasizing how such information might incite illness in vulnerable readers when it is published on those sites, never mind the current publication's far wider audience.

According to *The New York Times,* anorexic mindsets are just "very extreme versions of the non-eating-disordered woman's desire to be thin, which just happen, rivetingly, to carry the risk of the ultimate consequence." Only weight loss so "extreme" it makes us worry for someone's life is understood to be a problem, a "riveting" problem at that, word choice that spotlights the lasting allure of the sad, thin, dying girl as an ever-sellable storyline. While the media simply promotes the "non-eating-disordered woman's desire to be thin," pro-ED websites supposedly promote a disordered desire in "dark, private, and propagating spaces," imagery that evokes the womb as much as the doomscroll.

In my final year of middle school, I hoarded magazines and logged on to message boards, but it feels integral to emphasize that I found the magazines first. In my bedroom, I watched Hilary Duff and Lindsay Lohan shrink by the week. By the time I was googling weight loss, the magazines were wondering whether these girls were sick, but if they were, illness seemed to be earning them even more attention, and now

I knew exactly what to put in the search bar. On the websites I discovered, I read instructions that led me to hurt myself, but I also found out that I wasn't alone in my self-hatred or my terror that I'd never be loved because of the way I looked. I found girls going through exactly what I was. They taught me things that worsened my burgeoning eating disorder, yes, but those things were largely which of the various diet plans I'd already read about in the magazines were effective. They also taught me things that protected me from my worst beliefs about myself, and they taught me how to support someone without judging them, to express care without condescension, that the world had warped me and not to blame myself for the way I'd tried to survive.

In the summer of 2007, Nicole Richie threw a party. *Vanity Fair* put her on its cover with the headline "Nicole Weighs In," calling her "virtually unrecognizable as the pudgy sidekick" to Paris Hilton she'd supposedly once been. The journalist grilled her on anorexia rumors, while noting the "bitter irony" of the fact that "the attention showered upon Nicole seems to increase in inverse proportion to her declining weight," never mind that this article is doing exactly that. Magazines that had cruelly castigated her for being less thin than Paris assiduously tracked her weight loss, congratulating her right up until she crossed a line so blurry she couldn't possibly have seen it coming: the line between skinny and sickly, a line that these magazines demand their subjects attempt to live on.

The girl wanted to let loose. The invitation to a barbecue Nicole hosted on Memorial Day was leaked to the press and has since been immortalized online. *There will be a scale at the front door. No girls over 100 pounds will be allowed in. Start starving yourselves now!!* The backlash was immediate, with Nicole suddenly thrust into the same role as the pro-ana bloggers: bully, cult recruiter, disease vector, disturbed girl. When she protested, claiming she was clearly joking, the media disbelieved the sick, superficial girl. This from an industry that gave her cover after cover when her weight dipped into the double digits. So she put into words what the magazines had said silently: *No girls over 100 pounds will be allowed in.* What Nicole's joke did is what protest humor often

does, which is shred the drapes hiding power's directives, revealing the cruel absurdity of its dictates. Society might make girls sick, but it can never make us stupid. We reblogged Nicole's email and felt like she was letting us in on the joke, not to mention admitting what we all knew: that the world looked at you longer when you made yourself smaller, and that shrinking meant suffering.

On a pro-ED site, someone asks *how did people treat you differently, if at all, when 1) healthy skinny 2) unhealthily skinny?* The poster is pointing out the obvious, admitting that they are under no illusions that their disordered eating practices are healthy. While reporters insist that pro-ana bloggers are rebranding anorexia as a "lifestyle choice" rather than a disease, poster after poster announces their sickness and does not shy away from discussing their disorders' negative effects on their health. This poster describes receiving *much more attention from everyone* thin *vs invisibility* when bigger. This is an experience I have had, and one I've read and heard about countless times. My recovery was enabled by this very realization, by the recognition I received from other girls, the revelation that I wasn't crazy or imagining anything, but also that being seen isn't being loved, or even listened to. Across laptops and in whispers we followed this story to its saddest conclusion, the one where we starve to death but get to stay in the spotlight. But by then we were sisters, and we didn't want that for each other, so we turned the lights off and handed each other microphones.

By 2012, estimates of the prevalence of eating disorders were alarmingly high: one nationwide survey reported that three out of four American women suffered disordered eating symptoms. Other studies found that 62 percent of teen girls were trying to lose weight and over 13 percent of girls under twenty met the criteria for a *DSM* eating disorder diagnosis. This, combined with the media outcry over pro-ana, led to a wave of censorship. Tumblr, Pinterest, and Instagram carried out mass deletions, permanently erasing a lot of pro-ana content. On Tumblr, that content was replaced by a public service announcement listing treatment providers, hotlines, and awareness nonprofits, which popped up

if a user searched for censored hashtags. Instagram and Facebook soon embarked on similar campaigns.

Blanket censorship efforts took the mainstream media interpretation of pro-ana at face value, deleting blogs along the logic that they were sites of indoctrination, infection. In order to understand the backlash this provoked among those communities, as well as their innovative ways around the injunctions against their content creation practices, it's important to understand what these sites are used for beyond the weight loss tactics and thinspiration they are exclusively associated with in the public imagination—both of which we've seen can be read as simple distillations of mainstream media dictates.

One girl mourned Tumblr's decision and girls like the one she once was, who might not have survived adolescence without her blog and the community she found there. She wrote about meeting her best friend via a comment on one of her posts and bonding over their shared struggles. They messaged all day every day, supporting each other even once they both entered recovery. In an extremely dark time of her disease, she attempted suicide, but not before saying goodbye to the girl she'd met on Tumblr, who alerted the authorities and in doing so saved the poster's life. Anorexia's high mortality rate renders friendships like these important safety nets for an illness that so often has none, due to the difficulty of diagnosis, the limited efficacy of existing treatment options, and the scorn the disease so often attracts, as evidenced by media depictions of pro-ana bloggers.

Studies have repeatedly demonstrated the positive emotional support networks forged on these platforms. A 2013 meta-study engaging with a decade of research found that "well over half" of the people engaging with pro-ana sites "joined to obtain social/emotional support." This reason was ranked higher for the vast majority of users than access to thinspiration or diet tactics. These overwhelmingly female spaces (studies estimate these sites as anywhere from 82 to 97 percent female) are sites of "reciprocal self-disclosure," "tangible assistance, network support, esteem support, emotional support, and informational support" that have been "shown to improve self-esteem" in some cases. A 2015 study in *Media, Culture & Society* reported that pro-ana spaces

can "compensate for a lack of or negative offline therapeutic resources and can provide eating disordered individuals with an outlet for safe self-expression, non-judgmental support [and] a feeling of inclusion." Online, girls suffering from eating disorders are able to meet and "cope with, and sometimes escape from," the world making them sick. The people I spoke to all listed friendship, nonjudgmental understanding, and compassion as the main draws of pro-ED spaces. One person told me they are still in touch with people they met online over a decade ago. They spoke about the *isolation* that accompanies a disease whose sufferers are villainized, isolation alleviated by the *hours I spent talking to people who understood.*

Despite the fearmongering about vulnerable girls infected in forums, "there is no evidence that people without disordered eating tendencies were ever searching for, or engaging with, these very specific and highly demanding communities," as University of Sydney professor Zoe Alderton writes in her book *The Aesthetics of Self-Harm.* Alderton notes that the average user had been living with an eating disorder for years when she first logged on. If that is true, the cascade effect censorship efforts are ostensibly intended to disrupt never existed in the first place. A Tumblr user told me that *most servers have a rule that you have to have had an ed for a few months to join, so we don't get anyone who is not already sick.* According to the people who run them, many of these forums are creating spaces for people who self-identify as eating disordered to find each other, not attempting to indoctrinate people who are comfortable in their bodies into a cult of self-hatred. Locked forums require new members to get approval from a moderator, and public blogs often include trigger warnings. If ill girls are turning to these sites looking for friendship, solace, and support, not just instructions and inspiration, the pro-ED internet appears to serve a much different function in the disordered society girls are living in. Instead of a sharpened knife, these sites might be more like a Band-Aid on a wound that really needs surgery, when you're stranded in the CVS with your girls.

When I set out to write this essay, I didn't want to defend the girls I'd been told led me astray by books, articles, and doctors. But then I remembered that I sought them out, that my cyber sisters were the only girls who'd listen no matter how scary the words I spilled into the chat

box were, who'd steady me when I was shaking. Eating disorders are often construed as lonely diseases, and this is largely true in daily life. These illnesses isolate sufferers from communal activities, rendering shared meals harrowing and basic inquiries about how you spend your day invasive. The clinical literature also emphasizes their competitive undertow, but what is often elided in these depictions is that competition also breeds communalism. When my disordered eating led me to eat my meals in school bathrooms, it also led me to talk about that online with other girls doing the same thing. I didn't learn to eat sparingly in secret from those girls; I was already crying in the bathroom when I typed the words into the search bar. The point of this story is not to exonerate enablers but to recognize that enabling communities are communities of people in pain, and to ask what made so many of us believe a haunted house was a safe haven. Something had to be really fucking scary outside.

On pro-ED sites, treatment centers are often discussed, as people compare experiences or relate stories about almost going but not ending up able to go because of their parents' finances, or their insurer disbelieving their disorder, or not meeting diagnostic qualifications. As we've seen, existing treatment methods have dismally low long-term success rates, and even this ineffective treatment is out of reach financially for many, while others are kept out by fatphobic diagnostic criteria and insurance demands. In the massive vacuum created by these conditions, it should not surprise us that people turn to others going through the same struggles.

People suffering from stigmatized illnesses with few treatment options have historically worked together to create alternative modes of support and strategize ways to reduce the harms of their illnesses, even if they can't cure them. Drug users and HIV-positive people did just this during the early years of the AIDS epidemic, turning to each other and building harm-reduction programs in the face of government negligence. According to the National Harm Reduction Coalition, harm reduction's "spectrum of strategies" are aimed at "reducing negative consequences associated with drug use." Its principles include "safer

use, managed use, abstinence, meeting people who use drugs where they're at," as well as "non-judgmental, non-coercive provision of services" and giving drug users "a real voice in the creation of programs and policies designed to serve them." This is an ethos sorely lacking in medicalized eating disorder spaces, but one adopted by many communities of eating disorder sufferers online, both in pro-ED and pro-recovery spaces, where people are attempting to build support systems outside of the medical paradigms that have so often harmed them. After Reddit banned the forum r/ProED, which had more than thirty thousand subscribers, someone started a thread entitled *reddit ban endangered thousands of lives.* The post began with the declaration that *this morning, my only mental health resource was banned.*

The poster wrote about their experience of disordered eating in a larger brown body. Unable to receive an official diagnosis and facing disbelief from family and friends, they found acceptance, validation, and care on r/ProED. They wrote that *eating disorders afflict all genders, all ages, all races. . . . "Non-standard patients" are often completely ignored by mental health professionals and family/friends. . . . r/ProED was a place for these people to turn to for support . . . a place to be heard and a place to be believed . . . a place of love.* On deleted threads and in communities linked to blocked hashtags, there was content embracing harm reduction, providing care and compassion instead of stigmatization.

One Tumblr post entitled *Purging harm reduction for us mia girls (and boys n enbies ofc)* begins with the announcement that what follows are *safety tips* written because the poster *know[s] if I ask you to quit doing what you are, it will fall on closed ears.* They describe their own *fucking terrifying* experience with bulimia, involving vocal cord dysfunction, laryngospasm, and stomach sphincter weakness, all of which left them feeling like they were *being strangled.* The post has been reblogged over a thousand times and hearted almost forty-five hundred times. Comments include expressions of gratitude, additional safety tips, and follow-up questions, which the original poster in almost all cases replied to with suggestions and the hope that the commenter *stays safe.* Someone commented, *I purge but I don't have a diagnosed ED. So I don't talk about my problems with anyone. Should I?* The poster replied, encouraging them to share, validating their experience and offering to talk. Another com-

menter thanked the original poster for keeping her physically safe when she was in the throes of her disease, and wrote about recovery, encouraging other people to attempt it too.

When I reached out to a Tumblr user who ran a harm-reduction-oriented pro-ED blog, they initially reacted with a distrust I understood, bred from being misread, mischaracterized, and vilified by journalists in the past. They told me they and their friends had been interviewed by writers less interested in their experiences than in trying to *"expose"* *the "pro-ana" community* as *crazy evil teen girls who love anorexia,* the reductive, condemnatory take promoted by so many journalists. This user's experience in pro-ED spaces was nothing like that. They told me, *the first time I didn't feel disgusting because of my disorder* was on a pro-ana site, a revelatory moment of destigmatization spurred by realizing *I wasn't the only person with an eating disorder who wasn't underweight, or the only person with an eating disorder who binged and purged as well as restricting.*

When they first found the pro-ED internet and began making friends, they found *nice and welcoming* people who traded advice *to keep safe* and shared memes about *how good recovery would be,* interactions that ran counter to what they saw as the media's depiction of *people who rope in vulnerable teens and give them anorexia.* These relationships offered a *feeling of community that is irreplaceable. Nothing is TMI or too far, we talk about the scary, gross, shameful bits of ed that we can't anywhere else.* They told me that *these communities are so important* because they literally save lives, as people isolated in their eating disorders, as they once were, *feel too fat, and gross, and all alone, and kill themselves.*

A study on the effect of censorship and PSAs for self-harming practices including suicide attempts did not find that they decrease the likelihood people will engage in those activities, but did find that they decrease the likelihood that someone suffering will reach out for help. What Alderton calls the "sense of mass sadness" expressed in pro-ana spaces might be so eagerly censored by corporations because it poses a "threat to individualistic Western culture. . . . Collectivist self-harm groups can provide a deep challenge to the idea that healing an individual is possible" and in turn, purchasable through treatment, a challenge that threatens the medicalized treatment complex the nonprofits encour-

aging censorship are part of. The PSAs that replaced these communities link to eating disorder charity websites where anorexia is defined by low weight. It is not surprising then that a person who is suffering while not underweight might close the tab that's telling them they're not sick enough, and open one where people with the same illness will comfort them.

I am aware that it sounds counterintuitive to construe a self-harm message board as a harm-reduction space. On the other hand, it makes a paradoxical, perverse kind of sense for the pro-ED internet to serve a harm-reduction function in a society where beauty standards demand violence against the self. The expression of collective despair, the admission that the only way to meet the beauty ideal we've been fed is not feeding ourselves to the point of self-harm, is transgressive in its rejection of optimistic weight loss narratives. I am not defending all pro-ana spaces; I am simply saying that their existence shouldn't surprise us, nor draw the revulsion it tends to. As one poster asked, why do reporters *hate us so much*, and *demonize us*? Why is there so *little understanding or compassion for people who are sick and suffering*? They write that eating disorders feel like *the most condemned and misunderstood mental illness*, as news reports and medical authorities claim that *people with EDs promote disordered behavior simply by existing*. This poster is asking some good questions: Why, in the case of eating disorders, are visible symptoms understood as cause for censorship and condemnation? Why don't people see these spaces and feel crushing sadness, rage at the world that made us turn to this, instead of rage at people attempting to express their pain?

Before there were blogs, there were books, and to understand the message boards and banned hashtags, we need to understand the makeshift book clubs, the memoirs passed like contraband through treatment centers. In *Wasted*, a memoir turned manual for many, Marya Hornbacher remembers reading an anorexia memoir and *wanting to be [that girl]*. Victorian journalists worried that "literary anorectics [*sic*]" were "discomposing the stomachs" of readers. As Emma Seaber has pointed out, anorexia nonprofits have names like "Looking Glass" and "Mirror Mirror," while the phrase "looking anorexic" has become common parlance. If images

and stories are understood to pass anorexia, the disease becomes one of mimesis, copycat reading. Some scholars conceive of eating disorders as "reading disorders," casting patients as "too-credulous (and implicitly vacuous) consumers of mass media," according to Seaber. That perspective positions pro-ana girls as both stupid and violent, as opposed to, I'd argue, literate and caring.

The question becomes, if people read memoirs as manuals and articles about starlets' diets the same way, and then create websites that clarify what both texts are really saying, are they suffering from a "reading disorder" or are they just reading between the lines, while the rest of the media purposely pulls the wool over its eyes? Seaber writes that the "reading disorder" paradigm implies that "there may be a method, peculiar to readers with or predisposed to eating disorders, of interpreting texts in a maladaptive way." In treatment settings, rules imply that patients' reading is disordered: books and internet-connected devices are regularly confiscated, putting today's girls in a setting eerily reminiscent of the Victorian rest cure. Rather than admit that teen girls are smart enough to close read, academics would prefer to call them illiterate, diseased readers.

Imagining readers as germ incubators, eating disorder nonprofits preemptively limit the types of stories told to and about them, silencing diverse narratives in favor of optimistic, medicalized ones. These charities devote sections of their websites to guidelines for telling your story "responsibly," implying that patients' life histories harbor infectious potential. According to NEDA, aspiring storytellers should "try to strike a balance between 'serious' and 'hopeless' and always encourage people to seek help" by accessing NEDA's own "website, screening tool, toll-free NEDA helpline, or crisis text support" (as of this writing, NEDA has recently terminated its entire text support team, replacing them with a chatbot). BEAT, the U.K.'s largest eating disorder charity, reminds would-be writers to "avoid graphic or in-depth description of things readers may find distressing," which I'd argue includes most aspects of eating disorders.

In her work, the scholar Kristen Gay connects charities' narrative guidelines to Gayatri Spivak's notion of the female as the silenced subaltern. In her seminal essay "Can the Subaltern Speak?," Spivak contends

that "the subaltern as female cannot be heard or read" by the dominant culture because her speech is ignored, misread, or essentialized. Gay describes NEDA's guidelines and social media censorship enacting just this type of epistemic violence against the "self-starving woman," which wreaks more than emotional pain: "it can result in their death when organizations recommend professional intervention and then prevent them from accessing treatment because they are not 'really' or 'officially' anorexic." She worries that the more we silence women, the more they will keep silencing themselves through anorexia, and she suggests that "we might ask the women to tell us their stories, and not to save other women with their stories." But how sure are we that their stories won't save other women? Why are we so afraid of girls' sadness, self-hatred, and fear?

Writing about the contempt directed at personal essays about trauma, Melissa Febos argues that "resistance to the lived stories of women, and those of all oppressed people, is a resistance to justice," to the change that believing these stories would require from a society with a dreg of empathy. Censorship on social platforms, media demonization of sick people, and charities silencing sufferers are part of that resistance, one that inspires the dominant voice "to deny, discredit, and dismiss in order to avoid being implicated or losing power." So they transform the girl telling her story too honestly into a girl spreading a disease, and they interpret her emotions as sick instead of simply provoked.

But we've long known they find our anger grotesque, so we've been sneaking around and inventing secret codes for centuries. We know what the people in charge of media and medicine think of our pain, which is that it's made up, and what they think of our solutions, which is that they're witchcraft. I recognize that I'm being reductive, but so are the journalists and doctors. Teen girls invented fandom and finsta and zines, built entire artistic ecosystems in their bedrooms and coded their own websites. Censoring a tag? Girls can pass notes behind the strictest teachers' backs. So they switched hashtags, came up with new slang more quickly than the coders could block them. Researchers at the Georgia Institute of Technology found that Instagrammers got around censorship by using "increasingly complex lexical variants," inventing ever-evolving tags that fostered "increased participation and

support." They concluded that "despite Instagram's moderation strategies, pro-ED communities are active and thriving." Similarly, Tumblr bans have "not succeeded in deterring pro-ana activity," according to another 2017 study. One Tumblr user told me that *whenever someone on edblr gets termed [slang for erasure by censors], it's not long before you see them around again* under a new username.

The combination of censorship and sensationalizing news coverage serves the online platforms and the media, not the at-risk people both establishments purport to worry about. By simultaneously underestimating pro-ana users' intelligence and agency while misunderstanding their intent, this paradigm maintains the centrality of the sick, vacuous white girl as normative ED patient, a figure that both attracts sympathy and does not threaten power structures. By choosing to silence and demonize people making content about the diseases they've developed in thrall to the beauty ideal, media companies can continue coding their algorithms to promote that ideal, attracting huge numbers of eyeballs and in turn dollars from weight loss, wellness, and beauty companies that want those views, without any party admitting their own complicity in the existence of the content they are censoring. It's just those crazy girls, sick and superficial, at it again.

A thirteen-year-old girl downloads TikTok and starts scrolling her For You page (FYP), TikTok's proprietary, mystery-shrouded feed. An infinite scroll, the FYP populates with videos chosen by a combination of human moderators and algorithms. It displays popular videos, but it also serves up videos testing a user's interest in content subgenres. As she scrolls, the algorithm takes note of which videos she watches, which she hearts or comments on, and which she sends to friends. Then it fills her feed with videos it deems similar to the ones she spends the most time with. Soon after she begins scrolling, TikTok serves her a couple videos from some of its popular hashtags, those with a billion or more views, which include #skinny and #weightloss. She watches a few #glowups, in which women in athleisure display before and after weight loss transformations as Nicki Minaj's verse on "New Body" plays. She watches a woman consume a day's worth of food in a #whatieatinaday

video with hundreds of thousands of likes, fire emojis, and adoring comments, and wonders if she should start eating like that too. Because she didn't scroll past these videos, and instead watched what was presented to her, the algorithm serves her videos with hashtags other people who liked those videos like. Soon she's watching a video of a girl eating ice chips and another smiling softly into the selfie camera as she describes something called "the corpse bride diet."

A number of FYP trajectories parallel to the one I just described were discovered by *The Wall Street Journal* in its 2022 investigation into TikTok's promotion of pro-ED content. Soon after its U.S. debut, TikTok became a hotbed of pro-ED content. The media reports rolled in as usual, shaming minors. BuzzFeed published a screenshot of a thirteen-year-old user's profile, including her age, current weight, home state, and multiple images of the lower half of her body. It blurred out her username, but not her picture, and wrote that "what she's doing is dangerous." *The Guardian* claimed that even "innocuous hashtags such as #caloriedeficitsnacks and #weightlossprogress" are being filled with "problematic content encouraging users to restrict," never mind that encouraging restriction is the basic concept of a supposedly "innocuous" diet. TikTok adopted Tumblr and Instagram's approach, censoring hashtags and replacing them with PSAs. But just like Tumblr users before them, pro-ED TikTokers quickly subverted the attempted censorship, developing more than seventy-six different spellings of censored hashtags, according to *WSJ*.

What is new to pro-ana on TikTok and Instagram is the way users encounter the content, which is not of their own volition. Pro-ana spaces on platforms like Tumblr, Reddit, and Discord are accessed by users *actively searching* pro-ED hashtags. They are frequented by people who have usually been suffering from disordered eating for years. In order to find pro-ED content, a user needs to look for it and often even ask for it, as many forums are guarded by moderators requiring members to self-identify as eating disordered before engaging. In stark contrast to these corners of the web, which can function like virtual sorority houses, complete with membership codes and a locked front door, TikTok and Instagram leave the door wide open, usher new users in, show them around, and then slam the door shut while they're inside.

The *WSJ*'s researchers created a dozen bots coded as thirteen-year-olds to see what their FYPs would serve them if they expressed no interest in weight loss. Before the accounts had been active for a single month, they had been shown more than 32,700 videos about weight loss. A third explicitly mentioned eating disorders. When *The Guardian* carried out a similar experiment, which did search for diet content in an attempt to see if searching for "weight loss" would cause the app to show users what the media argues is unrelated pro-ED content, it found that a search for diets led to "full-blown eating disorder promotion in less than 24 hours." Research into Instagram's Explore page revealed a parallel phenomenon. A teen girl who traced her eating disorder to Instagram told *WSJ* that she found triggering imagery so omnipresent that she *just accepted it, that I was just going to live as this anxious human being with an eating disorder because of social media.* Another teen was actively searching for content depicting girls with her body type, which she described as *mid-size.* After searching for that term, her FYP delivered a few influencers who looked like her, but also began showing her pro-ana and weight loss content. Teens reported searching for fashion and makeup videos and quickly getting pro-ana content. An overarching, repeated sentiment from teens was that they had *no control* over their feeds and were often upset by content they did not seek out or even tried to avoid.

While harmful content is promoted to unsuspecting users, many TikTokers in the pro-recovery community find their videos taken down for mysterious reasons shrouded in legalese about "violating community guidelines." Those community guidelines seem to be the dictates of misogyny, racism, ableism, and white supremacy, judging from leaked instructions the company provided its moderators. These employees, who decide which videos should be promoted and which removed, were explicitly told to hide videos if creators had "ugly facial looks," "abnormal body shape," "beer belly," or any of a litany of physical features deemed "low quality," according to the leaked documents. Anecdotal accounts from Black and brown creators reveal that "ugly" is often code for "of color." Black creators recount videos deleted without explanation and suspicions of shadow banning, a term used to describe videos suppressed from feeds or searches.

All of this adds up to a scenario where TikTok is serving its users—an American subscriber base of 80 million people, more than 60 percent of whom are under twenty-five years old—diet content in the best-case scenarios and pro-ED content in the worst, while suppressing videos by fat creators and creators of color. TikTok and Instagram know their platforms are exacerbating eating disorders. Leaked internal Instagram documents admitted, "We make body image issues worse for one in three teen girls." In a survey of people who self-reported suicidal ideation, 13 percent of British and 6 percent of American participants said the feeling set in while they were scrolling Instagram.

When TikTok began banning pro-ED content, a *Wired* article claimed that "discovering, damage-controlling, and deleting pro-ana content has become a rite of passage for web companies." Damage control and deletion are, and always have been, the priority for these companies. They are aiming to protect their reputations and continue collecting data on users in order to sell ads, not prevent the spread of disordered eating. If they cared about that, they would also delete weight loss content, or at the very least stop targeting teenagers with it. Maintaining the artificial boundary between "healthy" weight loss and pro-ED content only entrenches the ideals that foster disordered eating, without which both the companies advertising on the platforms and much of the content disseminated on them would disappear. What could we create in that vacuum?

A 2019 *Qualitative Health Research* paper on pro-ana concluded that many users turn to these communities because the "cultural narratives" around eating disorders are "negative, narrow, or written by those with minimal or no lived experience" with EDs. The writers encouraged clinicians to look at the "unmet need" these spaces are filling and create others where people can forge the same types of connections.

Girls are doing this themselves in hashtags like #edrecovery and #recoverytok, where people offer stories of severe suffering and poignant, anachronistic moments in recovery, along with messages of hope, healing, and worry for others out there. They express rage at the world that made them starve themselves, denied it had made them sick, and

then censored their stories. In one video, a girl in a plaid scarf grins at the camera as the words *yes im gaining weight* hover overhead. Next, we see a montage of photos and clips. She's surrounded by friends, in the arms of a partner, eating, and typing, as phrases describing what she's gained along with weight float across the screen: *a social life, a love life, the ability to concentrate, my personality back, thick and healthy hair, food freedom,* and more. She's tagged this post #shadowbanned because many of her videos have been deleted by TikTok without explanation. Despite this, she continues to create content and connect with people both in recovery and hoping to recover soon.

Pro-recovery content creators offer helpful, grounded content about the day-to-day recovery process. They post realistic #whatIeatinaday videos to counter the deluge of videos from creators encouraging "healthy weight loss," who often post videos depicting days' worth of eating that nutritionists have pointed out often don't add up to the total suggested caloric intake for a toddler. After one of the many pro-ana trends that went viral on TikTok took over unsuspecting users' feeds, a pro-recovery creator posted a video with the text: *If this trend is on your for you page, i'm sorry. I'm sorry if it triggers you. . . . Please don't let it stop you from taking another step in recovery. Please go have that snack or meal. Please go put the cream in your coffee.* Her post was hearted 262,200 times and elicited almost 2,000 comments expressing gratitude and solidarity. She commented back to many.

When I scroll TikTok, my feed serves up advertisements every few videos. Usually they are for supplements, drinks, exercise classes, or individually curated diet regimens, all of which promise to help me reach my weight loss goals or, when the companies feel like speaking euphemistically, optimize my metabolic rate. These things are hawked by thin white women who dance in the rectangle of my phone as they point to rapidly appearing and disappearing phrases like "helped me lose the last five pounds" while shaking their hips to infinity and the purchase button.

If, inspired by all those thin women and exhortations to purchase my way to self-shrinking, I find myself feeling the very specific strains of self-hatred I used to feel all the time, I might type a pro-ED tag into the search bar. If I type in one of the too obvious hashtags, I'll find out

that TikTok is worried about me and wondering if I need help. Don't stress, TikTok tells me; someone is here for me—an organization that probably believes I am writing this story wrong, dangerously so. But in my view, the only way not to promote eating disorders on social media is to let girls tell their stories and show diverse bodies, the two things the social media platforms largely refuse to do, while the media acts in concert, filling magazines with impossibly small women while writing hit pieces about pro-ED teenagers. The fact that the only remaining communal spaces for disordered eaters are ones where people compare and contrast methods of self-harm should be cause for alarm, and for the creation of recovery-oriented spaces outside of traditional treatment models.

The media's depictions of pro-ED spaces as hotbeds of distorted values rarely mention the most insidious of those values: the racist beauty ideal driving them. The people logging on are a diverse group, but the images on thinspiration boards represent a starkly narrow, almost exclusively white population. Because the beauty ideal disordered eaters are striving toward is often the white supremacist one they were taught, these spaces replicate and crystallize that ideal. They also offer support to people even less likely than the average white woman suffering from an eating disorder to access care. This is a double-edged sword, but that is sometimes better than no weapon at all.

In upholding the mythological preeminence of the deranged, vacuous, white girl as eating disorder archetype, reporting on pro-ana spaces hides the real dangerous potential she harbors, which is the ever-deeper entrenchment of the racist and misogynistic beauty standard that girl is dying to embody. An infantile perma-girl, easily corrupted and easily saved, makes doctors and journalists feel great about themselves, even as they encourage those who don't look like her to engage in practices parallel to her disordered ones so they can look more like her. Recognizing the diversity of her actual experience and identities could loosen that imaginary girl's chokehold on the rest of us. But her continued reign is allowing an unbelievable number of companies to make an unbelievable amount of money, so the imagined victim-villain languishes in her gilded cage while so many others are denied access to treatment, and ever more people get sick.

Expressing our collective despair is an essential first step to unlearning the standards that made us feel this way, but we've been worshipping the ghost of a waif, and she was always a double agent. I am not advocating for silencing anyone; I'm asking more of us to speak up without worrying about character limits or video length or narrative guidelines, and listen to each other. I want us to find each other online and drag each other out, not down deeper.

Listen, we've already made our own languages and our own jokes, meme ecosystems and virtual clubhouses, so I know we can be honest with each other. Scrolling was sweet when I didn't think I deserved to taste tenderness, and soothing when walking down the hallway at school felt like emotional high-intensity interval training, but it was also seductive and sedative when I was first feeling yearning, by which I mean the yearning to be looked at, yearned for. The current of the scroll is strong, but it's a riptide in the preexisting, shark-infested ocean of the rest of our media, and I don't think casting the girls who get pulled out as demented villains is going to save anyone. We need lifeguards, and we might need to become them. I remember every click that made me feel a little less alone, even as I felt a little less beautiful at the same time. This is the scary part, the part I can't square. Validating our feelings of physical inadequacy can be cathartic and spark communion, but it can also further entrench the beauty standard that made us hate ourselves in the first place.

On the #edrecovery tag, I scroll through girl after girl, smiling, sobbing, shaking, whispering, telling me her secrets. Girls grin as they bite into puff pastries and pizza, and they post when they want to restrict but are determined not to, speaking about the urge and the power they've found in resisting it. They add melodic instrumentals to videos where they ask for support. People offer help in the comments and thank each other. Open mouths fill my screen, beckoning me somewhere I might be able to become myself.

Autobiography in It Girls

It's been a long night, but our girl's makeup is still intact. The dawn light glints off her skin, the satin heels dangling from long fingers. She's the type of girl who steps softly on tiptoes, born for stilettos. It's 2005, the first YouTube video in history has just been uploaded and the first iPhone is in development, but this girl is staring modernity down with a smirk and an updo. Stacked next to her in sky-blue font are the words *The It Girl*. This is the cover of the inaugural novel in a young adult fiction series, a spin-off inspired by the runaway success of the Gossip Girl books in the early aughts. The rest of the novels are titled with single adjectives, words that describe a girl who has and is "It." In one, the word *Classic* splays across a blonde, tucked into a trench coat and thigh-high boots. Now, a brunette, coy, crossing her legs. Right where dress meets bare thighs: *Devious* in baby blue. These girls are *Infamous, Lucky, Notorious*. Like all the It Girls I'd ever seen, they were also strikingly thin, limbs as narrow as the spines of the paperbacks they graced. I stopped breathing in the aisle of a suburban Barnes & Noble and bought three at a time.

In these books, girls got eating disorders at sleepovers and betrayed each other at parties; traded diet tips, flirting tactics, and barbed insults with equal enthusiasm. The 2000s saw a rash of fiction featuring cutthroat cliques of girls groping their way through ever-fluctuating hierarchies. Integral to the plot is the It Girl, the one kicking her legs up on the throne after a long day of taming her feral acolytes and taking a

long sip of champagne, never mind that she's underage. The plots pivot on the instability of power in groups of girls, on the threat of navigating girlhood's terrifying terrain alone, without sisters to bandage your bloodied knees. Sure, she pushed you, but you were about to step on a land mine.

Even It Girls age out of adolescence, if they're lucky. But if they're even luckier, no one notices they've become women. I've been entranced by this type of girl for as long as I can remember, and as I aged through adolescence, I collected idols real and fake. In 2007 *Gossip Girl* hit television screens and starlet-socialites like Lindsay Lohan, Nicole Richie, and Paris Hilton were anointed It Girls by the tabloids I bought in bulk. These tabloids and the always-updating gossip blogs documented their every stumble out of a club and strut down a red carpet. Magazines and websites alike tracked these girls' weights to the pound, publishing guesses pasted over bikini pictures. The headlines expanded and the girls shrank, but they stayed on the covers, which is what I thought mattered. In the crudest terms, the spotlight looked warm, and I was lonely, shivering.

Mystery around method is essential to It Girl mythology. The questions we ask, then and now, spawn further surveillance. What's in her bag? How does she do it? What does she eat in a day? But a girl who has "It" knows we want it for ourselves. So she guards her secrets, winks at the camera, and hopes she doesn't forget her clutch at the club. As a youthful observer, I didn't know their secrets, but I knew they were all thin. The girls I was growing up around, in real life and in online forums, noticed this too, and we thought if we put our heads together, that, at least, was something we could figure out how to copy.

The It Girls I met in real life were often tall and blonde, girls who wore silk blouses and delicate gold chain necklaces with pendants that fell right in the hollows at the base of their throats. I wanted to touch their necks, tenderly, and clasp their necklaces for them when they asked, but I also wanted to curl my fingers around those chains and yank them off, touch someone's skin and leave a mark. I still feel this way when I meet a certain type of girl on a certain type of night, and this could be because I want to be them, or because I want to breathe

their air, or because I want them to bite me, or because I want to ask: *What is it like?*

I met her walking through tall grass to a party. In the moonlight her hair was shinier than made sense, her legs brittle sticks that might crack. She asked for my name and said we rhymed. Later, we took a shot, and I told myself the heat in my throat was from the vodka.

Soon she and I were a scary pair at bars, dead-eyed and doing shots. Black out or back out, we liked to say, laughing, licking salt off our knuckles. We put the pieces of our nights together during mornings spent clutching hot coffees in clammy hands, scrolling through our camera rolls for clues. At this time I had supposedly recovered from my eating disorder, but I still daydreamed about looking like my friend, obsessively watched her obsessively watch what she put in her mouth. I wanted to tell her that we were allowed to walk around without being woozy from hunger, that sometimes eating enough was boring and other times it was terrifying, but mostly it was like a warm bath. We spoke about it once, in coded euphemisms, my hot fingers on her frigid wrist. Honestly, back then I didn't know if I had enough to offer her on the other side. I had a stomach that didn't gnaw at me all day, but it wasn't flat, and I didn't have her boyfriend or her Instagram following. I still follow her there, where she shrinks into the squares, the spiky geometry of her body growing ever smaller to a steady stream of fire emojis and *teeny tiny skinny legend* comments. I worry, and I wonder what I should have said, and I'm trying to figure it out now.

In 2019 an aspiring It Girl was betrayed by her former best friend. The dramatic friend breakup between Caroline Calloway, the self-mythologizing Instagram influencer-cum-wellness-scammer-cum-downtown-party-girl, and the girl who used to ghostwrite her Instagram captions enthralled a certain cadre of pop-culture-addled girls who knew what it felt like to love and lose a girl whose glow you wanted for yourself.

I read the ex-friend and ghostwriter's essay while biting my lip until

it bled. *I met a girl who was everything I wasn't,* Natalie Beach wrote, now estranged from that girl after a tumultuous, obsessive friendship. She listened raptly whenever Caroline opened her mouth, standing in the streetlight glow of her attention, balanced on one foot to stay in its thin band of light. She craned her neck to see into Caroline's closet and hoarded her compliments like heirlooms. But then she took it one step further, offered to write her Instagram captions, and became her voice.

She did what I never could, came right out and said what she wanted, *can I step into your mind?* Caroline said sure, unlocked the door and let her into a room painted Tiffany blue. *What happens to me next?* Caroline asked her, and Natalie forgot all about her own life and began writing in a tense she calls *first person beautiful.*

This is a tense many girls dream and journal in. Watching my teen idols and real-life friends live in it was harrowing, a fact Natalie's jealousy prevented her from seeing, as mine once did too. I think of first person beautiful as a tense for between times and power imbalances, the sliver of an era where gazes get stuck and girlhood goes wild. In this glimmering dimension, lingering is a luxury, and *the rules of time and inevitability were just different,* as Natalie wrote. First person beautiful is a tense where cause and effect get confused, which is why we so often villainize our It Girls for doing the very things we love watching them do, namely fall apart or misbehave beautifully, or become objects of sexual desire before we think it is appropriate or with partners we find unsuitable.

It is also a tense that requires an interlocutor: the girl living in the first person beautiful is not simply living in the first person; she is a fictional character as much as a real person. This is also why the rumors swirling around the girls I knew in real life perversely empowered them even as they tortured them, why the Gossip Girls needed a Gossip Girl to simultaneously stalk and legitimize them, and why the proliferating Instagram comments on a girl's photo can become a form of social currency.

So Natalie and Caroline spent nights speaking fast until they grew hoarse, and then they opened their laptops and spoke with one voice. Together they wrote *the Caroline character* in first person beautiful, a *fantastic YA protagonist* who *looked good crying.* When they cried, I thought my It Girls were so beautiful my head spun and my vision blurred. In

retrospect, I can see that this was simply a side effect of the intoxicating knowledge that I could console them. I was Natalie offering to write Instagram captions, desperate to become indispensable. I read them love letters I'd written in my head, in the tense I'll call "second person beautiful," and when they sniffed and asked if *I really meant it*, I nodded so zealously I could have given myself whiplash. Living in the second person beautiful is a devotional stance, a ritual practice of love lined in jealousy.

Natalie mentions Caroline's struggles with substance abuse only obliquely, too distracted by her ability to attract men, her shiny hair and expensive shoes, to notice that living in the first person beautiful has become unsustainable, dangerous. Another form of sororal death, perhaps, is dying to get into the It Girl canon, the final girl VIP room.

Dark room, purple-pink lights, damp dress, well, it's really a slip, splashed by someone's vodka soda, his camera pointed at me from across the bar—so this was it, after all that buildup? Being briefly beautiful is a letdown, the camera pans away as soon as you get used to sparkling in its crosshairs. You know the drill: boys get bored, the black eyeball roves, muses multiply, get minimized, get married to the guy who's got the glint in his eye, get uploaded to the cloud, get liked, get printed and framed, get bought, get divorced, get drunk. And maybe, finally, go home, get some sleep.

But I'm getting ahead of myself. Remember Mischa Barton in 2003? Evenly tanned golden girl, spaghetti straps and that stretch of midriff— now that was beauty, I thought. Boys got in physical fights just to stand in her line of sight and drove cars off the road to keep her from leaving them. Less a letdown, more a murderous miracle, her character Marissa's beauty kept her high on the fumes of being beloved until it killed her. Still, startlingly, what I felt as I watched her death scene was simple yearning: smoggy, vision-blurring jealousy. Smoke rose from the overturned car, the boy she loved emerged from flames, carrying her splayed silhouette Pietà style, and then she died for all those boys' sins, for all the girls like me sweating envy even as we cried and the credits played.

Back then I already knew beauty could break the body. I just thought

it was worth it, as I threw away my lunch at school and tried to make myself throw up after dinner. There used to be a Facebook application called Honesty Box that allowed people to send you anonymous messages. Pandora as e-girl made sure I knew I wasn't beautiful. On pro-ana forums, there are an array of threads devoted to Mischa's weight, all of which have been active for many years. The people posting on these pages wax poetic about what amazing thinspiration Mischa/Marissa made, and some of them write deeply disturbing screeds insulting Mischa's changed body over the years since she left *The O.C.*, calling these posts "reverse-spo" for the *secondhand despair* they inspire. For many of the people posting on these forums, Mischa pictures *really hit differently . . . because she was truly one of my very first thinspos.* A decade after Mischa quit *The O.C.* and endured the vitriol directed at her for gaining weight in her twenties, she became the spokesperson for a weight loss supplement company, a decision one gossip blog described as her "attempt to get back in the spotlight." This is the peril of the first person beautiful: when you are beloved for allowing yourself to be endlessly described, that spotlight can burn. For Mischa, time folded and crumpled, the timeline of her adolescence melting into the circumstances of her character's life, until she lost the plots and became a character herself. I think that's what Natalie meant about the first person beautiful; it is a tense where reality and fiction melt into each other.

Mischa has said that she quit *The O.C.* to preserve what was left of her mental health, but in order to do so she felt she had to kill her character. Perhaps this was an attempt to draw a dividing line between Mischa and Marissa, or maybe Mischa herself wasn't immune to the narrative allure of the classic first person beautiful trajectory, the one where the gorgeous girl dies young. Offered a storyline in which her character rides off into the sunset, Mischa chose death for Marissa instead. She has said that she found the ending *tragic* and *poetic*. She says people still come up to her and say they remember where they were when Marissa died. I, for one, remember where I was: on the same couch where I watched too many sororal deaths, too many girls gasping for their final breaths. I couldn't always tell whether I was jealous or afraid.

Almost two decades later, Mischa decided to speak in the pure first person and wrote an essay explaining her departure from the show, as

well as the pain she endured in a world that wanted to write the plot of her life for her. This was a first person beautiful mindset that led her down a path she admits caused *a few breakdowns*. So the character that made Mischa famous died by Mischa's own hand, but she didn't let that stop her from hogging the spotlight. Are you getting confused by these pronouns? So was Mischa, so was I, so were the girls sending desperate streams of text into the internet, wondering whether the actors were fucking their characters' love interests, whether Mischa and Marissa had the same drinking problems, the same rumored eating disorders, and whether we should get them too.

Tabloids wrote about the way Mischa would "take on the bad habits of fellow teen stars Paris Hilton and Lindsay Lohan," grouping the It Girls together and rendering "It" a contagion, passed back and forth over a shared shot glass along with eating disorders and addictions. Nicole and Lindsay were described in extremely cruel terms as the larger members of their clique. There were rumors of a weight loss pact. In one video of the two in 2008, they run into each other on a red carpet, gasping and gushing over each other's shrinking waistlines. Contagion metaphors abound in the clinical literature too, and I felt it myself in middle school, as I copied the cool girls' eating habits. Popularity and in turn power passed between girls like a virus, and so did feelings around food and self-hatred. If you didn't know why you fell out of the powerful, popular girl's favor, you couldn't fight it or justify yourself. You could convince yourself there was something wrong with you until you actually made yourself sick. The tabloid treatment of It Girl infighting followed the same logic: if we didn't know why one girl was on top one week and out the next, none of the girls themselves had any power, and the magazines anointed themselves clairvoyant.

This was not confined to supposedly trashy outlets. Critics at storied newspapers lavished Mischa with praise in terms reserved for the tragic ingenue, the future dying femme fatale. It was all about her "beguiling vulnerability," a term that ties her ability to allure to her ability to be hurt, begging the question of what "It" really is after all—a soft spot, or a shield?

Early in *The O.C.*, when Marissa is hospitalized after an overdose, she mentions an old anorexia diagnosis in passing. She shrugs it off;

she's over that. Later, in one of the show's most iconic scenes, a moment memed into eternity, her mother asks her how she *really feels* as she lies poolside drinking a cocktail, going gold in the morning sun. Marissa asks her if she's sure she wants to know, and when her mother nods, she releases a guttural scream as she throws each item of pool furniture into the bright blue water, one by one—a scene 2022 Mischa admitted was entirely improvised, *inspired by how I was feeling about my life at the time.* The refusal of food, the physical outburst, the screaming: all textbook signs of female hysteria, according to Victorian medical tomes. The scholar Carrol Smith-Rosenberg envisions hysterical fits as revolutionary outbursts: women expressing rage, despair, or even just pent-up energy in the language their doctors expected of women.

In their 1973 book on female hysteria, Barbara Ehrenreich and Deirdre English acknowledge that hysterical fits worked decently well as temporary power plays, giving women "brief psychological advantages over a husband or a doctor." But there's a fatal flaw in fits as a form of revolutionary guerrilla warfare: "hysterics don't unite and fight," and neither do our embattled, misbehaving It Girls. Instead they usually end up ensnared in a web of male professionals, policemen or doctors or reporters or paparazzi. This is the It Girl's dilemma: there's only one spot on the cover.

I first became fascinated with the hysteria diagnosis in college, right before I relapsed into my eating disorder. Soon I was obsessively reading about hysterical girls while refusing my favorite foods and collecting compliments and coffee shop loyalty cards, bittersweet and addictive. In an article titled "Faces of Female Discontent: Depression, Disordered Eating, and Changing Gender Roles," Deborah Perlick and Brett Silverstein argue that women struggling with the demands of femininity "have developed a syndrome comprised of disordered eating, depression, anxiety, poor body image, somatic symptoms," and more, a disease that takes on different names in different eras. They call it "Forgotten Syndrome" because it has today been "subdivided into multiple diagnoses," obscuring the connective tissue, which is that growing up a girl is all but impossible to do sanely. Back then I couldn't decide how the word "hysteria" fit around my neck, whether it was a necklace or a noose. Now I wonder if hysteria is an It Girl disease, what both Marissa

and Mischa suffered from—a state induced by living as an object in the first person beautiful, or by the depth of your desire to do so.

At the start of the new millennium, Lindsay Lohan and Tyra Banks stood back to back, It Girldom between them, Lindsay on the cusp and Tyra just aging out. In the film they starred in together, *Life-Size,* Lindsay accidentally brings her Barbie doll to life. Tyra, playing the improbably alive Barbie, has to learn to live in the real world, an experience she eventually rejects, preferring life as an inanimate object. This is almost too neat a legend of the It Girl. Do you want to be on top, even if it means breathlessly on a shelf?

So, *do you wanna be on top?* Each episode of *America's Next Top Model,* which ran for twenty-four seasons, or cycles, in *ANTM* lingo, begins with Tyra's voice repeating this question over and over as a montage of contestants' photos plays. At the close of every episode, an image of all the contestants in various stages of undress fills the screen, and the girl who has just been eliminated slowly fades to full transparency, disappearing from the group picture. As a metaphor for girlhood as both competition show and Shakespearean tragedy, this process is pretty accurate. We are taught to believe there is certainly not room for all of us in the frame, and we'll have to be more beautiful than our closest friends to make it in. Even the act of calling a season a cycle makes a statement: these girls are replaceable, and as soon as one hierarchical competition is settled, a new one will begin. Do you wanna be on top? Don't get comfortable.

The episodes are always titled using the same linguistic structure, "The Girl Who X," referring to a trait or behavior exhibited by one of the contestants that week. Some examples: "The Girl Who Is a Visual Orgasm." "The Girl Who Cries when She Looks in the Mirror." "The Girl Who Goes Ballistic." "The Girl Who Suddenly Collapsed." "The Girl Who Is Contagious." "The Girl Who Takes a Pill." "The Girl Who Is Rushed to the Emergency Room." "The Girl Who Breaks Down." "The Girl Who Everyone Thinks Is Killing Herself." This construction reduces girls to singular and stereotypical female humiliations. It makes sense for a show predicated on following girls living

in the first person beautiful, aspiring models fighting for the top slot in a beauty contest, who allow a panel of judges to describe their flaws in detail in front of everyone they live with, not to mention a national audience. "The Girl Who X" is a sensible descriptive driver for girls who are striving toward a paradox, hoping to differentiate themselves while also attempting to join a mass of girls who are essentially carbon copies of each other, models who share one body type and one wardrobe.

"The Girl Who Everyone Thinks Is Killing Herself" focuses on a contestant named Elyse. Her peers worry she is suffering from an eating disorder; she spends a lot of time in the bathroom and doesn't eat when the other girls do. The episode ends with the question of Elyse's eating disorder shrouded in mystery, and she is eliminated for unrelated reasons a few episodes later, with the issue never addressed. The epidemic rates of disordered eating in the modeling industry sometimes receive lip service from Tyra, but in almost every instance of a girl presenting with symptoms her friend-competitors worry about, Tyra avoids speaking to the girl directly, and she is soon eliminated for ostensibly unrelated reasons, a progression that both normalizes disordered eating and ignores its extraordinarily dangerous consequences.

In one cycle, a contestant describes her bulimic behaviors as proof of her devotion to her craft. In another cycle, the girls pose for a photo shoot depicting stereotypes about models. In one of the resulting images, a gaunt girl sits on a toilet. Her knees buckle toward each other; her frail fingers are coated in cream and pressed to her open mouth. Mascara runs down her face, and a paper plate of pastries sits between her feet. This girl was assigned bulimia as her stereotype. In another image, a girl wearing lingerie and high heels stares anxiously into the middle distance as she cinches a tape measure around her waist like a belt, posing as anorexia. While these images supposedly depicted negative and inaccurate stereotypes about models, in practice they served to glamorize and aestheticize these disorders. The judges praised both photos. As a viewer in the fourth grade, I saw a direct line between extreme slenderness and attention, admiration.

When I google the *ANTM* theme song now, the search engine lets me know that people also ask, *Which ANTM contestants had eating disorders?* And *Which ANTM contestants are dead?* When I follow the first ques-

tion to its own page of Google results, I find Reddit threads, pro-ana forums, and magazine articles cataloging the range of disordered eating behaviors models engaged in on the show, as well as the overt mentions of eating disorders, including both genuine, vulnerable admissions of struggle by contestants and moments when a disorder was used as an insult, a cudgel, or a badge of honor.

On *ANTM,* Tyra subjected contestants to what could be construed as the trials and tribulations of It Girldom: excruciatingly explicit and constant bodily critiques, reproachful judgments on comportment, constant surveillance, intellectual mockery. Tyra presented herself as something between a girlboss role model, a sister in suffering, and a fairy godmother to the girls she plucked out of obscurity and promised stardom. Tyra's career seemed to have instilled in her a solidarity speckled with vindictiveness, a desire to haze her wards, if only because she wanted them to come out stronger. When one contestant gained weight over the course of the season, she was forced to pose as an elephant in a shoot where models were assigned animals based on their personalities and as gluttony in one where each was assigned a deadly sin. The model who described her bulimic behaviors as a trick of her trade was never offered help; instead she was ridiculed for the size of certain limbs. If the show offered its contestants the same Faustian bargain every It Girl makes, that is, endure psychological and physical torture in front of the largest audience possible and the result will be, at least briefly, a consensus that you are beautiful and beloved, it didn't deliver. Most of its winners faded fast into obscurity. This is what the larger media machine that enthrones It Girls as fast as it dethrones them wants—to mystify the formula, and ensure that one It Girl can't coronate another. Importantly, this is not supposed to be a lineage. That could breed sorority where profitable cultural content runs on resentment, sisters turning on each other, the glint of a blade as it slices into a back.

The combination of *ANTM* and *Gossip Girl* gave the CW its highest ratings ever in 2008. The CW's rise from 2005 to the early 2010s coincided with the years Tumblr, LiveJournal, BlogSpot, and Xanga were growing exponentially in popularity, and the years when pro-anorexia websites and forums became easily accessible to anyone with a web browser. I and many other girls my age would watch these shows

religiously and then log on to discuss them with our sisters in It Girl scholarship, and we'd often end up trading devotional rituals around our bodies while we were at it.

Kim Kardashian is lying on a hotel bed in a cleavage-baring robe, eating salad with her hands. The camera zooms in as she picks up two pieces of lettuce and a strip of grilled chicken and places them between her glossy lips. Next, a slice of apple dripping with something viscous. Suddenly she's strutting down a hallway, salad in hand, and then we see her in a bubble bath, blowing soap off her fingers. The screen fades to white, and the Carl's Jr. logo appears in the center of the abyss. This advertisement, promoting a new Carl's Jr. salad, aired in 2009, and after it ran the CEO of Carl's Jr. gave an interview in which he said Kim was originally supposed to be filmed eating a burger, but "she wasn't good at" it. Asked whether Kim truly lacked the ability to eat a hamburger smoothly (sexily), a spokesperson for Kardashian claimed that she wanted to be seen "to eat something that tied in more with her brand." Kim has made her body, and engaging in a variety of body modification processes to perfect it, a central aspect of her brand since she first hit the scene. In 2009, she released a DVD workout series entitled Fit in Your Jeans by Friday, and since then she has served as a spokesperson or brand ambassador for waist trainers (contemporary corsets), the weight loss supplement company QuickTrim, laxative teas, and appetite-suppressant lollipops. The current centerpiece of her business empire is a line of spandex items called Skims Solutionwear, a name that implies the customer's natural form is a problem to be solved.

Over the past two decades, Kim rose from cultural laughingstock, revenge porn victim, and reality star to It Girl on the cover of *Vogue*, called the ultimate "modern muse" and the woman who "reinvented the socialite." Many Americans first met Kim on Paris Hilton's reality show, where she appeared as Paris's stylist and assistant. Like many an aspiring It Girl before her, she saw someone living in the first person beautiful, followed by cameras and shrieks, and set out to steal her spot. But where Paris was playing for laughs, maintaining a mirrored wall between her character and her self, Kim was playing to win, so she shattered the thin,

transparent remnants of the trick mirror left between her fiction and her reality and let us into her life. Kim replaced the paparazzi with her own selfie camera and a crew she hired, and then she created a video game in which all of us could live her life.

From her family's reality show to her unprecedented rate of posting on social media, Kim broke the existing rules of being an It Girl simply by following them too well, inhabiting her character so fully the mystery powering the machine disappeared and we were left with what we asked for, which is the last thing anyone wants to get. Over the course of her heavily documented rise to stardom, Kim's own cameras accidentally caught the levers of classism, racism, and misogyny that elevate an It Girl in action. The mystique behind the It Girl, it turns out, is simply an amalgamation of the aspects of American culture we prefer not to look at too closely.

Kim never shies away from her desire to be extraordinarily, unhealthily thin, nor from what it takes to sculpt that silhouette. In a story Kim posted to Instagram, one of her sisters says she looks anorexic, while another comments on how little she's been eating, and Kim responds with glee. *Oh my God, thank you!* Kim's willingness to let her public behind the curtain has also unveiled the disturbing racial dynamics underlying shifting It Girl aesthetics. Where Paris Hilton personified the waifish look associated with a lineage of extremely WASPy It Girls from Edie Sedgwick to Mischa, Kim remains incredibly thin while also earning monikers that refer to her world-famous ass and profiting by taking on aspects of a figure often associated with Black women.

In a 2014 cover photo shoot for *Paper,* Kim replicated a pose associated with a racist stereotype first forced upon a woman named Saartjie "Sarah" Baartman, referred to as the "Hottentot Venus." Forcibly exhibited for her supposedly unnaturally large butt in the early 1800s, Baartman was seen as an emblem of Black women's supposedly excessive sexuality. Kim's photo shoot replicated an image of Grace Jones, itself inspired by Baartman. The image quickly attracted a backlash as people pointed out the racist implications of a white woman receiving praise for an aesthetic Black women have long been demonized for. In the end, however, Kim's fame and fortune only grew in the following years, even as she and her sisters faced appropriation scandal after

appropriation scandal. From wearing cornrows and calling them box braids to their ever-fluctuating skin tones to their embrace and then rejection of the Brazilian butt lift look, the Kardashians have repeatedly, boldly, and basically unapologetically treated Black female aesthetics as trends to be adopted and rejected. Throughout it all, the Kardashians have put a premium on thinness, giving interview after interview on their diet and exercise regimens, publishing diet books, and partnering with weight loss companies. The minor waves of backlash often distract from the appalling implications of Kim's enduring It Girl status in the face of all this. Instead of draping the "It" factor in mystery, Kim makes it clear what it takes to be on top: whiteness, thinness, and the ability to pay huge amounts of money to change your body.

What outrages America far more than Kim's overt appropriation and subsequent casting off of Black aesthetics is, apparently, Kim comparing herself to an even whiter, smaller It Girl. When photos of Kim Kardashian wearing Marilyn Monroe's famed "naked dress" at the Met Gala hit the internet, both regular people and serious news outlets immediately began publishing alternating expressions of outrage and awe. The next day, Kim told an interviewer from *Vogue* that she was inspired to wear the dress after asking herself *what's the most American thing you can think of?* She concluded that the answer was clearly a slinky number simulating nudity, worn with a wink by an iconic sex symbol. When she tried the dress on for the first time she was shocked and appalled to the point of tears to find it didn't fit, so she embarked on an extreme diet and strict exercise regimen to lose a significant portion of her body weight in mere weeks, as she told multiple magazines and documented on her show. What's more American than a girl brought to the brink of despair by her own body, who starves and successfully shrinks herself, fits into the dress, and then pridefully regales women's magazines with the whole sordid story?

Kim might appear far more autonomous than It Girls past, the protagonist and producer of a show about her life and the CEO of her company, but she still functions as a mouthpiece for the same insidious messages about womanhood that previous It Girls' public images conveyed and that arguably destroyed many of them. It Girls attract feminist derision and reclamation in equal measure, begging the ques-

tion of why we care so much, and why we still seem to believe there's room for only one girl on the pedestal, one who can't be too heavy. There is a constant stream of takes on Kim as, alternately, a woman misogynistically mistreated by the press, a fake feminist complicit in the oppression of other women, a girlboss breaking glass ceilings, and a fountainhead of body dysmorphia and eating disorders for vulnerable youth. Similarly, opinions on Marilyn's feminist legacy run the gamut from Gloria Steinem's contention that feminism could have saved her life to Jacqueline Rose's conception of her as a feminist icon akin to Rosa Luxemburg. A 2008 *New York* cover featuring Lindsay Lohan wearing nothing but a sheet, her hair in a Marilyn wig, was accompanied by the headline "Lindsay Lohan Re-creates Marilyn Monroe's Legendary Last (Nude) Photo Shoot," highlighting the lasting endurance of Marilyn's body in the public's imagination, not to mention the fact that the same small form remains the one valorized in our media half a century later.

In 2020, *Dazed* announced that "Instagram Killed the It Girl" by ushering in an era where an It Girl can turn herself into an object for sale, rather than let the rest of us do it. *E!* published "Your It Girl Starter Pack for 2022": twenty-three products that are apparently must-haves for wannabe It Girls. Kim's rise doesn't herald the death of the It Girl but instead marks her logical apotheosis. Today she displays a false autonomy, choosing to become an amalgamation of products, an artificial construction embracing her plasticity, her crown bought for her by her public via their views, likes, and purchasing power. Whether the media is obsessing over the It Girl's transformation, replacement, or death, it's still obsessing over her, an activity that only, in the end, serves to sell us ways to become her that will inevitably fail, and lead us to the next product promising the same thing.

The phrase "It Girl" objectifies the woman with the very prose formation that purports to elevate her; by becoming an icon, she stops being a person and too often finds herself ending up a mannequin. The It Girl is stuck in a window-display-cum-fishbowl, her complexity calcifying. We've always underestimated the girls we put on pedestals. Marilyn's stage debut received shocked rave reviews, as though her public hadn't believed she could actually act, and to this day images of Marilyn reading literary texts periodically circulate online, as though we

still can't believe she could read. Similarly, Kim's pivot first to business and then to the law were each greeted with scorn and disbelief. None of this is shocking; at its core a pedestal is a place for an object and in our era, a product. The It Girl has always been a product herself, and she's always been selling things, usually products that promise to transform those of us who don't look like her into a closer approximation of her. Usually the product won't work, because the girl's "beauty" was built by a combination of her class position, race, and a diet regimen that could also be construed as a form of self-harm. When asked whether she ever worries about promoting a potentially toxic beauty standard, Kim told an interviewer, who Kim also recommended look into Botox, *If I'm doing it, it's attainable.* She then described both a recent extreme diet and the necessity of a nine-step skincare routine. When I was taking notes for this essay, I kept scrawling down "self-preservation" when I meant "self-presentation." In the first person beautiful, they might mean the same thing.

The only story likely to get more news coverage than an It Girl's rise is her fall, and this is integral to the lesson young girls internalize, the moral of the story. The problem with a pinnacle is that there's nowhere to go but down. If power is a platform, It Girls appear to be balancing on it, but balancing on a glass ceiling is precarious: move your heel wrong and it might crack. It's a lonely throne—that pose requires painful contortions, and it's a long way down. She is the moment, and every moment ends. When you see it approaching, after all that pain and performance, wouldn't you start shaking and screaming, maybe even get a little hysterical? After that it all happens fast, she's sent to treatment or the psych ward. In the meantime, we've been rapt and getting riled up online, as terrified of never living up to her as we are of becoming her.

Too Far

Glowing Girls and Virtuous Illness

A girl chops vegetables, places them in color-coordinated triangles atop a sludge of semi-liquified chia seeds, and then stands back to admire her work. She takes a photo of her creation and hits Post, #cleaneating. Clicking into the tag, she checks out her competition-cum-community. In the next square, more bowls, sixteen arranged along a grid, each holding its own piece of produce, below the heading "Nutrient Dense Low Calorie Foods." Superimposed on a dusty-rose background are the words "Healthy women glow the prettiest." Italic type reads: "Follow your gut," above a magenta cartoon of a colon. Keep scrolling and the bowls, girls, guts, plants, and probiotics keep coming. At the time of this writing, the hashtag #cleaneating on Instagram has 48,861,957 posts attached to it. A white girl is eating carrots. Manicured hands are washing lettuce in a farm-style sink. Two bottles of "vegan protein" supplements are on sale for $34. Matcha popsicles require only three ingredients, none of which is sugar. Low histamine food chart part 1. Before and after pictures of a woman who has been paleo-vegan for two months. Popular plant-based diets for weight loss. A bachelorette party in front of a neon sign screaming DETOX, wearing silk robes and holding juices. A blonde baring blindingly white teeth, holding a chalkboard explaining what macros are.

Search the same hashtag on TikTok, where it has over 500 million views, and you will be served a similar scroll of salads, smoothies, and tanned, toned white girls and women offering to enlighten you, promising to share their hard-earned wisdom on health, nutrition, and weight

loss, which is sometimes positioned as a thrilling collateral benefit to "health" and other times situated as the explicit goal. Foods I Eat and Foods I AVOID as a Model and Wellness Addict. GUT HEALTHY SWAPS PART 5. Watch My Body & Skin Transform after Taking Care of My Gut Health. Try this hack for hot girl stomach issues.

Scroll long enough and you'll come across more than a few frustrated nutritionists, outraged eating disorder survivors, and girls alternately telling terrifying stories and making jokes about the eating disorder they developed during their own forays into #cleaneating. A dietitian stitches her video with someone's "Detox Day 5" update, points out that the original poster never defines what a toxin is, and adds that she does not seem to be consuming adequate calories to sustain a child, a note of worry in her voice. A girl in a baggy T-shirt sipping a latte describes her descent into a restrictive eating disorder after attempting to copy her favorite wellness blogger's daily Instagrammed diet plan. Another girl sings along to the Fray, crooning, "Where did I go wrong?" as the words *when it started as you wanting to be healthier and now you're scared of eating a dorito* appear on screen. A slideshow of salads, workout schedules, selfies of a girl crying in the dark, macro calculators, the MyFitnessPal app icon, smiling skinny girls in athleisure, and then the words *the one eating disorder that is straight up ignored.*

In the mid-1990s an alternative medicine practitioner noticed his patients taking the "healthy diet" he prescribed "too far." One such patient, a young woman, came into his office asking what foods she should eliminate from her diet in pursuit of peak health. When she kept returning with the same question no matter how many foods she cut out, he recognized himself in her. Recalling his own Sisyphean journey toward "dietary perfection," which had involved periods of raw food veganism and macrobiotic obsession, he realized that what his client needed was to relax her rigid rules, but he also realized she wouldn't listen to that advice, convinced that her health consciousness was a moral virtue, something to be proud of. Luckily, Dr. Steven Bratman had a "therapeutic trick" up his sleeve: he would "stand her virtue on its head by calling it a disease." Despite its derivation from anorexia nervosa,

"orthorexia nervosa" was not meant to be an actual clinical diagnosis, just a "mental signpost to indicate a limit, a boundary not to go beyond in search of a healthy diet." Obviously, such a search is, to Bratman, inherently noble, and a limit in one direction implies a limit in the other. If we can manage to live in the valley between ill health and too much health, we must always be on the lookout for danger zones, ever-vigilant consumers.

"Orthorexia nervosa" translates to an obsession with eating "right." From its first use, as a doctor's manipulative attempt to "loosen the lifestyle corset" his patients were lacing up too tightly, orthorexia has been a cunning, slippery label caught between diagnosis and description, aspiration and admonition. Intended to function simultaneously as a hazard sign, a joke, and a fence, the term was intended to induce Bratman's patients to notice the harm their behaviors could wreak when taken to extremes, not inspire them to abandon those behaviors entirely. He wanted the corset loosened before it started cutting off airflow, but he didn't want bodies unbound. He realized that an obsession with cutting out "unhealthy" foods was leading some of his patients to cut out almost all foods; a subset of his patients developed anorexia symptoms. But Bratman takes pains to emphasize that orthorexia is rooted in "distinctly different motivations" than anorexia. In his definition, orthorexia is driven by a fear of impurity, not a fear of fat; the orthorexic yearns for health rather than beauty. This renders orthorexia a more virtuous, less vain disease, one that can be cured by a simple scaling back of behaviors, rather than their complete renunciation. Eating disorders are often reported on as cultural dictates "taken too far," illnesses of girls who take things too seriously, who can't relax or take a joke. But where anorexics are maligned for taking diet culture too far, orthorexics are thought to devote themselves too deeply to an otherwise valiant pursuit of health.

As such, orthorexics are accorded a strange respect from the medical establishment, which is reluctant to cast orthorexic behaviors as disturbed because they seem like overly impassioned responses to medicine's own moral messaging. But building hard boundaries between the impulses motivating orthorexia and those driving other eating disorders

launders a sickening beauty standard's reputation by aiming to cleave it from the health ideal it is inextricably bound to. Wellness influencers seed the soil of social media with diets while claiming they aren't promoting a beauty standard, just educating their followers on the foods that will detoxify, energize, and optimize their bodies. But can we sunder health and aesthetics? Do we really believe that wellness is about feeling well rather than looking it?

The way the grand majority of wellness influencers look—thin, white, lightly muscular—can't be separated from their messaging on what it means to be well, especially when their content often presents their appearances as evidence of health, of the efficacy of the purification processes they promote. Many of these influencers' narratives employ religiously infused rhetoric implying transfiguration, describing an arduous conversion experience that takes a tired, flabby, acne-ridden girl scrolling Instagram in bed and resurrects her as a gleaming, grinning, planking supergirl, the one whose ponytail bounces and shines in the video we are watching now. Scrolling through a sea of white smiles and colorful produce, long, tan limbs in motion and links to purchase, I see a beauty standard masquerading as a health standard, aesthetics dressed up as morals, and money seeping out of Instagram squares.

The Blonde Vegan was born in the wake of a juice cleanse, a journey that included the tearful realization that non-vegan whey protein had made its way into a supposedly vegan breakfast smoothie. Jordan Younger, then a twenty-two-year-old recent convert to veganism, started the Instagram account @theblondevegan in June 2013 and created an associated blog soon after. Jordan would become one of the first wellness influencers to gain a mainstream following in the hundreds of thousands. She began her journey early in the decade NBC would later call the "decade of health and wellness misinformation," five years after Gwyneth Paltrow founded Goop and five years before it would be valued at over $250 million. Both of Jordan's platforms focused on painstakingly curated, cooked, plated, styled, and photographed tableaus of vegan meals, a substantial portion of which were made up of nonsolid

foods like smoothies, oatmeal, parfaits, and juices, accompanied by recipes and testimonials on their purifying, detoxifying, brightening, and all-around health-inducing effects.

Behind the scenes, as Jordan relates in her memoir of veganism, orthorexia, and recovery, *Breaking Vegan* (2015), she was agonizing about eating anything, even the limited range of foods she Instagrammed, and she was also in a lot of physical pain. Jordan had originally turned to vegetarianism as a teenager in the hopes of curing her amorphous stomach issues, an array of problems including abdominal pain, bloating, diarrhea, and constipation that is often diagnosed as irritable bowel syndrome (IBS). Jordan, like tens of millions of Americans, suffers from the diagnosis doctors turn to when no physiological explanation for a patient's digestive distress presents itself. Estimates of prevalence vary, but at the high end count 45 million sufferers in the United States alone, with women almost twice as likely to be diagnosed with IBS as men. Hypotheses about etiology vary too, encompassing post-infection syndromes, stress, bacterial disturbances in the gut, and psychological origins. There is currently no cure and few treatments. Doctors often recommend mild laxatives along with efforts to relieve stress. Encouraged to unclench, see a therapist, or take psychiatric medication, many dissatisfied patients turn to the internet for answers, certain that food is causing their digestive issues, and where they find a thriving industry of gut influencers touting a variety of restrictive diets as the solution to stomach woes.

At age twenty-two, before becoming vegan, Jordan lost a significant amount of weight during what she called a *breakup diet* that involved *hardly eating anything,* which made her feel *powerful and in control* and resulted in a *calm and content stomach* free of the daily pain she was used to. The extreme restriction that both thinned her frame and seemingly solved her stomach issues led Jordan to wonder whether the foods she regularly ate were physically hurting her. To test the theory, she embarked on a plant-based cleanse, the results of which she describes as *utter glory.* Her weight dropped, her skin glowed, a friend told her she'd never seen her so small, and after years of feeling tortured by her digestive system, Jordan finally felt that her *outer frame reflected the mind-body connection I was developing with my plant-based diet.* The physical

reflection of mind-body equilibrium is central to the spirituality-draped conflation of health and beauty, thinness and purity, inherent in both the wellness-obsessed and orthorexic mindsets, if the two can be separated. Armed with compliments and a calm stomach, Jordan began studying, spending *countless hours* at the altar of vegan wellness influencers online.

In her own recollection, veganism gave Jordan access to the *"benefits" of more or less starving* herself (emphasis hers). She cut out most major food groups. When Jordan started her blog, she'd been both vegan and devoted to periodic fasts and liquid-only cleanses for a year, and she deeply *believed that plant-based veganism was the most surefire way to ward off future disease and weight gain.* She regaled her followers with tales of increased energy post-cleanse, mid-cleanse spiritual highs, inflammation-reducing smoothies, and gut-healing snacks. She amassed a thousand views in the first hours of her blog's existence and thousands of Instagram followers soon after.

While Jordan published breathless endorsements of cleanse company after cleanse company and wrote about the elimination of food group after food group, the painful stomach issues she prided herself on solving with her diet returned, worse than they'd ever been. She was exhausted all the time and panicked by social plans that might involve foods she feared. She writes about feeling *on top of the world* for losing specific numbers of pounds in a *superhuman amount of time* in the same breath as she describes feeling *utterly fatigued.* At her birthday dinner, one bite of non-vegan cake *so small a mouse would hardly be able to scavenge it off the ground* left Jordan feeling subhuman, like a sinner, someone who had broken the rules of *healthy living . . . a fat cow.*

Over the following year, as Jordan amassed ever more followers and posted vegan food she wasn't eating, the amount and type of food Jordan consumed shrunk and her digestive, energetic, and emotional problems grew. Her skin took on an orange cast, she stopped getting her period, her hair fell out. One day a friend (another wellness Instagrammer, original handle @skinnybytara, later changed to @thewholetara, if the health-as-thinness paradigm undergirding the wellness industry wasn't obvious yet) took Jordan to dinner. Over non-vegan food, Tara opened up about her own eating disorder, and Jordan had an epiphany. She had an eating disorder too, and she might even have had one for

longer than she'd been a vegan. She remembered swearing off junk food at age eleven and receiving early praise for weight loss.

Jordan traces her stomach issues to her earliest memories, but she also writes that she began connecting eating to external approval before she can remember. She describes a mindset I remember from my own disordered eating as a child. Whether Jordan's IBS or her disordered eating came first is unclear. But for many people, IBS they attempt to treat with veganism was in fact triggered by previous episodes of disordered eating they didn't recognize as such, a sequence that illustrates how prevalent supposedly "subclinical" disordered eating is.

A 2005 study by Catherine Boyd in the *Journal of Gastroenterology* found that 98 percent of patients in an inpatient eating disorder clinic suffered from gastrointestinal issues, 52 percent of them with diagnosed IBS. In another study on IBS and eating disorders, 64 percent of people with a history of eating disorders also suffered from IBS, and for 87 percent of those patients, the stomach problems started after the eating disorder. This is not surprising; food restriction, forced vomiting, bingeing, and laxative abuse all wreak havoc on the digestive system. They have been shown to cause gastrointestinal symptoms from constipation to esophageal rupture, water retention, seizure-inducing electrolyte imbalance, bowel perforation that can cause sepsis, and more.

Soon after Jordan's revelatory conversation with her friend, she sought medical and therapeutic help. In 2014 she announced that the Blonde Vegan was no longer vegan. Jordan wrote about suffering from orthorexia on all her social platforms, and the following year she released *Breaking Vegan,* which featured a preface by Bratman, the doctor who'd defined the disorder. There he describes the evolution of his own understanding of orthorexia since coining the term, an understanding that involved the "shocking" realization that something he had invented as a "tongue-in-cheek" moniker, meant to inspire a rueful chuckle and a reevaluation of a habit, also existed as a disease, one that was killing people and had almost killed the girl whose book he was introducing. Statistics on the prevalence of orthorexia vary widely because its diagnostic criteria are still a source of controversy and the condition is not included in the *DSM.* Its mortality rate is unknown. I don't have numbers to offer or convince you with, but I do have stories

from shrinking, struggling girls, and friends who fainted on cleanses, and people who contracted kidney issues from supplements and liver disease from detoxes, and gut-health procedures done in spas that sent patients to emergency rooms. I see Tumblr posts about dead friends and Instagram eulogies for girls who were never officially diagnosed, and while I'm not convinced a word could have saved them, the diagnosis they identified with is what they left us, so I'm trying to decipher what they wrote in code.

In the wake of Jordan's public adoption of the orthorexia label, media coverage of the disease skyrocketed. Few articles had appeared in the decade and a half since Bratman first defined orthorexia, but now hundreds of stories, news segments, and social media posts arrived, fretting over the newest eating disorder threatening the nation's girls. Specifically, the nation's wealthy white girls, the stereotypically imagined eating disorder patient who's long been the media's favorite star of a moral panic story. Jordan's class and racial position as a wealthy white woman played into the media fervor, which emphasized the expensive habits from juicing to in-spa cleanses that often accompany orthorexia. Because wealthy white women were far more likely to have access to the costly trappings of orthorexia, as well as expensive psychiatric care from doctors familiar with the novel illness, the majority of early diagnoses occurred in their demographic.

According to a study published in *Medical Humanities,* use of the hashtag #orthorexia more than doubled in the year following Jordan's announcement. The study's authors note that the media coverage accorded to a diagnosis not in the *DSM* is extraordinary. That coverage emphasizes its tenuousness as a diagnosis, as well as its basis in a morally laudable endeavor. A cursory Google search on the syndrome brings up article after article describing people's "innocent" descents into the orthorexic vortex. *Vogue* investigated the eating disorder that "often starts innocently with the desire to eat 'clean,'" while *Women's Health* called it "when healthy eating goes too far." An academic journal credulously published an article attempting to pry apart "Orthorexia Nervosa and Healthy Orthorexia." Today the diagnosis is being considered for

addition to the *DSM-6,* while debate swirls around whether orthorexia is a "unique eating disorder, a variant of existing eating disorders, a coping strategy of patients with eating disorders, or just a lifestyle," in the words of *Nutrients* journal.

Recently I listened to Jordan and another self-identified recovering orthorexic influencer discuss their eating disorders and digestive issues on a podcast. Both described long-term struggles with IBS, and their shock upon realizing that so many orthorexics suffer from the same stomach issues. They talked about learning that the extremely restrictive "health" regimens they'd embarked upon on the advice of other wellness influencers likely worsened their IBS symptoms, as did the emotional distress and anxiety incited by their eating disorders. They both described using IBS to hide restrictive tendencies, even during their recoveries. Veganism, detoxes, juice cleanses, fasts, and avoiding supposedly "inflammatory" foods are so normalized, they both said, that each of them could easily decline food for weight loss purposes while convincing those around them they were just treating their IBS, *just taking care of myself.* As Natasha Boyd has written, disordered habits of food restriction practiced under the guise of IBS are often "seen as an act of self-care, and not disordered eating. Instead of choosing not to eat, people with IBS *just can't.*"

Clearly, an obsession with gut health can mask a desire to shrink the gut, but wellness culture isn't the only culprit here; the collusion between digestive health, morality plays, and the slender ideal has been a profitable pursuit for centuries. Rather than a stand-alone disease, orthorexia might more accurately name our diseased conception of digestive health and nutrition, one long predicated on thinness, whiteness, and the clash between scientific and religious conceptions of the body.

In the middle of the nineteenth century, a woman saw God and he told her how to eat. Ellen Gould White, a founding member of the Seventh-day Adventist Church, had a vision of Adam and Eve frolicking in Eden, their bodies "perfect in symmetry and beauty . . . in perfect health." When she asked what had gone so wrong, leaving her era's Christians short, stout, and beset by digestive issues, God told her "it

was the disobedience of our first parents, leading to intemperate desires and violation of the laws of health."

We may have been locked out of the garden, but there was a way to get an Eden-ready body back: a diet. Moral Christians must abandon meat, leavened bread, and salt in favor of a diet largely consisting of fruits and vegetables. White shared this wisdom with her fellow parishioners, describing her own diet: two meals a day of fruits, vegetables, and unleavened bread. She admitted to feeling faint and "suffer[ing] keen hunger," but it was worth it; her "health has never been better."

The first half of the century had seen an epidemic of digestive complaints; "chronic constipation," believed to cause everything from pain to acne, migraines, muscular weakness, and "nervousness." The prevailing erroneous explanation was "autointoxication," the belief that food not excreted soon after consumption rotted in the gut, leaked toxins into the bloodstream, and led to all kinds of physical symptoms, along with psychiatric problems. Dr. William Lane, author of *The Operative Treatment of Chronic Constipation*—a condition he posited disproportionately afflicted women—advocated a strict diet intended to incite three bowel movements a day. Prominent doctors like John Harvey Kellogg and Sylvester Graham campaigned against autointoxication with fervor, while medical writers penned books with titles like *The Lazy Colon* and *Le colon homicide*. A 1928 tome warned that if you ate the wrong, ostensibly indigestible foods, they would end up "fermenting, decomposing, putrefying, filling the body with poisonous substances," rendering the bloodstream "sewer-like." Meanwhile, Kellogg contended that "there are few up-to-date medical men who do not recognize the close relation between intestinal stasis and a long list of chronic disorders."

Kellogg was one of White's followers, a devout member of the Seventh-day Adventists. Today, he is largely remembered for his cereals, which were designed to be flavorless, to avoid inciting the hunger White saw as sinful. He hoped to solve the "maladies of the modern stomach" as head of the Battle Creek Sanitarium, which combined elements of a hotel, spa, hospital, and college into a "Health University" focusing on diet and digestion. Most chronic diseases, he claimed, could be traced to the "poison-forming toxins" apparently embedded in foods like "carbs, starch, and sugar." Kellogg prescribed a diet of "antitoxic,"

"laxative foods" intended to purify the gut, alongside a regimen of enemas for inducing bowel movements.

While the proto-detox-spa drew wealthy patrons by the thousands, the rest of the country was left to experiment on their own, with diet books and laxatives sold by patent medicines peddlers. Advertisements for a popular brand, Bile Beans, featured slender blonde women on beachside strolls alongside promises that a few beans a day would keep women "healthy and slim." That ad rendered explicit what was woven into the fabric of all the morally inflected fearmongering about autointoxication: a notion of feminine beauty tied inextricably to thinness, and a conflation of a woman's health with her outward appearance that percolates to this day.

Kellogg understood digestive distress as an especially dire issue for women, writing a *Ladies' Guide in Health and Disease* in the hopes of convincing women that their "vicious habits" of diet (eating meat and candy, among other misdeeds) were dangerous. An illustrative chapter cautioned against the "harmful effects of candies" and the "pernicious results of eating between meals." Instead, young women were to avoid meat, flour, and bread as they were "fattening, not strengthening." The existence of an entire chapter devoted to "Personal Beauty" in a text claiming to be invested in "Health and Diseases" highlights the slippage between beauty and health, and the idea that both resulted from digestive purity: "nothing contributes so much to the maintenance of a beautiful complexion, a sparkling eye, and grace of form . . . as an active liver and sound digestion," maintained, of course, through "scrupulous attention to diet."

Kellogg wasn't the only one deeply nervous about Western girls' nervous stomachs. Marion Harland's book *Eve's Daughters* calls for inculcating girls with "a stomachic conscience," taking a strictly disciplinarian tone, insisting that girls' diets are moral duties with repercussions for the nation. Sabrina Strings has expertly explored the racism undergirding the thinness-health-cleanliness axis in her book *Fearing the Black Body: The Racial Origins of Fat Phobia,* searingly indicting Victorian women's magazines for their embrace of "an ideal rooted in the multiple and colliding factors of Protestant asceticism, scientific racism, and the proto-science of health and beauty." Kellogg's and Harland's

promulgation of a beauty standard that functions as outward proof of health plays into this dynamic, demanding white women maintain certain physical forms as markers of their place in the racial hierarchy, or risk the future "degeneration" of their race. Kellogg wrings his hands time and again over the "large class of maladies" afflicting "especially women of the more civilized nations" due to their "neglect of laws" of diet in favor of the fleeting pleasures of taste, paralleling White's vision, which held that giving in to "intemperate desires" led to "degeneracy."

Without effort, attention, and discipline, white women would not be able to sculpt themselves into the slender bodies the medical and religious authorities interpreted as proof of health, which distinguished them from the "primitive races." Both authors write in explicitly racialized, moral, and religious terms. Kellogg dramatically announces that "the only hope for the race is in the future of its girls. . . . Woman's responsibility to the race is vast and incomprehensible," so when the dietary "tempter comes to you, count the cost to yourself and to the race before you yield yourself to sinful indulgence." Harland also writes directly to the woman on the brink of picking up a "confection": "You have no more right to eat or drink what you know will disagree with your digestion than you have to drop a furtive pinch of arsenic . . . into your school-fellow's cup of tea," before comparing the duty to eat "wholesomely" to the duty to "pray." One advertisement for Kellogg's sanitarium invites potential patients to visit for "race betterment through 'biologic living.'" Medical men, religious authorities, domesticity experts, and women's magazines devoted themselves to a "health" industry that eerily presaged today's wellness era. Old notions of cleanliness and purity obscure racialized beauty standards, disciplining and surveilling women's consumption under the guise of concern for our health.

As the nineteenth century drew to a close, a statuesque blonde woman sold out amphitheaters across the country, performing a one-woman show that combined vaudeville, auctioneering, modeling, and lecturing on the topic of female health and beauty: promising to teach her "sisters in misery" how to copy her body. Across several hours and multiple outfit changes, she preached her "Religion of Beauty," recounting tales

of history's most beautiful women, a group that included Helen of Troy, the Roman goddess Diana, and, herself, Madame Yale. The *Boston Herald* praised her "offer of Health and Beauty" in a country where "every woman wants to be well and well-looking," notably not mentioning which comes first.

After the show, women took home booklets entitled *Madame Yale's Physical and Beauty Culture*, which combined memoir with lofty philosophizing about health and aesthetics, dietary suggestions, exercise regimens, and a long list of products she promised would render women both healthy and beautiful, one predicated on the other. Her Natural Beautifiers brought "results in this matter-of-fact, investigating age," she wrote, before claiming that "beauty is a woman's birthright, her inheritance; as sacred as her honor or her life, and it is hers to cultivate and perfect, not to cast aside like the tinseled trappings of a gay bal masque." She explicitly severs the superficial values of pleasure and vanity associated with a party costume from a moralized form of beauty that is part and parcel of a project of racial uplift, as evidenced by her call to "salute the thoroughbred" beauty who maintains perfect health and has her beauty to show for it.

Like Kellogg and his ilk, Yale located beauty's nemesis in the clogged gut, where proof of sinful consumption festered, causing pain and weight gain. Women must be vigilant, for they have "a greater tendency toward accumulation of fatty tissue" than men, and "the least excess of this adipose tissue" is "fatal to beauty." A spate of her products targeted women whose digestion was "deranged," including an "intestinal lubricant" and "laxative-cathartic pills" for "cleansing the human waste pipes." Yale insisted that "corpulence is repellent, because it obliterates all delicacy." The repeat appearance of "delicacy" across the work of writers like Yale, Kellogg, and Harland and the ease with which Western women are described as contracting digestive diseases serve a dual purpose, both differentiating the delicate white Western woman from her supposedly sturdier counterpart of color, and disciplining her, teaching her that her suffering is self-inflicted and a threat to her health and race. Only beauty can prove she is doing her moral, religious, and national duty, protecting the balance of her delicate system—a paradigm that both "degrade[s] Black women and discipline[s] white women," as

Strings has written. These more subtle expressions of racist logic are reinforced by a spate of bleaching products advertised at the end of Yale's catalog, from a "Lily Skin Whitener" to a "Complexion Bleach."

Advertisements for Yale's products conflate beauty, health, and having a moral compass in a single metaphor, Yale's "Trinity of Beauty: Physical, Mental, and Spiritual." This causal relationship between health and beauty permeates today's wellness industry as much as the nineteenth century's. True, wellness is about feeling better. But it is also about looking better, and the almost religious fervor with which women want to believe that the two are twinned. Taught that the two worst things for a woman to be are ugly and vain, is it surprising that wellness has emerged at their nexus in disguise? Because the pursuit of health is morally unassailable in a way that the single-minded pursuit of beauty is not, wellness offers us a trapdoor, just as the digestive health craze of the late 1800s allowed women to pursue thinness as a moral duty.

Today wellness entrepreneurs like Gwyneth Paltrow and Lauren Bosworth (both, like Yale, blonde white women) sell supplement sets with names like the "New You Kit," which promise to support your "gut, mind, feminine health, skincare and metabolism." They replace the language of religious duty with language about self-care, while retaining the rhetoric of discipline, but this time you are ostensibly serving yourself, not your country or your race.

In a profile of Gwyneth, Taffy Brodesser-Akner writes that she "addressed questions that the modern woman couldn't seem to find answers to: Why am I so unhappy? Why am I so tired? Why am I so fat?" Our emotions are placed in a chain with our physicality, and all ills can be traced back to our size. Gwyneth is qualified to tell you why you are so tired, so unhappy, and so fat because she is none of these things. She is *People*'s Most Beautiful Woman. As Brodesser-Akner points out, her name appears "in the same paragraph as the word 'luminous' 227 times when searching it in a LexisNexis database." Of all the ways to describe Gwyneth's beauty, "luminosity" gets right to the core of the appeal she shares with Yale. These are women who emit light. Their beauty is rooted in a fetishized notion of purity, a sought-after natural illumination that connotes not just beauty but good health and even good morals. "So this is why people hate her?" Brodesser-Akner

wonders. "Because I have discipline?" Gwyneth asks. Women are ugly because "women are lazy," Yale announces.

Gwyneth and Yale strike unstable poses of solidarity and judgment, telling their fellow women they too have been there. They just pulled themselves up by their face creams and macrobiotic diets, arduous heroine's journeys replicated by bloggers like the Blonde Vegan. Strings, drawing on Ehrenreich and English, outlines the way doctors like Kellogg taught women, "especially elite white women," the necessity of disciplining their appetites to forge the thin bodies "that first religion, then medicine mandated." While figures like Kellogg, Harland, and Yale combined the moral imperatives of Christianity with the pseudoscientific demands of nineteenth-century medicine, modern wellness figures cloak their disciplinarian, moralizing ethos in a capitalist, every-girlboss-for-herself ethic of self-care with an anti-technological bent. Advertising to a largely unreligious audience, figures like Gwyneth and Jordan replace the language of religious purity with an emphasis on the modern food system's many impurities, from pesticides to preservatives, while retaining the religiously infused rhetoric of good and bad foods, sinful and virtuous consumption. At their core both Gwyneth's and Yale's empires were built on the drives capitalism instills in its daughters: a heady mix of self-hatred and self-improvement.

I once got a summer job at one of Gwyneth's boutiques and tried to become a Goop girl: glowy, grinning, breathily encouraging customers to purchase a box of juices that would replace their meals for a week, or the skin cream invented by a doctor who once worked on a burn unit. My manager drank Monster energy drinks she hid in the storeroom and never ate lunch, and then she raved to customers about the ashwagandha supplements we sold, the way they sped up her metabolism and spurred her out of bed in the morning. I was instructed to wear makeup that made it look like I wasn't wearing makeup. Goop girls were naturally beautiful, blemish-free but not noticeably made up. We were meant to be modern-day iterations of Yale's and Kellogg's ladies, girls whose "beautiful complexion" and "grace of form" were the fruits of our assiduous dietary labors, as "without these, it is useless to depend upon cosmetics." To be a natural beauty you must be born into a beauty standard, and all the store employees were white. Gwyneth, on the magazines

we placed around the store, smiled softly into the middle distance. Her customer-acolytes turned the pages and paid us with a prayer in their eyes.

Near the end of *Breaking Vegan,* Jordan eats chocolate cake, not to mention meat and fish. She confidently proclaims that her *veganism triggered a serious eating disorder* she is now recovering from, declares that *being the healthiest version of myself does not mean I am eating the cleanest diet,* and renames her blog *The Balanced Blonde,* reorienting it toward a "balanced" version of wellness, rather than a restrictive one. At first glance, this might seem a radical reorientation, but an obsession with balance implies that there are scales and measurements, a formula to fit yourself into. Even in recovery, she relies on the rhetoric and logic of orthorexia, a reflection not of her own failures but of the Sisyphean battle that is recovering from orthorexia in an orthorexic society, recovering from any eating disorder in a society with a disordered relationship to eating. The wellness industry at large is functioning along an orthorexic logic, one that understands individuals as solo actors responsible for their bodies, that sees digestive purity as a highway to health and a thin body as proof that you've made it there.

Because orthorexia is rooted in the same values our white Protestant capitalist culture has valorized for centuries—the pursuit of an imagined morally infused purity at any cost, and a single, equally imaginary version of outwardly legible health—it retains a sheen of virtue other eating disorders don't. Clinicians have gone on the record about the difficulty of treating orthorexia, given this tension. One eating disorder treatment provider, quoted in *Qualitative Health Research,* called the condition "murder to treat" in light of the "high validation of some manifestations of [orthorexia nervosa] in society (e.g., healthy eating, weight loss)."

This has created a disordered eating ecosystem in which orthorexia is positioned as the "recovery eating disorder," because it is less stigmatized, considered less dangerous, and relatively easy to disguise as an interest in health. One study found that symptoms of orthorexia were commonly present in anorexic and bulimic patients, and that they

"increase after treatment" for those disorders. The study itself plays into this dynamic, claiming that "orthorexia nervosa seems associated with the clinical improvement of anorexia nervosa and bulimia nervosa and the migration towards less severe forms of eating disorders." This construction explicitly casts orthorexia as a marker of improved health after another eating disorder, reinforcing its healthy connotations and downplaying its dangers. The subtext is that anorexics and bulimics need help; orthorexics just need to relax.

One clinician described patients embracing orthorexia as their "escape route" out of anorexia, explaining that people will claim, "I'm totally cured but I just don't eat" major food groups like "dairy, bread, gluten." Social media confirms this pattern, as well as the danger it poses. Tweets about orthorexia include posts like *ana→recovery→BED→orthorexia→ ana.* In response to a Twitter user asking the internet, *is it possible to recover without gaining weight??* a person replied, *just develop orthorexia,* a tongue-in-cheek response that users took so seriously the poster had to clarify that they were joking. Posts like *I'm so tired of seeing recovery pages only post people who have recovered from anorexia now being orthorexic,* and *a lot of "recovered" eating disorder patients don't recover but develop orthorexia,* are numerous. To put it another way, as one user did: *recovery from a restrictive eating disorder does not mean: going to the gym, doing power yoga, going on hot girl walks, drinking aesthetic matchas, eating nourish bowls and smoothie bowls all day.*

In 2017, three years after the publication of *Breaking Vegan* and one year after returning to a diet of complete veganism, Jordan wrote a blog post explaining her recent embrace of many behaviors she had called symptoms in another era. Since 2018, Jordan has posted repeatedly about cleanses, detoxes, and cutting out all sugars, oils, and salts from her diet, publishing an SOS (sugar-oil-salt) free diet, as well as a Handy Food Combining Chart (basically a macronutrient counter), a purchasable food elimination guide, and a 101 on Coffee Enemas. She has done three-day water fasts and employed a nutritionist to monitor her biometrics and ensure she is *burning fat for fuel rather than glucose,* even as she claims none of this is inspired by a desire to lose weight. While admitting that a water-only fast *could be triggering to those in recovery from eating disorders,* she endorses it.

At its core, she writes, her blog's identity hasn't shifted; it's been about *WELLNESS & health! since it all started*. She now rejects the idea of an *obsession with clean eating* as a slippery slope. She looks back at the version of herself who saw clean eating as an eating disorder with *immense sadness*, and has re-embraced her *healthy & pure vegan way of life*. She finds herself distraught when she sees people on social media *asking how they can heal from clean eating*. Reading that, she thinks, *Nooo! Clean eating is the whole point, however not in a restrictive way*. While these stances obviously contradict themselves, such linguistic knots aren't uncommon in the wellness space; they are reminiscent of academic, media, and medical authorities' attempts to distinguish between orthorexia and their own equally disciplinary and rigid constructions of health.

In his foreword to Jordan's memoir, Bratman wrote that "a focus on healthy food" that "any intelligent person" should embrace can become "dysfunctional" and end up as orthorexia. "Dysfunction" is the pivotal term, the way proponents of existing regimens of health mark people who supposedly misunderstood their dictates, deeming them failures. But how many of us are functioning correctly amid all the advice and devices and charts? The prevalence of orthorexia in the general population ranges from less than 7 percent to almost 90 percent, a variation the scholarship attributes to "flawed measurement tools," the variety of groups studied, and varying diagnostic criteria. But perhaps that range simply results from the difficulty of separating symptoms from value systems, diseases from diets, and self-harm from self-improvement in a society that sees health as an aesthetic, a religion, and a calculation instead of a state of being.

In the depths of her orthorexia, slowly starving herself by eliminating ever more foods and dealing with pain, exhaustion, and anxiety, Jordan turned to a nutritionist. He told a terrifying tale about the toxins in her gut, which were apparently *decomposing, fermenting*, and *rotting* in her large intestine, then slithering into her bloodstream. He suggested that she "clean" her diet, and she *resolved to eat as little as possible and replace meals with juices*. Jordan's terror parallels the fear nineteenth-century women must have felt upon reading popular health writers' warnings. Figures like Kellogg, Yale, and Harland pioneered the genre of moral-

izing food bibles maintained today by books like Gwyneth's 2019 tome, *The Clean Plate: Eat, Reset, Heal,* which warns readers against "toxic trigger" foods. (For all of Goop's articles on "detoxifying," its former CCO now admits "wellness culture can be toxic" itself.)

In the #colonic tag on TikTok, which has almost 100 million views, people undergo colon hydrotherapy, narrating the whole procedure as their shaky camera films the whirring white machine pumping water into their bowels and pulling liquid out. *They're sucking allllll the toxic shit out of meee,* a female voice says in one video, her tone high with what could be pain or excitement—probably both. On the TikTok accounts of spas that offer colonics, videos depict yellow and green liquids streaming through clear tubes, while text explains that this patient, for example, had "[redacted] pounds of toxins" in her colon. In reality, what is flowing through that plastic are not toxins but water, fluids like coffee, undigested food, and, in rare and dangerous cases when the colonic tube perforates the bowel, bits of organ lining. Across the colonic conversation online, weight loss is touted alternately as a happy side effect of stomach purification and as the goal. In one video, posted by a clinic with the handle @baysidecolonics, the camera zooms in on a woman lying on a cot as another woman massages her abdomen. Then we pan over to a large machine with a clear tube attached, greenish-gray slime flowing through it. In the bottom corner of the frame is a chunk of text: "Struggling to lose weight? Your colon could be full of toxins! This client lost [redacted] after just one session!"

Although they receive endorsements from wellness figures across the follower-count gamut, from powerhouses like Gwyneth and Jordan to up-and-comers, colonics are also injuring people seriously, permanently, and often. After Goop posted a colonic directory, published an article listing their benefits, and began selling an at-home colonic machine, doctors took to social media to decry the procedure. A study in the *Journal of Family Practice* documented colonics resulting in pelvic abscesses, anal gangrene, electrolyte imbalances, colitis, and septicemia, or blood poisoning. Ironically, one of the only medically documented ways to get that "sewer-like blood" is through bowel perforation during a colonic, after which the feces in your intestines actually can enter the bloodstream, causing sepsis.

While scrolling through colonic videos, #guttok gut health explainers (591 million views on TikTok), and #cleaneating and #detox tags, I quickly started seeing advertisements for a product called ColonBroom and its associated "Anti-Bloating Diet" book, which promised to list "gut-healthy," "anti-inflammatory" foods. In the advertisements, girl after girl dances in spandex separates as different benefits float in text bubbles around her. She points at or shimmies into them, tapping words like "cleanses waste from the gut" and "less than a month to reach your body goals" with her hips. When I click over to the company's Instagram page, one post endeavors to educate readers on the "less known fact that an average adult may be carrying up to [redacted] pounds of toxic fecal matter in their gut." This is a direct restatement of Kellogg, Yale, and their ilk's profitable misunderstanding of digestion, one that wields ingrained fears around "toxicity" to tie slenderness to a functioning gastric system. Positioning instant weight loss as proof of a purified body, the logic undergirding colonics has retained its allure for over a century despite being scientifically disproven. The product's website touts its ability to "improve your body's detoxification process by . . . eliminating accumulating toxins," leaving you with both a "protected intestine" and "easy to reach weight goals." Notably, customer testimonials praise its weight loss effects more often than its ostensibly detoxifying ones. "After the first box I could see my thigh gap," one customer raved, while another felt "drastically lighter." When I take the site's quiz, which promises to tell me if ColonBroom is right for me, I don't mention chronic constipation or irritable bowels. I am told they have calculated that I can lose a significant amount of weight in three months if I purchase a Colon Broom bundle that includes a diet book and powdered "fasting aids." Of course, I am also promised "balanced gut microbiota."

In Kellogg's time and our own, medical authorities are unsure what, exactly, renders the gut microbiome balanced and even what is meant by "balance" in the context of gut bacteria. Today it is widely understood within the medical community that colonics and laxatives certainly do more harm than good for gut health in almost all cases. Cutting to the chase in an interview about the colonic craze, the director of clinical gastroenterology at Mount Sinai Hospital, David Greenwald, said a

colonic "has never been shown to have any clinical benefit. The colon doesn't need to be cleansed." The fervor with which people pursue these procedures and supplements reflects the depth of our desire for healing, and our desire for that healing to be reflected in our outward appearance. The question then becomes, if our guts are functioning fine, what are we healing, and what are we trying to project with our performative purity, our detoxified diet plans, and our willingness to endure painful, risky procedures to mold our bodies into the shape of someone we aren't? The next question, then, is who are we trying to become, and is she dying?

What's Your Number?

Lizzo is gazing into her phone's selfie cam, wearing a logo-drenched Fendi trench coat and a sun hat. A robotic female voice intones, "How did I go from this . . . to this," as Lizzo takes off her hat, using it to momentarily block the camera. When we see Lizzo again, she is standing tall, framed by baby-blue sky, skin gleaming in the sun. She wears a skimpy red bikini and shakes her hips, flips her hair. On TikTok, users attach audio memes to their videos, and this audio of a girlish robot describing a transformation is often used by TikTokers who want to show off a weight loss journey.

Click on the post's audio and you will watch a parade of shrinking women. Before and after slideshows display bodies bent and sculpted into submission, large women staring solemnly into selfie cameras replaced by smiling small ones posing in power positions or coyly crossing their legs. Subverting this trend, Lizzo used the sound effect to accompany an outfit transformation, showing off her luxuriously adorned large body in smirking mockery of the way this audio is usually employed. A fat woman in Fendi and a bikini fabulously disinterested in changing her body, instead invested in decorating it. Most of the comments on the post praise Lizzo in omgs and fire emojis, but a subset insult her size, and others use falsely supportive language to encourage her to lose weight, supposedly for her own health. One commenter posts plaintively, calling Lizzo beautiful but admitting that they feel *fat and insecure*, jealous of Lizzo's confidence, to which another commenter replies, "Eat salad and do cardio."

Type "Lizzo" into a Google search bar, and a drop-down list of suggested searches appears: "Lizzo songs," "Lizzo net worth," and "Lizzo weight loss." She posts often on various social media platforms about her healthy lifestyle, which involves a nutritious diet and regular exercise. On social media and in mainstream news outlets alike, journalists, medical professionals, personal trainers, and average people judge Lizzo's health, alternately declaring her a body-positive role model and a danger to young people.

Lizzo has been open about the stigma she faces as a fat Black woman, even one who is an internationally famous pop star. People do not believe her when she says she eats a nutritious diet, refusing to accept that a fat Black body can be a healthy one. In one TikTok video, a user pages through a magazine, holding her camera shakily over a quote from Lizzo that reads, "Being fat is normal." In a voiceover, they declare, "Shame on Lizzo for not empowering women to be more healthy." Notions of shame and willpower haunt our centuries-old debate on health, beauty, and body size, and our resulting obsession with surveilling, quantifying, and attempting to calculate our way to the top of a paradoxical pyramid.

Intermittently, Lizzo takes to TikTok to educate the haters on their flawed conceptions of health or to support another fat person speaking about similar issues. But mostly Lizzo attempts to live her best life publicly, showing off her body just as often as the thin pop stars who are praised for their slenderness and asked how they stay in shape. When Lizzo is asked, over and over, whether she's trying to lose weight, she says she isn't, and she often cracks a joke. Between her serious, front-facing camera monologues about her genuinely healthy lifestyle she has fun, and she eats. She posts looping clips of herself dancing, flashing flesh in the sunlight, smiling.

Meanwhile, in a Quora thread entitled "Is Lizzo Too Fat?," anonymous strangers guess Lizzo's body mass index as they argue about how her weight will affect her life expectancy.

Across the Western world, public health officials wring their hands over the "obesity epidemic," and children are taught young, around the same time that they first learn about food pyramids and basic nutrition, that

fatness leads to disease. The link between large body size and fatal disease is inscribed on government documents, in medical textbooks, and in magazines, books, and blogs. But that supposedly steel link has actually been a gossamer thread since its inception in the Victorian era, based largely on social Darwinism and the profit motive. Despite the multitude of attempts by the medical establishment, the weight loss industry, and governmental bodies to solidify that flimsy connection, newer science dispels it; remember that 2005 finding that the "ideal weight for longevity was overweight."

But long before the so-called obesity epidemic, before diet culture and fat camps and Weight Watchers and the multi-hundred-billion-dollar-a-year weight loss industry, a Belgian scientist named Adolphe Quetelet was working toward a goal he hoped would render Belgium competitive with the other continental powers: a national observatory. Across Europe, the ticking of pocket watches promised to wring order out of the wet blackness. To calculate the speed of a planet's or star's path through the void, astronomers gazed into telescopes and measured. But ten men with ten watches would get ten ever so slightly different measurements, so a man named Carl Gauss invented the average, a statistic he claimed was as close to the genuine truth as humans could possibly get.

Quetelet wondered where else he'd find Gaussian curves if he pointed his telescope around him instead of above. Gauss had posited that with multiple people measuring something, their various answers usually fell along a bell curve, with the mean at its peak. Quetelet saw that peak as an ideal and applied it to human bodies. He thought that the characteristics that appeared most often must be the ones we were meant to have, redefining variation as imperfection. Just as statistical averages clarified messy measurements, to Quetelet the notion of an average man clarified a confusing population: average man is the one God meant to make, and the rest of us are just messy early drafts.

Conveniently for Quetelet, the early nineteenth century was the dawn of data as we know it today. Suddenly, censuses documented age, gender, biometric information, total numbers of marriages, births, and people incarcerated for crimes. Quetelet saw Gaussian hills everywhere and began using their data to construct his Average Man. He led the first cross-sectional study looking at the height and weight of newborns

in 1832, followed quickly by a similar study on adults, both of which measured only white Europeans. These studies, and others on suicide rates, criminality, the size of various human limbs, complexion shades, and marriage age, among myriad other statistics, together made up his 1835 treatise defining the new field of social physics. In its application of statistical science to every aspect of society, the text pioneered the then novel conception of a person as a series of numbers—height, weight, limb length, an ever-expanding set of measurements—which he thought predicted the person's life expectancy and social standing.

In a chapter titled "Of the Development of Weight and of Its Relation to the Development of the Height of the Body," Quetelet created the formula today used to calculate BMI, calling it his Quetelet index: the average, ideal man's weight is the cube of his height, and dividing a person's weight by the square of their height will result in a number that reflects their location on the bell curve.

Quetelet wrote wistfully that "if an individual at any given epoch of society possessed all the qualities of average man he would represent all that is great, good or beautiful." On the other hand, the man drawn when God's pencil needed sharpening elicited his disgust. For Quetelet, differing from the norm renders a person deformed, and exceeding the norm renders them "monstrous." The conceit is excess as an indicator of the inhuman, largeness as degraded, proto-fatphobia draped in mathematics and religion. Along Protestant logic, the body provides a portal to the soul, and an overly large one reveals vast voids, where dangerous appetites lurk.

It is unsurprising then that the infamous eugenicist Francis Galton drew on Quetelet's Average Man in his work defining the then nascent field. As eugenics and data-based surveillance congealed into a racist, genocidal mass over the next century, scholars contending that supposedly degenerate races were doomed to criminality and disease cited Quetelet's work. Cesare Lombroso was one of these social scientists, but he focused specifically on women, whose bodies he saw as even more indicative of inner character than men's. His 1895 tome *The Female Offender* purported to compare the bodies of female sex workers, lunatics, and criminals to the bodies of "average moral females." Lombroso

insisted that "in prisons and asylums the female lunatics are far more often exaggeratedly fat than the men." The Average Man's primacy reigns even in the asylum, where fatness does heavy metaphorical work. Using height and weight tables akin to Quetelet's, Lombroso claimed to demonstrate that female criminals were more likely to be above average weight than "women leading moral lives," writing that "60 percent of female poisoners, 59.4 percent of female assassins, and 46 percent of female thieves have a weight above the average," while a far lower percent of "moral women" weighed above average.

When he wrote about sex workers, Lombroso's disgust for their profession melts into his disgust at the sight of a woman with a large body. It is unclear which contempt came first when he writes, "The greater weight among prostitutes is confirmed by the notorious fact of the obesity of those who grow old in their vile trade, and who gradually become positive monsters of adipose tissue." Lombroso called African women "simple monsters of obesity," drawing on fatness to shroud the Black female body in deformity and animality. The word "monstrous" is weaponized to dehumanize people with bigger bodies, a tactic that simultaneously provides a logic for brutalizing Black women on the basis of their supposed subhumanity and serves to enforce self-surveillance and self-discipline on white women, who are encouraged to sculpt themselves into forms defined against Blackness.

Across Europe and the United States, scientists were founding ever more disciplines devoted to categorizing and evaluating bodies, imagining people as machines as predictable as the ones rapidly producing novel consumer items. Like cotton mills or steam engines, bodies were understood as the result of formulas, and the scientists wanted efficiency. The so-called experts doing all this quantifying were white European men, writing statistical reports on behalf of governments in the business of chattel slavery and imperialism. Their statistical science took their fellow white males, and sometimes white females, as the prismatic blank subjects, rendering the female body in most cases and the Black body in all cases an error even further beyond the pale than the too-large white male one.

Disturbingly, Quetelet's devotees spanned the political spectrum as

well as the continental one. There were the expected racists and liber-
tarians, but there was also Florence Nightingale, who eulogized him,
and Karl Marx, who thought the Average Man's primacy was proof of
historical determinism. Nightingale's and Marx's reverence for Quete-
let's ideology reveals the insidious allure of a normative determinism
to the white intelligentsia, a phenomenon that has continued apace for
centuries as generations of people across the political spectrum have
accepted a statistic designed to idealize the white male body as the single
most effective measure of health for all bodies.

According to the Christian colonizing male subject, God wouldn't
allow a sinner the good life, and the bodies that succeed in a burgeoning
capitalist society wouldn't do so if they weren't God's favored bodies.
For the female subject and the colonized subject, this logic functioned
like the corsets elite society's women were laced into: as a painful,
motion-restricting stricture that by its very presence reified a bodily
ideal the wearer's physicality deviated from, while obscuring the very
fact that such deviations existed naturally.

The new fetish for measurement made its way to the factory floor in
the first decades of the 1900s. With the rise of scientific management,
yet another application of the Gaussian curve plotted bodies along a
bell curve, this time quantifying the average time necessary to complete
any industrial task. Relying on close surveillance, data collection, and
proto-predictive modeling, this approach aimed to optimize labor effi-
ciency and punish workers who failed to meet productivity quotas. With
mass industrialization and enforcement of these principles came massive
numbers of industrial accidents, ever more bodies broken in pursuit of
another statistical ideal. Unions fought for employers to pay healthcare
costs, in part leading to the rise of the employer-backed insurance indus-
try. Before the twentieth century, life insurance was a relatively small
economy in the United States, but as the quantification of human life
continued apace, private life insurance held obvious profit potential—
the number of life insurance companies operating in the United States
more than tripled between 1905 and 1914.

Suddenly, all the new life insurance companies needed a way to price their plans. MetLife, which by 1909 was America's leading life insurance company, along with the rest of the industry, wanted a way to estimate life expectancy so plans could be priced accordingly. The first standardized height-weight tables used by a life insurance company debuted in 1908. Over the following decades, insurance companies repeatedly commissioned studies intended to validate their pricing models, which linked high weight with mortality. Between 1921 and 1942, the number of studies focusing on health risks associated with high weight published in the *Journal of the American Medical Association* almost doubled.

This numbers-focused biopolitics fostered an embrace of thinness alongside a fear of fatness. Strings has written about the way women's magazines and health entrepreneurs responded to waves of immigration from eastern Europe in the late nineteenth and early twentieth centuries by encouraging white American women to distinguish themselves from women of other ethnicities and races by becoming thinner, rendering "thinness a form of American exceptionalism." Dieting became a religion to be pursued with both the fervor of the Protestant ethic and the scientific ethos of industrialization. In the early 1900s, newspapers ran advertisements for products like "rubber reducing garments" (elastic corsets) and "obesity soap" promising to wash fat away.

Then the feminists flung their corsets onto the fire and threw on their slips, slinking into the second decade of the twentieth century with a ballot in one hand and a drink in the other. Or so the folk feminism of the girlboss era tells us, in the best-selling books about gutsy women that unspool narratives of proto-feminists freeing themselves of their corsets, never mentioning the fact that many of those women's guts had been permanently distended, leaving them infertile or with chronic pain. The aesthetic evolution of women's fashion from the Victorian era to the Roaring Twenties is often told as a fairy tale of empowerment with a side of well-earned hedonism. While there was much real activism going on, the strictures surrounding women's bodies would prove even tighter than their corsets, as racist and patriarchal ideals of slenderness morphed to fit the fashions of the day. In reality, corsets were too heavy to fling anywhere, whalebone and steel couldn't conduct fire, and

women were mostly using matches to light the newly omnipresent mass-produced cigarettes that promised to keep them slim now that corsets no longer artificially shrank their waists.

The steel bars strapping in women's stomachs had come off in the fires of war, not the fires of feminism. As the United States entered World War I, newly formed weapons, ammunitions, and armor factories found that they didn't have enough steel to work with, because the country's reserves had been depleted by the corset industry. In 1918 the United States' War Industries Board passed a corset ban, diverting the steel that encased women's ribs to the weapons industry. By ending corset production, the Warner Brothers Corset Company directed twenty-eight thousand newly available tons of metal to the production of helmets and ammunition. The same year, the first best-selling diet book in history was published: Lulu Hunt's *Diet and Health: With Key to the Calories*. According to Hunt, the key to losing weight and staying thin is thinking in calories, translating food into equations, running the numbers of your body. Early in the book, she writes, "Hereafter you are going to eat calories of food. Instead of saying one slice of bread, you will say 100 calories of bread." The first at-home bathroom scale went on sale in the United States, and soon another diet book entitled *Food and Life: Eat Right and Be Normal* hit shelves. Astounded by the drastic increase in weight loss products and mathematical diets, one journalist in 1925 called reducing a "national fanaticism," writing that "people now converse in pounds, ounces, and calories" instead of words.

By 1930, one in every five Americans was insured by MetLife, charged according to their place in those height-weight tables. MetLife's CEO, Louis Dublin, helped rewrite them using Quetelet's formula, imposing the normal distribution curve on to bodies. Drawing on a research group of hundreds of thousands of white people who held insurance policies at forty-three different companies (in addition to its lack of racial diversity, the sample included twice as many men as women), the new charts attempted to locate the height-weight ratio correlated with lowest mortality at the peak of a Gaussian curve, one drawn based on data collected only from white people, but applied indiscriminately across racial groups. The insurance industry, and the doctors who, as UCLA sociologist Abigail Saguy told *The Atlantic*, "intentionally made

a case that fatness was a medical problem" in order to frame their field as the profession that should be paid to treat said problem, spawned the obesity research industry, culminating in the formation of the National Obesity Society in 1949.

By the start of the sixties, obesity researcher Ancel Keys was staring sternly out of the cover of *Time,* while a man stood forlornly over a scale in the image's background. At-home platform scales were widely available, giving people a simple way to reduce themselves to a number and embark on a (usually lifelong) journey to reduce that number. One 1958 advertisement for a personal scale depicts a naked woman in profile, gazing anxiously down at the dial. Next to her face, cursive letters read, "Healthy and wise is the woman who keeps a watchful eye on her weight." Health, wisdom, beauty: all ostensibly under this woman's control, and encapsulated in the number on the scale.

Throughout the '60s, calorie counting and cigarettes combined with the nascent diet pill industry to build an extraordinarily profitable holy trinity of weight loss industries. In 1973, fifteen thousand paying members of Weight Watchers poured into Madison Square Garden to see their high priestess. *The New York Times* described the event, a celebration of the company's ten-year anniversary, as "like a revival." From a larger pulpit than most preachers would ever see, a Queens housewife turned CEO and patron saint of weight loss named Jean Nidetch preached her "evangelistic message," praying at the altar of the scale and the calorie counter. By the time she died (as her obituary noted, at her goal weight) in 2015, her program was known around the world, and Oprah Winfrey had just been announced as its newest devotee, success story, spokesperson, and major shareholder.

Oprah went to her first diet doctor when she was twenty-three years old. More than four decades later, she still has the check she wrote him for prescribing her a *calorie regimen* meant to make her flesh fade away fast. In 1988, Oprah debuted a brand-new body to thunderous applause in a live taping of her namesake show, in an episode titled "Diet Dreams Come True." Half of the U.S. daytime television audience tuned in. Onstage, Oprah threw off a fuchsia jacket, displaying her suddenly slender frame, twirling in tight clothes as the audience screamed and shook pom-poms. Later, she briefly exited the stage, only to return pulling a

bright red child's wagon behind her. In the wagon was a massive clear plastic bag filled with animal tissue. Oprah announced that she was lugging around the total number of pounds she'd lost, rendered in raw meat, and then attempted to lift the pinkish mass with her hands. She dramatically struggled, failed, and let it thud back into the wagon. *I'm glad I did this for my heart,* she said, *my poor heart, that had to send blood to all of this.* Her tone turned mournful as she motioned at the meat, slimy and stretching its plastic casing.

Decades later, Oprah said that at the time, she believed fitting into *those Calvin Klein jeans made me worthy as a human being.* To do so, she said she *had literally starved myself for four months* on the Optifast diet, which she promoted during the episode. Optifast is a liquid-only diet that requires medical supervision, in which patients work with a doctor to determine which and how many proprietary Optifast meal replacement drinks they should consume daily for up to four months. After a slew of deaths associated with protein-formula diets, companies like Optifast added the doctor supervision element to their product offerings. When Oprah went on Optifast, the program cost between $3,000 and $5,000, and patients were not allowed solid food for at least three months, after which they were instructed to maintain a low-calorie diet for life. Onstage in her Calvin Klein jeans, Oprah announced that she was *by no means through* with dieting: *Every day for the rest of my life is going to be a struggle.* After the episode aired, the company that produces Optifast reported receiving more than two hundred thousand calls from interested customers.

In 1991, the Federal Trade Commission charged Optifast's parent company, which also owned multiple other commercial diet programs, with publicizing misinformation about their diets' efficacy as well as not disclosing the diets' health risks. While Optifast advertisements promised patients they would not regain weight lost on their liquid diet once they reintroduced food, a longitudinal study of Optifast found that 40 percent of Optifasters had regained all or more of the weight they lost on Optifast thirty months later, and the rest regained almost half of any lost weight. Studies have documented gallstones and liver shrinkage induced by the diet. While consuming only Optifast meal replacement

products, patients have experienced side effects including hair loss, loss of menstrual periods, light-headedness, and dizziness, all of which are also anorexia symptoms. Still, Optifast exists to this day. In 2005, Oprah said that she *started eating [food] to celebrate* her success immediately after the "Diet Dreams Come True" episode aired. *Within two days,* she said, those Calvin Klein *jeans no longer fit.*

Ronald Reagan, whose second presidential term was winding down when Oprah's diet dreams came true, presided over an era of deregulation, lower taxes, and cuts to social services. Both people and companies were expected to quantify their existences, crunch the numbers, and optimize. On the campaign trail, Reagan had denounced the so-called welfare queen, calling her a "pig at the trough." Within the neoliberal paradigm, fat Black women were imagined as gluttonous animals, Lombroso's female offender updated for the twentieth century, the width of her limbs still predicting her future, reflecting her supposedly greedy soul.

The scales, calorie counting, and assembly lines of the first three-quarters of the twentieth century inducted much of the Western public into the cult of self-quantification. By the century's final decades it was no surprise to find U.S. presidents exhorting international organizations to quantify the rest of the world according to American standards. The WHO, IMF, and World Bank obliged, bluntly slicing the world with the dull knife of their statistics, applying the gross domestic product and body mass index indiscriminately across the Southern Hemisphere: the WHO adopted BMI as a global health metric in 1995.

Meanwhile, Cher Horowitz was sidling on to the silver screen and announcing that she felt *like a heifer.* Baring lithe thighs in a red plaid skirt suit, she rattled off everything she'd eaten at breakfast in numerical quantities, as her best friend nodded sympathetically. At the same time, the United States was exporting its eating disorders alongside its movies, BMI, and financial privatization schemes. The year of *Clueless* was also the year American television programs were first broadcast on Fiji, where barely any cases of eating disorders had been reported. Three years later, a study found that 15 percent of Fijian teen girls suf-

fered bulimia symptoms. Over the course of the 1990s, rising rates of eating disorders were reported in countries from Pakistan to Nigeria.

In 1999 the *Journal of the American Medical Association* published an entire issue investigating obesity as a dire threat to the country's health. Underreported alongside all the headlines about obesity's killer potential was where the funding for all these studies came from, which, as mentioned earlier, was largely weight loss companies and pharmaceutical companies that sold weight loss drugs. The International Obesity Task Force, author of multiple WHO studies on obesity, and the American Obesity Association are both largely funded by weight loss and pharmaceutical companies, which are invested in their products being seen as medicine, which means the condition they treat needs to be understood as a dangerous disease. An illustrative example of the kind of research this funding fosters: one recent review of medical treatments for obesity concluded that Weight Watchers, Jenny Craig, Nutrisystem, and Optifast (the company that made Oprah's diet dreams come true) are programs doctors should consider prescribing obese patients. At the very end of the article, a disclaimer noted that one of its authors was paid by Novo Nordisk (Ozempic's manufacturer) and Weight Watchers, while the other was paid by Weight Watchers and Shire pharmaceuticals (Vyvanse's manufacturer).

Amid all the fearmongering and studies funded by weight loss companies, independent studies have published findings contradicting the conventional wisdom about the dangers of fatness on almost every front. As previously highlighted, people with overweight BMIs actually live longest according to a 2005 study using national data collected by the CDC, while being significantly underweight is strongly correlated with mortality—"the relative risks associated with underweight were greater than those associated with even high levels of obesity," though the risks of thinness are rarely discussed. An obese BMI is correlated with higher survival rates in certain chronic conditions, a situation that contravenes mainline medical wisdom so much that it is referred to as the "obesity paradox" in clinical literature. Even being on the lower end of the "normal" spectrum is associated with higher mortality than being deemed grade 1 obese.

In 2018 the Office of Minority Health reported that Black women are the most overweight and obese, by BMI, of any racial and gender group. The report emphasizes the correlation between high BMI and rates of stroke and heart disease, without mentioning the fact that diet-induced weight cycling has been convincingly tied to those issues while high BMI alone hasn't. Significant changes in weight, like those induced by repeated dieting, are associated with heart problems across BMI ranges—adding a heartbreaking layer to Oprah's scene with that wagon of fat, apologizing to her heart for making it pump blood to all of that, when she should have been apologizing for confusing it, demanding it pump blood to so many different-size bodies instead of simply the one it was meant to. Blaming Black women's lower life expectancy on their BMIs allows the medical establishment to evade responsibility for its own racism. Doctors disbelieve Black women's pain and misattribute symptoms of other diseases to obesity in larger Black women, so Black women end up receiving treatment much later than white women with similar diseases, a phenomenon that likely contributes to higher Black female mortality.

There are a plethora of other problems that likely contribute to the mortality often attributed to high BMI. The stress caused by the stigmatization fat people experience is correlated with heart disease and stomach ulcers, and the fatphobia entrenched in the medical profession often drives doctors to blame fat people's health issues on their size, leading them to counsel patients to lose weight, which is often detrimental to their health, before screening them for other diseases, in the process missing diseases at early stages. Studies have shown that 40 percent of American doctors had a negative reaction to the idea of treating a fat patient for any condition at all. One study discovered that fat women are less likely to be screened for cancer than women of "average" size.

Back in the early '80s, even Keys knew that some body fat "may not hasten death." Speaking at an international nutrition conference in Los Angeles in 1980, after the release of a study disputing the insurance industry's thesis that being overweight is directly correlated with earlier mortality, Keys admitted that "the tables of ideal or desirable weight are armchair concoctions starting with questionable assumptions. . . . Those

tables have been reprinted by the thousands and are widely accepted as gospel." Like all gospels, this one would prove as hypnotic as it is hypocritical, and almost impossible to dispel.

In 2008, I downloaded a new app to my iPod. The icon featured a silhouetted figure in the middle of a balletic jump, lithe and limber like I wanted to be, and when I clicked open the app I was welcomed and asked to input my height, current weight, age, gender, and goal weight. MyFitnessPal, which debuted on the app store in 2005, is to this day one of the most popular calorie counting apps worldwide. Its icon is also regularly featured in eating disorder starter pack memes and discussed on pro-ED websites. *Does anyone else have MyFitnessPal app trauma???* someone posted, while another joked darkly about *the myfitnesspal to eating disorder pipeline,* and another mocked *myfitnesspal's yassification of orthorexia.* The app is focused on calories in and out, calculating your personalized daily allotment based on your biometrics and the date by which you'd like to hit your weight goal. During the era I spent addicted to the app, every time I considered putting something in my mouth, I searched it in the app's expansive database, and often decided against eating it after seeing its caloric content. What I did eat, I entered, and the app updated my remaining calories for the day accordingly. The app quickly became a ritual and a rulebook, and scrolling my daily record in bed at night a practice as yearnful and penitent as running my fingers through rosary beads.

Two years after MyFitnessPal hit the app store, a start-up addressed investors with a vision: What if you could track your fitness data with more accuracy and less effort? Fitbit found itself on the vanguard of wearable self-tracking technology, building the first biometric-tracking bracelet that told users how many calories they burned along with data like heart rate and body temperature. Seeing similar products on the horizon and considering the thriving marketplace for self-recorded personal data, *Wired* editor Gary Wolf began asking himself questions about the future of self-knowledge, self-control, science, and subjectivity. He thought about the many ways we use numbers and code to solve our modern-day problems, and wondered, "Why not use numbers on

ourselves?" In 2007, Wolf and a fellow editor coined a term that would spawn a movement and inaugurate an era of avid counting, calculating, and decoding personal data. The "Quantified Self," according to Wolf and his cocreator Kevin Kelly, is an orientation to "self-knowledge through numbers," a mindset devoted to quantitative self-surveillance.

In the following decade, Apple Watches, Oura Rings, and myriad other self-tracking devices debuted, many easily linkable to apps like MyFitnessPal. The general mood in the media was laudatory, optimistic, confident in a future of high-functioning, fit bodies keeping themselves simultaneously healthy, hot, and productive with a little personalized algorithmic guidance. Journalists called wearable health trackers "the future of healthcare" and "the Key for Effective Weight Management." The word "biohacking" became common parlance, described as an "earnest approach to applying the tech-hacker ethos to biology" by *The Atlantic,* and by 2021 the self-tracking wearable-tech industry was worth $115.8 billion. Like the health movements that came before it, this one conflated small body size and health, and the release of metabolism breath analyzers, gut microbiome test kits, and scales that calculate body fat percentages gave people ever more numerical information on what, exactly, rendered their bodies "unhealthy."

Guido Nicolosi has christened our current biohacking era the dawn of an "orthorexic society," borrowing eating disorder terminology to reveal that health ideology was never neutral but is instead symptomatic of the West's sick misunderstanding of health. The prevailing vision of health fosters an illusion of choice by the imagined consumer, who must have disposable income to devote to the upkeep of their perfectly healthy body. This construction ignores social determinants of health to demonize the largely low-income Black and brown populations who lack access to health foods and often live in neighborhoods where the air and soil are literally toxic, in stark contrast to the imagined toxicity mostly wealthy white wellness influencers claim is present in, for example, white bread.

Quantified-self technologies, with all their rhetoric of empowering individuals, smoothly license governmental health bodies and the medical establishment to abdicate responsibility for citizens' health. These technologies also often lead people down paths that leave them feeling

far from in control, instead trapped by the directives of their devices. There has been a glut of studies, funded by powerful Silicon Valley players financially invested in the quantified-self and biohacking industries, lauding fitness trackers for their successes, listing increased exercise frequency, better sleep, and lost weight. Meanwhile, a recent *Journal of Medical Internet Research* review of self-tracking research found a "significant paucity of empirical research examining the potentially adverse psychological consequences of self-tracking."

Only one study has investigated the potential connection between eating disorders and fitness trackers, even though the apps carry obvious potential to exacerbate disordered eating by giving users ever more trackable information. Self-tracking using numbers is a central facet of many eating disorders' symptomatology, as evidenced by the self-quantification in pro-ED online spaces, where users often put their lowest weight, current weight, and goal weight in their bios. A 2021 study investigating the interrelation of fitness apps and disordered eating found that undergraduate women who "used diet or fitness apps showed higher levels of eating disorder symptoms," while in a group of women with diagnosed eating disorders, 73 percent said that MyFitnessPal contributed to their eating disorders.

Meanwhile, the wearable-tech companies are touting their supposed weight loss effects (despite the fact that said effects are likely either triggering eating disorders or not effective in the long term, or both) to claim that they can, paradoxically, aid in eating disorder recovery. Oura, a Silicon Valley darling, is a ring that tracks an array of biometrics. In the "stories" section of its website, one post by a ring-wearer details "How Oura Helped Me Recover from My Eating Disorder." Studying her Oura data one day, she had a *wakeup call:* because she could *literally see the effects of her bingeing,* she decided to change. The post follows the narrative ethos of the quantified-self heroine's journey. Access to objective data forces the unhealthy person to stop deluding themselves and gives them the numerical tools to build a formula for optimal health, one that is both the user's prerogative as a consumer and their moral obligation as a person.

The conflation of physical health with the good life is at the core of our quantification-obsessed society and the bootstraps myth it enables.

Along these linguistic lines, a 2021 review of the landscape in the *Journal of Medical Research* praised tracking systems that "empower users to take greater responsibility for their health." Apple donated a thousand Apple Watches to people with eating disorder histories as part of the Binge Eating Genetics Initiative, an initiative that in its very name pushes the narrative that eating disorders are genetic and biological problems, rather than social issues. A scientist working on the study said they hope to look at data like heart rate and blood pressure to locate "a biological and behavioral signature" that marks bingeing and purging episodes, which, if discovered, sounds like a ready-made tool for demonizing people who are nutritionally "misbehaving."

By the time I deleted MyFitnessPal from my phone, I'd gone through recovery twice and met many other girls who relied on the app to enable and exacerbate their eating disorders, as well as people whose issues began the first time they snapped on a Fitbit and got congratulated for their daily calorie burn. I still remember the exact calorie counts I learned on the app for many items of food, and I still sometimes think about myself as a collection of numbers, inputs and outputs I can hack with the right combination of macronutrients and exercise, a formula that will solve for x, my best self. But the real variable is life, and I want to be able to eat a meal with friends without glancing at a bracelet that tells me when to take the last bite.

As the dangerous, insidious effects of diet culture have come under fire in the past decade, straightforward weight loss discourse has become more taboo, and some major players in the industry have rebranded their diet plans as lifestyle choices oriented toward health and wellness. Meanwhile, as neoliberalism morphs into libertarian-infused techno-capitalism, the calorie counting of yore has evolved into the biohacking, macro counting, ketosis-inducing wellness industry. The discourse around wellness promises women they can find liberation in controlling their bodies, insisting that self-imposed body fascism doesn't feel like fascism at all, and instead feels like having it all: the ideal body as the physical proof you're thriving in the new economy.

Weight Watchers, which as of 2020 counted 4.4 million paying subscribers, has rebranded as WW and attempted to reposition itself as a "health and wellness brand." The core premise remains calorie count-

ing, but masked in a new, tech-infused language of SmartPoints that the company's app claims to calibrate specifically for each user. Oprah, with a $43 million stake in the company, has professed religious levels of belief in the program, claiming she plans to stay on it for the rest of her life. In 2019 the company released a version of its app designed for children, supposedly an attempt to counter childhood obesity, despite the American Academy of Pediatrics' published warning that children should not be exposed to weight loss programs because they heighten the risk of eating disorders, which are on the rise among kids. The number of children hospitalized for eating disorders increased over 100 percent in the first decade of this century, and over the course of the COVID-19 pandemic, eating disorder hospitalizations among teens jumped, more than doubling at many hospitals.

In 2018, Weight Watchers' CEO announced that "healthy is the new skinny." While the headlines still scream about obesity, tens of thousands of people die of eating disorders and unknown numbers die of diet-induced heart attacks. Also uncounted: those dying sacrificially at the altar of our fetish for efficiency and idealization of homogeneity, of diseases undiagnosed by fatphobic doctors.

Oprah is standing in front of her fridge, throwing food away. She picks up a large cake and says, *Goodbye, bananas foster cake,* as she upturns the plate over the trash. It's the start of a new year, and Oprah wants those of us viewing this Instagram video to know that it's *time for a reset,* which means *clearing out the fridge.* If we want to *get back in control* of our lives, by which she means our bodies, she urges us to join her at *ww.com so we can hit reset together.* On the site, we are urged to understand our bodies in explicitly economic and mechanistic terms, to "budget" points across meals.

Back in 2020, Oprah went on the *Today* show and told its audience of millions that *wherever you are in your weight loss journey, if you're focusing on mind, body and spirit and making yourself as well and whole as possible, then you're on the right path.* Drawing on the holistic language of wellness, Oprah entreated Americans to join her on this journey, even though it is one she has referred to as a *cycle of discontent* that began

when she saw her first diet doctor and resulted in arduous losses and painful gains throughout the following decades, as well as diagnoses of multiple metabolic and thyroid conditions.

If Oprah had never set foot in a diet doctor's office, never counted a calorie or stepped on a scale, her heart might be healthier today, but she likely would not be as rich or as famous. Oprah lives in the United States, where fatness inspires fear, especially when it appears in a Black body, and slenderness sells. Today, small bodies are still celebrated right up until the point when they stop functioning. On the flip side, fat people face stigma in job interviews, workplaces, medical settings, and daily life. In a country where counting and quantifying are approached with religious devotion, ratings rule in the end, and the most watched episode in the history of Oprah's show is still her weight loss reveal episode, the day her Diet Dreams Came True. When she walked onto that soundstage pulling a toy wagon filled with fat and debuted her new body, more Americans tuned in to her show than ever had before or ever would again.

Skinny, Sexy, Seizing

In February 2020 I saw a tweet. It was a thread about choosing an antidepressant, asking, *hey girls what is an antidepressant that has made u lose weight? If I'm going to have the libido and mental function of a sea sponge I might as well get skinny.* Among the replies was a litany of praise for Wellbutrin, ending over 90,000 likes, 6,000 retweets, and hundreds of replies later with tweets like this one: *starting back on wellbutrin today so let's hope it makes me horny or skinny or both. Maybe less depressed, too.* I found myself clicking and clicking.

In online forums, on Twitter and Tumblr, young women trade tongue-in-cheek death wishes and deathly serious diet tips. They crack jokes, throw in wink emojis and relevant gifs with their weight loss wishes and fantasies of emotional atrophy. There is a Tumblr called *Live Fast Die Young Sad Girls Do It Wellbutrin* and another one titled *Wellbutrin Dreams,* which has the phrase *I'm only pretty when I'm medicated* displayed prominently on its homepage. I started dm-ing some of the girls replying to the tweet, or posting on these blogs, and found many pseudo-sisters, girls who'd also been allured by the drug's marketing, or heard about its weight loss effects online and hoped *getting skinny* would alleviate their depression, even if the drug itself didn't. Sarah, a twenty-two-year-old who began taking Wellbutrin during her first year of college, described TikTok as one place young people hear about Wellbutrin, *the skinny horny zoom zoom antidepressant.* Dasha Nekrasova, host of the cultural commentary podcast *Red Scare,* has a Twitter account called @dash_eats, where she posts about both what she eats

and her physical appearance, sometimes including her weight in pounds. She has called herself a *wellbutrin success case,* and in an April 2020 podcast interview, she cited a desire not to gain weight as part of what drove her toward Wellbutrin instead of traditional SSRI formulations. Type "Wellbutrin" into Twitter's search bar, and this is just a small sampling of what you might read:

> *skinny legends take wellbutrin*
> *Twitter got me calling my doctor talking about "Take me off of Zoloft. Put me back on Wellbutrin. I wanna come out of this skinny and numb"*
> *I will stay on Wellbutrin forever because I'm a woman and being skinny obv trumps happiness (gif of a skeleton dancing)*
> *I want to take wellbutrin to get skinny again bc tbh the only person I really want dead is me:^)))))))*

Online, those in search of an antidepressant that leads to weight loss recount stories of pliant psychiatrists prescribing Wellbutrin, despite the explicit FDA warning that patients who "have or had an eating disorder" at any point in their life should not take the drug. Wellbutrin can cause seizures, and a patient's risk of experiencing one is extremely heightened if they purge or are malnourished—a side effect documented in studies as early as 1988 and as recently as 2018. Wellbutrin is also contraindicated with eating disorders—medical terminology for "prescribe with caution"—due to its reported risk of triggering a relapse in patients with disordered eating histories, as unintentional weight loss is a common precursor to eating disorder relapses. Still, over the years, sales representatives for the pharmaceutical company that manufactures Wellbutrin, GlaxoSmithKline, cast Wellbutrin as the "happy, horny, skinny pill," promoting its use for weight loss and sexual function, though it had not been approved as a treatment for either.

I first heard about Wellbutrin from a friend. We were in the bathroom of our college apartment, getting ready to go out. Everything in there was greenish beige, tiles and stall doors and dirty sinks. The tableau

could easily have been mistaken for the desaturated before shot in an antidepressant ad—if one of us had been alone, gazing forlornly into the mirror. Instead, we were loud, laughing over the music floating out of an open bedroom door. My friend leaned forward to apply eyeliner, and her hip hit the porcelain with a dull thud. She made a pained noise as she rubbed the pre-bruise, and I complimented her bones.

Well, not exactly, or not in those words. But if I'm honest, strip bare a lot of the praise I heaped on my friends' bodies in those days and that's the sentiment you would end up with. It's what I was really murmuring during much of that time in my life, twenty-one and tender. It's what I meant when I marveled at their curves and angles, when I tapped out heart-eye and fire emojis in Instagram comments. She was used to hearing this type of effusive, yearning comment from me. This time, instead of *thank you* or *stop*, she said, *It's the Wellbutrin*. To my surely wide eyes, she continued, *It's fucking amazing*. Then she told me a story that left me salivating.

In the story, she started out sad. Her psychiatrist suggested an antidepressant with a stimulant effect that might also heighten her sex drive. Days later she was bouncing out of bed and blacking out even faster. She said the drug got her drunk fast, but by the time she remembered to have only two drinks she'd already had three. The only annoying thing, she said, was that she wasn't hungry.

A couple hours later, tipsy in a different bathroom, I googled "wellbutrin weight loss" on my phone. The first result was a *Harper's Bazaar* article titled "The Happy, Sexy, Skinny Pill?" Fingers damp with anticipatory sweat and vodka soda condensation, I clicked. The page loaded to a close-up of a woman's face. Her skin was pale and poreless, her expression pleasure gone plastic, eyes closed and mouth open, painted with pinup makeup, red lips and a smoky eye. Visible against the black void of her open mouth is a small mound of pink tongue, playing pillow to a heart-shaped pill.

The article outlines one woman's Wellbutrin journey, which began when she went to her doctor "seeking an antidepressant but with two firm deal breakers: I wouldn't take any drug that would make me gain weight or one that would make sex more problematic." Ignoring the knocking on the bathroom door, I kept scrolling. At the time, I thought

I'd found my spirit guide through the confusing forest of psychopharmaceuticals. Rereading it now, I am terrified for that drunk girl in the bathroom, about to follow a wolf in hot girl's clothing right off a cliff.

Mental health is a medical issue, but it is also a rhetorical one. Unlike almost any other bodily problem, the only way to convey symptoms of mental health issues to a doctor is through words and descriptions. There's no scan or blood test that betrays elevated levels of misery or mania. Emotional illnesses are necessarily narrative, and this dynamic works in the opposite direction too, before the patient becomes a patient, when they are merely a person feeling bad.

A person feeling bad is often in search of a story they can slot themselves into, one easier to explain to a doctor than a nebulous array of symptoms. The psychopharmaceutical industry knows this, so it offers people storylines in advertisements. Today, a person's drug choice journey resembles a choose-your-own-adventure game, with various cartoon happy endings presented in the pages of magazines, on television, and in social media feeds. But it wasn't always this way, and it still isn't in most countries: before 1997, advertising drugs directly to consumers was heavily regulated in the United States, and the practice is illegal today in every country but this one and New Zealand.

In the second half of the twentieth century, when drug companies were pumping out new psychopharmaceutical formulations rapidly, they marketed their drugs only to doctors. Peer-reviewed medical journals were rife with advertisements for psychopharmaceutical drugs, illustrated fables that always had happy endings, instructing doctors to call the companies for free samples and further information. A 1970 Valium ad tells a tragic woman's tale that spans fifteen years in a series of photos. A young woman ages from twenty to thirty-five, posing with her father in the first photo, and then with a series of men, and finally, alone. She's hit rock bottom: "35, single and psychoneurotic." To psychiatrists, Valium's manufacturer says of its fictional woman, Jan: "You probably see many such Jans in your practice. The unmarrieds with low self-esteem" in need of a tranquilizer that might render them calm enough to catch a man.

Changes to federal regulations in 1997 allowed pharmaceutical companies to start advertising directly to potential patients, instead of just their doctors. In under a decade, pharmaceutical spending on advertising ballooned from $300 million to over $3.3 billion in 2005. SSRI ads were suddenly a commonplace sight in women's magazines, and just as most tranquilizer advertisements directed at doctors starred female patients, marketing materials for SSRIs featured more woman protagonists than men. Suddenly women who didn't know how to describe their psychological distress had a variety of narratives to choose from, stories to imagine themselves inside, where complex problems had simple, swallowable solutions.

A 2004 Effexor ad shows one woman in two starkly different situations. In the first, she stares out the window glumly, surrounded by her thoughts: "My sadness just won't go away." On the opposite page, the same woman is grinning, locked in an arm-wrestling battle with one man while another caresses her shoulder. The storyline is clear: if you're single and sad, one might be causing the other, and both can be fixed in one fell swoop.

By 2016 psychopharmaceutical manufacturers were spending $5 billion on direct-to-consumer advertising. All these ads end the same way, with an entreaty to the reader. Ask your doctor about Wellbutrin or Abilify or Zoloft or Effexor, they exclaim brightly, in sixteen-point type, before the text becomes diminutive in the side effects section.

Popular culture tells these tales too. Movies and books and television shows depict women and girls breaking down in boardrooms and boarding schools, their lives veering off course before little orange pill bottles start stacking up on their night tables, settling them down. They show women too sad to get out of bed, unable to answer the man on the other end of the ringing phone or scaring him off with her sobs. These girls and women are usually as sexy as they are sad, yet they end up skipping to school hand in hand with a boyfriend eventually. In the show *90210*, a girl almost loses her boyfriend and her life in a depressive episode, freaking him out with her wailing and almost jumping in front of a train,

before she is saved by medication. In *You're the Worst,* the biggest obstacle in the protagonist's love life is her depression, which often leaves her housebound and surrounded by tissues, until she agrees to take her pills regularly. By the show's finale, she's medicated and engaged.

I watched *90210* in high school, and during the commercial breaks, antidepressant ads played. The one I remember most vividly was for an antidepressant called Pristiq, featuring a woman and a wind-up doll. The ad starts out desaturated, the woman's skin sallow and her lips chapped. "Depression can take so much out of you," the woman began, before describing how it robbed her of her energy, her good moods, and her interest in life. She said she felt like a doll she had to wind up just to get out of bed, which is where the little porcelain girl comes in, in a pink dress with a metal screw in her back. She's stooped over and gets close to standing up straight when the woman winds her up, but she doesn't make it, stuck instead at an odd angle.

Suddenly the color comes back into the video.

The woman's skin is bright, just like her facial expression, as she watches the doll. She is no longer slumped over. She walks. "Ask your doctor about Pristiq," the narrator says. Sounds like "pristine," I thought to myself, looking around at my depression den of a room, takeout containers and clothes covering the floor, and watching the woman's freshly moisturized lips tip into a grin.

I watched these shows after dinner but before I took my bedtime antidepressant. I was first prescribed the SSRI escitalopram, brand name Lexapro, at age thirteen in an outpatient eating disorder clinic, after my first encounter with the dangerous depths of my desire to be thin. None of this seemed that out of the ordinary: I knew girls hospitalized for eating disorders, and though I hadn't looked up the following statistics then, I don't think they would have surprised me. Over 13 percent of American girls will experience eating disorder symptoms in their teens, and 97 percent of inpatient eating disorder patients have a comorbid mental health issue. To me, taking a drug seemed the obvious ending to that story. Of course I needed an antianxiety medication to start eating again, my doctors told me; otherwise eating would retain its power to inspire nightmares and panic attacks. They promised me I'd be calmer

and happier, and I'd seen it happen. My mother used the word "malaise" to describe her weeks in bed, which didn't sound medical, but I saw the pill bottles on her nightstand once she started popping out from under the blankets in the morning. I'd seen similar bottles in the bathrooms of other female relatives when I snuck in to see which women in my family were like me.

I'd also read about these pills in Elizabeth Wurtzel's 1994 memoir, *Prozac Nation: Young and Depressed in America,* a cultural artifact that also functions as direct-to-consumer advertising for Prozac. Wurtzel is the cover model, her name scrawled in large, faux-handwritten letters over her visible midriff. Her hair is greasy, unwashed and uncut, falling down to her taut, exposed stomach. She looks young, free so far from laugh or frown lines, though there's a slight groove of worry on her forehead. She looks like a girl who would definitely get ID'd at a bar but would also definitely get in, even if she had to bat her eyelashes at the bouncer. In her story, she cries a lot. She checks into psych wards. She does drugs, drinks to excess, attracts boys and men but can't keep them. Through it all, she returns to the refrain that she wants to *become herself* again, the girl growing into a promising young woman. Men are driven away by what are either her symptoms or her antics, depending on whom you're asking. She inhabits the trope of the woman who has lost her normal, happy self and become someone else, someone who interrupts her man's days with her moans. At one point, a boyfriend dumps her because he wants to play basketball with his friends without worrying that she is off sobbing somewhere.

The book ends with a paean to Prozac, *the miracle that saved my life and jump-started me.* The *New York Times* review read not unlike pharmaceutical ad copy, describing Wurtzel as "one of the first people given the antidepressant fluoxetine, brand name Prozac, which righted a diagnosed chemical imbalance just enough to enable her to mix the metaphor quoted above and write this book." While denigrating her prose, after all she's just a girl talking about herself, the reviewer credits Prozac with ridding the world of someone whose life consisted of "disagreements with mother [that] turn into screeching denunciations;

spats with boyfriends [that] become tear-drenched Armageddons." In other words: a shitty daughter and shittier girlfriend.

Like SSRIs, the book was a best seller. SSRI prescriptions doubled in the United States between 1995 and 2002. *The Guardian* described Wurtzel's writing as "both glamorizing and pragmatic," two adjectives I would also use to describe antidepressant advertisements that depict forlorn women with perfect blowouts and women doing mundane household chores while grinning.

The thing about SSRIs is that they may have made us happier, but often they also made us heavier. SSRIs like Prozac and Zoloft have been the most commonly prescribed antidepressants for decades now. These drugs—which function by blocking the reuptake of serotonin into neurons—are also associated with weight gain. Harvard Medical School's Women's Mental Health Resource has a devoted subpage for "Antidepressants and Weight Gain," *Psychology Today* has reported on the phenomenon, and a 2014 *Atlantic* article investigated "The Depression-Weight-Gain Cycle."

In America, heavy and happy too often feel like opposite poles, two places it's impossible to be at the same time, as the eating disorder statistics make clear. This is not true for all women and girls, obviously. For many women suffering from clinical depression, SSRIs vastly improved their quality of life, and the accompanying weight gain was a minor inconvenience. But a subset of us found the fog lifted, our vision clarified, and our reflection in the mirror suddenly distressing. Back into the fog, thought some of us. I can't look at that. Others went back to their psychiatrists, asking about options.

The drug companies had their scientists get back to work, testing antidepressant formulations that "improved on [the] safety and tolerability" of SSRIs, in the scientists' own words. "Tolerability" is the term pharmaceutical companies have settled on to describe side effect severity, and the two side effects they found women consistently complaining of on SSRIs were lowered libido and weight gain. A drug called bupropion, marketed under the name Wellbutrin, not only didn't seem to cause weight gain, but often incited weight loss. In trials, scientists

reported efficacy rates about as high as SSRIs compared to placebos, while patients not only maintained their starting weights but often lost a few pounds and experienced increased libido.

The pharmaceutical companies realized they had a moneymaker on their hands, with one caveat, a messy side effect. While Wellbutrin evaded common SSRI side effects, it caused seizures in some cases. Its manufacturers slapped a warning label on the bottle and kept running trials as the drug went to market. Soon after its release, patients started ending up in emergency rooms after seizures. The prevalence of seizures was too high in bupropion users in general, but a small, then unpublished study discovered a startling concentration of seizures among bulimic women prescribed the drug: four out of fifty experienced a seizure. The drug company that manufactured bupropion—Burroughs Wellcome, which was later purchased by GlaxoSmithKline—temporarily pulled the drug from the market while running its own studies. A 1989 trial found that .48 percent of all patients, or one in two hundred, taking the then target dose of 450 milligrams experienced a grand mal seizure.

The other alarming study had specifically investigated bupropion and bulimia. The drug had at first seemed like a perfect fit for eating disorder patients, usually also diagnosed with depression or anxiety but often resistant to SSRIs out of fear of the weight gain associated with them. They began eagerly swallowing a pill that promised to protect them from extra weight. Their doctors reported harrowingly high seizure rates. Bulimics had been considered ideal candidates for Wellbutrin, as doctors assumed the drug's correlation with weight loss indicated it could prevent binge eating. The doctors hadn't thought about the purging part, the fact that frequent vomiting alters electrolyte levels, elevating seizure risk, as bupropion already does, or that the drug's stimulant effect can suppress hunger, exacerbating restrictive eating disorders and malnourishment, which in turn also heighten seizure risk. The 1988 study on treating bulimia with bupropion reported objectively terrifying results: a successful reduction of binge episodes, while 7 percent of patients had seizures.

The seizing women were a PR disaster for the drug manufacturers, so they set their scientists to work developing a formulation with a lower seizure risk. In 2003 GSK released a new extended release capsule with

a maximum dose (450 milligrams—the former target dose) instituted to prevent seizures. Wellbutrin's label now notes its contraindication with eating disorders, but GSK still spent much of the 2000s marketing Wellbutrin in part as a "skinny" pill. When Wellbutrin was first rereleased, the director of the Public Citizen's Health Research Group worried its weight loss reputation meant it would still be sought out by people with or at risk of eating disorders, fearing that those "in the same risk category that they took the drug off the market for" were still in danger, especially if its weight loss effects were advertised.

A 2004 advertisement directly targeted patients frustrated by the side effects of their current SSRIs. The advertisement depicts a woman laughing in the center of the frame, as a man paddles them across a lake in a canoe. The sun is shining, and the text reads, "Wellbutrin XL works for my depression with a low risk of weight gain and sexual side effects. Can your medicine do all that? Experience Life." The message is clear: in the world of these ads, a full life is a skinny, heteronormative one. Another advertisement shows a woman's face in the foreground, eyes closed and smiling, as a man whispers something, presumably sexy, in her ear. This sentiment runs throughout Wellbutrin's advertising campaigns and is also a prominent current in media coverage. The question becomes: If you can become a sex-crazed Barbie doll, won't the rest of your life fall into place? Who wouldn't hire her or fuck her, or hire her and then fuck her on the office copier?

These days, your choice of antidepressant is just one more in a long series of consumer decisions that define your identity. In an era when girlbosses sell self-care, women are expected to vigilantly monitor our bodies and minds for any sign of dysfunction. If we find one, we can research it ourselves: on WebMD if we're looking for a pseudo-professional opinion, on Goop if we're looking for a celebrity opinion, and on social platforms if we're looking for our friends' or a stranger's opinion. We can monitor our heart rates and sleep quality on our Apple Watches, and record how our diet affects our weight and our moods in apps. Our new and ever-expanding ability to self-surveil has met our long-standing drive to self-improve. We fear that a failure to optimize

our bodies and minds might keep us from achieving the perfect life, the one we want to Instagram.

One in four American women takes prescription psychiatric drugs, according to a 2011 report. CDC data on psychiatric prescription patterns in the first decade of the twentieth century reported an almost 400 percent increase in antidepressant use over the course of the decade. Women are over twice as likely to be prescribed antidepressants as men, and this disparity appears across age groups. Today, an eleven-year-old girl may be about to embark on her first psychopharmacological journey, and she might also already be on her first diet. If that child also spends time on TikTok, where high schoolers in their bedrooms make videos about losing their appetites on Wellbutrin, she might ask her psychiatrist about the drug and end up popping a pill that enables a nascent eating disorder.

Let's go back to college, to the girl in the bathroom who read that article and desperately hoped it was telling the truth. That night I pocketed my phone and went back to the bar. We danced and drank and shouted. I woke up hungover and hungry, so I dragged two of my friends out of bed and to the dining hall. I piled my plate high, poured batter into the do-it-yourself waffle iron, and mixed three types of sugary cereal in a bowl. I ate with my hands. My friend broke pieces of bacon in half and dropped them back on her plate. I picked up pieces of meat she'd pushed away and watched my fingers go glimmery with grease. We bussed our table and headed to the library, where I opened my laptop and googled "Wellbutrin weight loss" again.

I reread the article sober, so excited I almost felt drunk. The author described getting "trimmer without changing my diet or exercising more," and said she felt like a "veritable porn star" on Wellbutrin. I found another article titled "True Health Confession: 'The Pill That Made Me Happy, Horny and Skinny.'" I decided to turn to the experts and went to the Wellbutrin pages on the National Alliance on Mental Illness website. I learned that Wellbutrin is used to treat major depression and nicotine addiction, and that its most common side effects are dry mouth, insomnia, and weight loss. Under "What Should I Discuss

with My Healthcare Provider Before Taking Bupropion," alcohol and drug use and suicidal ideation are listed, but eating disorder history is not mentioned. At the very bottom of the page, four paragraphs into the "Rare/Serious Side Effects" subsection, seizure risk is described as "low," but apparently "increases" if you have an eating disorder.

Then I turned to the real experts, at least in my opinion: the girls in eating disorder forums who had never lied to me before. They reported better moods and lower weights, though it wasn't clear which caused the other. One wrote that *the "wellbutrin effect" (whether it is appetite suppression, hyperness, or just generally happier so not emotionally eating all day) is still working for me.* Another wrote that on Wellbutrin *I have no problem losing weight. . . . Sometimes I need to make myself eat,* and another called the drug *a win-win for my husband. Happier, thinner, hornier wife.*

I was sold. I searched through therapist listings, looking for a youngish woman on the Upper East Side. I thought a woman would be most understanding about my aversion to weight gain and desire for a higher sex drive. I figured one who worked on the Upper East Side would be interested in pleasing customers and lax with her prescription pad. A week after graduation, I had three prescriptions waiting for me: Wellbutrin, Xanax, and trazodone. Crinkly CVS bag in hand, I couldn't believe how easy it had been.

I'd read on the forums that some doctors refuse to prescribe Wellbutrin to recovered eating disorder patients, which was what I thought I was, but most of the women online seemed able to get the drug with enough perseverance. I expected a little resistance; what I got was extra drugs. Because Wellbutrin is also a stimulant, my doctor worried it would interact poorly with my anxiety, might heighten panic or make my intrusive, circular thoughts spin faster, so she prescribed Xanax for those moments. She also worried about my sleep schedule on a stimulant, so she prescribed me a sleeping pill. I left the pharmacy weighed down with drugs, hopeful I'd feel lighter soon.

In 2005, Wellbutrin was the twenty-first most commonly prescribed medication in the United States. In 2012 GlaxoSmithKline pleaded guilty to illegally marketing Wellbutrin as a drug that could spur weight

loss and increase libido. In 2016 I got my first prescription for Wellbutrin from a doctor who knew about my disordered eating. The lawsuit brought by the U.S. government alleged that GSK hired public relations firms to encourage off-label use, the official term for prescribing a drug for something it is not approved by the FDA to treat. The suit documented a corporate pattern of paying doctors, giving free samples to pediatric psychiatrists despite the heightened risk of suicide in children, and hosting supposedly "independent" medical events promoting the drug. The company paid TV doctor Drew Pinsky $275,000 in advance of a show in which he said Wellbutrin made a woman come sixty times in one night and helped her shed pounds. An internal GSK memo reported that 387 million people had come into contact with some form of media touting Wellbutrin as the "happy, horny, skinny" pill. GSK settled for $3 billion. It probably considered that the cost of doing business, and a reasonable one, because potential patients clearly weren't alienated: by 2020 the drug had moved up three places in the rankings. It was prescribed 28.8 million times that year.

Ainsling, eighteen, said her doctor put her on Wellbutrin when she was in ninth grade, after the lawsuit against GSK and the FDA's warning about the drug's contraindication with eating disorders. *I was never told anything regarding the fact that it is not supposed to be prescribed to people who have or are at risk for eating disorders,* she told me. *I was a [redacted]-pound, five-foot girl, so I guess he didn't really see me as anyone who might have an eating disorder.* Asking patients about contraindicated conditions and alcohol or drug use before prescribing them psychiatric medications is a regular practice at psychiatrist offices. Yet the patients I spoke to said their doctors did not ask about whether they suffered from eating disorders. In turn, they were prescribed drugs known to interact poorly with and exacerbate the illnesses.

Once her doctor prescribed the drug, Ainsling did some research, found out about its weight loss effects, and *used it to fuel my eating disorder.* Similarly, after reading about its weight loss effects, Sierra *became obsessed [with taking Wellbutrin]* and *found myself super deep into subreddits about eating disorder recovery talking about how Wellbutrin made them lose weight.* Another patient said her psychiatrist introduced her to the drug in 2019 and did not tell her about its contraindication with eating

disorders. *I'm overweight, so I'm not sure he was worried about me having an ED*, she said.

Like me, Rachel first heard about Wellbutrin from a friend, one who had wanted to switch to the drug because she heard about its supposed weight loss benefits. *My doctor did not mention anything about eating disorders*, Rachel said. *I have a "normal" BMI, so I physically didn't look sick*, though she was suffering from an eating disorder when her doctor prescribed the drug. She described her year plus on Wellbutrin as a *rollercoaster*. Initially, she lost weight, and began losing more once her doctor prescribed a combination of Wellbutrin and another drug. The drug-induced weight loss, she said, *made my eating disorder worse because I felt motivated*. Lia heard about Wellbutrin from a doctor in 2014, when she was a teenager. They did not ask if she had an eating disorder and *said it would help me lose weight because at the time I was super fat*, she told me. Lia struggled with eating disorder symptoms while taking the drug. *It also contributed to an eating disorder relapse, 'cause I started taking it and lost [redacted] pounds and then was like, "I must lose more."*

According to Dr. Frank Greenway, the chief medical officer at Pennington Biomedical Research Center, who has studied Wellbutrin's potential as a weight loss drug for obese patients, medicine has moved away from a paternalistic model, wherein the doctor is considered the unequivocal expert on the patient, toward a model where decisions about medications are made through dialogue between patients and doctors. It is common practice for doctors who are prescribing medications to ask patients if they have contraindicated conditions—for example, if a drug is not recommended for people with high blood pressure or diabetes, doctors ask patients if they have these conditions, rather than assuming they would disclose them first. Yet with eating disorders, the onus of disclosure is on the patient. Greenway told me that because there are so many mental health conditions, "those diseases understandably might not be discussed in the conversation leading to the choice of a therapy." This assumption, alongside the expectation that patients are doing their own research, can end up endangering people with eating disorders who are hoping to lose weight, whatever the cost.

While the turn toward open doctor-patient communication seems at first like a road toward reversing the Western history of overmedicat-

ing women, it finds itself up against a medical system in which doctors neglect the epidemic prevalence of eating disorders. The questions doctors ask—or don't—in the precious span of time before anything is written on a prescription pad have consequences, and for many vulnerable young people, the current model is sending them down the rabbit hole, and onto the internet.

On Reddit, there are threads like *i miss my skinny pills* and *somehow managed to get myself wellbutrin without even trying* where people describe doctors who prescribed them the drug without asking if they had an eating disorder history. Someone waxes nostalgic for Wellbutrin-taking *skinny me.* Another user writes about seeing a psychiatrist after being hospitalized for self-harm and receiving Wellbutrin she knows will enable her eating disorder: *maybe this'll give me extra skinni and give me back my will to live.* Some people posting about Wellbutrin online cite reports that it's dangerous if taken while restricting food and drinking. Others tweet about the seizure risk, but they write in an irony-soaked tone that approaches the issue as more of a vague bummer in the final calculus than a deal-breaker. Someone tweets, *Wellbutrin gave me a seizure so like, pinch of salt ya know.* Another online poster recognized that the drug could cause an eating disorder relapse and wrote about considering taking it anyway. They wrote about going through an inpatient eating disorder clinic, only for their doctor to *fuck up. He prescribed me Wellbutrin XL. . . . Time for a relapse?*

Someone who has never been one of these girls might read these messages, jaw slack, and roll their eyes. In most, the writers relish or yearn for Wellbutrin's ability to suppress appetite and spur weight loss, and they seem to consider its potential antidepressant feature a possible nice side effect. But that's an outsider's reading. As someone who has been one of these girls, I remember that mindset, the way an eating disorder warps your logic, transforming thinness into an ideal to be achieved at any cost, one with a mirage as its goalpost, dissipating into the distance as you approach it. Eating disorders are illnesses that skew priorities as much as self-image, fostering thought patterns that are all

too easy to fall back into, ones I have found myself slipping toward when I scroll the Wellbutrin tag for too long.

On Wellbutrin, I marveled at how much food I could leave on a plate without the old ravenousness clawing at my stomach, and I marveled at myself in windows on the street. I used my body on Wellbutrin as a battering ram against my self-loathing and sadness—distracting myself from reflective moments with reflective surfaces.

At my postgrad job, I took an extra long lunch and a cab to the Upper East Side once a week. I sat across from my therapist, with her highlights and her ringlets and her cashmere sweaters, and usually I cried. She kept increasing my dose of Wellbutrin. On it, air tasted like gasoline, crispy. I was wide-awake, and my mind felt like a book I was reading: I could tell that it was trying to describe emotional pain, but I couldn't feel it. Well, sometimes I did, excruciatingly, but I had Xanax for those days.

I had a job in fashion. My coworkers and I were fun-house-mirror versions of each other, well-educated brunettes in our twenties with slightly different coping mechanisms: specific diets, specific spirals. One of my friends was on Whole30. Another ate the same salad from Juice Press every single day. Another swore by "the cabbage soup diet," a system she'd been taught by her grandmother, apparently invented by World War II–era dieters. Some of us liked vaping, others liked to do coke on the weekends, some liked teetering on the edge of a blackout at happy hour.

We showed up to work hungover and gnawed on the straws of our iced coffees. In our cubicles, we typed away. We sent professional emails rife with exclamation points, always started with apologies, prefaced requests with "just wondering." We made sure the crossbody bags and stiletto heels were ordered from warehouses and on their way to stores. We told our bosses they had good taste. The words tasted creamy, sweet, stuck between our teeth like the frosting on the cupcakes our bosses bought us on our birthdays, which we took one bite of and then threw away. We smiled and nodded and worked overtime and applied for promotions. We instant messaged each other about weekend plans

and death wishes on the intra-office message system. Secretly, we hoped someone in HR was reading them, but no one was.

During lunch, I wandered through Midtown, my hopelessness somehow buoyant. My mind was like a balloon that had slipped out of a kid's sweaty hand. It was overfull with nothing, stretched taut, floating languidly out of my line of sight. It would pop eventually, but by then I'd be somewhere else, out of earshot. I started imagining freak accidents while I was working out. Paranoia is another lesser-known side effect of Wellbutrin, as are fantasies of violence and self-harm.

In September 2018, Drs. Yael Dagan and Joel Yager—one of the doctors who authored the study on terminal anorexia—published a case study in the *International Journal of Eating Disorders*. The report told the story of a twenty-one-year-old's Wellbutrin abuse. Is a twenty-one-year-old a woman or a girl? I don't know how to write about her without making her struggle into a manual or a vision board. But I am going to try to write about her anyway, because hers is one of the few academically documented cases of Wellbutrin abuse and the interaction between preexisting disordered eating and a Wellbutrin prescription in the wake of GSK's lawsuit. I will try to write her story clearly and concisely, without the aestheticizing that ends up canonizing victim-heroines. You have to die to become a saint, and what I'm trying to say is that life is worth living. There are already enough stories about enthroned skeletons, glamorous dead girls, and I'm trying to convey the barren emptiness of the view from up there. I don't mean to sound callous, I love this girl like a sister, but I'm trying to stop making martyrs of women who didn't have to hurt.

The doctors called her Ms. A. At twenty-one, she started taking Wellbutrin. She had been hospitalized twice in her teens for eating disorders, both anorexia and bulimia, as well as self-harm and suicide attempts. The doctors met her when she was twenty, an inpatient in their eating disorder clinic. After her release, she set out to get prescriptions for Wellbutrin in order to lose weight, requesting and receiving prescriptions from two primary care doctors whom she did not tell about her eating disorder history. After six months of taking much more than

her prescribed daily dose, she suffered a grand mal seizure that sent her to the emergency room. She continued to take the same amount of Wellbutrin daily and had another seizure two months later. The report's writers, her doctors, emphasize that she "well understood that the seizures resulted from her bupropion XR abuse, and she was strongly advised to stop using it, but she nevertheless continued her abuse and continued to lose weight." Ms. A was clearly abusing the drug: taking multiple prescriptions' worth per day, consuming more than double the maximum prescriptible daily dose. But with a drug that is known to cause seizures in the eating disordered, shouldn't those girls on Twitter, shouldn't I, be construed as abusing the drug too? After all, we were explicitly using it to enable another illness, putting ourselves at risk of seizure in the process.

On nationaleatingdisorders.org, there is a forum where eating disorder sufferers who want to get well post about their victories, relapses, intrusive thoughts, and panic attacks, and comfort each other. There is a thread called *Wellbutrin XL and eating problems* . . . started by a user who writes:

I'm on Wellbutrin XL and if I don't take it, I get anxious because I actually feel hunger without it. I am afraid to stop taking it but it feeds into my restricting. . . . I mean I feel trapped. If I take it I can be okay with how much I eat a day plus my exercises (however I do get really dizzy come midday) anyway, when I don't take it id eat the same amount but feel I have to purge. Or I'd eat a little more and feel like purging. So when I don't take it I am unhealthy but when I take it I am unhealthy. Since taking it people I knew before I shut everyone out tells me how much [weight] I've lost. . . . But it makes me all the more never want to stop taking this medicine. . . . I'm not sure what to do without it. I'm not sure what to do period.

She never posted on the thread again. I hope she got well, but I am afraid for her.

I remember the party blush-coated, but that can't be right. In my mind, we're all shades of orange, in our summer skins at golden hour. It was

a party thrown by a group of guys we were friends with in college, the type of party I liked during this period, when guys who once looked through me hit on me and girls complimented how small I'd gotten. One such guy started a conversation. I added liquor to my cup of the sugary punch everyone was drinking so I could get drunker on fewer calories. He asked if I wanted to go dancing with him and his friends, and he was hot and laughing at my jokes and I could tell my friends were impressed, so I said yes and then we were in an Uber and then we were drinking and then we were dancing and then we were in my bed.

In the morning, he tried to touch me, but I rolled away and said I was feeling kind of weird. Normally, I went to an exercise class on Sundays no matter how weird I felt, but I really didn't feel like I could do anything that morning. After he left, I texted a friend and asked if I could come over. I was nauseous and dazed on the L train, unable to attach my thoughts to each other in order, but I figured it was the hangover. In her apartment, I sat down cross-legged on the hardwood floor, facing my friends on the couch, and we began our traditional trading of anecdotes, who'd said something funny and who'd been flirting with whom. Halfway through a story I was telling, I felt the familiar dread start to seep in. I wondered if I'd been fun to fuck and if I'd said anything embarrassing.

The last thing I remembered when I woke up was the party. I thought I was still there. I was on my side and assumed I'd fallen. Blinking hard, I recognized my friend's apartment, but not the red boots or the legs in front of me. I don't remember what they asked me, but I remember them telling me it was Sunday morning, and I didn't understand, and I passed out again. When I woke up the second time I stayed awake, and the EMT told me I'd had a seizure, and my friends stood behind him looking scared.

In the hospital, when the doctor asked me if any of my prescriptions had changed recently, I told him that my doctor had just increased my daily dose of Wellbutrin, and he looked me up and down with raised eyebrows, shaking his head. He told me the dosage I'd listed was a high dose for a man, sometimes called the "seizure dose" for women by doctors, in private. It was late afternoon by then, and he said I should stop

taking it and discharged me onto the Brooklyn sidewalk, back into that golden-hour light.

Immediately after it happened, I didn't think it was worth writing about. I didn't understand myself as a victim of a grand conspiracy by the capitalist pharmaceutical patriarchy, or even as a collateral casualty of a well-intentioned capitalist pharmaceutical patriarchy. I blamed my therapist to anyone who would listen, and blamed my disordered eating and my drinking and my drug use to myself. I went off antidepressants completely, cold turkey.

There were months of withdrawal: thoughts that cut like razors, no longer coated in cellophane, slicing through my suddenly ravenous, lethargic days. Without the drug to provide a floor, my stomach felt bottomless, and without the drug's windowpane effect on my mind, I actually felt my emotions. I still miss my Wellbutrin body sometimes, and other times I miss my Wellbutrin brain, addled and apathetic instead of drenched in emotion, swampy. My friend doesn't take it anymore either, and sometimes we talk about our time on it, laughing nervously, hiding our wistfulness. I want to be above it, a woman who loves all bodies, even my own, and hope I will become her one day. But I don't blame myself anymore.

The history of women and their psychiatrists is long, and when I accept my membership in the sorority of female patients, I watch my adolescent body get thrown like a pebble into a pond. The blame ripples out, past my therapist, another woman floating on her back in the water, into green fields of money and men. I see magazines filled with waifish models and antidepressant ads I flipped past on my childhood bedroom floor. I see the Instagram ads that still pop up on my feed, offering me mental health quizzes and meditation for women apps and Gwyneth Paltrow's Netflix show and diet tea. I see the eating disorder memes and weight loss progress Instagram accounts and slim, smiling influencers, and wonder how I could have ended up anywhere but at the bottom of the lake.

Coda

Against Dissociation Feminism

Years ago I screenshotted a tweet and sent it to my best friends. Most of them had already seen it, because it had over eighty thousand likes and eighteen thousand retweets, many by women I respect and admire. The tweet read: *what i love about my friends is that 70 years ago we all would have been lobotomized.*

I sent it to a group chat I had ironically named "Female Hysteria" all the way back in 2016, when we thought we might be reclaiming the word. We were women, and most of us had at least one psychiatric diagnosis, though the name felt fitting for reasons beyond our officially disordered minds. *Lmao same,* I wrote under the screenshot in the group chat, even though something about the tweet made me vaguely uneasy in the same way a lot of feminist media does these days.

I've noticed a lot of brilliant women giving up on shouting, complaining, and protesting, and instead taking on a darkly comic, deadpan tone when writing about their feminism. This approach presents overtly horrifying facts about feminine struggles and delivers them flatly, dripping with sarcasm. Maybe it's a curdling of the hyper-optimistic, #girlboss, "Run the World (Girls)" feminism of the aughts, which was characterized by an uneasy combination of plaintive begging and swaggering confidence that gender equality was just past the horizon line. But *Sex and the City* and *Cosmo* tutorials on how to come didn't make much of a crack in the glass ceiling. So instead of shouting loudly enough to shatter it, we now seem to be interiorizing our existential aches and angst,

smirking knowingly, and numbing ourselves to maintain our nonchalance. Let's call it dissociation feminism.

What I am calling dissociation feminism began with the denial of a trope: women irritated at the assumption that we were always on the verge of opening our laptops, gazing out the window, and monologuing like Carrie Bradshaw about our oppression or the man who just left us. Leslie Jamison called it "post-wounded," a state characterized by "jadedness, aching gone implicit." She saw it in the girls of *Girls*, insulting each other for wallowing in their self-pity, and in a feminist scholar who told Jamison she was "so tired" of Sylvia Plath.

The internet is integral to dissociation feminism's allure, and practice. Take Twitter, perhaps the perfect medium on which to dissociate. Tethering the tweeter to nothing but the cloud, disconnecting words from context, not to mention the body that never had to speak them. Dasha Nekrasova's meal-tracking Twitter account also includes posts like *nice and dissociated after pilates and a Brazilian wax.*

I know what she means, as someone who has dissociated—which is not to use the word's medical definition, but to say, willfully detached my consciousness from my immediate bodily and emotional experience—during both. These activities involve physical discomfort in the service of impressing a future outside observer, so dissociating is essential both to gritting my teeth and getting through it and understanding why I am doing so. I am flapping my arms in a crunch alongside twenty other people who also want to "strengthen the core" (read: carve abs into our stomachs). I am getting hot wax applied to and then ripped off the most sensitive part of my body, so someone will have something soft to touch.

The rise of the internet as a means of mass communication seems to have opened up a lot of new ways to dissociate. In 2017, alongside a photo of her bruised body, the journalist Helen Donahue tweeted *sux men in media hate women yet write abt feminism n masquerade as allies but its sadder this happens. 2015 I screamed @ my own reflection.* This might be the apotheosis of a sober dissociation: giving the internet access to an old version of your body, one someone else violently left their mark on, and captioning it in the modern language of abbreviations, both of words and emotions. Writing for *n+1* about the experience of see-

ing accusations of abuse she made on Twitter published by the *Daily Mail*, Dilara O'Neil describes *a disturbing multimedia collage that reads strangely stilted, as if not written by a human at all.* This is the dissociation of tweeting your trauma, then realizing it's been swallowed up and regurgitated by an algorithm.

The *Daily Mail* could drive anyone to dissociation, and according to my younger sister, it is where a lot of teen girls get their news these days. She has told me that on most days the *Daily Mail*'s Snapchat story tells her what Emily Ratajkowski is wearing and then something along the lines of "Middle school teacher spied on teen students in bathroom." When I clicked through recently, I saw Emily Ratajkowski in a high-waisted bikini, as promised, and then I saw a photo of a pop star overlaid with the words "slim & sleek: 'I used to cry but now I sweat,'" and then "Being called fat broke my heart: Model reveals how an insult when she was 13 pushed her to shed pounds," with before and after photos of the model. All of this tells my sister that she should try, above all else, to be hot—but if she succeeds, her teachers might spy on her in the bathroom. This lesson is objectively upsetting, but it is not necessarily wrong.

So: many girls learn to dissociate early, usually in early adolescence but really whenever we first notice the way our outfits and makeup or lack thereof can provoke reactions. We adopt the daily, quotidian dissociation of getting dressed in the morning or preparing to go out at night, a process that involves stepping out of your body to see it from the outside and dressing it depending on the occasion. We are witches, dissociated fortune tellers, predicting whether an outfit will get us asked out, or taken seriously, or simply left alone.

Soon after, many women—particularly those who engage in relationships with men—learn to dissociate during certain types of sex. In Kristen Roupenian's viral short story "Cat Person," during sex the protagonist does not want to be having, she *imagined herself from above, naked and spread-eagled.* She leaves her body to watch herself. The story went viral, with women of all ages proclaiming on Twitter that they have had this sex. A new sex position: the bird's-eye view.

The characters of *Sex and the City* and *Girls*—not to mention Nekrasova, Jamison, Plath, Roupenian and her "Cat Person" protagonist—belong to a subset of women who undeniably have it much easier than

most. They are white, attractive, have a certain amount of class privilege, and are intelligent and witty. As Shannon Keating put it in her analysis of *Three Women*, Lisa Taddeo's ode to heterosexual female despair, what is most "dispiriting" about the "swirling conversation around . . . women's loneliness and fragility and heartache and unhappiness" is that it revolves around women "with the whole world at their feet." Rebecca Liu pointed out a similar trend in the "archetypal Young Millennial Woman" of *Girls*, *Fleabag*, and Sally Rooney's novels, writing that this woman is "pretty, white, cisgender, and tortured enough to be interesting but not enough to be repulsive. Often described as 'relatable,' she is, in actuality, not."

There seems to be a platonic ideal of the beautiful, depressed woman, and I find that her unrelatability is an integral part of both her appeal and the spark of revolted recognition in my gut when I watch her, or read her, or yearn to be her. These women are both vindicating and distressing: If Rooney's skinny, precocious Irish beauties are this upset, then certainly I have every right to give up on the world. On the other hand, giving up on progress is perhaps the epitome of white feminism; it promotes a nihilism that is somewhere between unproductive and genuinely dangerous.

But rather than "post-wounded," I actually found the girls of *Girls* pretty openly wounded and addicted to picking their scabs. Hannah Horvath didn't dissociate but instead lived fully within her skin, no matter how uncomfortable it was. She sobbed and bled, stuck her fingers deep inside herself and Q-tips too far down her ear canal. She begged people to love her and contorted her body according to the instructions of the men she went to bed with. She obsessed over petty insults and passing slights.

When *Girls* was on television, almost everyone found Hannah (and the rest of the show's characters) annoying, self-centered, and simply gross, from critics to the masses. Hannah was included in *The Atlantic*'s list of worst TV characters ever (where she was compared to Hannibal Lecter), and *HuffPost* called her "one of the most disliked characters on television, and that's including all the villains, anti-heroes, and sociopaths."

As *Girls* entered its final seasons, we began watching Fleabag, the

title character of Phoebe Waller-Bridge's hit series, engage in much of the same bad behavior Hannah practiced: drinking to excess, picking fights with people close to her, fucking near strangers and her friends' lovers, diving into a seemingly infinite well of desire and emerging dripping in her own self-interest. But Fleabag deftly evades the accusations of whining and wallowing hurled at Hannah because, instead of complaining during moments of turmoil, she simply dissociates.

Fleabag is constantly leaving her body during climactic moments (breakdowns, sex, fights) and turning directly to the audience with snarky, often self-deprecating if not fully self-loathing commentary on whatever debacle is unfolding. In the series premiere, Fleabag's boyfriend tells her not to "turn up at my house drunk in your underwear. It won't work this time." Her boyfriend is tearful, but Fleabag turns to the camera with a half smile and tells us, "It will." Where Hannah's voice would have cracked, Fleabag's purrs.

Perhaps because Fleabag never whines or feels sorry for herself, just mocks herself from afar, we love her. Both seasons of the show were released to almost universal acclaim. *New York* magazine named *Fleabag* the best show on TV, and *The New Yorker* praised the way the protagonist "whispers a quip from the corner of her lipsticked mouth." Waller-Bridge took home multiple Emmys. While Fleabag and Hannah both get fucked up and fuck around, Fleabag would never blame society for her specifically feminine emotional traumas. Instead, she blames herself and makes a joke about it, which is much easier for the viewing public to swallow. Hannah called herself a capital "G" Girl, told us that we weren't watching TV but were instead looking in a mirror, and we threw a knife at it in self-disgust. Fleabag describes herself as a rotting, insect-infested pile of trash, and we applaud, smug in our new understanding of womanhood.

The dissociated girl of *Fleabag* might be the cool girl or chill girl's cousin, just as the desperate girl of *Girls* might be the hysteric's. While the hysteric shrieks, the chill girl speaks slowly, raspy. She is coughing on the weed smoke. I have heard boys describe her as "down." This is a chilling adjective for the chill girl: it requires that she have no conflicting plans of her own, no strong desires to counter his. At its etymological

core, "down" implies subjugation. Is a chill girl laid-back? Maybe, but she is probably also pretending, and bored.

I have tried to be her. I have tried to become agreeability distilled to a fine cognac, my compliments so potent they could get the strongest boys drunk. But I am much closer to Hannah than Fleabag. I can't totally dissociate even in blackouts and am always being told I called someone crying, or waking up to see I sent craven, abject texts I can't bear to read.

Rachel Syme, writing about Natasha Stagg's essay collection *Sleeveless*, finds that "dissociation is always better than desperation." She admires Stagg's emotionless, out-of-body ruminations on being a woman for their winking refusal of self-pity. In that collection, Stagg seems to find feminism that demands too much change just a little bit desperate. She describes an ideology that "rushes in and trips over itself, the fast-talking blowhard." Stagg seems embarrassed by the shrieking sisterhood of her forebears, but she is not denying that they had a point. Talking about feminism with friends, I often find us rolling our eyes and making jokes, attempting to make the perfect, pithy, ever-elusive quip about womanhood or feminism from the corner of our own lipsticked mouths. We modulate our tones, fear accusations that we're ranting, or whining, or getting distracted from facts by feelings.

As Zoe Hu writes in her own study of the studied seriousness feminists adopt to evade the sullen and silly allegations, our obsession with appearing emotionless contains within it a betrayal of our fellow women, pivots on "the implication that other women, even in attempting to transcend their sorry lot, cannot help but act like women: meaning, emotional. Meaning, stupid." Fast-talking blowhards, desperate girls. Women relying on emotional detachment to earn intellectual clout while also dulling their pain isn't a new phenomenon. Mary McCarthy's "The Man in the Brooks Brothers Shirt" featured a woman dissociating during sex in 1941. Elizabeth Hardwick was distancing herself from Adrienne Rich, whose poems basked in their pain and blamed the world for most of it, in 1951, writing, "She deliberately made herself ugly and wrote those extreme and ridiculous poems." On the flip side, she lauded McCarthy as a "determined rationalist" who refused "tribal reaction" in gender issues, chose seriousness over sisterhood.

Speaking of blowhards: a 2018 study of heterosexual behavior on dating apps found that advanced degrees are correlated with a decrease in matches for women. My own dating profile used to list my occupation as "grad student" in self-effacing lowercase. It also listed my favorite foods, a performative assortment of the fried and fattening things I ate only in front of other people, to make them think my body was an accident. This is part of the chill girl act, and it involves a complete commitment to that bird's-eye view of your life, an ability to disconnect mind from growling stomach.

It is also a rejection of wellness optimism—when we thought happiness was on the horizon, some of us thought it might be nice if our bodies were healthy when we achieved it. In her 2016 novel *Problems*, about an anorexic opioid addict, Jade Sharma wrote that *smart women are supposed to say certain things,* and one of those things is that they care about being healthy, not skinny. This is the perky influencer Instagramming her post-workout acai bowl, claiming the image represents her quest for mental equilibrium and is unrelated to her desire for a certain body.

The dissociative feminist, in contrast, simply refuses sustenance and laughs hoarsely at that influencer's lies, while living sometimes within and sometimes outside the craggy body society adores, surviving off men's lustful gazes and other women's jealous ones. Instead of starving in silence, these women tweet jokes about how they live up to unfair standards. Cat Marnell, replying to a troll who tweets that he would not invite her to a barbecue: *i don't want to be at your cookout; i don't even eat.* Nekrasova tweeting *delirious anorexic coming through.* Sharma describes hunger as *the vibration you felt under your feet on a train.* When I was starving, my mouth found sensation in things that were not strictly food. Compliments tasted bittersweet like dark chocolate, saccharine with an edge of musk, something suspect that sunk into my tongue and stayed there.

I used to have a weekend routine: blacking out at night and taking a Xanax midmorning, when the questions about what I had said or done began to gnaw at my brain, which was tender already from the chunks taken out of it the night before. Once I was benzo content and basically lucid dreaming, I recounted my high jinks to friends from a safe distance, wove threads of my nights into cogent narratives of the girl who

goes out at night and sometimes goes awry, and sometimes I lied, and sometimes I started to believe my own words.

These days, there's a new feminist on our screens. A retro pinup with fresh acrylics on her nails and syringes of filler in her face, experiencing an online renaissance. She's got a few tricks up her faux-fur sleeve, but one that's especially surprising, the last thing you'd expect from an e-feminist in 2023: she's happy. She arrived on TikTok declaring her feminism alongside the fact that actually, she's in a fabulous mood. She's had enough of the complaining and the crying, and she's just as sick of putting herself down. Done being the butt of the joke, she'd rather show off her ass on Instagram, rake in the likes and free dinners from men who'd like to do more than double tap. She is heavily made up, often surgically enhanced, blinking vacantly into the void.

A caption reads: *the feminine urge to dress like a whore and appeal to the male gaze.* In a video titled "Qs I Get Asked As a Bimbo," words float across the screen: "can u be smart?" *No, that's exhausting,* the hot girl replies. People ask if she "hates men," but the answer is obvious: *no, I don't hate my food* (translation: not if he's picking up the bill). *When you act a little slow, people take it a little easier on you,* another explains, to a chorus of praise in the comments section, including one fan's new motto: *don't ask what you can do for misogyny, but what misogyny can do for you.* A woman smirks in a video captioned *when they pay for another 1 ml of filler and buy u lunch #bimbofication.* Many of these videos are accompanied by a fragment of the song "Shake It Off," looping the line "got nothing in my brain" as people pout, pucker up, and preen. As *Vice* put it, "a large part of bimboism's appeal is in its potential to shield oneself from harm—smooth-brain style." Welcome to BimboTok, where "New Age Bimbos" are "reclaiming," rehabbing, and revitalizing the once derogatory term.

Years before brain-dead by choice bimbos took over TikTok, they were a staple in a particular subgenre of porn, in which characters are "bimbofied," aesthetically and intellectually transformed into the archetypal dumb, hot blonde. Watching this kind of porn, theorist and critic

Andrea Long Chu observes people instructed to "submit themselves to hypnosis, brainwashing, brain-melting, and other techniques for scooping out intelligence." This instructive, hypnotic mode is also in circulation on BimboTok, where "bimbo hypnosis" videos feature people purring Bimbo mantras (often about avoiding thoughts) as stereotypically hypnotic visuals—swirling curlicues, etc.—replace their irises. Long Chu describes an image taken from traditional porn, bimbofied: a woman sucks a dick until, according to the caption, "he breaks your tiny brain." That broken brain is not an injury but a victory. Long Chu quotes someone posting in a forum for devotees of this type of porn, who wrote that in their regular life, *my brain is always full. I'm always worrying. . . . Am I making good choices? Do people actually like me? How can I live in a country like this with this current political climate?* In today's world, she points out, "no one in their right mind would want to be a woman," and yet many of us are and do. Long Chu explores this contradiction in a project called Bad Politics, by which Long Chu means "what happens when subjects living under oppression just don't feel like resisting that oppression and do something else instead"—an apt description of both BimboTok's ironic embrace of a constrictively patriarchal fantasy of femininity and dissociation feminism's eye-rolling self-flagellation.

BimboTok takes the age-old adage that ignorance is bliss to a hyper-feminized, self-aware extreme. Bimbos' winking fantasies of brain-dead, paid-for pleasure might be a manifestation of "womanly nihilism," the political science scholar Robyn Marasco's term, via Simone de Beauvoir, for a feminine pursuit of power and privilege on an individual level at the expense of sorority and solidarity, in the face of a patriarchy so entrenched that the individual woman believes attempting to change it is futile. Marasco quotes de Beauvoir on mirrors, as I also will, because she might as well have been describing the selfie cam, filter added, and linked to a live stream: "The whole future is concentrated in this rectangle of light, and its frame makes a universe; outside these narrow limits, things are no more than disorganized chaos." Marasco finds that "the narcissistic will to everything and the nihilistic will to nothingness are but two symptoms of the same underlying sickness—a sickness that is not primarily subjective but social and historical." So the individual

woman adopts traits historically used to justify her oppression—the bimbo's embrace of unintelligence and superficiality—in order to get ahead in the unjust system, never mind that doing so entrenches stereotypes used to keep women as a class down.

This desire for personal pleasure at a collective cost is a "desire fanned by oppression," per Marasco, the nihilistic, narcissistic will to nothingness that is also a will to power, wanting it all, which leaves someone else empty-handed. It is the bimbo's desire for a man to buy her a meal after her years spent being underpaid and underestimated, never mind if she makes him believe women are idiots in the process. It is a bottomless hunger and a sweet tooth after years of anorexia. Anorexics end up with binge eating disorder after starving for food, and the former feminists, starved of respect, attention, and affection, become bimbos, posting their way to a yearned-for oblivion. We're all sick, and I'm scared, and I know I'm ranting, rambling, and certainly sounding desperate. But I'm worried that in emptying our minds of all the voices that have hurt us, we're losing each other too, settling back on the hysteric's fainting couch, which has always rested on another woman's glass ceiling, and pretending we're too dumb to notice.

So: the earnestly tragic heroine, the angry feminist, and the cheerful girlboss all appear to be dying breeds, denizens of the twentieth-century novel, the history book, and the now-empty corner office. On the internet, the dissociated e-girl reigned for a while and is now fighting the bimbo for the throne. While the dissociated feminist might have given up on fighting the patriarchy and decided leaning into its demands is her best bet, she's depressed about the whole thing. She's tweeting about it from bed, because that's her best selfie angle and she's too malnourished to get up anyway, which she'll tell you. The bimbo feminist, on the flip side, has decided that being depressed is depressing. It's a tale as old as time: the sarcastic brunette versus the faux-dumb faux blonde, trying to please patriarchal figures instead of talk to each other; a battle between nihilistic, individualistic hotties, neither of whom seem likely to get a happy ending.

In today's era of state, self-, and social media surveillance, we can

see ourselves and the girls we know we are supposed to emulate in ever higher definition. Up close and zoomed in, it can seem like there's no hope of cracking the bell jar, there's just documenting it, so we've been forced to get meta and made self-awareness our prized virtue. There is a sense that previous generations of feminists tried to change the workplace, family structures, and beauty standards, failed, and left us with nothing but sob stories and an internet sick of them, a web now hungry instead for our selfies and our sarcasm. So we starve ourselves in public and crack jokes about it, because that appears to be the only way to hack the patriarchy. We'll play by your rules, but we'll let you know we think they're fucked up. This rhetorical stance is integral to the creep of disordered eating symptoms into ever-larger swaths of the population, through its power to normalize behaviors and artificially lower the stakes of engaging in them. How bad can it be if she's laughing through it?

This all started with a tweet, and this year I was sent another viral tweet by friend after friend, with heart-eye emojis and eye-rolling emojis and *lol if only*s. It was a meme, a fake update to the website of Claire's, the accessory emporium millennial girls may remember as the go-to spot for proto-bimbo or Tumblr girl glitter and chokers. The shop also offered ear piercing, and the fake update promised another surgical service: "Front. Lobe. Lobotomizing. Is. Here. Book your appointment now."

In her 2017 book *Literally Show Me a Healthy Person* (famously spotted in Kendall Jenner's hands), Darcie Wilder writes sentences like *plan b is kind of a party drug,* and *I angHave to be Prettyty.* The emergency contraceptive Plan B isn't not a party drug when your definition of partying involves forgetting to use a condom in a blackout or acquiescing to not using one with your inhibitions down, which I'll admit mine can. The misspellings read like text messages mistyped drunk or high, clawing at a deeply ingrained mindset. Wilder wants to know *how come "put me out of my misery" only really means one thing,* which is death, perhaps the ultimate dissociation.

A disturbing corollary to the trend toward dissociation might be the trend toward suicide. Between 2007 and 2015, the suicide rate doubled for American teen girls. Suicide is the second leading cause of death for women under nineteen and third for women in the next age group, up to forty-four. When a beautiful, popular Ivy League college freshman died by suicide and left behind a perfect Instagram feed in 2014, huge swaths of America couldn't stop scrolling. The story was covered breathlessly, despite the fact that such coverage of teen suicides has time and again incited copycat clusters. Case in point: teen suicide rates surged in the month after the 2017 premiere of the Netflix series *13 Reasons Why,* yet another story of girl suicide. A suicide expert advised Netflix against releasing the show, advice Netflix ignored. Later a group of pediatricians wrote an op-ed describing their patients experiencing increased suicidality after watching. The show ran for four seasons. *This is my thirteenth reason,* my friends and I will sometimes say wryly, about some slight or rejection or depressing piece of news, our tone caustic and casual and, if you listen for it, hurt. A 2022 analysis of suicide rates by state found a correlation between a state's abortion restrictions and its suicide rate, which led researchers to posit that decreasing access to abortion will be accompanied by suicide spikes among women of reproductive age.

If all this is getting overwhelming, you might begin to understand the appeal of dissociating on drugs. In *Problems,* the narrator's friend uses heroin to numb her feelings and says that *death would only be a welcome side effect on the way to her goal.* Lena Dunham herself has been seduced by the daze of life on benzos. Her addiction worsened during the show's run. The first season of HBO's acclaimed show *Euphoria* opens with the fifteen-year-old protagonist Rue getting picked up from rehab by her mom. She is a perfectly dissociated chill girl, lanky and zoned out, fresh off an overdose and looking to score. *Euphoria* premiered in the summer of 2019, and we've now watched two seasons of Rue's harrowing trajectory through addiction, seen her hurt herself and those around her, try to heal, and keep finding herself stuck instead in a loop of self-harm in service of self-escape. Millions of Americans are suffering from opioid addiction, trapped in the same cycle. The crisis has its

origins in the often told story of Purdue Pharma—a story that parallels pharmaceutical companies' misleading marketing around the dangerous addictive potential and lethal side effects of Wellbutrin, Vyvanse, Adderall, and diet drugs. All of these drugs' manufacturers have been fined and reprimanded by the U.S. legal system, in most cases at rates low enough to register as accounting errors.

Before today's prescription opioid epidemic, heroin fostered its own epidemic, which also inspired an unfortunately enduring aesthetic. "The model who invented heroin chic," according to *The New York Times,* was Gia Carangi, who died of AIDS at age twenty-six after contracting the disease from a used needle. The aesthetic not only survived but thrived in the wake of her death. It was editorialized in fashion magazines throughout the '90s, when the *LA Times* called the prevailing starved-out and drugged-up aesthetic a "nihilistic vision of beauty." Oxycontin was approved in 1995, inciting the first wave of prescription opioid deaths a few years later, according to the CDC. Over the next two decades, deaths from opioid overdoses more than quintupled, rising over 400 percent among women.

As that epidemic worsened at the start of the 2020s, a troubling trend hit runways and celebrity Instagrams—the "return" of heroin chic. The Kardashians were suddenly startlingly thin—gossip sites speculated about reversed surgeries and injectable weight loss drugs. On a 2022 episode of their show, Kendall expresses concern that Khloe's rapid, extreme weight loss might point to a problem, perhaps disordered eating, and Khloe's mouth gapes as she goes giddy with pride, asking whether Kendall really thinks she's thin. Bella Hadid posted an Instagram in which she wore a coffee sleeve around her biceps, accidentally giving young people online another way to measure and compare shrinking limbs. By fall 2022, *The New York Post* announced aloud what people on social media had been murmuring suspiciously for months: "Heroin chic is back."

The response on social media was largely one of resigned alarm: *genuinely a preemptive RIP to all the girlies/gays falling back into the pro-ana era.* In other corners of the internet, there was a dissociative, deadpan embrace of the trend. Tweets include *I'm not trying to pull off*

heroin chic, im just actually that skinny and malnourished and constantly fatigued, and *the constant desire to be heroin chic thin* followed by an emoji smiling, a single tear on its spherical face.

While body positivity may have had a moment in the 2010s, it never progressed far past tokenism, with a few plus-size models making it on to magazine covers while the fashion industry at large remained in thrall to extreme slenderness. All the rhetoric of return obscures the fact that the emaciated white beauty ideal never went away. The overt celebration of a beauty ideal like "heroin chic," which emulates the effects of our two most fatal mental illnesses, opioid addiction and anorexia, is distressing to a point that might make you give up and give in, dissociating and dieting, or inspire a bimbofied fantasy of not being able to read any of these articles at all.

I have a question for bimbos and dissociated girls alike: How are we shaping our bodies and behaviors to become desirable to the most powerful, according to their value system, one we insist we hate while stepping on its scale every morning? This is a collective problem more than an individual one, a social sickness, but I worry that our (rightful) belief in collective responsibility is being misused to absolve ourselves of individual responsibility, to avoid asking ourselves whom we're stepping over to climb onto a throne that will inevitably be cold to the touch and won't hold us long.

In an essay on Elliot Rodger, incels, and the political economy of sexual desirability, Amia Srinivasan made an argument that provoked outrage from many corners of the internet. Rodger, in the manifesto he published just before embarking on a murder spree that would, he wrote, target "hot, beautiful blonde girls," cast his life story as a parade of rejections by just such women. Srinivasan found both homicidal misogyny and "racialized self-loathing" in Rodger's screed, and she also found something discomfitingly reminiscent of the racism, misogyny, fatphobia, and transphobia that subtly dictate the larger sexual and romantic economy, and which, I'd argue, bolster the slim ideal making so many of us sick. She found evidence in dating app match data and

people's public in-app preferences, which included phrases like "NO FATS NO ASIANS." Condemning incel logic and violence, Srinivasan also asked us to consider our complicity in a sexual economy that runs on white supremacy and fatphobia, to ask ourselves what we've been taught to find desirable and why.

Many were moved, many were outraged, and someone complained that pointing out that people's lives are often defined by unfair power structures out of their control is "as banal as it gets." Boredom in the face of extraordinary injustice lives somewhere between the dissocia-ter's droning sarcasm and the bimbo's faux ignorance, and it is usually evinced by people who are able to benefit, to at least some degree, by the circumstances and power structures they claim to be bored by. These are often the platonically upset pretty white girls who can live up to the system's demands via some self-harm, shrug, and claim they didn't create the system.

Responding to Srinivasan's essay, Long Chu recognized the histori-cal violence encoded in our sexual preferences, from transphobia to fatphobia, and not least the "world historical defeat of the female sex." Still, she "can't stand body positivity," its "moralizing" posture. At first, this might read as a bimbofied take, simply turning our gaze away from that defeat, assuming its reversal a depressingly heavy lift for dainty girls. But I read Long Chu's point as more, for lack of a better word, pointed, a blade lifted in self-defense. We risk disciplining the most marginalized, those already overly subject to unwarranted discipline, when we start disciplining anyone's desires. She rightly notes that such moralism has been used to uphold homophobia, that "moralism about the desires of the oppressor can be a shell corporation for moralism about the desires of the oppressed."

Srinivasan claims that what she wants isn't more discipline, but less. "What is disciplined" in her vision "isn't desire," but "the voices that have spoken to us since birth," telling us who and what and how to desire, and what we should look like to inspire others' desire. This is an emancipatory vision, and a beautiful one, and I wish I could shut up and believe it, but I can't help finding Long Chu's rhetoric a bit more realistic, her contention that "a desire's desire not to exist" isn't enough

to erase it, resonant with my own experience. She knows "it's really fucking hard to figure out a way to tell people to change their desires that isn't moralistic," but she doesn't say it's impossible, or unnecessary.

I kept getting caught on the word "discipline," and I couldn't figure out why, until I remembered the way eating disorder treatment tried to discipline the very voices in my head Srinivasan wants me to discipline; they just called them "ED mind." The beauty standard I and so many others endured eating disorders were aspiring to is the same one making women feel like they'll never find love and fearing for their lives. Disciplining the voices I didn't put in my head, shutting up the intrusive thoughts I've lived with as long as I can remember and discovering the desires I repressed so long ago I don't remember them, is really fucking hard and really fucking lonely. I thought recovery was about living more freely, not vigilantly monitoring my every move and thought. By that I don't mean that I am not responsible for analyzing and rejecting the ideas I've been indoctrinated with, the ones that have hurt people. I mean that imagining that effort exclusively as a disciplinary project against voices put in my head by oppressive systems actually absolves me of more responsibility than it puts on me. It allows me to stay self-obsessed, dueling with dictates embedded in my own mind, instead of looking outward, listening to people living otherwise, to someone who might actually have a better value system to offer, who doesn't believe in judging people according to our existing value systems, who wants to tell me a story, who doesn't want to talk about me at all.

Love, Simone Weil wrote, is seeing someone in pain and being able to say to him: "What are you going through?" and then listening. This is attention, and respect, and care, and seeing someone in pain not just as "a specimen from the social category labeled 'unfortunate,'" as Simone put it, but as someone you could have been, and might become. I'm not going to lie; it might hurt. Your stomach might turn, drop from the fear. But after the fear comes friendship, the desire to make the person you've gotten to know feel better, to make the world a safer, softer place for them to live in. A genuine, unforced desire for another's ease, pleasure. On the other hand, disciplining desire, making desiring someone a moral feat, is a condescending stance that dehumanizes its object as

much as it desires them, renders them a "specimen from that social category labeled 'unfortunate,'" instead of a person with a life story you didn't yet ask them to tell you.

Maybe what we need is not a feminism of discipline or dissociation, but a feminism of attention. Who knows whom we'd love if we got out of our own heads and listened to each other? That constructed contradiction between intellect and emotion, the dichotomy long bedeviling our feminisms, accuses us of lacking objectivity. But maybe a practice of sororal attention can bloom between intellect and emotion, and if we put our hearts into it, we'll feel each other's thoughts.

Exploring contemporary feminism in *Gawker*, Zoe Hu sees rigor as "the value that feminism has historically both coveted and resented," positioned as it is as antithetical to that assumed uber-feminine state: emotional. She asks, might emotions be intellectual motors, powerful "response[s] to a lived truth of humiliation and denigration"? Or are "feminine anger and depression merely threats to objectivity"? The dissociated feminist and the bimbo have both noticed this conundrum, and where the dissociated girl attempts to appear objective with her flat voice and wry quips, the bimbo asserts that she doesn't want to be objective, because when you look at women's lot objectively, you're not going to feel good. Hu sees "a retreat from the marshes of feminist emotion into a better-lit but perhaps emptier space" in today's (post-)feminisms, and I wonder whether simple, sororal attention might be our way out of both the bimbo's and dissociated girl's ring-lit bedrooms. Listening like this—channeling your attention toward another person, stifling the urge to interrupt with an anecdote or an inquiry, trusting their story to take you somewhere, never mind if the journey is rough—is rigorous and emotional.

I've been wondering whether we should turn the lights off and talk. Phones on silent, facedown, somewhere dim where I can listen to you, see your tears in whatever resolution you want me to, somewhere we can realize that what we look like really doesn't matter much, admit that saying that aloud feels false, and recognize that both those things can be true at once. Let me talk to you through one more girl: Elena Comay del Junco mourns the fact that "femininity and intellect seem to find themselves through an implicit 'despite.'" I want other words

connecting girls and their minds, and I think if we pay enough attention to each other, we'll start to hear them: and, through, toward, with, alongside, like like like.

When she won multiple Emmys for *Fleabag*, a photo of Phoebe Waller-Bridge went viral. She reclines with a cigarette in one hand and a cocktail in the other, surrounded by trophies; her eyes are almost closed and her dress glints in the flash. When I look at that photo, I see a woman far from the maligned desperate blowhard feminist. I see a feminist mid-dissociation, perhaps practicing what *Fleabag* preached: the virtues of living with the world kept at arm's length. But maybe that reading doesn't tell the whole story.

Although the first season of *Fleabag* was unapologetically and aggressively dark, the show's second season took an unexpected turn toward the optimistic, verging at points on heartwarming. Over the course of the season, *Fleabag* goes where most viewers never imagined our grief-ridden, substance-loving heroine would: on a self-improvement journey. She supports her sister emotionally, encourages her café patrons to converse with one another, and embarks on a complex, intimate relationship. She listens earnestly and learns about other people's lives, people she'd never stopped to wonder about before, and her world expands, her borders blur. The first love interest to truly know Fleabag also becomes the only character who notices her dissociative tendencies and even calls her out on them. We see Fleabag vulnerable and—finally, painfully—in touch with her emotions. Could Waller-Bridge be suggesting that genuine human connection might be able to render reality bearable and dissociation unnecessary?

At the end of *Euphoria*'s second season, we also see Rue do something we rarely see in that show: speak with her friends about her pain and theirs, apologize, listen, and perhaps most strikingly, smile. She doesn't know how long she'll be able to stay sober and sentient in this world, but she's going to try her hardest. She's going to sit on her former best friend's bedroom floor and fix their relationship, hold a loved one's pain in her palms, and so what if it burns?

I still find myself dissociating episodically, overwhelmed by the depth

of an outsize depressive hole or well of insecurity, but I have also been trying to inhabit my body more fully and allow myself to experience my emotions physically. When I notice a fleshy fold or the slick of anxiety sweat, I attempt to put the feeling into words. Instead of bingeing on something in a bid for a high, I've been realizing that utterly rejecting reality might not be the avenue to a higher plane I once thought it was. I am trying to listen, to live here with everyone else stumbling around, trying to open our eyes a little wider and perk our ears up in case a story is being told, one that might change our lives. I might be actively unchill and even a little bit hysterical, but I'm here, and I hope you'll stay.

A Note on Sourcing

This book is a choral narrative, one that could not exist without the words of other girls, other people in pain. It would not exist without Tumblr, Twitter, Reddit, TikTok, and Instagram posts created by people whose honesty and eloquence astound me, without the vulnerability and courage of both anonymous online sources willing to tell me their stories in direct messages and the people who spoke to me from all over the country, in person, over the phone, and via video chat. I couldn't have written this book without any of those people, and I am endlessly grateful to them.

I also recognize that none of the individuals whose posts I drew on in my research necessarily intended for the words they typed into the internet to reach an audience beyond the communities and forums where they originally posted them. As such, I wanted to respect their privacy and looked at models for ethical social media sourcing. One model I turned to was Kaitlyn Tiffany's analysis of fangirls, *Everything I Need I Get from You,* which relied on posts in niche Tumblr and Twitter communities, communities whose "structural insularity demands different [privacy] consideration, as do posts made on any platform by people who do not have a large online following and would not expect to see their words reappearing in this context," in Tiffany's words. Those privacy considerations apply in freighted ways to pro–eating disorder online communities, whose users have been repeatedly subjected to purposeful misinterpretation, vilification, and mockery by journalists, as well as personal attacks by other internet users in the wake of that reporting.

People who rely on these online spaces for mental, emotional, and social support often keep that information from friends and family who would

not understand such engagement. This reality renders privacy essential to users' ability to access their support systems. In light of this, Julian Burton, writing in *A Tumblr Book: Platform and Cultures* about ethically citing minors on Tumblr, wrote that he tries to "minimize the chance" that his work "would lead to participants' activity on Tumblr becoming known to their families or others in their offline social worlds."

Following Tiffany, Burton, and other internet scholars, I aimed to protect the privacy of the people whose words were so integral to this project. No usernames or handles are listed directly in this book, so people who posted pseudonymously online can remain so. Following the same ethos, interview subjects' first names have been pseudonymized or shortened to first initials (except in cases when the interview subject has published writing on the subject and consented to the use of their name, as with Kelsey Osgood, or when the interview subject approved the use of their name in previously published versions of a chapter, as with some subjects in "Skinny, Sexy, Seizing"). This book contains one composite character, C, a collage created to protect the privacy of various individuals and incorporate more stories than I otherwise could, drawing on interviews, experiences recounted on forums, and other research.

I can only hope that this text respects its sources' privacy while also allowing them to speak to and through other people in the same pain, people who posted on similar sites but never found each other, and even those who rarely posted at all, people like me who mostly lurked online but still found friends, sisters, and saviors, and is trying to thank them for their words now. Thank you, and I know it hurts, and I hope this helped.

Acknowledgments

Thank you to my mother, for your witty dignity and mischievous, stunning, startling sentences, and my father, for your humor, intelligence, and belief in me. Thank you to my sister for loving me more than I deserve and being utterly unlike anyone I've ever met. Thank you to my godmother, friend, and teacher, Susan Minot, for modeling a life forged from poetry and friendship and salt water, for writing books that made me want to write and books that let me love words even when I couldn't write them.

Thank you to my editor, Vanessa Haughton, for sharing my passion for this book, for your clarity, intelligence, and patience, and, above all, for bringing *Dead Weight* to life with me. Thank you to my agent, Monika Woods, for your unflagging belief in this book and for guiding me through this process with wisdom and kindness. Thank you to the team at Triangle House and to the production, marketing, and publicity teams at Knopf. Thank you, Isabel Cristo, for your indefatigable, exhaustive, ingenious fact-checking and editorial insight, for giggling in the Google doc with me, and for knowing everything, including the color of Cher Horowitz's skirts, the text of captions at the Cloisters, and how to talk me down from a fact-finding spiral.

Thank you to the friends and readers whose insight, care, conversation, laughter, encouragement, and feedback I couldn't have written this book without: Sophia Steinert-Evoy, Alexandra Baer Chan, Xandra Ellin, Carlene Buccino, Michael Peters, Claudia Buccino, Siena Canales, Zoe Wood, Anthony Parks, Eliza Callahan, Nora Tomas, Jake Nevins, Stacey Streshinsky, Adrianna Vallee, Caitlin de Lisser-Ellen, Zoya Teirstein, Claire Dorfman, Zoe Zakin, Emma Myers, Maia Scalia, Miranda Litwak,

ACKNOWLEDGMENTS

Urvashi Pathania, Chase Harrison, Becca Zimmerman, Christa Guerra, and Sarah Gale.

Thank you to my teachers, whom I am lucky enough to also call mentors and friends, whose examples are a beacon always and whose belief in me is an honor to hold: Leslie Jamison and Kate Zambreno. Thank you to Eli Gottlieb, Wendy Walters, Kate Bolick, Jordan Kisner, Ruth Franklin, Margo Jefferson, Gideon Lewis-Kraus, and Hilton Als.

Thank you to Rachel Sanders at BuzzFeed, Tajja Isen at *Catapult*, Michael Lindgren at *Majuscule*, Matthew Schnipper at *Vice*, and Hannah Gold at *Berlin Quarterly* for editing and publishing work that would become part of this book.

Thank you, once again, to everyone whose words and stories appear in these pages. This book is for you. Thank you for sharing part of your lives with me.

Thank you to Project HEAL, FEDUP Collective, and Nalgona Positivity Pride for offering genuine care, hope, healing, and community to people suffering disordered eating.

Selected Works Cited

Ackerly, D. Clay, Ana M. Valverde, Lawrence W. Diener, Kristin L. Dossary, and Kevin A. Schulman. "Fueling Innovation in Medical Devices (and Beyond): Venture Capital in Health Care: The Amount of Venture Capital Dollars in Health Care May Be Viewed as a Proxy for the Amount and Type of Innovation Being Supported." *Health Affairs* 27, supp. 11 (2018): w68–75. https://doi.org/10.1377/hlthaff.28.1.w68.

Adams, Stephen M., Karl E. Miller, and Robert G. Zylstra. "Pharmacologic Management of Adult Depression." *American Family Physician* 77, no. 6 (2008): 785–92.

Adler-Bolton, Beatrice, and Artie Vierkant. *Health Communism: A Surplus Manifesto.* Brooklyn, N.Y.: Verso, 2022.

Alderton, Zoe. *The Aesthetics of Self-Harm: The Visual Rhetoric of Online Self-Harm Communities.* New York: Routledge, 2018.

American Psychiatric Association Division of Research. "Highlights of Changes from *DSM-IV* to *DSM-5:* Feeding and Eating Disorders." *FOCUS* 12, no. 4 (2014): 414–15. https://doi.org/10.1176/appi.focus.120408.

Attia, Evelyn, Kristy L. Blackwood, Angela S. Guarda, Marsha D. Marcus, and David J. Rothman. "Marketing Residential Treatment Programs for Eating Disorders: A Call for Transparency." *Psychiatric Services* 67, no. 6 (2016): 664–66. https://doi.org/10.1176/appi.ps.201500338.

Auger, Nathalie, Brian J. Potter, Ugochinyere Vivian Ukah, Nancy Low, Mimi Israël, Howard Steiger, Jessica Healy-Profitós, and Gilles Paradis. "Anorexia Nervosa and the Long-Term Risk of Mortality in Women." *World Psychiatry* 20, no. 3 (2021): 448–49. https://doi.org/10.1002/wps.20904.

Aviv, Rachel. *Strangers to Ourselves: Unsettled Minds and the Stories That Make Us.* New York: Farrar, Straus and Giroux, 2022.

Barton, Mischa. "The Grim Truth About Growing Up in the Public Eye." *Harper's Bazaar,* June 11, 2021.

Beach, Natalie. "I Was Caroline Calloway." *New York Magazine,* September 10, 2019.

Bell, Rudolph M. *Holy Anorexia.* Chicago: University of Chicago Press, 1987.

Better Homes and Gardens. "Bulimia Can Kill a Smile," February 1987.

Botton, Sari. "The Happy, Sexy, Skinny, Pill?" *Harper's Bazaar,* February 19, 2014.

Boyd, Catherine, Suzanne Abraham, and John Kellow. "Psychological Features Are Important Predictors of Functional Gastrointestinal Disorders in Patients with Eating Disorders." *Scandinavian Journal of Gastroenterology* 40, no. 8 (2005): 929–35. https://doi.org/10.1080/00365520510015836.

Boyer, Anne. *The Undying: Pain, Vulnerability, Mortality, Medicine, Art, Time, Dreams, Data, Exhaustion, Cancer, and Care.* New York: Farrar, Straus and Giroux, 2019.

Bratman, Steven. "Orthorexia vs. Theories of Healthy Eating." *Eating and Weight Disorders: EWD* 22, no. 3 (2017): 381–85. https://doi.org/10.1007/s40519-017-0417-6.

Bratman, Steven, and David Knight. *Health Food Junkies: Overcoming the Obsession with Healthful Eating.* New York: Broadway Books, 2000.

Bray, Brenna, Boris C. Rodríguez-Martín, David A. Wiss, Christine E. Bray, and Heather Zwickey. "Overeaters Anonymous: An Overlooked Intervention for Binge Eating Disorder." *International Journal of Environmental Research and Public Health* 18, no. 14 (2021): 7303. https://doi.org/10.3390/ijerph18147303.

Bray, George A. "Life Insurance and Overweight." *Obesity Research* 3, no. 1 (1995): 97–99. https://doi.org/10.1002/j.1550-8528.1995.tb00125.x.

Broder, Melissa. *Milk Fed.* New York: Scribner, 2021.

Brody, Jane E. "Diet That Made Oprah Winfrey Slim Demands Discipline, Specialists Say." *New York Times,* November 24, 1988.

Brody, Jane E. "Study Defines 'Binge Eating Disorder.'" *New York Times,* March 27, 1992.

Bruch, Hilde. *The Golden Cage: The Enigma of Anorexia Nervosa.* Cambridge, Mass.: Harvard University Press, 2001.

Bulik, Cynthia M., Laura Thornton, Andréa Poyastro Pinheiro, Katherine Plotnicov, Kelly L. Klump, Harry Brandt, Steve Crawford, et al. "Suicide

Attempts in Anorexia Nervosa." *Psychosomatic Medicine* 70, no. 3 (2008): 378–83. https://doi.org/10.1097/psy.0b013e3181646765.

Burns, Maree. "Eating Like an Ox: Femininity and Dualistic Constructions of Bulimia and Anorexia." *Feminism & Psychology* 14, no. 2 (2004): 269–95. https://doi.org/10.1177/0959353504042182.

Burns, Paul, ed. *Butler's Lives of the Saints: February.* Tunbridge Wells, Kent, U.K.: Burns & Oates, 1998.

"Burroughs Wellcome to Relaunch Antidepressant Wellbutrin in Mid-July After Aborted Launch in 1986; FDA-Approved Labeling Includes Data on Seizure Risk." *Pink Sheet Citeline Regulatory,* July 3, 1989.

Butler, Kiera. "The Waistland." *Mother Jones,* January 1, 2009.

Campos, Paul, Abigail Saguy, Paul Ernsberger, Eric Oliver, and Glenn Gaesser. "The Epidemiology of Overweight and Obesity: Public Health Crisis or Moral Panic?" *International Journal of Epidemiology* 35, no. 1 (2006): 55–60. https://doi.org/10.1093/ije/dyi254.

Carr, Danielle. "Mental Health Is Political." *New York Times,* September 20, 2022.

Centers for Disease Control and Prevention. "Prescription Painkiller Overdoses." *CDC Vital Signs,* September 4, 2018.

Chancellor, Stevie, Jessica Annette Pater, Trustin Clear, Eric Gilbert, and Munmun De Choudhury. "#thyghgapp: Instagram Content Moderation and Lexical Variation in Pro–Eating Disorder Communities." In *Proceedings of the 19th ACM Conference on Computer-Supported Cooperative Work & Social Computing,* 1201–13. San Francisco: ACM Press, 2016. https://doi.org/10.1145/2818048.2819963.

Chastain, Ragen. "Weight Watchers—Up to Their Old Tricks." *Weight and Healthcare,* Substack newsletter, November 12, 2022.

Clarke, Diana. *Thin Girls.* New York: Harper Perennial, 2020.

Columbia University Irving Medical Center (website). "Yo-Yo Dieting Linked to Heart Disease Risk in Women," March 6, 2019.

Comay del Junco, Elena. "Cool Women." *The New Inquiry,* February 21, 2020.

Cornelissen, Piers L., and Martin J. Tovée. "Targeting Body Image in Eating Disorders." *Current Opinion in Psychology* 41 (October 2021): 71–77. https://doi.org/10.1016/j.copsyc.2021.03.013.

Cosgrove, Lisa, Justin M. Karter, Zenobia Morrill, and Mallaigh McGinley. "Psychology and Surveillance Capitalism: The Risk of Pushing Mental Health Apps During the COVID-19 Pandemic." *Journal of Humanistic Psychology* 60, no. 5 (2020): 611–25. https://doi.org/10.1177/0022167820937498.

————, and Sheldon Krimsky. "A Comparison of *DSM-IV* and *DSM-5* Panel Members' Financial Associations with Industry: A Pernicious Problem Persists." *PLoS Medicine* 9, no. 3 (2012): e1001190. https://doi.org/10.1371/journal.pmed.1001190.

Covington Armstrong, Stephanie. *Not All Black Girls Know How to Eat: A Story of Bulimia.* Chicago: Lawrence Hill Books, 2009.

Crow, Scott J., Carol B. Peterson, Sonja A. Swanson, Nancy C. Raymond, Sheila Specker, Elke D. Eckert, and James E. Mitchell. "Increased Mortality in Bulimia Nervosa and Other Eating Disorders." *American Journal of Psychiatry* 166, no. 12 (2009): 1342–46. https://doi.org/10.1176/appi.ajp.2009.09020247.

Czerniawski, Amanda M. "From Average to Ideal: The Evolution of the Height and Weight Table in the United States, 1836–1943." *Social Science History* 31, no. 2 (2007): 273–96. https://doi.org/10.1017/S0145553200013754.

Daga, G. Abbate, C. Gramaglia, A. Pierò, and S. Fassino. "Eating Disorders and the Internet: Cure and Curse." *Eating and Weight Disorders* 11, no. 2 (2006): e68–71. https://doi.org/10.1007/BF03327763.

Dagan, Yael, and Joel Yager. "Severe Bupropion XR Abuse in a Patient with Long-Standing Bulimia Nervosa and Complex PTSD." *International Journal of Eating Disorders* 51, no. 10 (2018): 1207–9. https://doi.org/10.1002/eat.22948.

Das, Shanti, and Jon Ungoed-Thomas. "'Orchestrated PR Campaign': How Skinny Jab Drug Firm Sought to Shape Obesity Debate." *The Observer,* March 12, 2023.

Davidson, J. "Seizures and Bupropion: A Review." *Journal of Clinical Psychiatry* 50, no. 7 (1989): 256–61.

Deloitte Access Economics. *Social and Economic Cost of Eating Disorders in the United States of America: A Report for the Strategic Training Initiative for the Prevention of Eating Disorders and the Academy for Eating Disorders,* June 2020.

Depa, Julia, Juan Barrada, and María Roncero. "Are the Motives for Food Choices Different in Orthorexia Nervosa and Healthy Orthorexia?" *Nutrients* 11, no. 3 (2019): 697. https://doi.org/10.3390/nu11030697.

Derman, Talia, and Christopher P. Szabo. "Why Do Individuals with Anorexia Die? A Case of Sudden Death." *International Journal of Eating Disorders* 39, no. 3 (2006): 260–62. https://doi.org/10.1002/eat.20229.

Donohue, Julie. "A History of Drug Advertising: The Evolving Roles of Consumers and Consumer Protection." *Milbank Quarterly* 84, no. 4 (2006): 659–99. https://doi.org/10.1111/j.1468-0009.2006.00464.x.

Duffy, Mary E., Kristin E. Henkel, and Valerie A. Earnshaw. "Transgender Clients' Experiences of Eating Disorder Treatment." *Journal of LGBT Issues in Counseling* 10, no. 3 (2016): 136–49. https://doi.org/10.1080/15538605.2016.1177806.

Dunn, Thomas M., and Steven Bratman. "On Orthorexia Nervosa: A Review of the Literature and Proposed Diagnostic Criteria." *Eating Behaviors* 21 (April 2016): 11–17. https://doi.org/10.1016/j.eatbeh.2015.12.006.

Ehrenreich, Barbara, and Deirdre English. *Witches, Midwives, and Nurses: A History of Women Healers.* 2nd ed. New York: Feminist Press, 2010.

Elliot, Cass. "What a Way to Lose 110 LBS.!" *Good Housekeeping,* 1969.

Erman, Michael. "Novo Nordisk Rivals See Room to Compete in $100 Billion Weight-Loss Drug Market." Reuters, May 8, 2023.

Ernaux, Annie. *A Girl's Story.* New York: Seven Stories Press, 2020.

Espi Forcen, Fernando. "Anorexia Mirabilis: The Practice of Fasting by Saint Catherine of Siena in the Late Middle Ages." *American Journal of Psychiatry* 170, no. 4 (2013): 370–71. https://doi.org/10.1176/appi.ajp.2012.12111457.

Fallon, Patricia, Melanie A. Katzman, and Susan C. Wooley, eds. *Feminist Perspectives on Eating Disorders.* New York: Guilford Press, 1994.

Farrar, Tabitha. "Eating Disorder Treatment Lessons: Treatment Should Not Traumatize Patients." *Eating Disorder Recovery for Adults* (blog), February 19, 2019.

Fassler, Joe. "Finding Meaning in Going Nowhere." *The Atlantic,* January 17, 2017.

Feng, Shan, Matti Mäntymäki, Amandeep Dhir, and Hannu Salmela. "How Self-Tracking and the Quantified Self Promote Health and Well-Being: Systematic Review." *Journal of Medical Internet Research* 23, no. 9 (2021): e25171. https://doi.org/10.2196/25171.

Fildes, Alison, Judith Charlton, Caroline Rudisill, Peter Littlejohns, A. Toby Prevost, and Martin C. Gulliford. "Probability of an Obese Person Attaining Normal Body Weight: Cohort Study Using Electronic Health Records." *American Journal of Public Health* 105, no. 9 (2015): e54–59. https://doi.org/10.2105/AJPH.2015.302773.

Firkins, Ashlyn, Jos Twist, Wendy Solomons, and Saskia Keville. "Cutting Ties with Pro-Ana: A Narrative Inquiry Concerning the Experiences of Pro-Ana Disengagement from Six Former Site Users." *Qualitative Health Research* 29, no. 10 (2019): 1461–73. https://doi.org/10.1177/1049732319830425.

Fischer, Arlene. "Eating Disorders of Youths Explored." *New York Times,* May 31, 1981.

Fixsen, Alison, Anna Cheshire, and Michelle Berry. "The Social Construction of a Concept—Orthorexia Nervosa: Morality Narratives and Psycho-Politics." *Qualitative Health Research* 30, no. 7 (2020): 1101–13. https://doi.org/10.1177/1049732320911364.

Flegal, Katherine M., Brian K. Kit, Heather Orpana, and Barry I. Graubard. "Association of All-Cause Mortality with Overweight and Obesity Using Standard Body Mass Index Categories: A Systematic Review and Meta-Analysis." *JAMA* 309, no. 1 (2013): 71–82. https://doi.org/10.1001/jama.2012.113905.

Fonda, Jane. *My Life So Far.* Trade paperback edition. New York: Random House, 2006.

Friedman, Asia M., Jennifer R. Hemler, Elisa Rossetti, Lynn P. Clemow, and Jeanne M. Ferrante. "Obese Women's Barriers to Mammography and Pap Smear: The Possible Role of Personality." *Obesity (Silver Spring)* 20, no. 8 (2012): 1611–17. https://doi.org/10.1038/oby.2012.50.

Fruh, Sharon M., Joe Nadglowski, Heather R. Hall, Sara L. Davis, Errol D. Crook, and Kimberly Zlomke. "Obesity Stigma and Bias." *Journal for Nurse Practitioners* 12, no. 7 (2016): 425–32. https://doi.org/10.1016/j.nurpra.2016.05.013.

Gaudiani, Jennifer L. *Sick Enough: A Guide to the Medical Complications of Eating Disorders.* New York: Routledge, 2018.

———, Alyssa Bogetz, and Joel Yager. "Terminal Anorexia Nervosa: Three Cases and Proposed Clinical Characteristics." *Journal of Eating Disorders* 10, no. 1 (2022): 23. https://doi.org/10.1186/s40337-022-00548-3.

Gay, Kristen Nicole. "Unbearable Weight, Unbearable Witness: The (Im)Possibility of Witnessing Eating Disorders in Cyberspace." Graduate thesis, University of South Florida, 2013.

Gerard, Sarah. *Binary Star.* Columbus, Ohio: Two Dollar Radio, 2015.

Ging, Debbie, and Sarah Garvey. " 'Written in These Scars Are the Stories I Can't Explain': A Content Analysis of Pro-Ana and Thinspiration Image Sharing on Instagram." *New Media & Society* 20, no. 3 (2018): 1181–1200. https://doi.org/10.1177/1461444816687288.

Gordon, Kathryn H., Marissa M. Brattole, Laricka R. Wingate, and Thomas E. Joiner. "The Impact of Client Race on Clinician Detection of Eating Disorders." *Behavior Therapy* 37, no. 4 (2006): 319–25. https://doi.org/10.1016/j.beth.2005.12.002.

Greenfield, Lauren. *Thin.* San Francisco: Chronicle Books, 2006.

Guarda, Angela S., Annette Hanson, Philip Mehler, and Patricia Westmoreland. "Terminal Anorexia Nervosa Is a Dangerous Term: It Cannot, and Should Not, Be Defined." *Journal of Eating Disorders* 10, no. 1 (2022): 79. https://doi.org/10.1186/s40337-022-00599-6.

Gunby, Phil. "A Little (Body) Fat May Not Hasten Death." *JAMA* 244, no. 15 (1980): 1660. https://doi.org/10.1001/jama.1980.03310150008005.

Hahn, Samantha L., Ashley N. Linxwiler, Tran Huynh, Kelsey L. Rose, Katherine W. Bauer, and Kendrin R. Sonneville. "Impacts of Dietary Self-Monitoring via MyFitnessPal to Undergraduate Women: A Qualitative Study." *Body Image* 39 (2021): 221–26. https://doi.org/10.1016/j.bodyim.2021.08.010.

Haider, Areeba, and Lorena Roque. "New Poverty and Food Insecurity Data Illustrate Persistent Racial Inequities." *Center for American Progress* (blog), September 29, 2021.

Hainer, Vojtech, and Irena Aldhoon-Hainerová. "Obesity Paradox Does Exist." *Diabetes Care* 36, supp. 2 (2013): S276–81. https://doi.org/10.2337/dcS13-2023.

Hanganu-Bresch, Cristina. "Orthorexia: Eating Right in the Context of Healthism." *Medical Humanities* 46, no. 3 (2020): 311–22. https://doi.org/10.1136/medhum-2019-011681.

Harland, Marion. *Eve's Daughters; or, Common Sense for Maid, Wife, and Mother*. New York: J. R. Anderson & H. S. Allen, 1882.

Hay, Phillipa J., Stephen Touyz, and Rishi Sud. "Treatment for Severe and Enduring Anorexia Nervosa: A Review." *Australian & New Zealand Journal of Psychiatry* 46, no. 12 (2012): 1136–44. https://doi.org/10.1177/0004867412450469.

Hazzard, Vivienne M., Katie A. Loth, Laura Hooper, and Carolyn Black Becker. "Food Insecurity and Eating Disorders: A Review of Emerging Evidence." *Current Psychiatry Reports* 22, no. 12 (2020): 74. https://doi.org/10.1007/s11920-020-01200-0.

Hoerburger, Rob. "Karen Carpenter's Second Life." *New York Times*, October 6, 1996.

Hofmann, Stefan G., Anu Asnaani, Imke J. J. Vonk, Alice T. Sawyer, and Angela Fang. "The Efficacy of Cognitive Behavioral Therapy: A Review of Meta-Analyses." *Cognitive Therapy and Research* 36, no. 5 (2012): 427–40. https://doi.org/10.1007/s10608-012-9476-1.

Hopkins, Caroline. "Eating Disorders Among Teens More Severe Than Ever." NBC News, April 29, 2023.

Horne, R. L., J. M. Ferguson, H. G. Pope, J. I. Hudson, C. G. Lineberry,

J. Ascher, and A. Cato. "Treatment of Bulimia with Bupropion: A Multicenter Controlled Trial." *Journal of Clinical Psychiatry* 49, no. 7 (1988): 262–66.

Hu, Zoe. "Rigorous Feelings: The Tension at the Heart of Contemporary Feminism." *Gawker,* June 29, 2022.

Huston, Nancy. *Longings and Belongings: Essays.* Toronto: McArthur, 2005.

Institute of Medicine (U.S.). *Employment and Health Benefits: A Connection at Risk.* Edited by Marilyn J. Field and Harold T. Shapiro. Washington, D.C.: National Academy Press, 1993.

Ireland, Corydon. "Fijian Girls Succumb to Western Dysmorphia." *Harvard Gazette,* March 19, 2009.

Jahoda, Gustav. "Quetelet and the Emergence of the Behavioral Sciences." *SpringerPlus* 4, no. 473 (2015). https://doi.org/10.1186/s40064-015-1261-7.

Jamison, Leslie. "Grand Unified Theory of Female Pain." *Virginia Quarterly Review* 90, no. 2 (Spring 2014) : 114–28.

———. *Make It Scream, Make It Burn: Essays.* New York: Little, Brown, 2019.

Jargon, Julie. "She Tried to Block Eating-Disorder Content on TikTok. It Still Pops Up Daily." *Wall Street Journal,* September 24, 2022.

Jáuregui-Garrido, Beatriz, and Ignacio Jáuregui-Lobera. "Sudden Death in Eating Disorders." *Vascular Health and Risk Management* 8 (2012): 91–98. https://doi.org/10.2147/VHRM.S28652.

Jones, Coulter, John Fauber, and Kristine Fiore. "Risk/Reward: Diet Drug Companies Spent $60 Million Since 2010 amid Push to Win FDA Approval for New Products." *Milwaukee Journal Sentinel,* April 19, 2015.

Jones, Rebecca. "Lesbians and Body Image: Anorexia, Bulimia and Constructions of Thinness." *Journal of Aesthetic Nursing* 2, no. 8 (2013): 394–97. https://doi.org/10.12968/joan.2013.2.8.394.

Jones, Rebecca, and Helen Malson. "A Critical Exploration of Lesbian Perspectives on Eating Disorders." *Psychology and Sexuality* 4, no. 1 (2013): 62–74. https://doi.org/10.1080/19419899.2011.603349.

Jozefik, Barbara, and Maciej Wojciech Pilecki. "Perception of Autonomy and Intimacy in Families of Origin of Patients with Eating Disorders with Depressed Patients and Healthy Controls: A Transgenerational Perspective—Part I." *Archives of Psychiatry and Psychotherapy* 12, no. 4 (2010): 69–77.

Jung, Jinhyun, and Adriane Fugh-Berman. "Marketing Messages in Continuing Medical Education (CME) Modules on Binge-Eating Disorder

(BED)." *Journal of the American Board of Family Medicine* 33 no. 2 (2020): 240–51. https://doi.org/10.3122/jabfm.2020.02.190129.

Kalm, Leah M., and Richard D. Semba. "They Starved So That Others Be Better Fed: Remembering Ancel Keys and the Minnesota Experiment." *Journal of Nutrition* 135, no. 6 (June 2005): 1347–52. https://doi.org/10.1093/jn/135.6.1347.

Kang, Harjeevan Singh, and Mark Exworthy. "Wearing the Future—Wearables to Empower Users to Take Greater Responsibility for Their Health and Care: Scoping Review." *JMIR mHealth and uHealth* 10, no. 7 (2022): e35684. https://doi.org/10.2196/35684.

Kaye, Walter. "Eating Disorders: Hope Despite Mortal Risk." *American Journal of Psychiatry* 166, no. 12 (2009): 1309–11. https://doi.org/10.1176/appi.ajp.2009.09101424.

———, and Cynthia M. Bulik. "Treatment of Patients with Anorexia Nervosa in the US—A Crisis in Care." *JAMA Psychiatry* 78, no. 6 (2021): 591. https://doi.org/10.1001/jamapsychiatry.2020.4796.

Kaysen, Susanna. *Girl, Interrupted.* New York: Turtle Bay Books, 1993.

Keating, Shannon. "Are Straight Women OK?" BuzzFeed, July 19, 2019.

Kellogg, John Harvey. *Autointoxication: Or, Intestinal Toxemia.* Battle Creek, Mich.: Modern Medicine Publishing Company, 1919.

———, *Ladies' Guide in Health and Disease: Girlhood, Maidenhood, Wifehood, Motherhood.* Battle Creek, Mich.: Good Health Publishing Company, 1892.

Kendall, Mikki. "When Black Girls Hear That 'Our Bodies Are All Wrong.'" *New York Times,* February 21, 2020.

Kennedy, Erin. "Miss California Talks to Students About Eating Disorders." *Fresno Bee,* November 20, 2004.

Khalsa, Sahib S., Larissa C. Portnoff, Danyale McCurdy-McKinnon, and Jamie D. Feusner. "What Happens After Treatment? A Systematic Review of Relapse, Remission, and Recovery in Anorexia Nervosa." *Journal of Eating Disorders* 5, no. 20 (2017). https://doi.org/10.1186/s40337-017-0145-3.

Kim, Young Sun, and Nayoung Kim. "Sex-Gender Differences in Irritable Bowel Syndrome." *Journal of Neurogastroenterology and Motility* 24, no. 4 (2018): 544–58. https://doi.org/10.5056/jnm18082.

Kolbe, Laura. "The Physician as Patient: Medicine After COVID-19." *Yale Review* 110, no. 2 (Summer 2022): 5–13. https://doi:10.1353/tyr.2022.0000.

Kongstvedt, Peter R. *Health Insurance and Managed Care: What They Are and*

How They Work. 4th ed. Burlington, Mass.: Jones & Bartlett Learning, 2016.

Kraus, Chris. *Aliens and Anorexia*. South Pasadena, Calif.: Semiotext(e), 2000.

Kresge, Naomi. "New Weight-Loss Drug Found to Be Effective in Pill Form, Wegovy Maker Says." *Bloomberg*, May 22, 2023.

Lawson, Carol. "Anorexia: It's Not a New Disease." *New York Times*, December 8, 1985.

Lebow, Jocelyn, Leslie A. Sim, and Lisa N. Kransdorf. "Prevalence of a History of Overweight and Obesity in Adolescents with Restrictive Eating Disorders." *Journal of Adolescent Health* 56, no. 1 (2015): 19–24. https://doi.org/10.1016/j.jadohealth.2014.06.005.

Le Grange, Daniel, Sonja A. Swanson, Scott J. Crow, and Kathleen R. Merikangas. "Eating Disorder Not Otherwise Specified Presentation in the US Population." *International Journal of Eating Disorders* 45, no. 5 (2012): 711–18. https://doi.org/10.1002/eat.22006.

Lehoux, P., F. A. Miller, and G. Daudelin. "How Does Venture Capital Operate in Medical Innovation?" *BMJ Innovations* 2, no. 3 (2016): 111–17. https://doi.org/10.1136/bmjinnov-2015-000079.

Lester, Rebecca J. *Famished: Eating Disorders and Failed Care in America*. Oakland: University of California Press, 2021.

Linebaugh, Kate, and Kuntson, Ryan. "The Facebook Files, Part 2: 'We Make Body Images Worse.'" *Wall Street Journal*, podcast audio, September 14, 2021.

Liu, Rebecca. "The Making of a Millennial Woman." *Another Gaze*, June 12, 2019.

Lombroso, Cesare, and Guglielmo Ferrero. *The Female Offender*. New York: D. Appleton & Company, 1897.

Long Chu, Andrea, and Anastasia Berg. "Wanting Bad Things." *The Point*, July 18, 2018.

Maine, Margo, William N. Davis, and Jane Shure, eds. *Effective Clinical Practice in the Treatment of Eating Disorders*. New York: Routledge, 2008. https://doi.org/10.4324/9780203893890.

Malcolm, Janet. "Advanced Placement." *The New Yorker*, March 3, 2008.

Martin, Crescent B., and Cynthia L. Ogden. "Attempts to Lose Weight Among Adults in the United States, 2013–2016." *NCHS Data Brief* 313 (July 2018).

Marzilli, Eleonora, Luca Cerniglia, and Silvia Cimino. "A Narrative Review of Binge Eating Disorder in Adolescence: Prevalence, Impact, and Psychological Treatment Strategies." *Adolescent Health, Medicine and*

Therapeutics 9 (January 2018): 17–30. https://doi.org/10.2147/AHMT
.S148050.

Mayes, Rick, and Allan V. Horwitz. "*DSM-III* and the Revolution in the Classification of Mental Illness." *Journal of the History of the Behavioral Sciences* 41, no. 3 (2005): 249–67. https://doi.org/10.1002/jhbs.20103.

McBee, Susanna. "The Dangerous Diet Pills." *Life*, January 26, 1968.

Memon, Areeba N., Asavari S. Gowda, Bhavana Rallabhandi, Erjola Bidika, Hafsa Fayyaz, Marina Salib, and Ivan Cancarevic. "Have Our Attempts to Curb Obesity Done More Harm Than Good?" *Cureus* 12, no. 9 (2020): e10275. https://doi.org/10.7759/cureus.10275.

Mikhail, Megan E., and Kelly L. Klump. "A Virtual Issue Highlighting Eating Disorders in People of Black/African and Indigenous Heritage." *International Journal of Eating Disorders* 54, no. 3 (2021): 459–67. https://doi .org/10.1002/eat.23402.

Mishori, Ranut, Aye Otubu, and Aminah Alleyne Jones. "The Dangers of Colon Cleansing." *Journal of Family Practice* 60, no. 8 (2011): 454.

Mortimer, Rose. "Pride Before a Fall: Shame, Diagnostic Crossover, and Eating Disorders." *Journal of Bioethical Inquiry* 16, no. 3 (2019): 365–74. https://doi.org/10.1007/s11673-019-09923-3.

Moshfegh, Ottessa. *Eileen*. New York: Penguin Press, 2015.

———. *My Year of Rest and Relaxation*. New York: Penguin Press, 2018.

Moskowitz, P. E. "Psychoanalysis Can Help Us Dream of Things Outside of Capitalism." *Mental Hellth*, Substack newsletter, November 1, 2021.

Murray, Stuart B., Eva Pila, Scott Griffiths, and Daniel Le Grange. "When Illness Severity and Research Dollars Do Not Align: Are We Overlooking Eating Disorders?" *World Psychiatry* 16, no. 3 (2017): 321. https://doi .org/10.1002/wps.20465.

National Center for Drug Abuse Statistics (website). "Average Cost of Drug Rehab [2023]: By Type, State & More," accessed July 6, 2023.

National Council on Disability (website). "Appendix B: A Brief History of Managed Care," August 11, 2015.

National Institute of Mental Health. "Release of '13 Reasons Why' Associated with Increase in Youth Suicide Rates." Press release, April 29, 2019.

Neumärker, Klaus-Jürgen. "Mortality and Sudden Death in Anorexia Nervosa." *International Journal of Eating Disorders* 21, no. 3 (1998): 205–12. https://doi.org/10.1002/(SICI)1098-108X(199704)21:3<205::AID -EAT1>3.0.CO;2-O.

Nicolosi, Guido. "Biotechnologies, Alimentary Fears and the Orthorexic Society." *Tailoring Biotechnologies* 2, no. 3 (March 2007): 37–56.

O'Neil, Dilara. "Grief Network." *N+1*, October 11, 2018.

Osgood, Kelsey. *How to Disappear Completely: On Modern Anorexia*. New York: Overlook Press, 2013.

Palmer, Robert. "Bulimia Nervosa: 25 Years On." *British Journal of Psychiatry* 185, no. 6 (2004): 447–48. https://doi.org/10.1192/bjp.185.6.447.

Parekh, Natasha, and William H. Shrank. "Dangers and Opportunities of Direct-to-Consumer Advertising." *Journal of General Internal Medicine* 33, no. 5 (2018): 586–87. https://doi.org/10.1007/s11606-018-4342-9.

Parker, Lacie L., and Jennifer A. Harriger. "Eating Disorders and Disordered Eating Behaviors in the LGBT Population: A Review of the Literature." *Journal of Eating Disorders* 8, no. 1 (2020): 1–20. https://doi.org/10.1186/s40337-020-00327-y.

Paul, Kari. "'It Spreads Like a Disease': How Pro-Eating-Disorder Videos Reach Teens on TikTok." *The Guardian*, October 16, 2021.

Peckmezian, Tina, and Susan J. Paxton. "A Systematic Review of Outcomes Following Residential Treatment for Eating Disorders." *European Eating Disorders Review* 28, no. 3 (May 2020): 246–59. https://doi.org/10.1002/erv.2733.

Perkins, S. J., S. Keville, U. Schmidt, and T. Chalder. "Eating Disorders and Irritable Bowel Syndrome: Is There a Link?" *Journal of Psychosomatic Research* 59, no. 2 (2005): 57–64. https://doi.org/10.1016/j.jpsychores.2004.04.375.

Pétrement, Simone. *Simone Weil: A Life*. New York: Schocken, 1988.

Phillips, Kaitlin. "Ottessa Moshfegh Plays to Win." *The Cut*, July 19, 2018.

Phillips, Tom. "'Everyone Knew She Was Ill. The Other Girls, the Model Agencies . . . Don't Believe It When They Say They Didn't.'" *The Observer*, January 14, 2007.

Pike, Kathleen M., Faith-Anne Dohm, Ruth H. Striegel-Moore, Denise E. Wilfley, and Christopher G. Fairburn. "A Comparison of Black and White Women with Binge Eating Disorder." *American Journal of Psychiatry* 158, no. 9 (2001): 1455–60. https://doi.org/10.1176/appi.ajp.158.9.1455.

Pirie, Iain. "Disordered Eating and the Contradictions of Neoliberal Governance." *Sociology of Health & Illness* 38, no. 6 (2016): 839–53. https://doi.org/10.1111/1467-9566.12408.

——. "The Political Economy of Bulimia Nervosa." *New Political Economy* 16, no. 3 (2011): 323–46. https://doi.org/10.1080/13563467.2011.519020.

Pratt, Laura A., Debra J. Brody, and Quiping Gu. "Antidepressant Use in Persons Aged 12 and Over: United States, 2005–2008." *NCHS Data Brief* 76 (October 2011): 1–8.

Quetelet, Lambert Adolphe Jacques. *A Treatise on Man and the Development of His Faculties.* Edited by T. Smibert. Translated by R. Knox. Cambridge: Cambridge University Press, 2013.

"QuickStats: Suicide Rates for Teens Aged 15–19 Years, by Sex—United States, 1975–2015." *Morbidity and Mortality Weekly Report* 66, no. 30 (August 2017). https://doi.org/10.15585/mmwr.mm6630a6.

Radhakrishnan, Lakshmi, Rebecca T. Leeb, Rebecca H. Bitsko, Kelly Carey, Abigail Gates, Kristin M. Holland, Kathleen P. Hartnett, et al. "Pediatric Emergency Department Visits Associated with Mental Health Conditions Before and During the COVID-19 Pandemic—United States, January 2019–January 2022." *Morbidity and Mortality Weekly Report* 71, no. 8 (February 2022). https://doi.org/10.15585/mmwr.mm7108e2.

Rasmussen, Nicolas. "America's First Amphetamine Epidemic 1929–1971: A Quantitative and Qualitative Retrospective with Implications for the Present." *American Journal of Public Health* 98, no. 6 (2008): 974–85. https://doi.org/10.2105/AJPH.2007.110593.

Regier, Darrel A., William E. Narrow, Emily A. Kuhl, and David J. Kupfer. "The Conceptual Development of *DSM-V*." *American Journal of Psychiatry* 166, no. 6 (2009): 645–50. https://doi.org/10.1176/appi.ajp.2009.09020279.

Richards, Arielle. "Bimbofication Is Taking Over. What Does That Mean for You?" *Vice*, February 2, 2022.

Riebel, Linda. "Hidden Grandiosity in Bulimics." *Psychotherapy: Theory, Research, Practice, Training* 37, no. 2 (2000): 180–88. https://doi.org/10.1037/h0087718.

Roupenian, Kristen. "Cat Person." *The New Yorker*, December 11, 2017.

Russell, Gerald. "Bulimia Nervosa: An Ominous Variant of Anorexia Nervosa." *Psychological Medicine* 9, no. 3 (1979): 429–48. https://doi.org/10.1017/S0033291700031974.

Saito, Yuri A., Philip Schoenfeld, and G. Richard Locke. "The Epidemiology of Irritable Bowel Syndrome in North America: A Systematic Review." *American Journal of Gastroenterology* 97, no. 8 (2002): 1910–15. https://doi.org/10.1016/S0002-9270(02)04270-3.

Salam, Maya. "For Online Daters, Women Peak at 18 While Men Peak at 50, Study Finds. Oy." *New York Times*, August 15, 2018.

Schott, Nicole Danielle, and Debra Langan. "Pro-Anorexia/Bulimia Censorship and Public Service Announcements: The Price of Controlling Women." *Media, Culture & Society* 37, no. 8 (2015): 1158–75. https://doi.org/10.1177/0163443715591672.

Seaber, Emma. "Reading Disorders: Pro–Eating Disorder Rhetoric and Anorexia Life-Writing." *Literature and Medicine* 34, no. 2 (2016): 484–508. https://doi.org/10.1353/lm.2016.0023.

Sedgwick, Eve Kosofsky. *Tendencies.* Series Q. Durham, N.C: Duke University Press, 1993.

Segura-Garcia, Cristina, Carla Ramacciotti, Marianna Rania, Matteo Aloi, Mariarita Caroleo, Antonella Bruni, Denise Gazzarrini, Flora Sinopoli, and Pasquale De Fazio. "The Prevalence of Orthorexia Nervosa Among Eating Disorder Patients After Treatment." *Eating and Weight Disorders* 20, no. 2 (2015): 161–66. https://doi.org/10.1007/s40519-014-0171-y.

Sharma, Jade. *Problems.* Minneapolis, Minn.: Coffee House Press, 2016.

Sher, Gail. "The Fasting Spirit." *San Francisco Jung Institute Library Journal* 8, no. 2 (1988): 61–80. https://doi.org/10.1525/jung.1.1988.8.2.61.

Siber, Kate. " 'You Don't Look Anorexic.' " *New York Times,* October 18, 2022.

Small, Charlynn, and Mazella Fuller, eds. *Treating Black Women with Eating Disorders: A Clinician's Guide.* New York: Routledge, Taylor & Francis Group, 2021.

Smink, Frédérique R. E., Daphne van Hoeken, and Hans W. Hoek. "Epidemiology, Course, and Outcome of Eating Disorders." *Current Opinion in Psychiatry* 26, no. 6 (2013): 543–48. https://doi.org/10.1097/YCO.0b013e328365a24f.

Smyth, B. P., J. Barry, E. Keenan, and K. Ducray. "Lapse and Relapse Following Inpatient Treatment of Opiate Dependence." *Irish Medical Journal* 103, no. 6 (2010): 176–79.

Södersten, P., C. Bergh, M. Leon, U. Brodin, and M. Zandian. "Cognitive Behavior Therapy for Eating Disorders Versus Normalization of Eating Behavior." *Physiology & Behavior* 174 (May 2017): 178–90. https://doi.org/10.1016/j.physbeh.2017.03.016.

Specter, Emma. " 'Mama Cass' Elliot Died Almost 50 Years Ago, but Her Memory Is Still Obscured by Fatphobia." *Vogue,* July 29, 2021.

Srinivasan, Amia. *The Right to Sex: Feminism in the Twenty-First Century.* New York: Farrar, Straus and Giroux, 2021.

Stagg, Natasha. *Sleeveless: Fashion, Image, Media, New York 2011–2019.* South Pasadena, Calif.: Semiotext(e), 2019.

Steiger, Howard, and Linda Booij. "Eating Disorders, Heredity and Environmental Activation: Getting Epigenetic Concepts into Practice." *Journal of Clinical Medicine* 9, no. 5 (2020): 1332. https://doi.org/10.3390/jcm9051332.

Steinhausen, Hans-Christoph. "The Outcome of Anorexia Nervosa in the

20th Century." *American Journal of Psychiatry* 159, no. 8 (2002): 1284–93. https://doi.org/10.1176/appi.ajp.159.8.1284.

———, and Sandy Weber. "The Outcome of Bulimia Nervosa: Findings from One-Quarter Century of Research." *American Journal of Psychiatry* 166, no. 12 (2009): 1331–41. https://doi.org/10.1176/appi.ajp.2009.09040582.

Stice, Eric, C. Nathan Marti, Heather Shaw, and Maryanne Jaconis. "An 8-Year Longitudinal Study of the Natural History of Threshold, Subthreshold, and Partial Eating Disorders from a Community Sample of Adolescents." *Journal of Abnormal Psychology* 118, no. 3 (2009): 587–97. https://doi.org/10.1037/a0016481.

Strickland, Stephanie. *The Red Virgin: A Poem of Simone Weil*. Madison: University of Wisconsin Press, 1993.

Strings, Sabrina. *Fearing the Black Body: The Racial Origins of Fat Phobia*. New York: New York University Press, 2019.

Strober, Michael, Roberta Freeman, and Wendy Morrell. "The Long-Term Course of Severe Anorexia Nervosa in Adolescents: Survival Analysis of Recovery, Relapse, and Outcome Predictors over 10–15 Years in a Prospective Study." *International Journal of Eating Disorders* 22, no. 4 (1997): 339–60. https://doi.org/10.1002/(SICI)1098-108X(199712)22:4<339::AID-EAT1>3.0.CO;2-N.

Strohacker, Kelley, Katie C. Carpenter, and Brian K. McFarlin. "Consequences of Weight Cycling: An Increase in Disease Risk?" *International Journal of Exercise Science* 2, no. 3 (2009): 191–201.

Stunkard, Albert J. *The Pain of Obesity*. Palo Alto, Calif.: Bull Publishing Co., 1976.

———, and Mavis McLaren-Hume. "The Results of Treatment for Obesity: A Review of the Literature and Report of a Series." *AMA Archives of Internal Medicine* 103, no. 1 (1959): 79–85. https://doi.org/10.1001/archinte.1959.00270010085011.

———, R. Berkowitz, T. Wadden, C. Tanrikut, E. Reiss, and L. Young. "Binge Eating Disorder and the Night-Eating Syndrome." *International Journal of Obesity and Related Metabolic Disorders* 20, no. 1 (1996): 1–6.

———, W. J. Grace, and H. G. Wolff. "The Night-Eating Syndrome: A Pattern of Food Intake Among Certain Obese Patients." *American Journal of Medicine* 19, no. 1 (1955): 78–86. https://doi.org/10.1016/0002-9343(55)90276-x.

Sukkar, Isabella, Madeleine Gagan, and Warren Kealy-Bateman. "The 14th Century Religious Women Margery Kempe and Catherine of Siena Can

Still Teach Us Lessons About Eating Disorders Today." *Journal of Eating Disorders* 5, no. 1 (2017): 23. https://doi.org/10.1186/s40337-017-0151-5.

Tadmon, Daniel, and Mark Olfson. "Trends in Outpatient Psychotherapy Provision by U.S. Psychiatrists: 1996–2016." *American Journal of Psychiatry* 179, no. 2 (2002): 110–21. https://doi.org/10.1176/appi.ajp.2021.21040338.

Tan, Jacinta O. A., Tony Hope, and Anne Stewart. "Anorexia Nervosa and Personal Identity: The Accounts of Patients and Their Parents." *International Journal of Law and Psychiatry* 26, no. 5 (2003): 533–48. https://doi.org/10.1016/S0160-2527(03)00085-2.

Thomas, Jennifer J., Lenny R. Vartanian, and Kelly D. Brownell. "The Relationship Between Eating Disorder Not Otherwise Specified (EDNOS) and Officially Recognized Eating Disorders: Meta-Analysis and Implications for *DSM*." *Psychological Bulletin* 135, no. 3 (2009): 407–33. https://doi.org/10.1037/a0015326.

Thomas, Katie. "Shire, Maker of Binge-Eating Drug Vyvanse, First Marketed the Disease." *New York Times,* February 24, 2015.

Tillmann, Lisa M. "Body and Bulimia Revisited: Reflections on 'A Secret Life.'" *Journal of Applied Communication Research* 37, no. 1 (2009): 98–112. https://doi.org/10.1080/00909880802592615.

Tong, Stephanie Tom, Daria Heinemann-LaFave, Jehoon Jeon, Renata Kolodziej-Smith, and Nathaniel Warshay. "The Use of Pro-Ana Blogs for Online Social Support." *Eating Disorders* 21, no. 5 (2013): 408–22. https://doi.org/10.1080/10640266.2013.827538.

Toulany, Alène, Paul Kurdyak, Astrid Guttmann, Thérèse A. Stukel, Longdi Fu, Rachel Strauss, Lisa Fiksenbaum, and Natasha R. Saunders. "Acute Care Visits for Eating Disorders Among Children and Adolescents After the Onset of the COVID-19 Pandemic." *Journal of Adolescent Health* 70, no. 1 (2022): 42–47. https://doi.org/10.1016/j.jadohealth.2021.09.025.

Touyz, Stephen, and Phillipa Hay. "Severe and Enduring Anorexia Nervosa (SE-AN): In Search of a New Paradigm." *Journal of Eating Disorders* 3, no. 1 (2015): 26. https://doi.org/10.1186/s40337-015-0065-z.

Treasure, Janet, and Gerald Russell. "The Case for Early Intervention in Anorexia Nervosa: Theoretical Exploration of Maintaining Factors." *British Journal of Psychiatry* 199, no. 1 (2011): 5–7. https://doi.org/10.1192/bjp.bp.110.087585.

Udo, Tomoko, Sarah Bitley, and Carlos M. Grilo. "Suicide Attempts in US

Adults with Lifetime *DSM-5* Eating Disorders." *BMC Medicine* 17, no. 1 (2019): 120. https://doi.org/10.1186/s12916-019-1352-3.

Udovitch, Mim. "The Way We Live Now: Phenomenon; A Secret Society of the Starving." *New York Times,* September 8, 2002.

UNC Gillings School of Global Public Health. "Survey Finds Disordered Eating Behaviors Among Three Out of Four American Women (Fall, 2008)." *Carolina Public Health Magazine,* September 26, 2008.

U.S. Department of Justice, Office of Public Affairs. "GlaxoSmithKline to Plead Guilty and Pay $3 Billion to Resolve Fraud Allegations and Failure to Report Safety Data." Press release, July 2, 2012.

Vamado, P. J., D. A. Williamson, B. G. Bentz, D. H. Ryan, S. K. Rhodes, P. M. O'Neil, S. B. Sebastian, and S. E. Barker. "Prevalence of Binge Eating Disorder in Obese Adults Seeking Weight Loss Treatment." *Eating and Weight Disorders* 2, no. 3 (1997): 117–24. https://doi.org/10.1007/BF03339961.

Van Pelt, Jennifer. "Eating Disorders on the Web—The Pro-Ana/Pro-Mia Movement." *Social Work Today* 9, no. 5 (2009): 20.

Von Ziegesar, Cecily. *Gossip Girl.* Rev. ed. New York: Poppy, 2020.

Wallach, Judith D., and Eugene H. Lowenkopf. "Five Bulimic Women. MMPI, Rorschach, and TAT Characteristics." *International Journal of Eating Disorders* 3, no. 4 (1984): 53–66. https://doi.org/10.1002/1098-108X(198422)3:4<53::AID-EAT2260030407>3.0.CO;2-Y.

Weil, Simone. *First and Last Notebooks: Supernatural Knowledge.* Simone Weil: Selected Works. Translated by Richard Rees. Eugene, Ore.: Wipf & Stock Publishers, 2015.

———. *Gravity and Grace.* New York: Routledge, 2002.

———. *Simone Weil: An Anthology.* Edited and introduced by Siân Miles. London: Penguin, 2005.

———. *Waiting for God.* New York: Harper Perennial, 2009.

White, Ellen G. *Ellen G. White Letters & Manuscripts with Annotations.* Hagerstown, MD: Review and Herald Publishing Association, 2015.

Whorton, J. "Civilization and the Colon. Constipation as 'the Disease of Diseases.'" *BMJ* 321, no. 7276 (2000): 1586–89. https://doi.org/10.1136/10.1136/321.7276.1586.

Wichstrøm, Lars. "Sexual Orientation as a Risk Factor for Bulimic Symptoms." *International Journal of Eating Disorders* 39, no. 6 (2006): 448–53. https://doi.org/10.1002/eat.20286.

Wilder, Darcie. *Literally Show Me a Healthy Person.* New York: Tyrant Books, 2017.

Wildes, Jennifer E., Kelsie T. Forbush, Kelsey E. Hagan, Marsha D. Marcus, Evelyn Attia, Loren M. Gianini, and Wei Wu. "Characterizing Severe and Enduring Anorexia Nervosa: An Empirical Approach." *International Journal of Eating Disorders* 50, no. 4 (2017): 389–97. https://doi.org/10.1002/eat.22651.

Wing, Rena R., and Suzanne Phelan. "Long-Term Weight Loss Maintenance." *American Journal of Clinical Nutrition* 82, no. 1 (2005): 222S–225S. https://doi.org/10.1093/ajcn/82.1.222S.

Wolf, Gary. "The Data-Driven Life." *New York Times,* April 28, 2010.

Wolf, Naomi. *The Beauty Myth: How Images of Beauty Are Used Against Women.* New York: Harper Perennial, 2002.

Wollen, Audrey. "Middle Sister." *Affidavit,* March 10, 2020.

Wolpert, Stuart. "Dieting Does Not Work, UCLA Researchers Report." *UCLA Newsroom,* April 3, 2007.

Wurtzel, Elizabeth. *Prozac Nation: Young and Depressed in America.* Bridgewater, N.J.: Replica Books, 1999.

Yager, Joel. "Managing Patients with Severe and Enduring Anorexia Nervosa: When Is Enough, Enough?" *Journal of Nervous & Mental Disease* 208, no. 4 (2020): 277–82. https://doi.org/10.1097/NMD.0000000000001124.

———. "Why Defend Harm Reduction for Severe and Enduring Eating Disorders? Who Wouldn't Want to Reduce Harms?" *American Journal of Bioethics* 21, no. 7 (2021): 57–59. https://doi.org/10.1080/15265161.2021.1926160.

———, Jennifer L. Gaudiani, and Jonathan Treem. "Eating Disorders and Palliative Care Specialists Require Definitional Consensus and Clinical Guidance Regarding Terminal Anorexia Nervosa: Addressing Concerns and Moving Forward." *Journal of Eating Disorders* 10, no. 1 (2022): 135. https://doi.org/10.1186/s40337-022-00659-x.

Yale, Madame. *Madame Yale's System of Physical and Beauty Culture.* New York: Madame Yale, 1909.

Younger, Jordan. *Breaking Vegan: One Woman's Journey from Veganism, Extreme Dieting, and Orthorexia to a More Balanced Life.* Beverly, Mass.: Fair Winds Press, 2016.

Yudkovitz, Elaine. "Bulimia: Growing Awareness of an Eating Disorder." *Social Work* 28, no. 6 (1983): 472–78. https://doi.org/10.1093/sw/28.6.472.

Zhao, Yafu, and William Encinosa. "Hospitalizations for Eating Disorders from 1999 to 2006." In *Healthcare Cost and Utilization Project (HCUP)*

Statistical Briefs [Internet]. Rockville, Md.: Agency for Healthcare Research and Quality (U.S.), 2006. Statistical Brief #70.

————. "An Update on Hospitalizations for Eating Disorders, 1999 to 2009." In *Healthcare Cost and Utilization Project (HCUP) Statistical Briefs [Internet].* Rockville, Md.: Agency for Healthcare Research and Quality (U.S.), 2011. Statistical Brief #120.

Zuboff, Shoshana. *The Age of Surveillance Capitalism: The Fight for a Human Future at the New Frontier of Power.* New York: PublicAffairs, 2019.

A Note About the Author

Emmeline Clein's writing has appeared in *The New York Times Magazine*, *The Yale Review*, *The Nation*, *Smithsonian*, *Berlin Quarterly*, *VICE*, BuzzFeed, *Catapult*, and *Antigravity*, among other publications. Her chapbook, *Toxic*, was published by Choo Choo Press in 2022. She received her MFA from Columbia's School of the Arts; she lives in New York.

A Note on the Type

This book is set in Fournier, a font designed by Pierre-Simon Fournier le jeune (1712–1768). In 1764 and 1766 he published his *Manuel typographique,* a treatise on the history of French types and printing and the measurement of type by the point system.

Typeset by Scribe, Philadelphia, Pennsylvania

Printed and bound by Berryville Graphics, Berryville, Virginia

Designed by Betty Lew